This Book is Presented with Best Wishes from:

ROBERT J. REBY & COMPANY

2001

AMERICA
The Beautiful

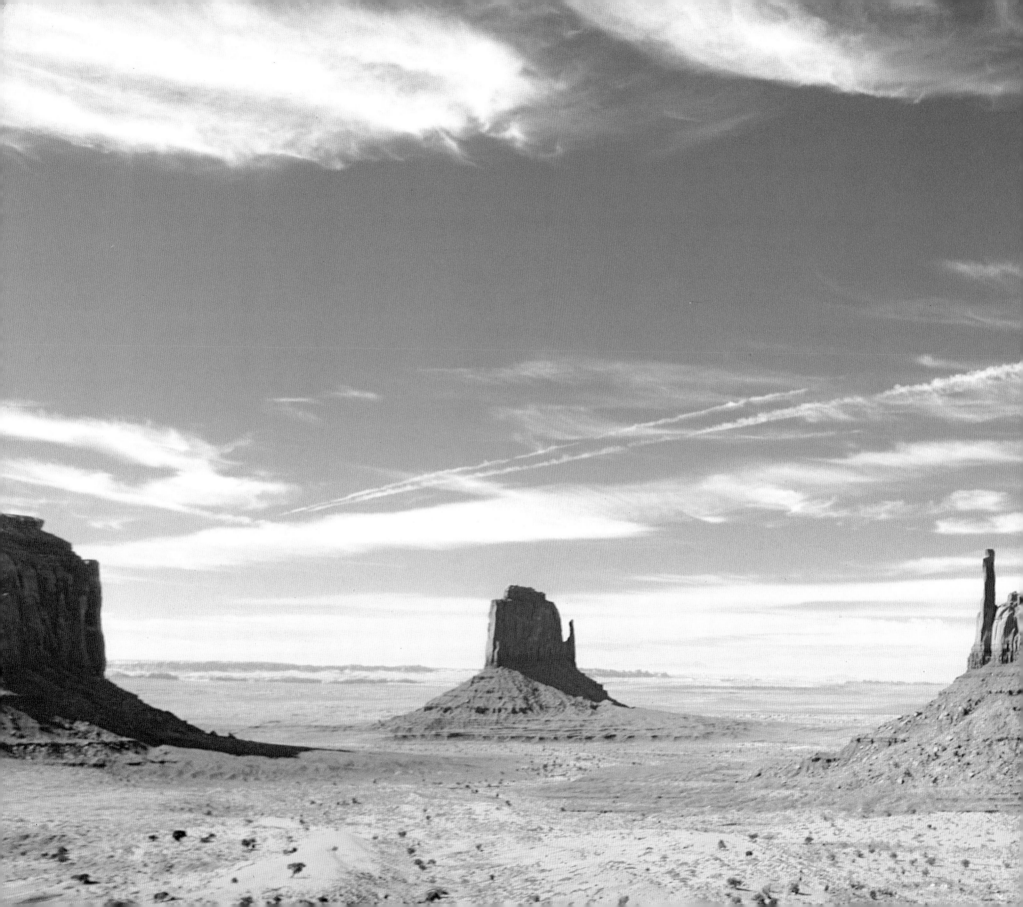

AMERICA
The Beautiful

ROBIN LANGLEY SOMMER

MetroBooks

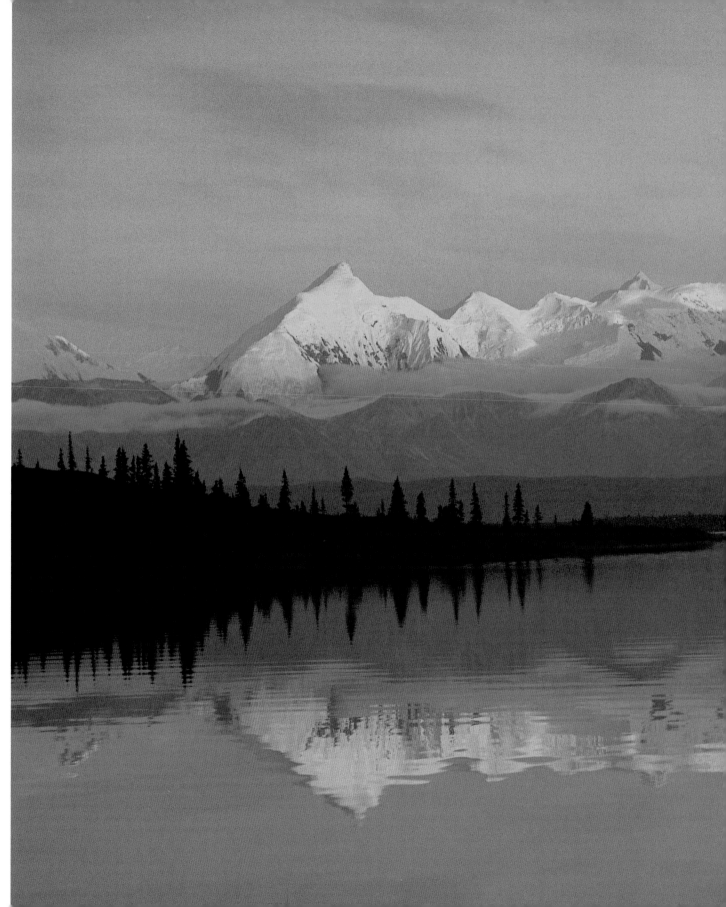

MetroBooks

An Imprint of the Michael Friedman Publishing Group, Inc.

©1993 Brompton Books
reprinted by Michael Friedman Publishing Group, Inc.

ISBN 1-58663-250-7

Printed in China by Leefung-Asco Printers Ltd.

3 5 7 9 10 8 6 4 2

For bulk purchases and special sales, please contact:
Friedman/Fairfax Publishers
Attention: Sales Department
230 Fifth Avenue
New York, NY 10001
212/685-6610 FAX 212/685-3916

Visit our website:
www.metrobooks.com

PAGE 1: The Portland Head Lighthouse on the rocky coast of Maine. George Washington ordered the construction of the lighthouse in 1790.

PAGES 2-3: Monument Valley, located on the Arizona–Utah border within the Navajo Indian Reservation, was often the setting for director John Ford's Westerns, beginning with *Stagecoach* in 1939.

PAGES 4-5: Wonder Lake and the Alaska Range in Denali National Park, Alaska. The four-million-acre park contains the highest mountain in North America, glaciers, caribou and grizzly bears.

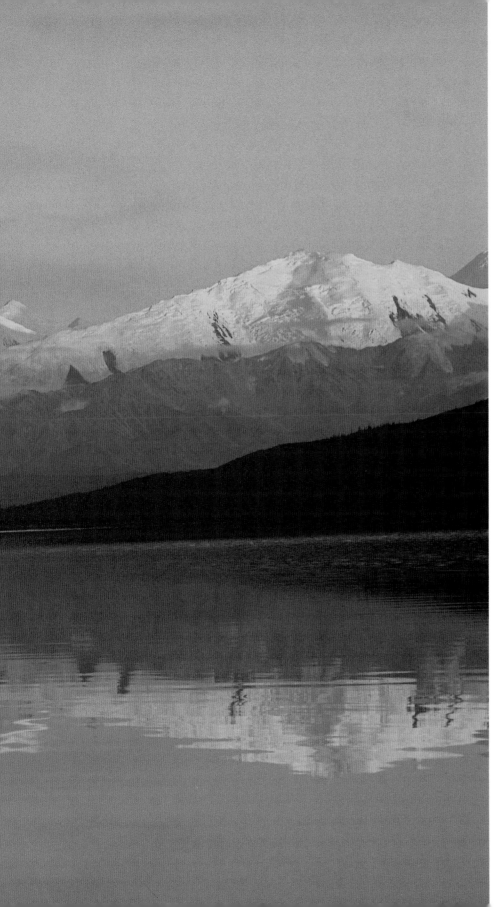

CONTENTS

INTRODUCTION

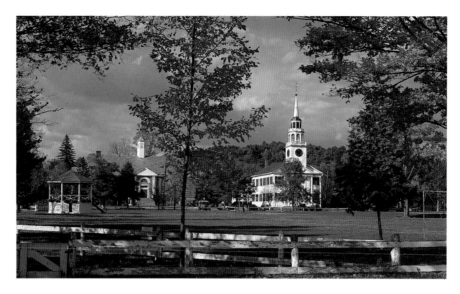

The richness and variety of America the beautiful can only be hinted at in a book. To grasp it more fully, one must travel the country roads, city streets, small towns, and suburbs of the nation. The diversity of America's places and people reflects the many ethnic, cultural, and geographic strands that have been woven together to form the tapestry of American life. In the process, the country has continuously reinvented itself, so that it is difficult to say, "Here is America," or "There she is."

The seaside and inland towns of New England, with their white clapboard churches and village greens, still have much in common with Old England, from which so many settlers came. The bustling cities, shores, and farmlands of the Middle Atlantic States eventually give way to the warmer climates and historic battlegrounds of the Deep South, where life is still lived at a more relaxed pace despite the growth and prosperity of the Sun Belt's recent past. Florida's vacation facilities, palm-studded beaches, keys, and Everglades make it a world apart, both resort and permanent home for millions of Americans in search of the subtropical good life.

America's heartland, the Middle West, has its own beauties of rolling countryside, prairies, rich agricultural areas and prosperous cities. The Southwest maintains its ties with its Indian and Hispanic past while looking toward the 21st century in terms of technology, population growth, finance, and commerce. West of the Rocky Mountains, the Pacific Northwest and Alaska exert their powerful attractions of seacoast, mountains, ports, and waterways. Far out in the Pacific, Hawaii enjoys the fragrant trade winds and tropical flowers of an island paradise. All this and more has been captured in fleeting glimpses for this "family album" of the nation.

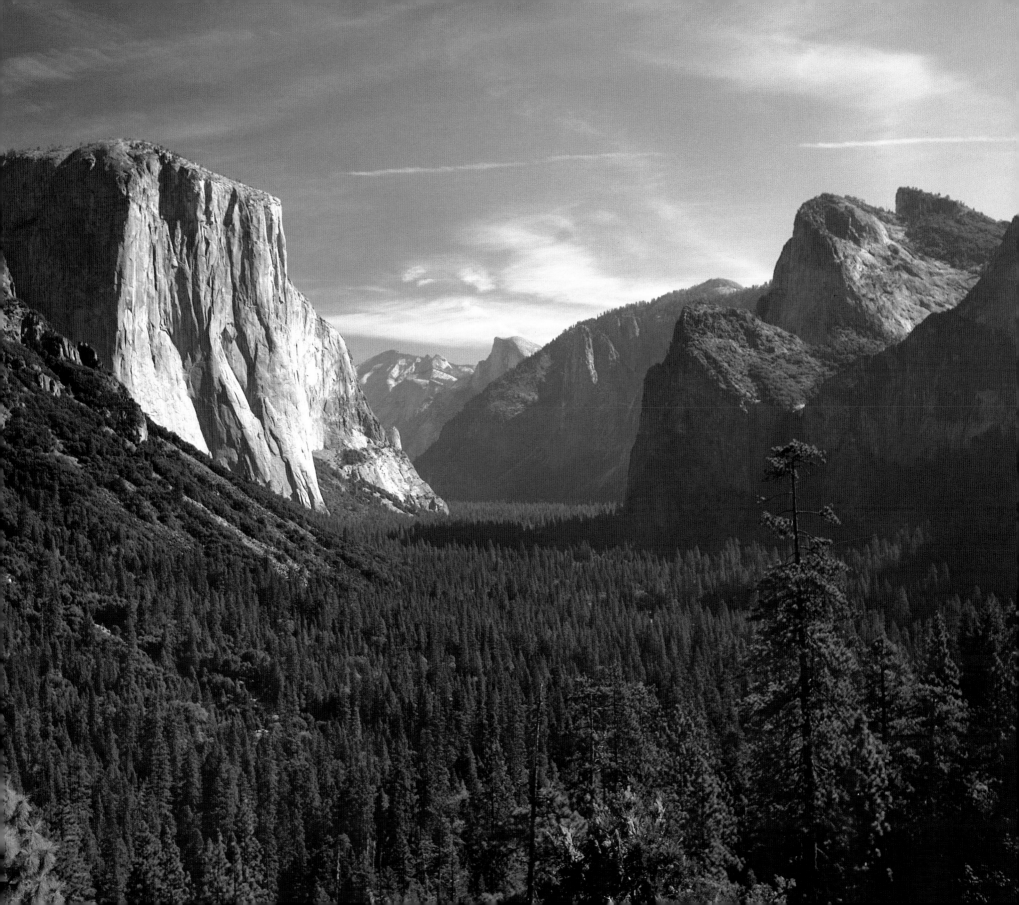

NEW ENGLAND

The region we call New England – which includes Maine, New Hampshire, Vermont, Massachusetts, Rhode Island, and Connecticut – has been shaped by the great glaciers of the Ice Age and by the Atlantic Ocean. Its waters carried hardy settlers from the Old World to establish communities near its bays and harbors. Atlantic waters were a source of food and a trade route to other parts of the world. Skilled shipbuilders launched their fleets from Boston and Providence, which are important centers of trade and commerce to this day. Commercial fishermen and sport fishermen still ply the region's waters.

New England shorelines vary from the sheer rock cliffs of Maine to the flat, sandy ground of the lower coastal plain. Many islands and navigational hazards dot the coast, whose many lighthouses recall the days of sailing ships. Fierce winter storms – Northeasters – may ravage shoreline communities that are idyllic resorts during the mild summer months. Many salt marshes support a unique ecological community, including muskrats, seabirds, otters, rabbits, and raccoons. Swaying beach grass sinks its roots deep into the sandy soil and provides food and shelter for many small life forms, and pink marsh mallows add color to the scene.

Farther inland, there are still extensive woodlands of deciduous and evergreen trees and shrubs, with their undergrowth. Population density has almost eliminated former wild animal populations such as the mountain lion and the bear, but animals that have adapted to manmade communities are thriving – deer and rabbits are the bane of New England gardeners. This historic region provides a wealth of sights, sounds, and cultural attractions for its residents and visitors.

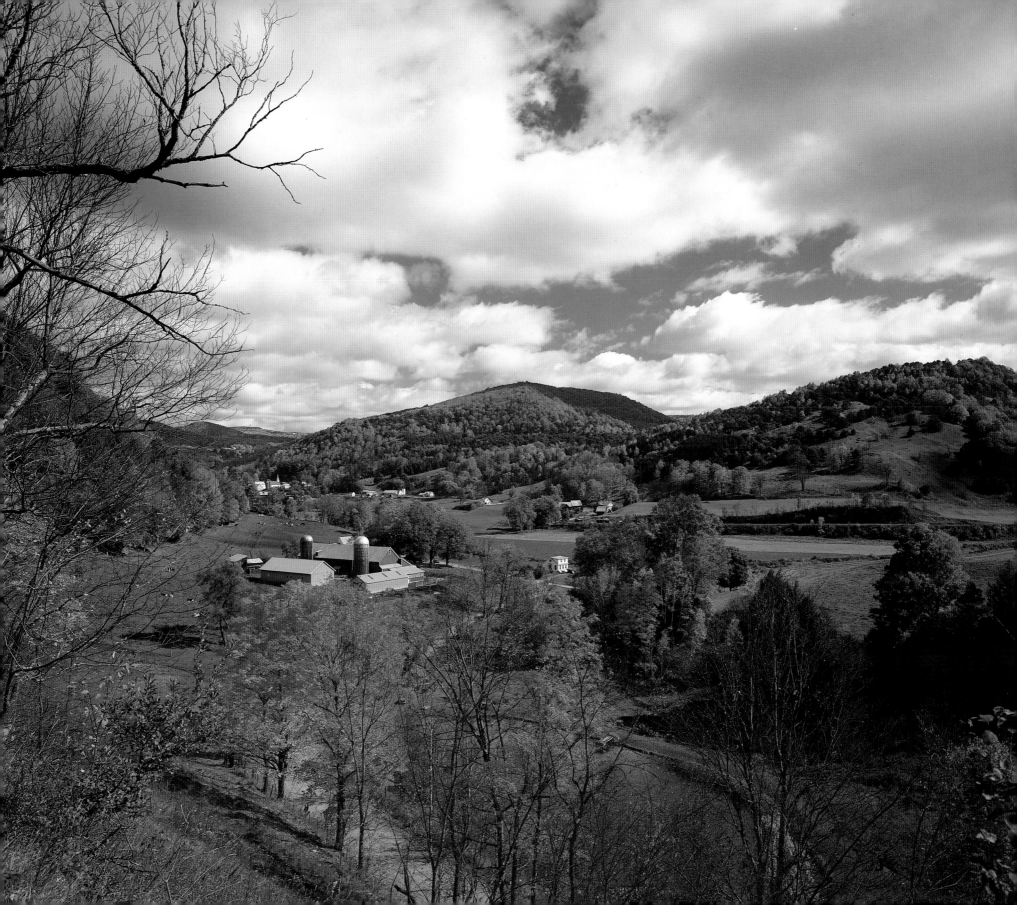

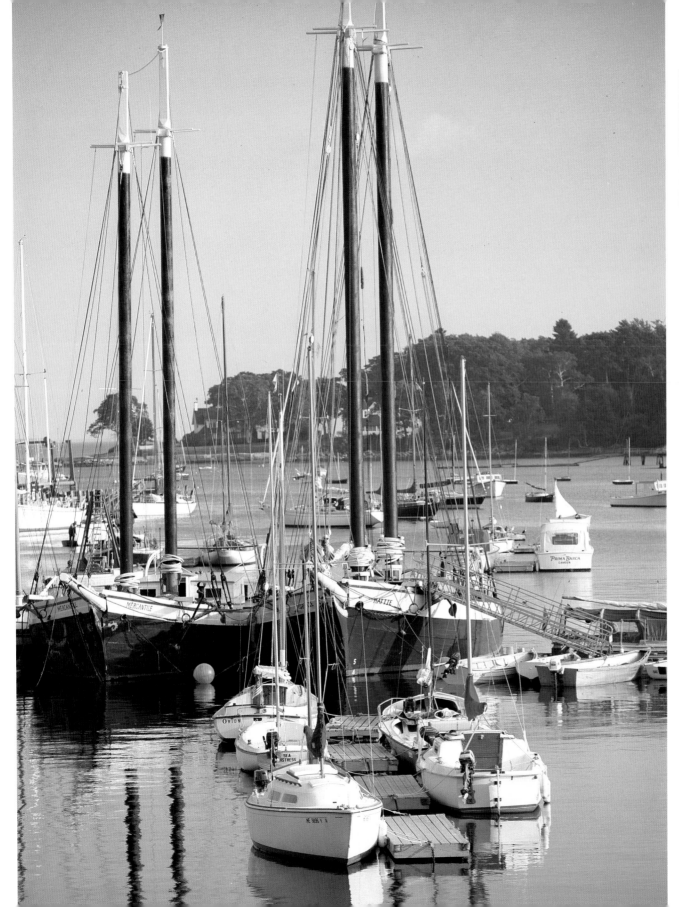

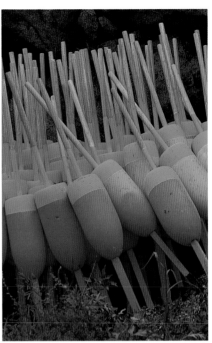

LEFT: For Down-Easters, boating is as natural as breathing.

ABOVE: Colorful floats await their return to Atlantic waters.

OPPOSITE: The lighthouse at Pemaquid Point, Maine, built in 1827, crowns a steep cliff of rock along the rugged coast.

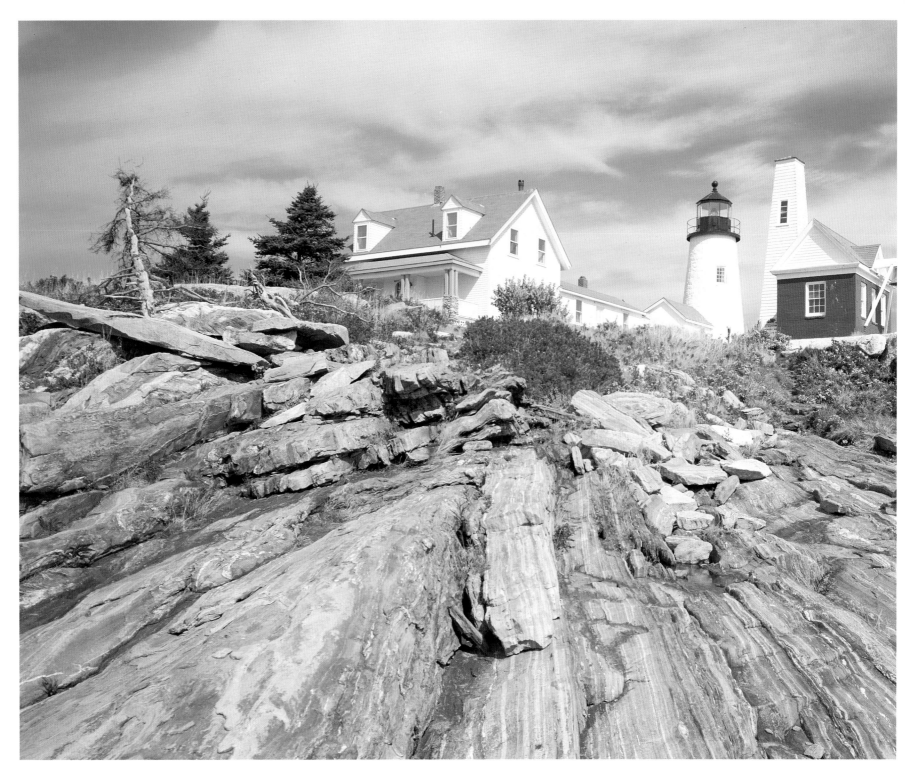

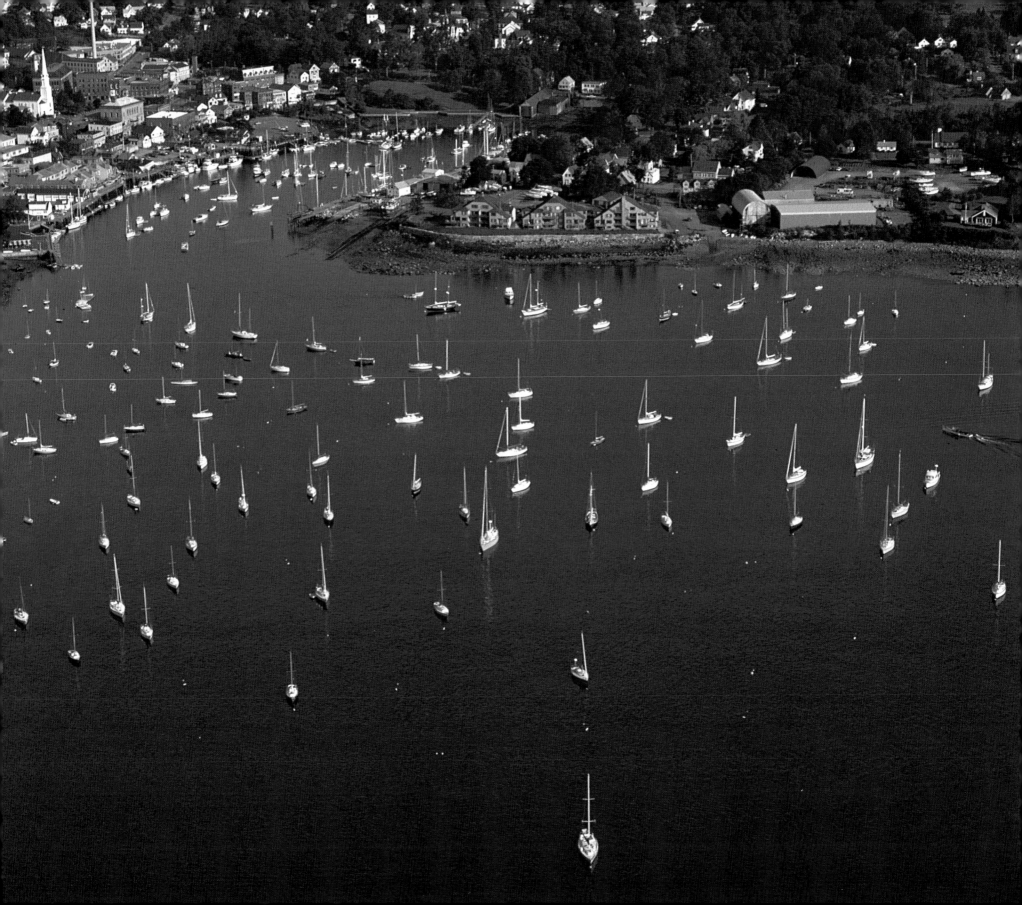

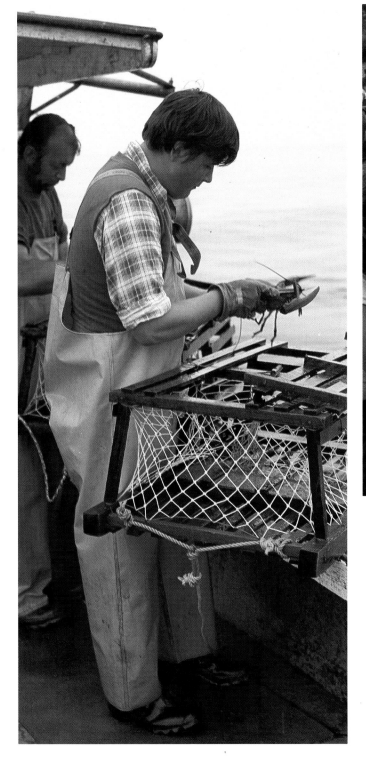

OPPOSITE: The coastal resort of Camden, Maine, is a haven for yachtsmen. It overlooks Penobscot Bay with its scenic islands.

LEFT: A lobsterman at work. Maine supplies more pounds of lobster to the rest of America than any other state.

ABOVE: Lobster and clam bakes are a popular feature of summer vacations in Maine. Summer fare is plentiful and hearty for appetites sharpened by the salt air.

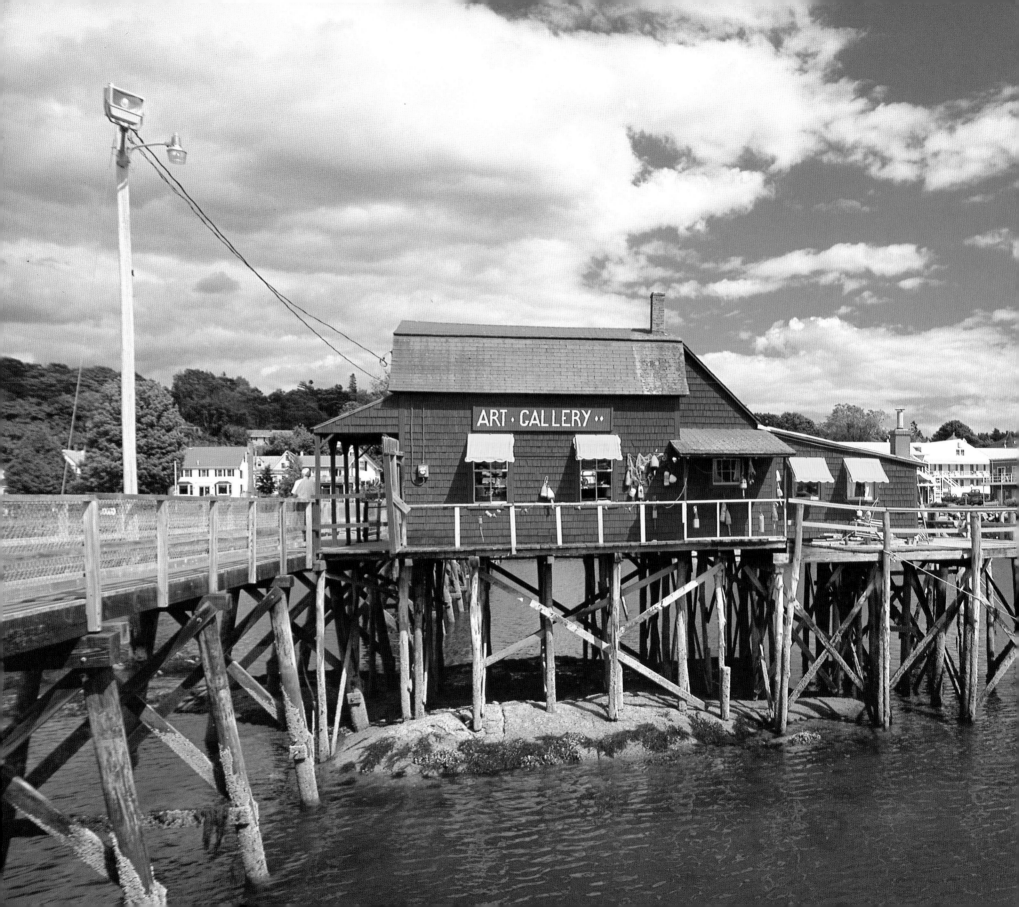

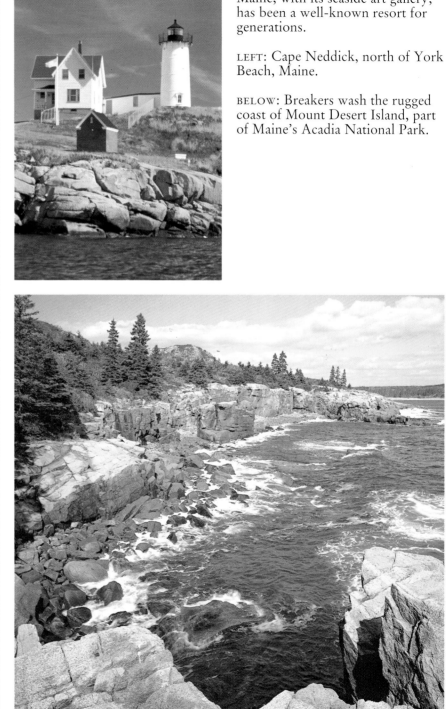

FAR LEFT: Boothbay Harbor, Maine, with its seaside art gallery, has been a well-known resort for generations.

LEFT: Cape Neddick, north of York Beach, Maine.

BELOW: Breakers wash the rugged coast of Mount Desert Island, part of Maine's Acadia National Park.

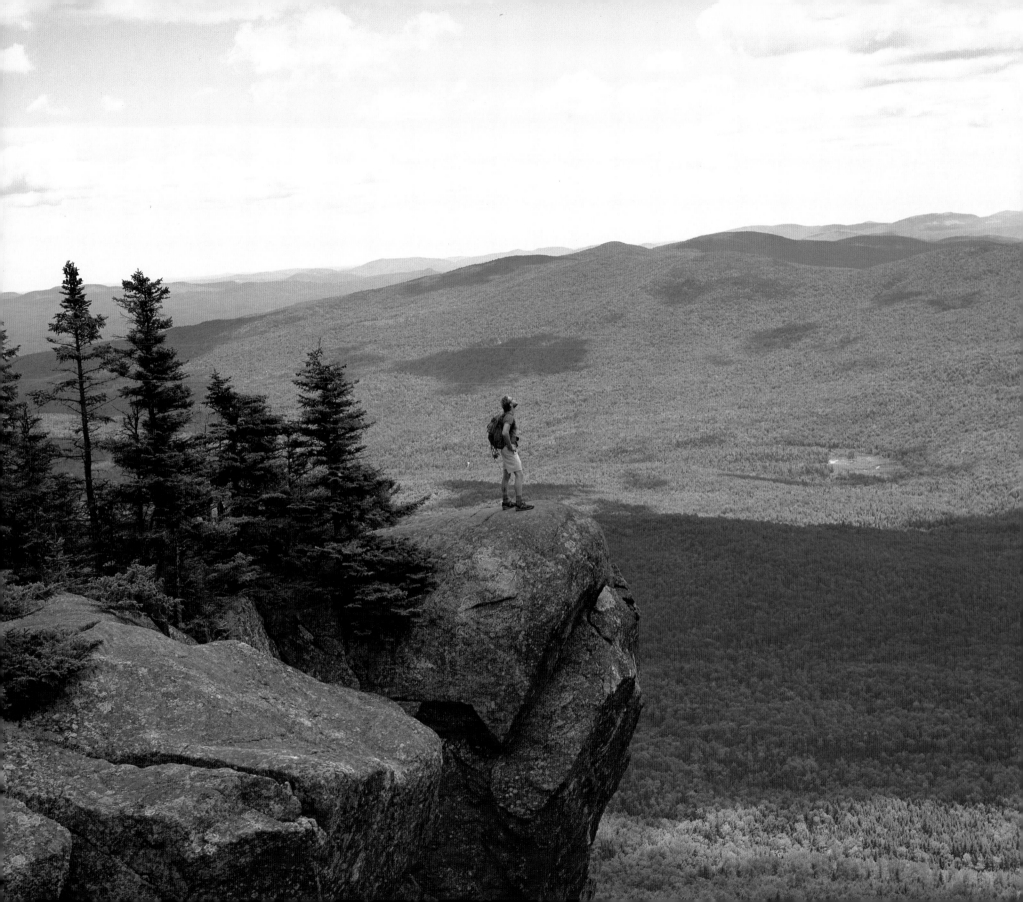

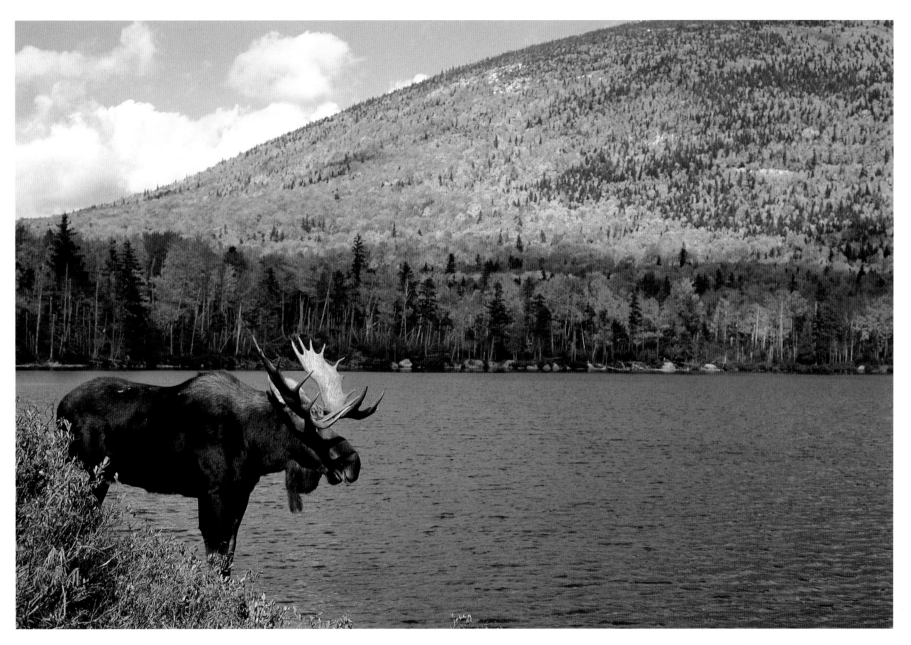

OPPOSITE: A hiker's long trek is rewarded with a breathtaking view from the promontory at Tumbledown, Maine.

ABOVE: A magnificent bull moose grazes on water plants in the safety of Baxter State Park, Maine.

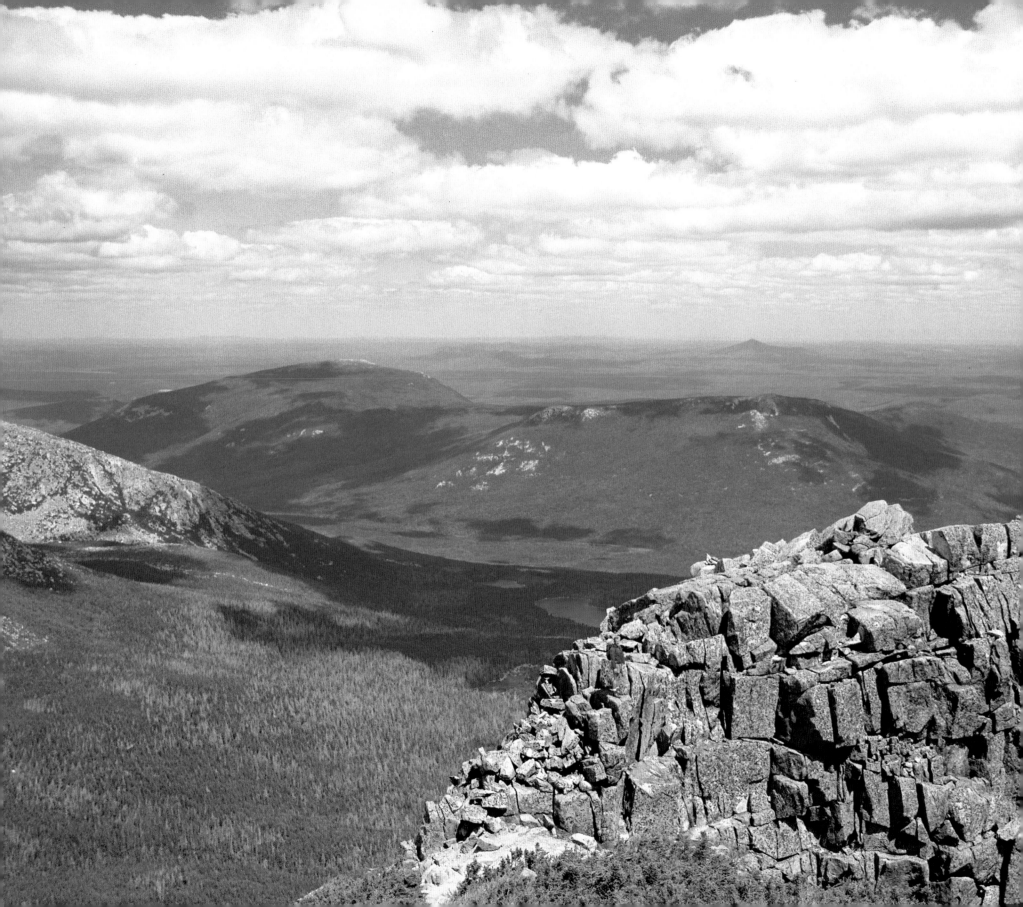

LEFT: The imposing rock formation called Knife's Edge on Maine's Mount Katahdin, in Baxter State Park.

RIGHT: A Down East farmer sorts eggs for market.

BELOW: Elegant Bar Harbor rivaled Newport, Rhode Island, as a resort for wealthy and socially prominent Easterners during the 19th century.

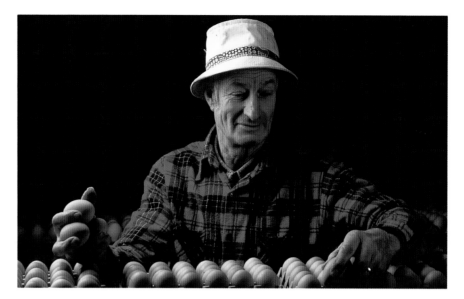

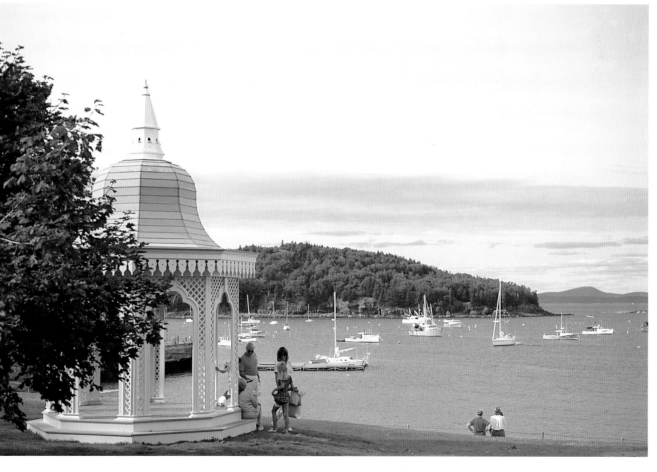

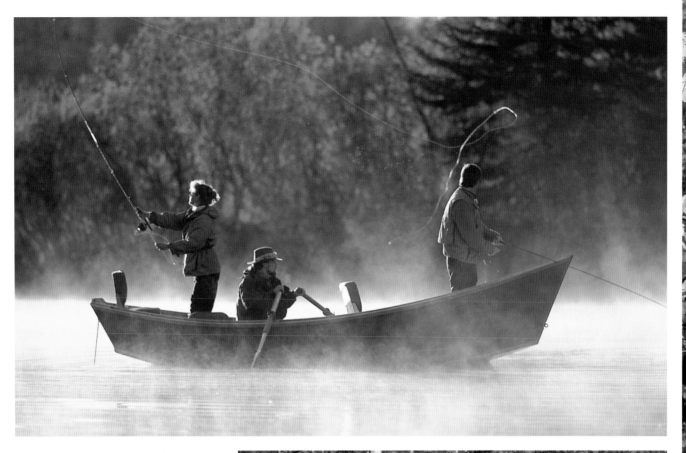

ABOVE: Maine is a mecca for those who love to fish. Here's a group on the Androscoggin River.

RIGHT: Exotic livestock – South American llamas – are an unusual sight in placid Jackson, New Hampshire.

FAR RIGHT: A historic covered bridge carries a country road across New Hampshire's Swift River.

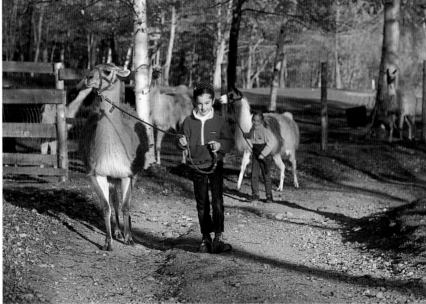

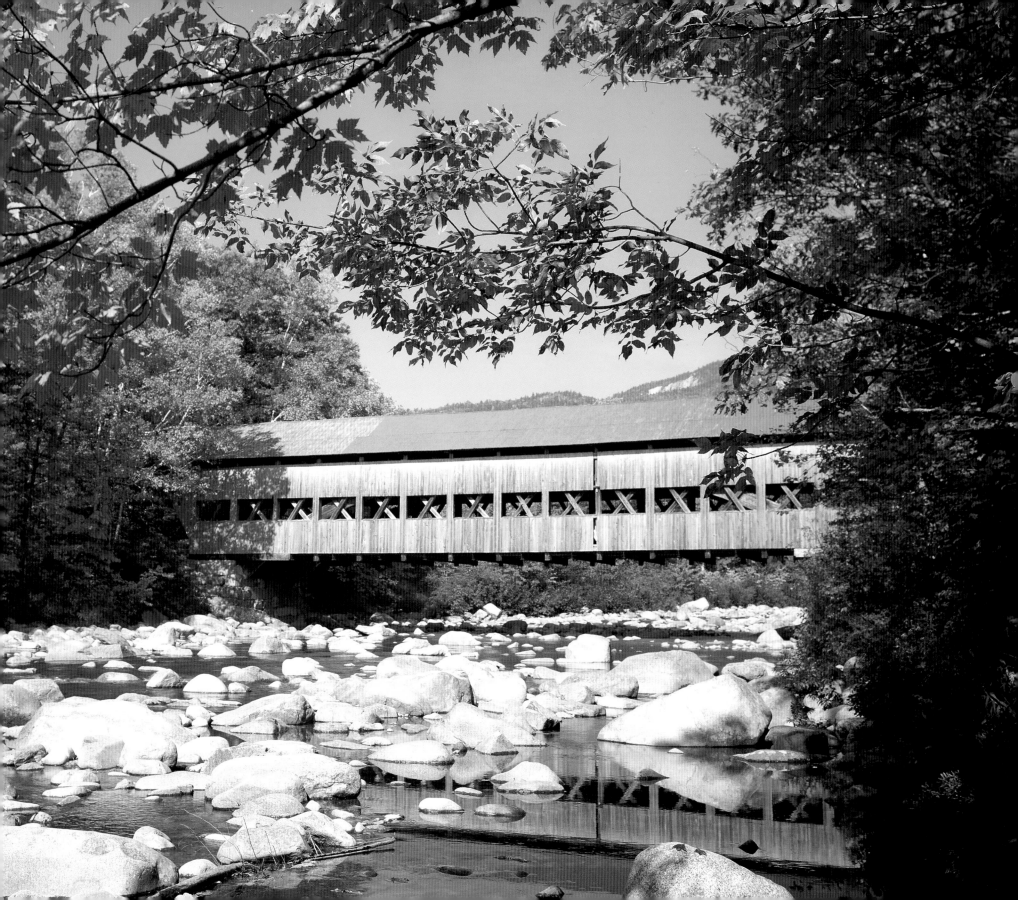

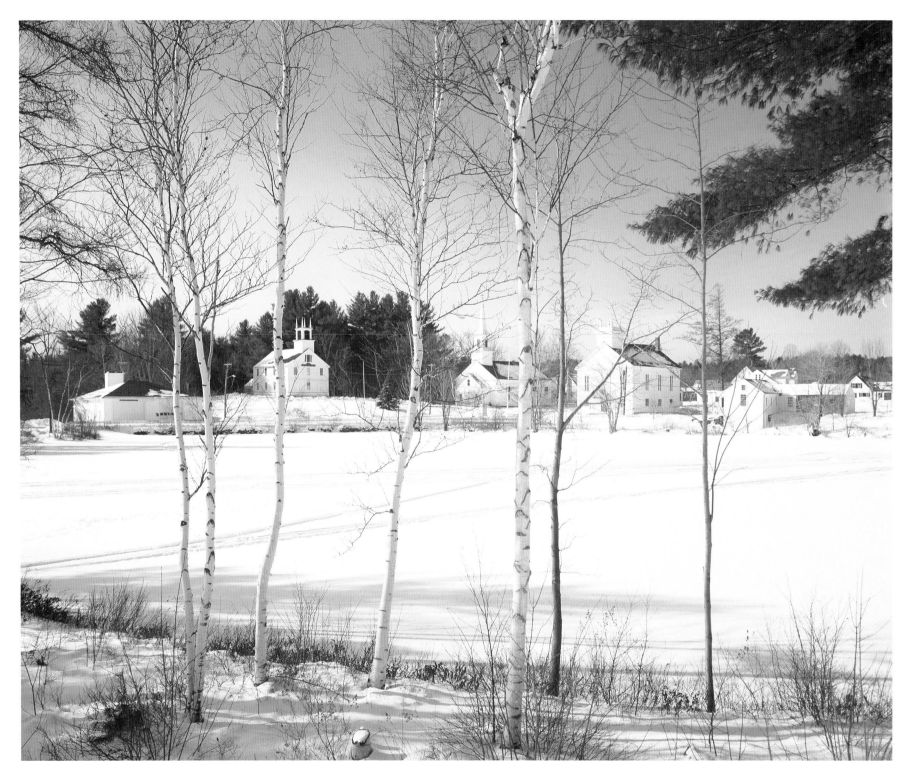

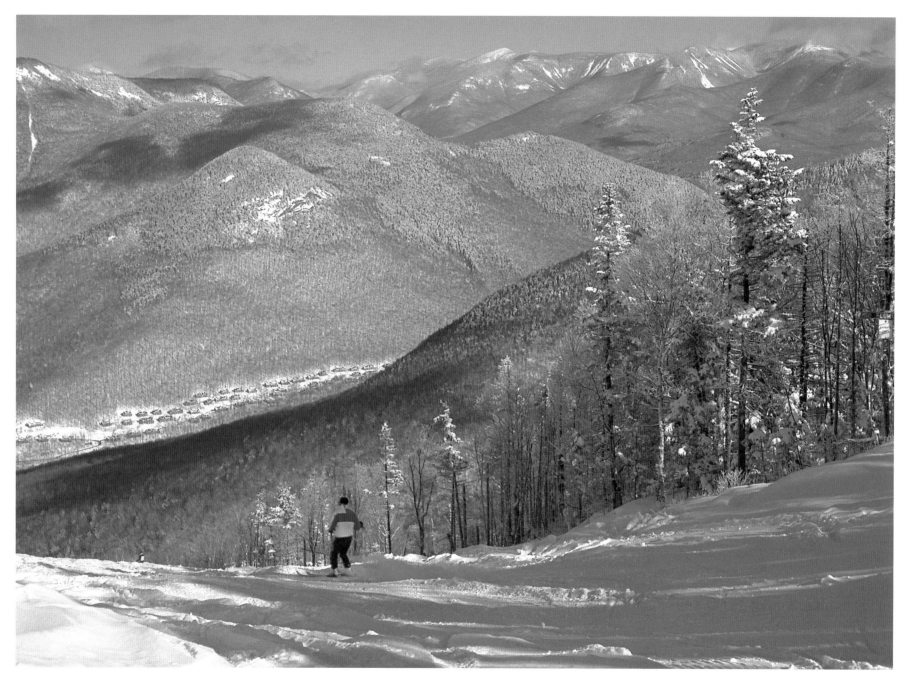

OPPOSITE: Marlow, New Hampshire, along the Asheulot River, under snow, framed by evergreens and graceful white birches: a picture of serenity.

ABOVE: Skiers come into their own on Loon Mountain, in New Hampshire. The state is still largely rural and offers many exciting winter sports.

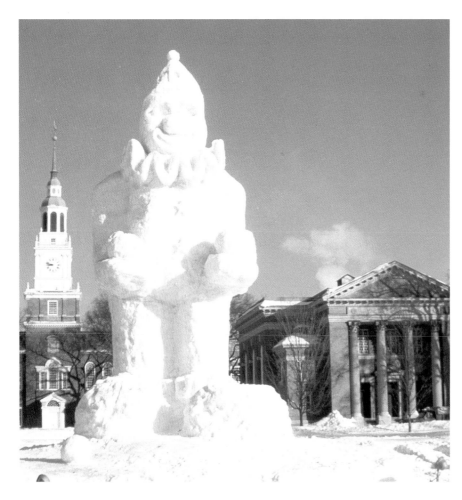

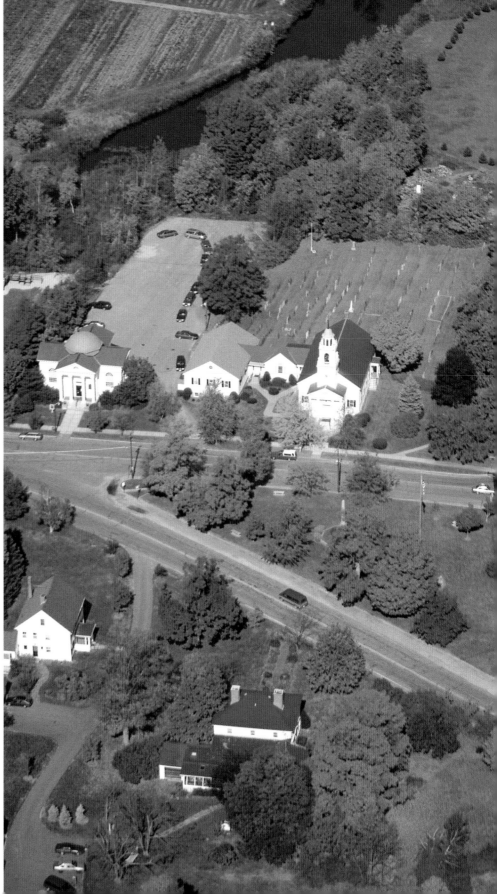

ABOVE: Winter Carnival time at Dartmouth, one of the nation's oldest colleges, in Hanover, New Hampshire.

RIGHT: An aerial view of well-tended Hollis, New Hampshire.

OPPOSITE TOP RIGHT: The 18th century comes back to life at Strawberry Banke Museum in Portsmouth, New Hampshire.

OPPOSITE BOTTOM RIGHT: President Franklin Pierce grew up in this house in Hillsboro, New Hampshire. The Franklin Pierce Homestead was built in 1804.

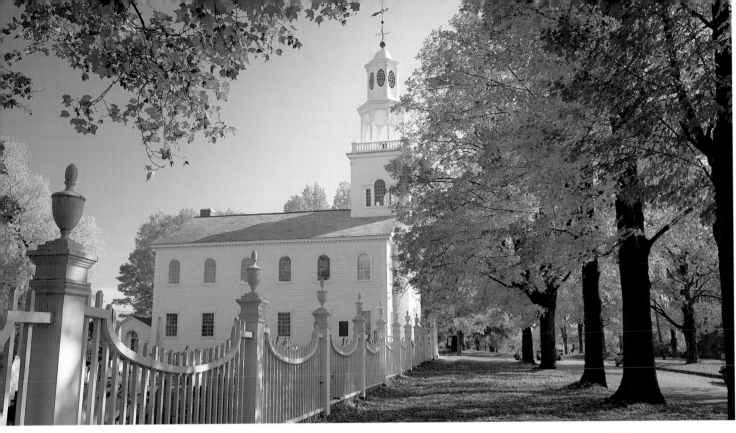

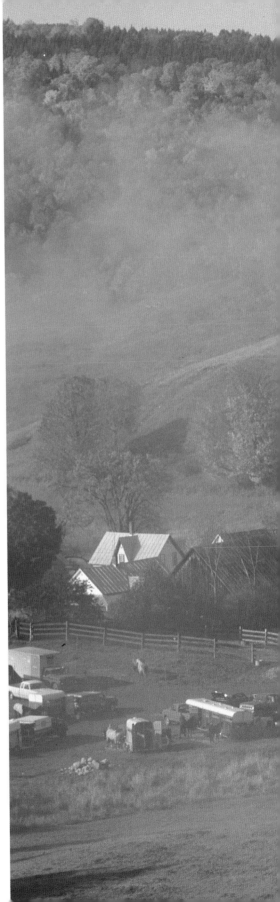

ABOVE: Graceful fence posts surmounted by urns enclose the cemetery of this New England Colonial church in Bennington, Vermont.

LEFT: The arrival of fall stills a fountain in Newfane, Vermont, and sets colorful leaves floating in its basin.

RIGHT: Morning mist slowly dissipates over East Corinth, Vermont.

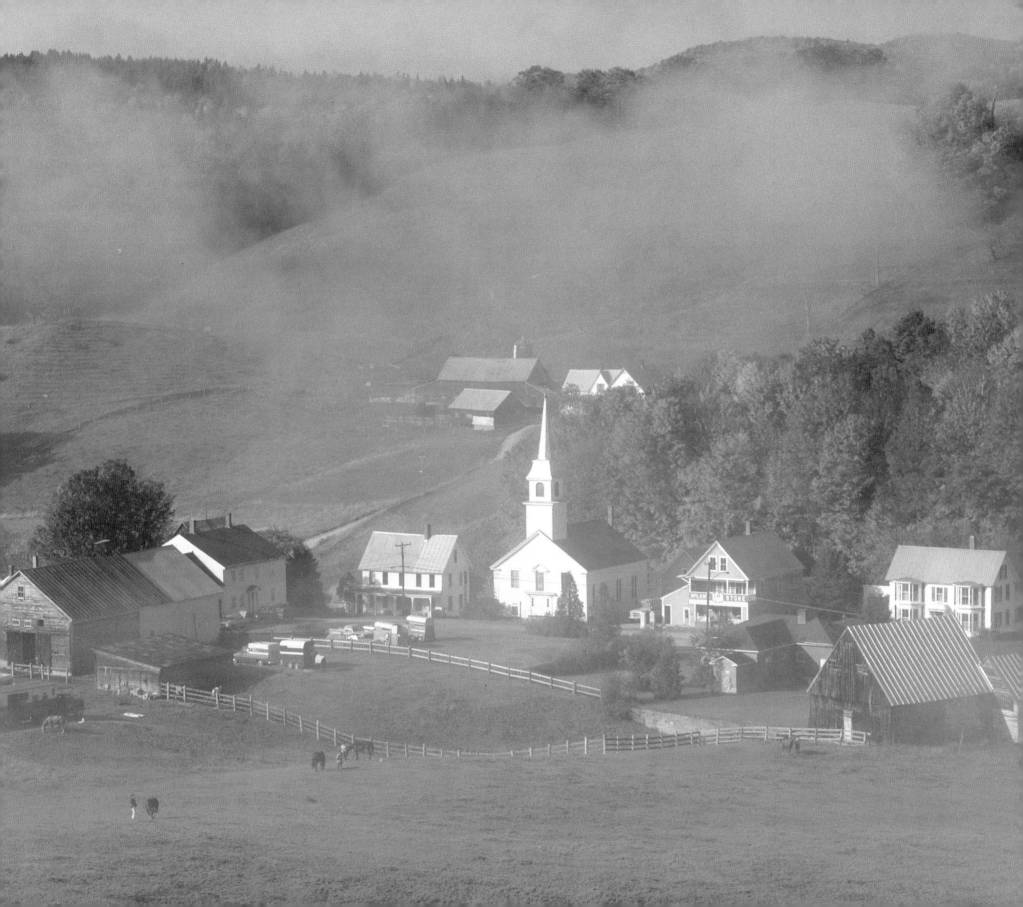

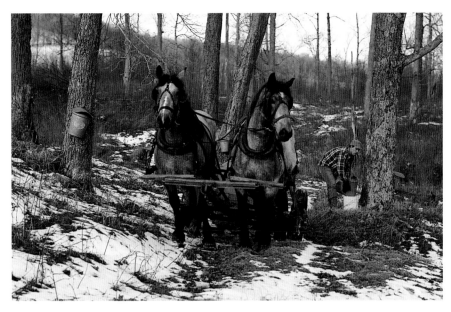

LEFT: Maple sugaring the traditional way in Franklin County, Vermont, as sap is collected from the maple trees.

BELOW: A panoramic view greets these skiers on Vermont's Jay Peak.

RIGHT: A dairy farm under snow in Reading, Vermont.

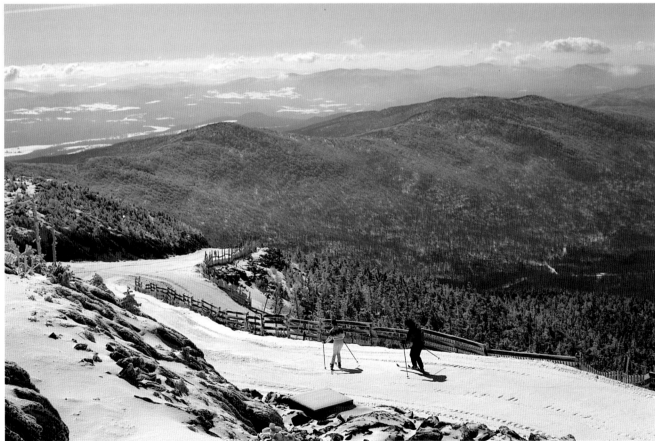

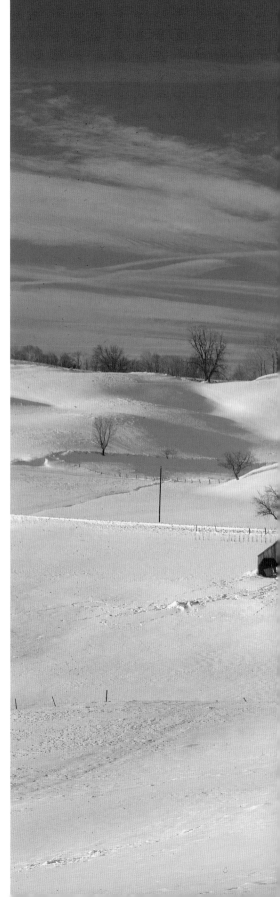

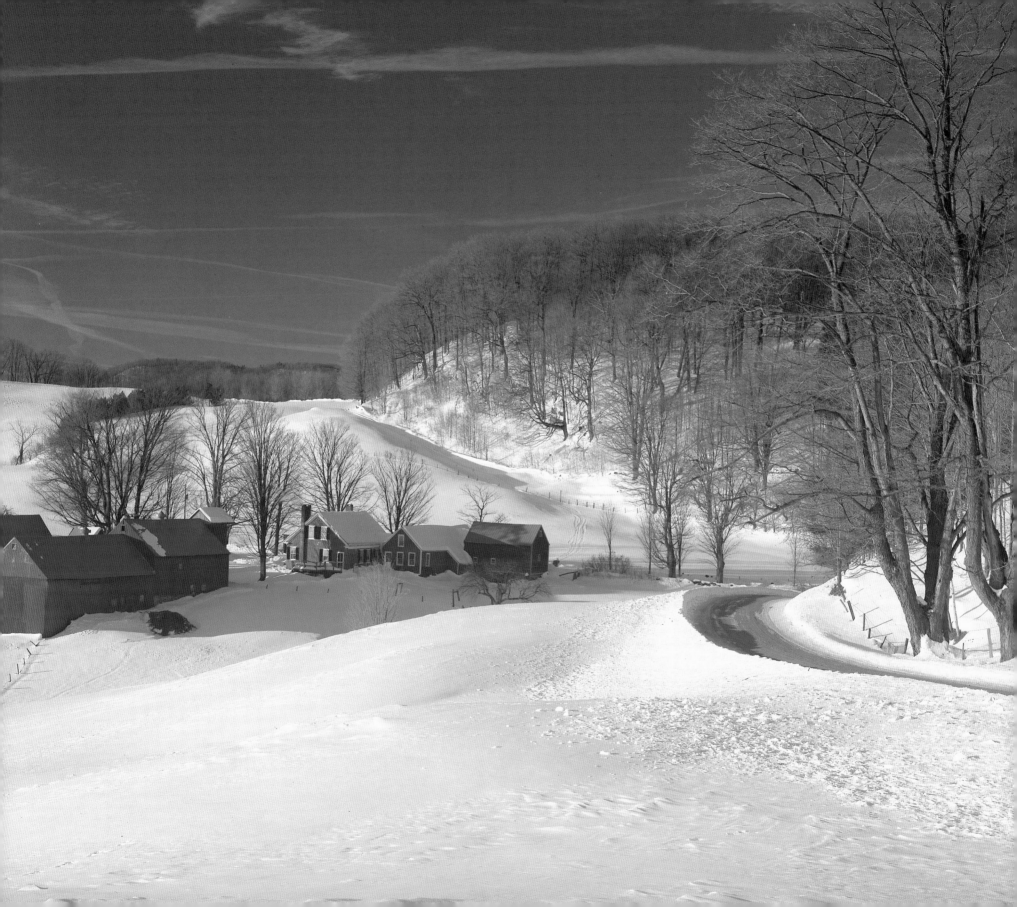

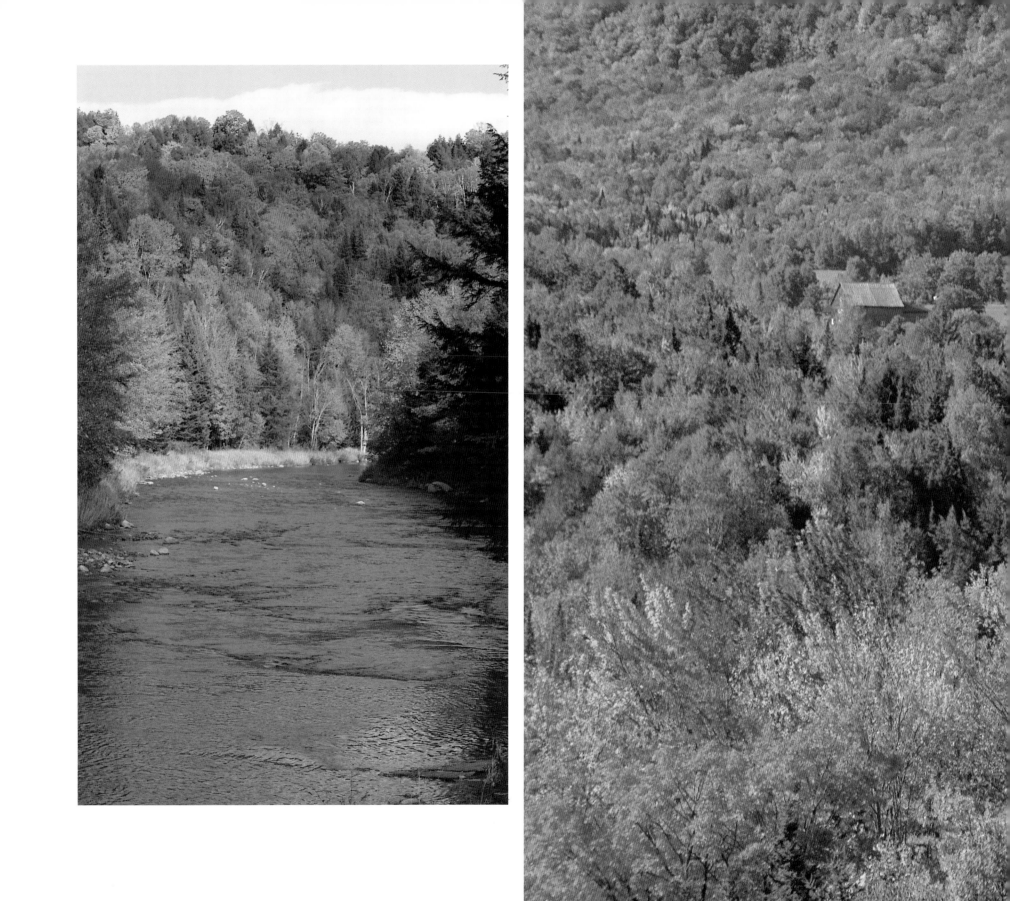

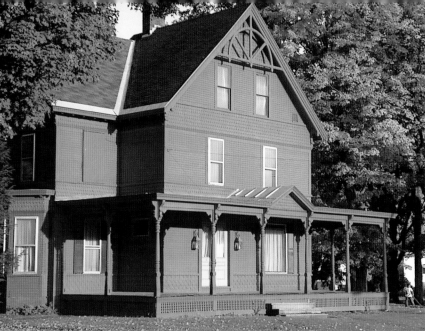

OPPOSITE FAR LEFT: A stream makes its way through a Vermont woodland as the leaves change colors.

CENTER: Fall foliage attracts many visitors to scenic Danville, Vermont, and similar sites in the Green Mountain State.

LEFT: A traditional rust-colored homestead in Bethel, Vermont, dates back to Colonial times.

BELOW: Outdoor markets on the village green are still a feature of life in Royalton, Vermont.

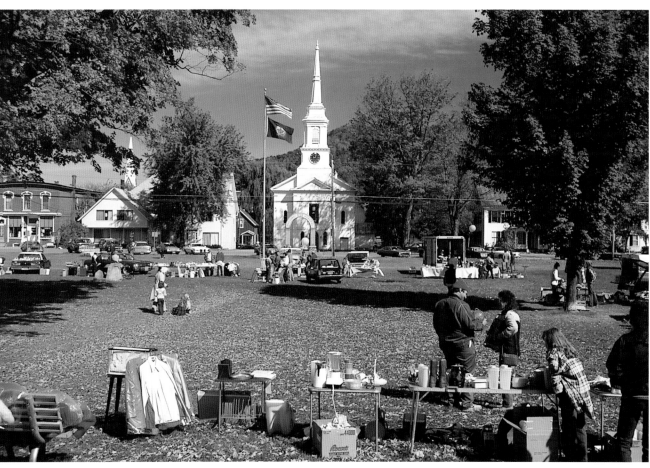

33

RIGHT: The marketplace at historic Faneuil Hall in New England's queen city, Boston.

BELOW: Haymarket Square draws farmers and merchants to Boston for the trade in fresh produce.

FAR RIGHT: Part of Boston's skyline, as seen from the Charles River.

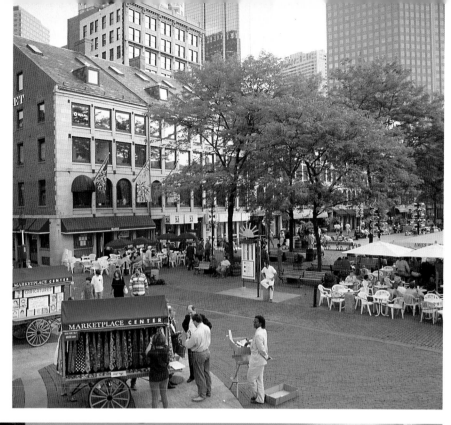

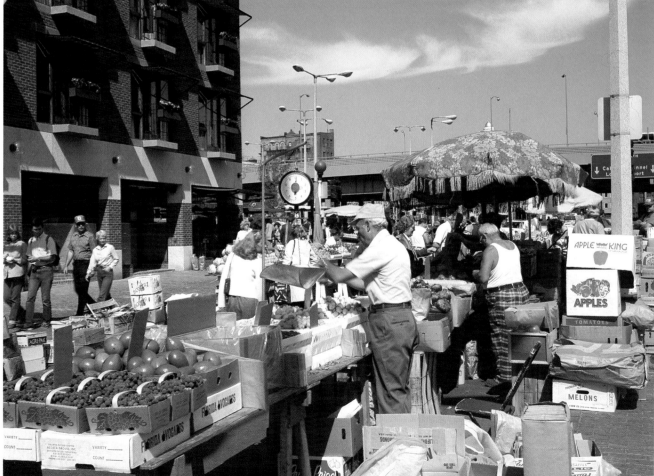

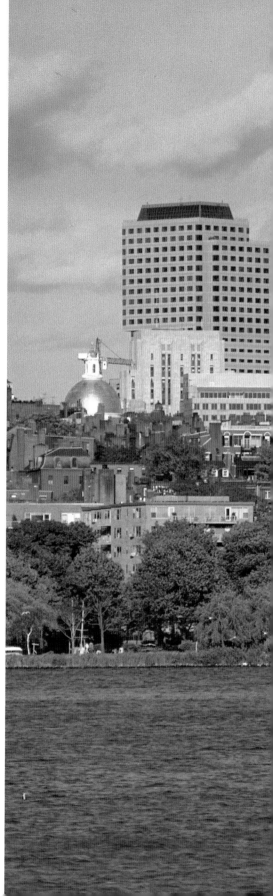

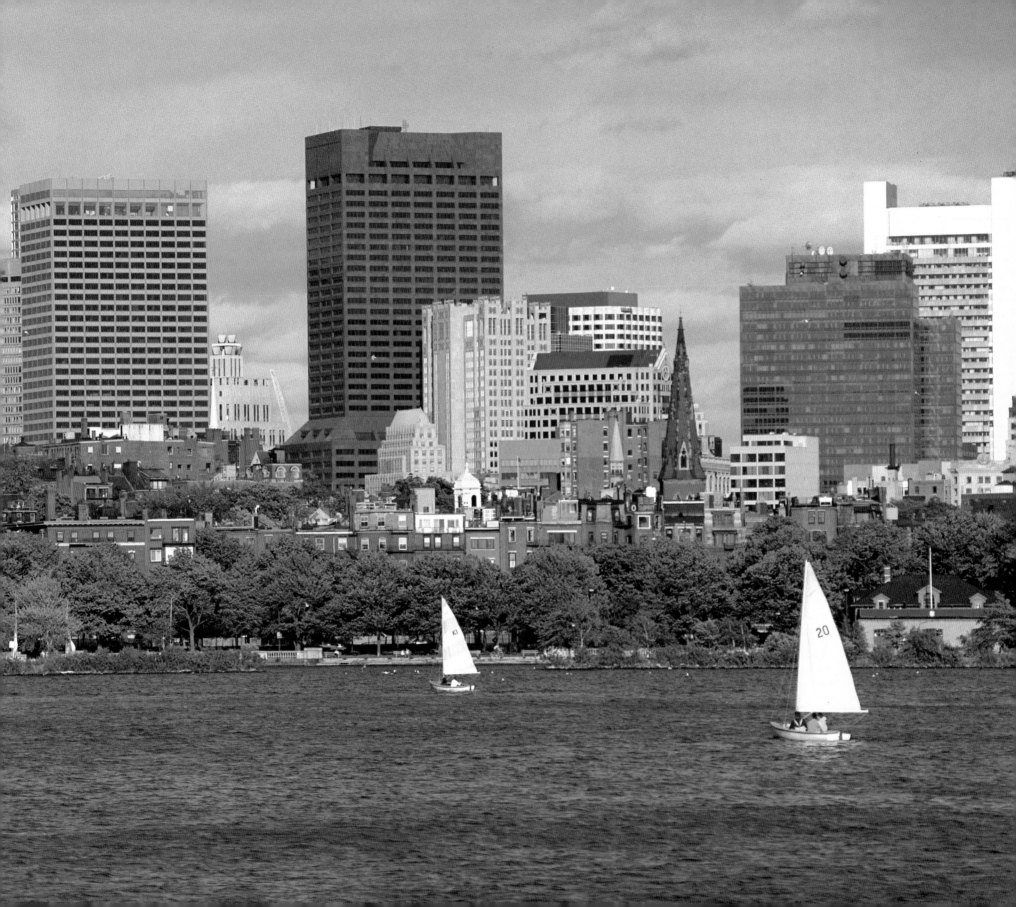

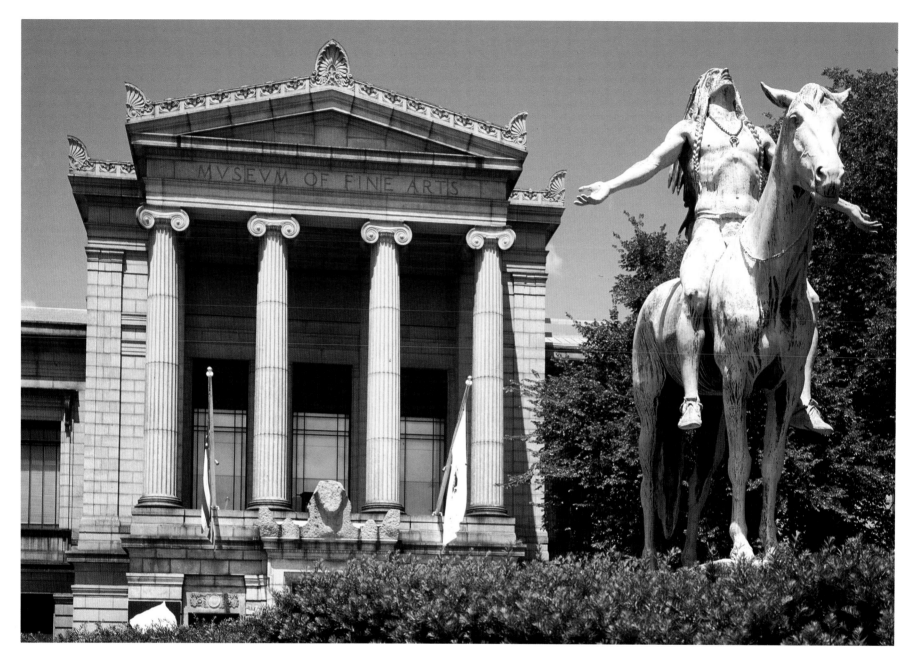

ABOVE: The Cyrus Dallin sculpture *Appeal to the Great Spirit* stands before the Boston Museum of Fine Arts.

OPPOSITE LEFT: Runners in the Boston Marathon surge up "Heartbreak Hill."

OPPOSITE TOP RIGHT: The golden dome of Boston's Massachusetts State House has been a landmark since the late 1790s.

OPPOSITE BOTTOM RIGHT: Tanglewood, in the beautiful Berkshire Mountains, is the summer home of the Boston Symphony Orchestra.

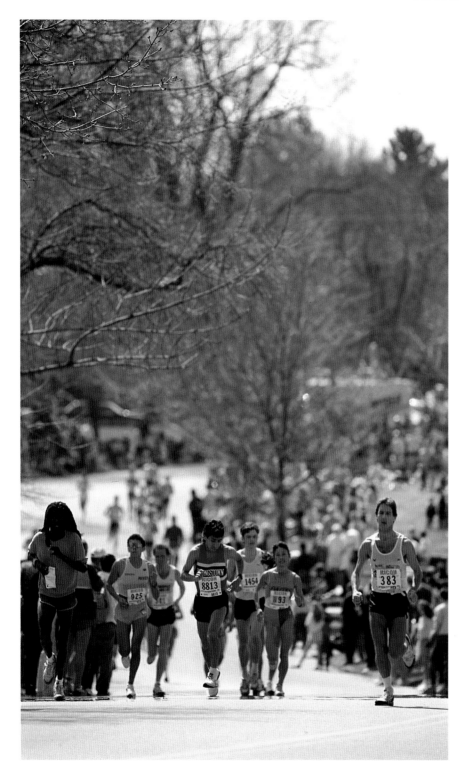

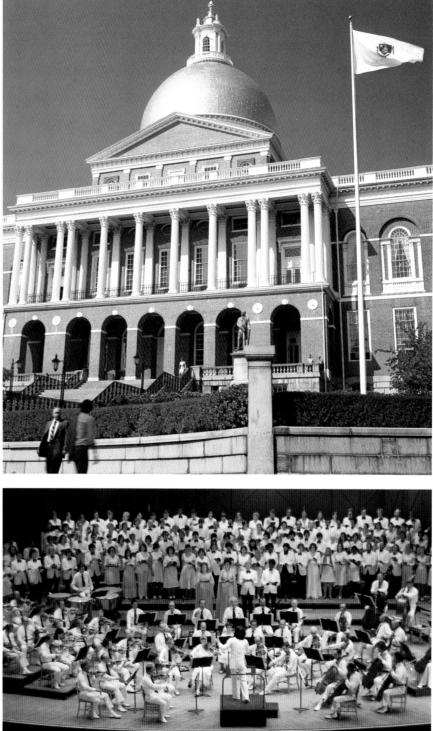

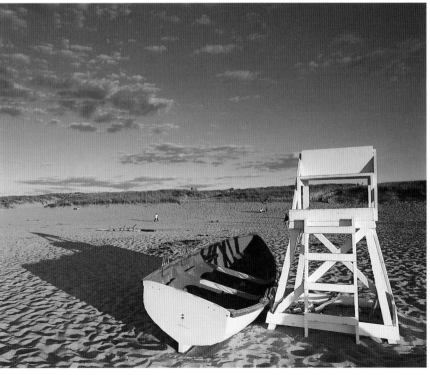

FAR LEFT: Sunrise over Rockport, Massachusetts, on beautiful Cape Ann.

ABOVE: A pleasure boat cruises the smooth inland waterway of the Cape Cod Canal. Opened in 1914, the 17-mile canal saves mariners the 100-mile trip around the cape, through dangerous waters.

LEFT: The beach at Provincetown's Race Point, at the tip of Cape Cod. Provincetown is where the Pilgrims first landed in 1620.

RIGHT: Harvesting cranberries in a bog at Carver, Massachusetts.

BELOW: A Massachusetts livestock farmer brings his prize-winning oxen to the Topsfield Fair.

BELOW RIGHT: This shingled windmill at Eastham is the oldest one on Cape Cod. It was built in Plymouth in 1680, moved to Truro, then to Eastham.

OPPOSITE: Best known as a summer resort, Cape Cod is equally beautiful under a blanket of snow.

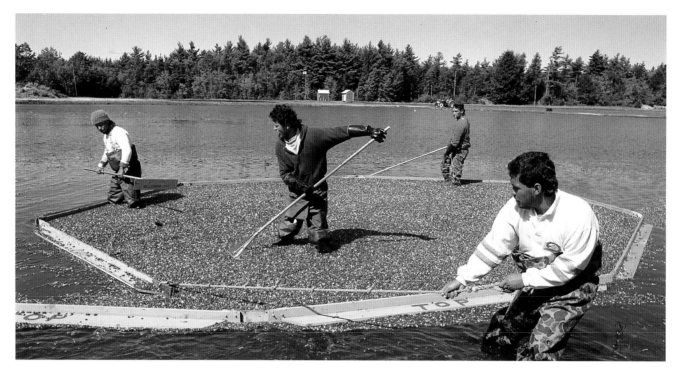

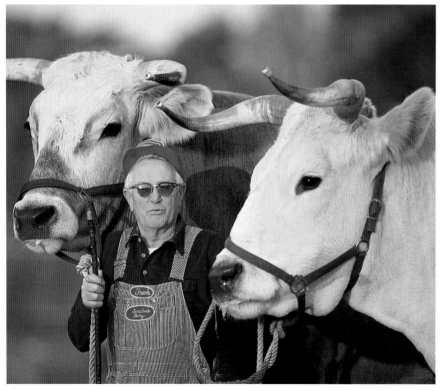

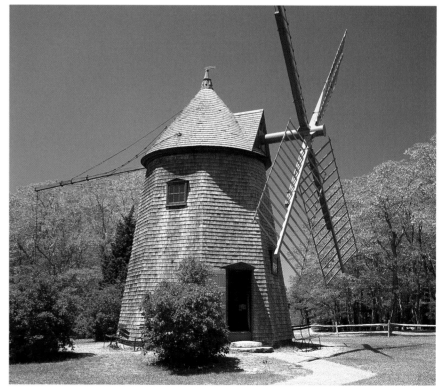

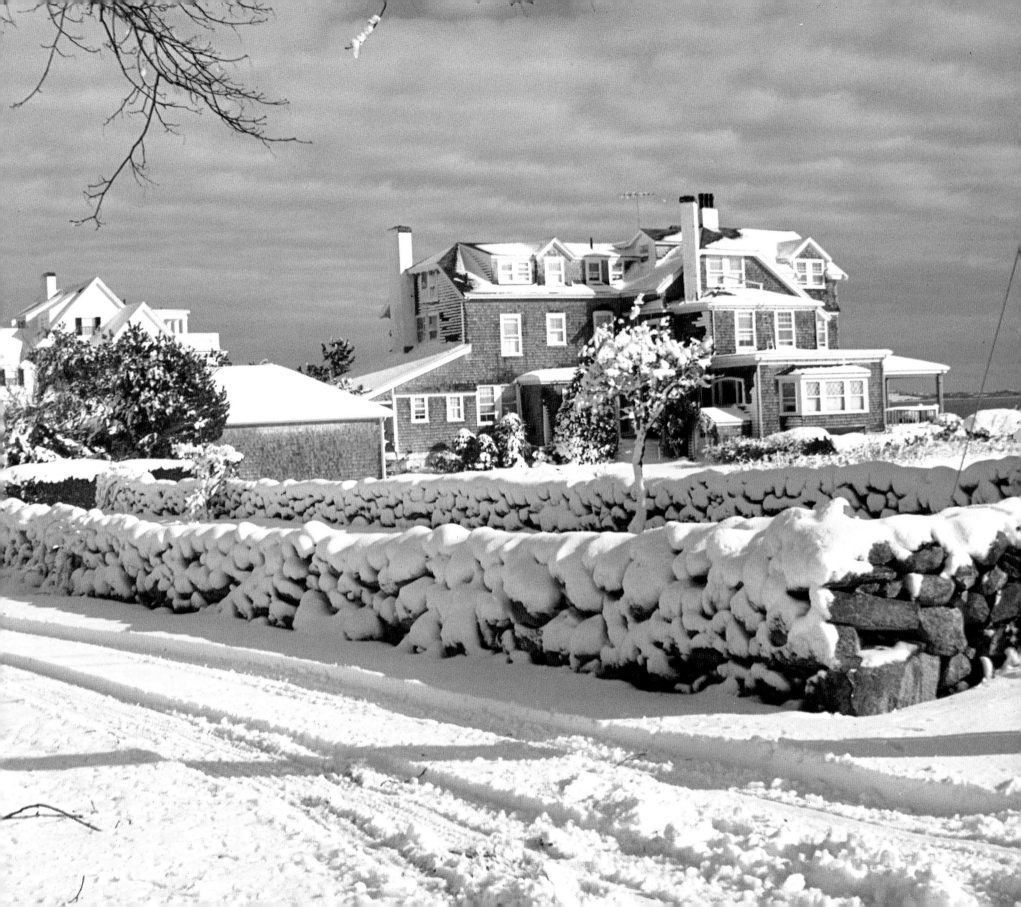

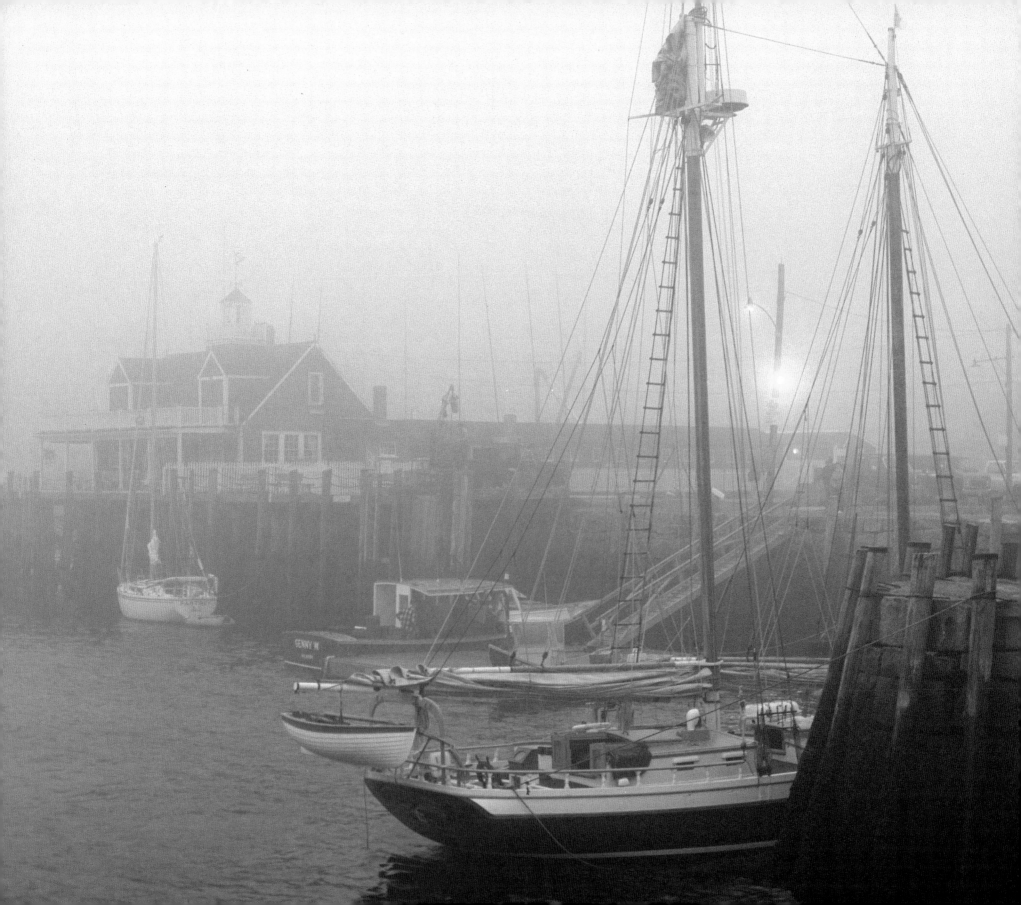

OPPOSITE: A fog-shrouded harbor on the Massachusetts coast.

RIGHT: A roomy house overlooks one of New England's innumerable tidal estuaries.

BELOW: A clouded sky broods over South Wellfleet, Massachusetts.

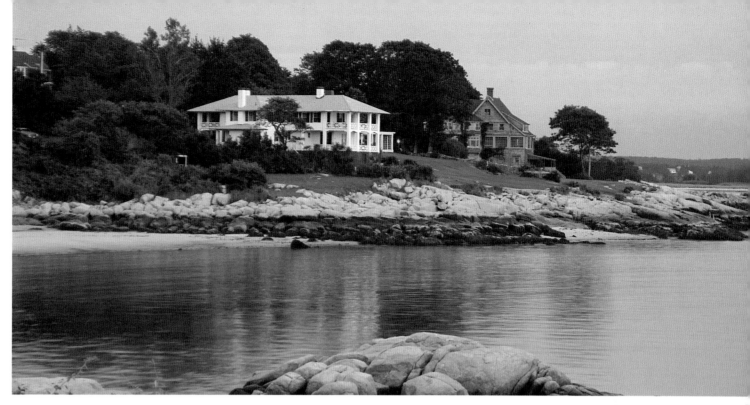

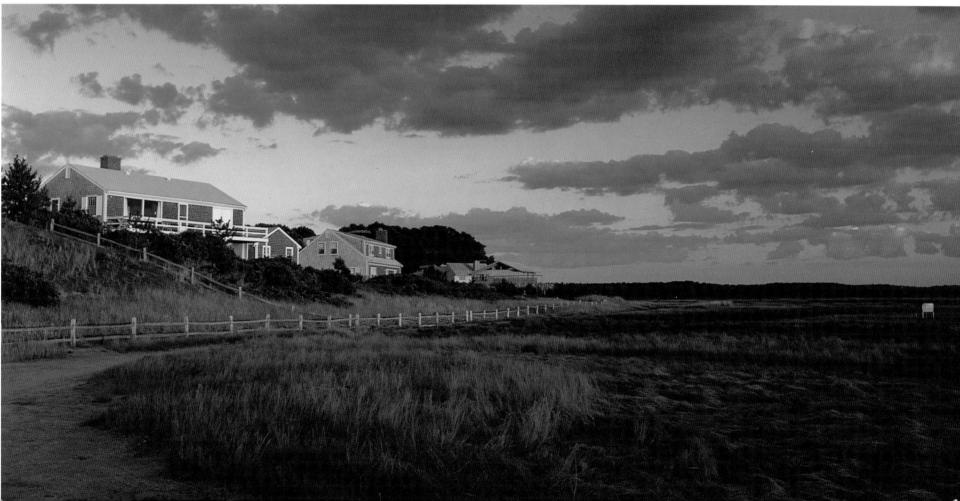

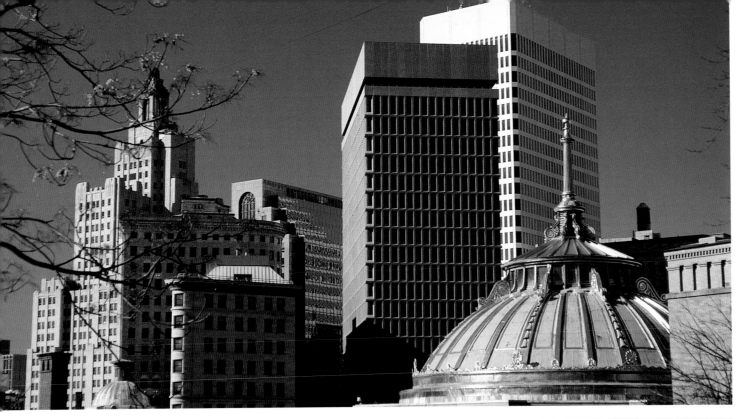

LEFT: Downtown Providence, Rhode Island, the capital of the nation's smallest state, with the Old Stone Bank in the foreground.

BELOW: The historic John Brown House in Providence was designed in the 18th century by Joseph Brown, one of four brothers who left their mark on Rhode Island history.

OPPOSITE: The imposing Rhode Island state capitol. Constructed of white Georgia marble, the building's dome is the second-largest marble dome without skeletal support in the world (the largest is on St. Peter's in Rome).

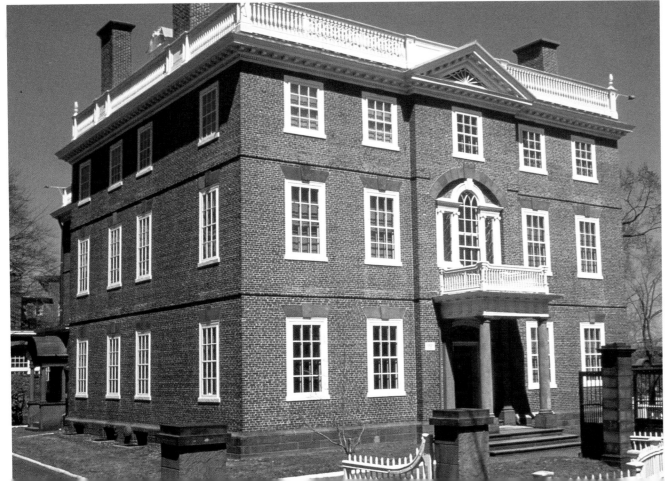

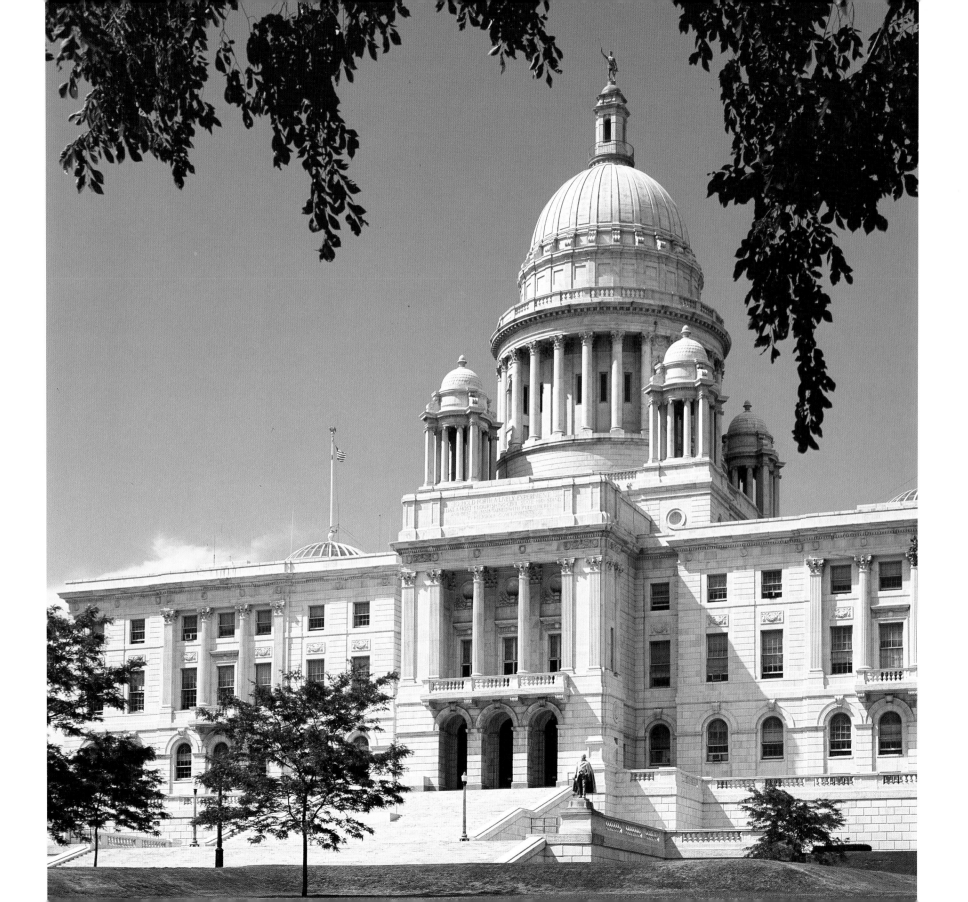

RIGHT: Pristine Cormorant Point, on Block Island.

OPPOSITE TOP: A surf caster tries his luck in seagirt Rhode Island, a fisherman's haven.

OPPOSITE BOTTOM LEFT: Commercial fishermen sort their silver catch at dockside.

OPPOSITE BOTTOM RIGHT: A weathered barn near Block Island's Great Salt Pond. The unspoiled island is one of Rhode Island's most popular summer resorts.

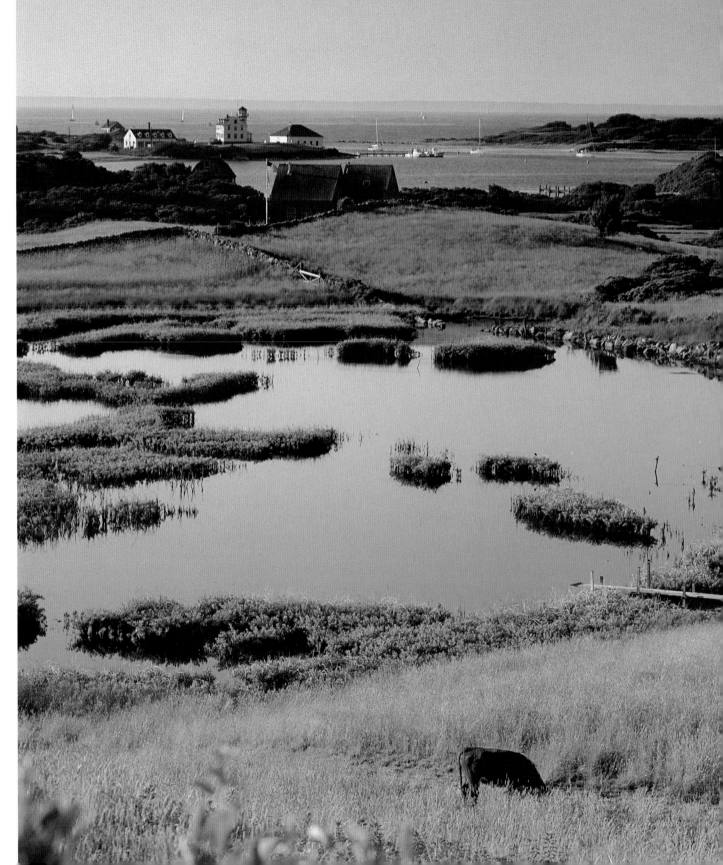

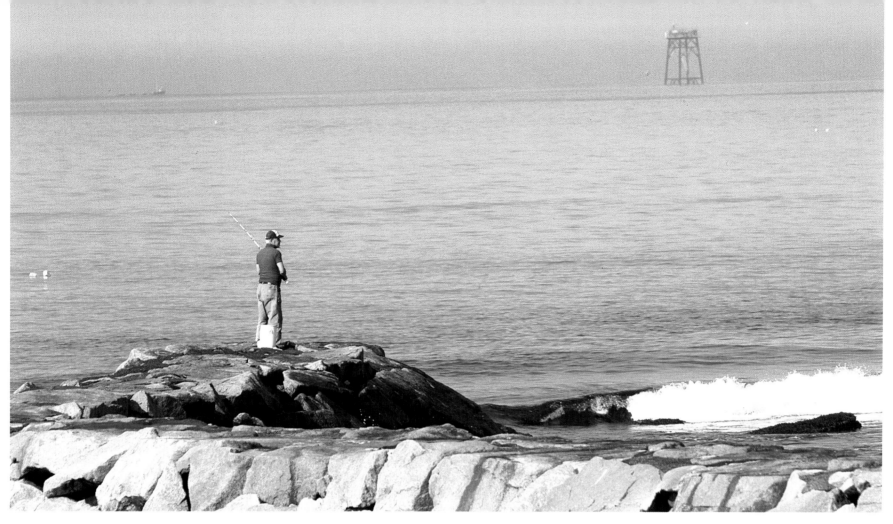

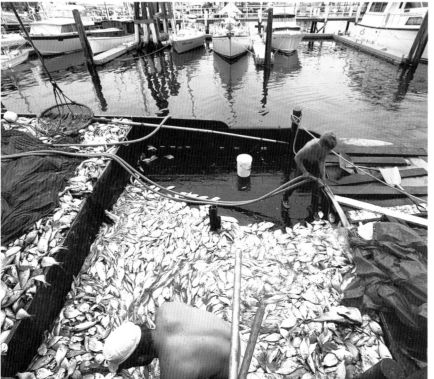

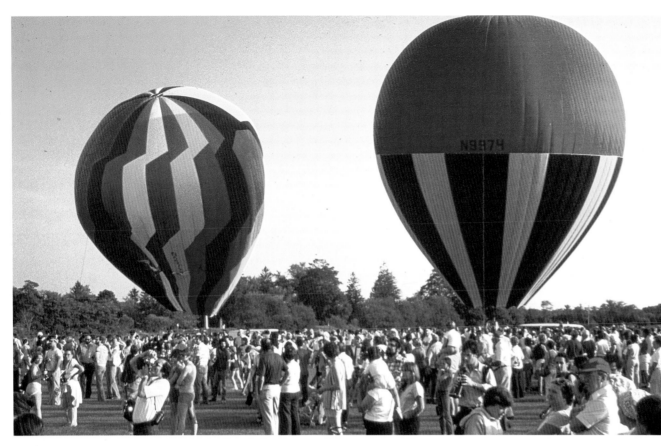

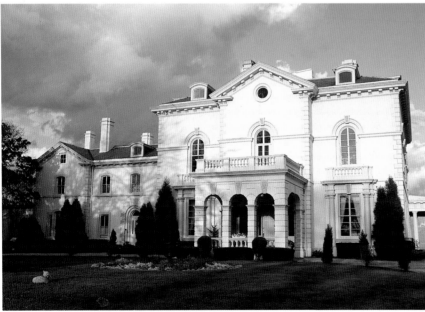

ABOVE: The hardy sport of ballooning attracts spectators at a summer gathering.

LEFT: Beechwood is one of many extravagant "summer cottages" built by wealthy Easterners in Newport during the late 19th century.

RIGHT: Russian olive trees at Block Island's Rodman Hollow thrive in the salt air.

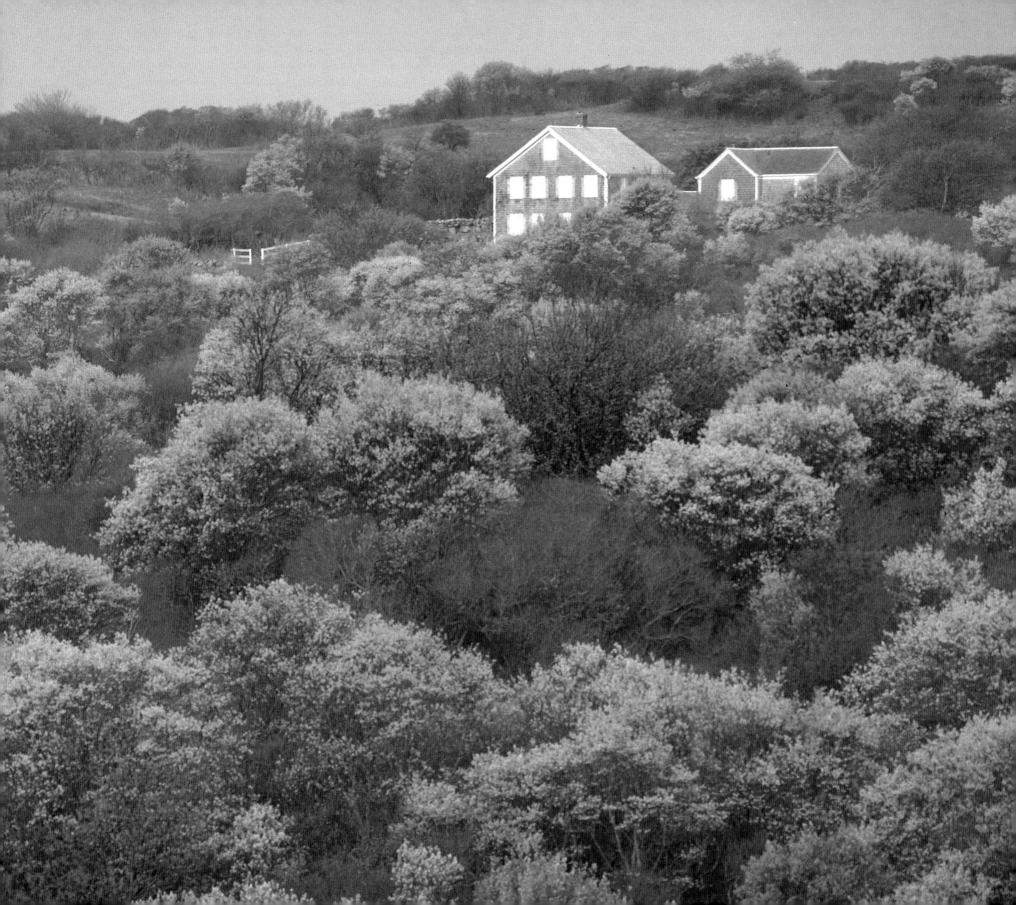

BELOW: Yale University, at New Haven, Connecticut, one of the country's first institutions of higher learning, was founded in 1701.

OPPOSITE: The broad Connecticut River reflects the lights of Hartford, the state capital.

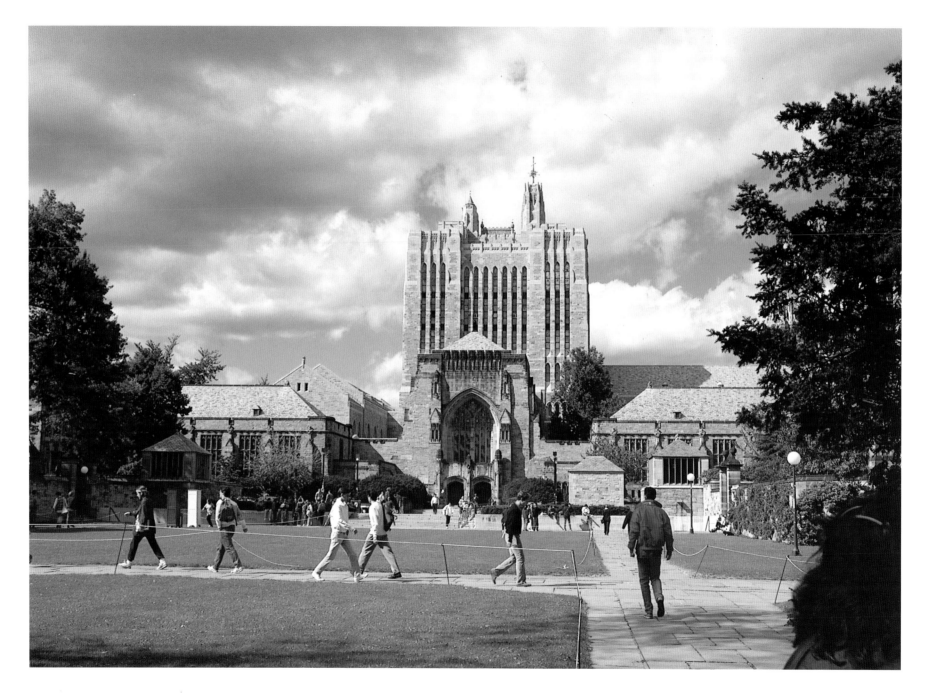

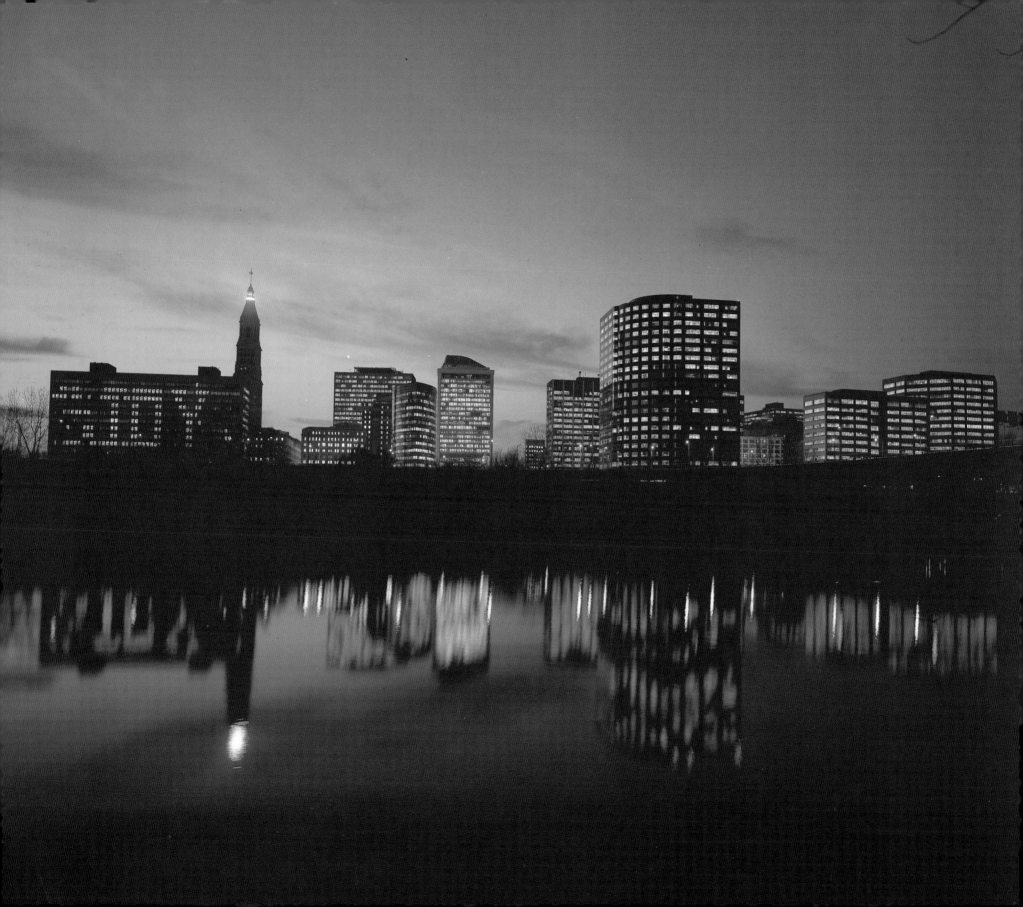

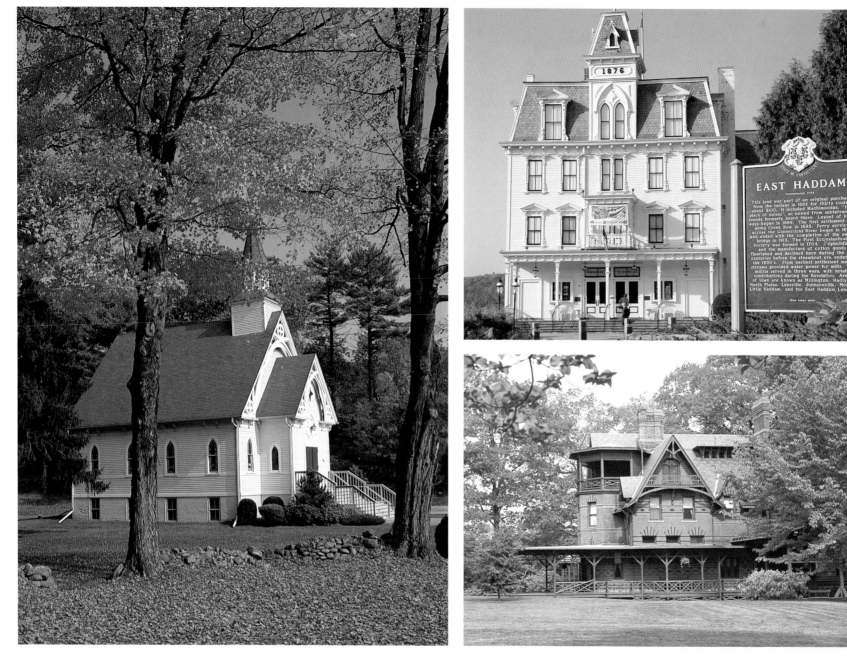

ABOVE: Rustic St. Bridget's Church in Cornwall, Connecticut.

TOP RIGHT: The splendid, six-story Victorian Goodspeed Opera House, on the Connecticut River in East Haddam.

ABOVE: The restored Mark Twain House, built near Hartford in 1874 and now a museum of America's best-known humorist.

OPPOSITE: The 18th-century Timothy Skinner House in Litchfield, in northwestern Connecticut.

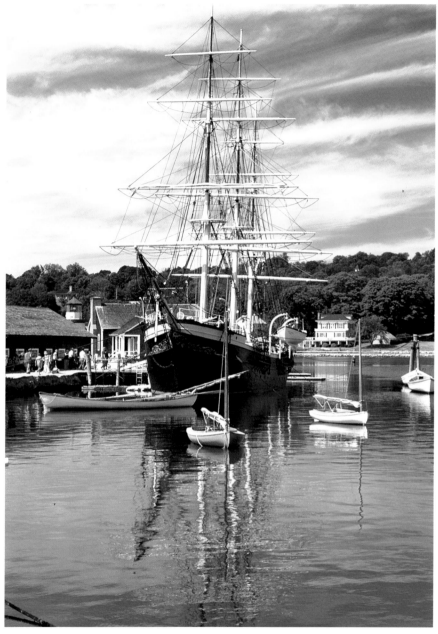

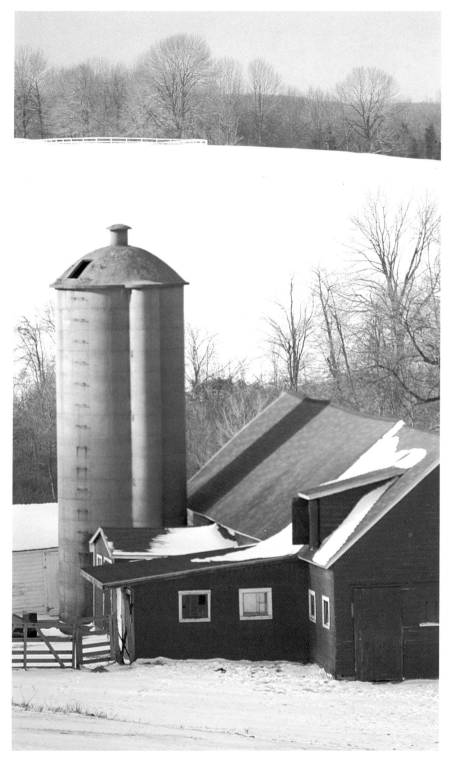

OPPOSITE: Old Lyme has some of Connecticut's most attractive village scenes.

LEFT: Much of rural Connecticut is still farmland and pastureland, primarily for dairy cows.

ABOVE: The Marine Historical Museum at Mystic, Connecticut, preserves the state's seafaring heritage.

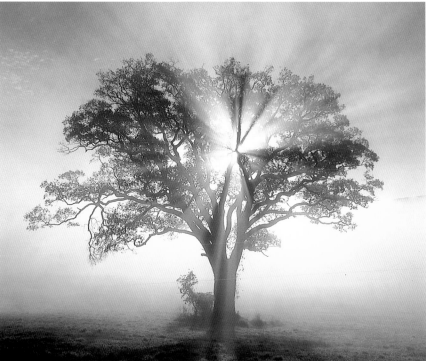

ABOVE: Pink phlox and sunny cosmos thrive in a Sharon, Connecticut, garden.

ABOVE RIGHT: An oak tree prisms the light of a New England sunrise.

RIGHT: The quiet Housatonic River, near Canaan, Connecticut.

OPPOSITE: A view of rolling Connecticut hills from Bear Mountain, near Salisbury.

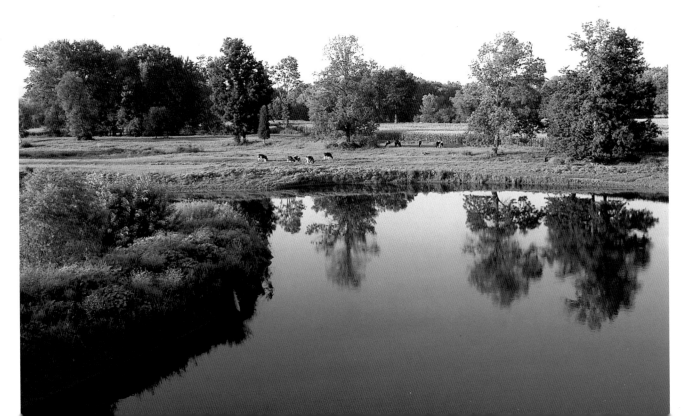

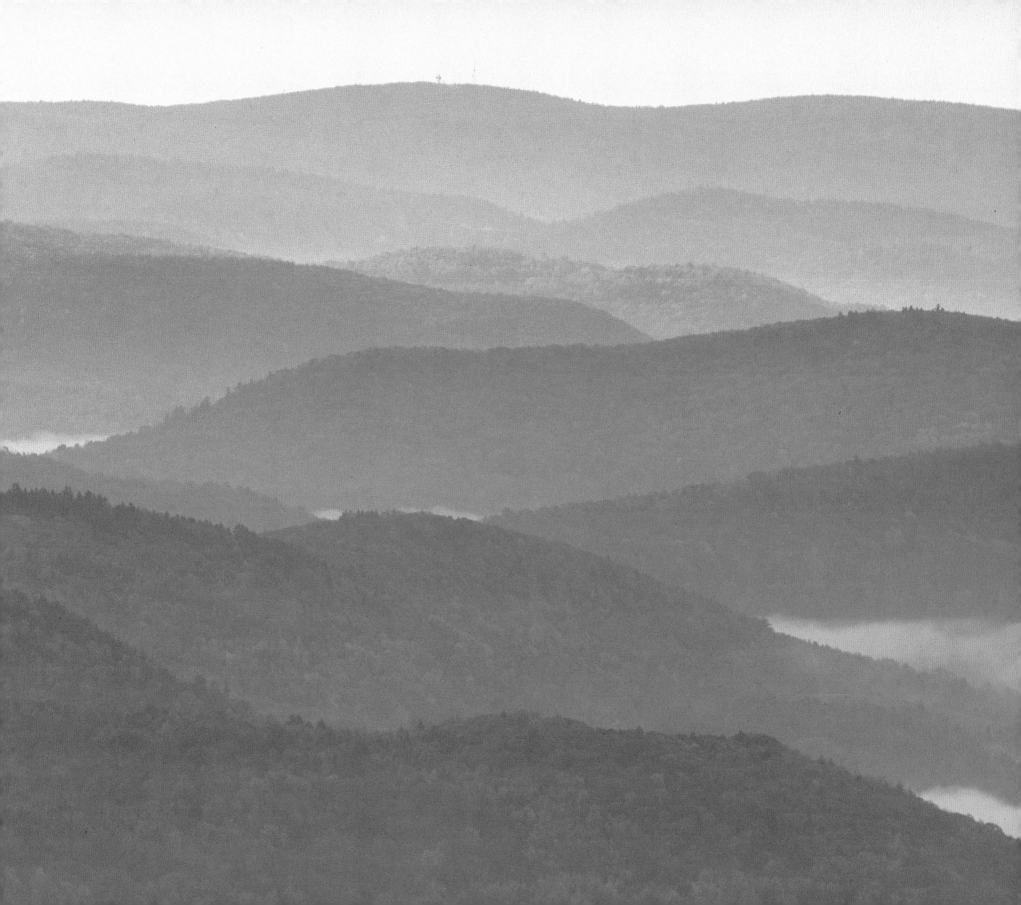

THE MIDDLE ATLANTIC STATES

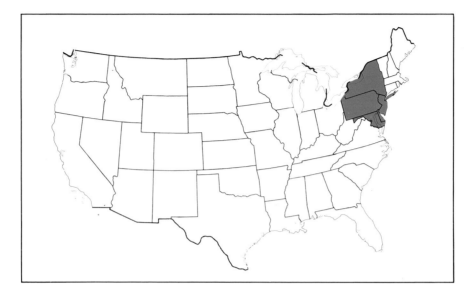

Moving south from New England are the Atlantic seaboard states, among the first regions of the country to be settled by Europeans. They include New York, New Jersey, Pennsylvania, Maryland, Delaware, and the District of Columbia, which is not yet a state but may become one before the decade is out. This area is densely populated, with an urban corridor that extends south from New York to the nation's capital, but it also contains much scenic countryside and is dotted with small towns, waterways, and prosperous farms.

All of the Middle Atlantic states were part of the original thirteen colonies, and the region is rich in history. Philadelphia was the scene of the Declaration of Independence and the Constitutional Convention that framed the laws of the new land after the Revolutionary War. Valley Forge, Pennsylvania, was the site of Washington's camp during the bitter winter of 1777-78. Once the nation's most populous city, New York has been an important center of trade and commerce since the 1600s. The towering Statue of Liberty in New York Harbor testifies to the city's role as a portal for immigrants seeking a new life in the New World. Pittsburgh was a frontier fort during the French and Indian Wars and has preserved its strength as the nation's steel center while diversifying into new industries and ideas.

The region's natural wonders include Niagara Falls, in northern New York at the Canadian border, and the Catskills, Poconos, and Adirondacks and other Appalachian ranges. No matter where you go in the Middle Atlantic states, there is something to admire, to inspire, and simply to enjoy.

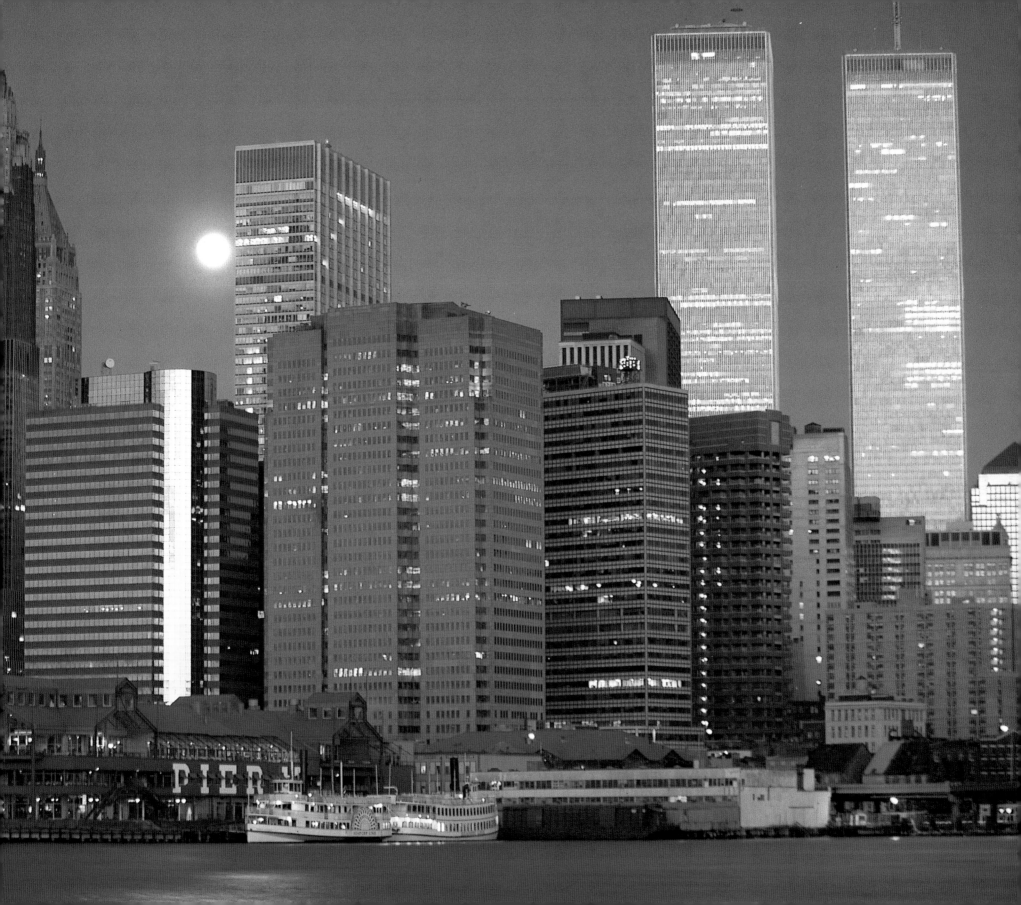

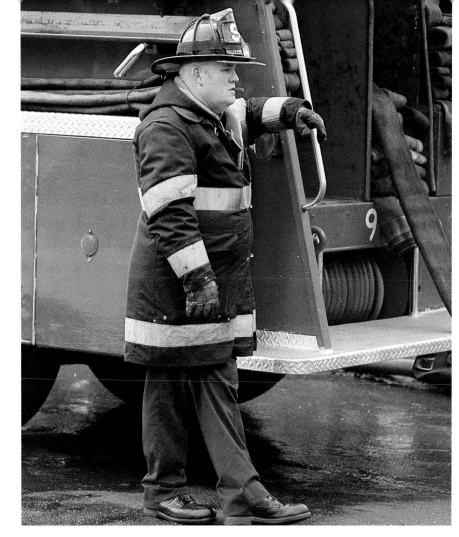

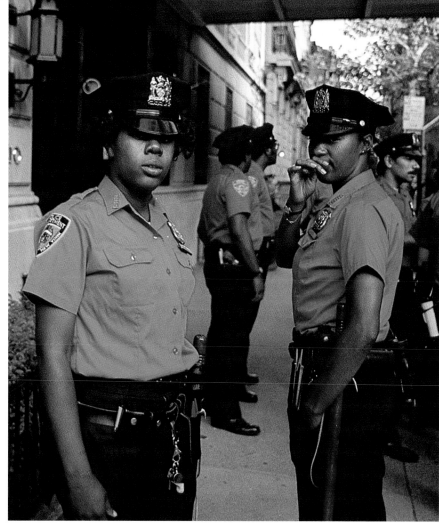

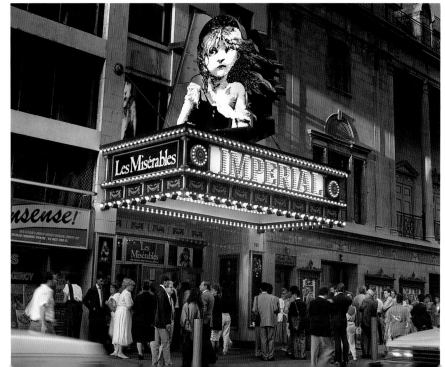

TOP LEFT: Many of New York's firemen are descended from the Irish immigrants who played an important part in the city's civil service and politics.

LEFT: Manhattan's theater district, collectively called Broadway, has drawn crowds to the Great White Way since the 1800s.

ABOVE: The city's police department, "New York's Finest," once an Irish-American enclave, now offers opportunities to black, Hispanic, and female officers.

OPPOSITE: A panoramic view includes the Williamsburg, Manhattan, and Brooklyn bridges to Manhattan Island, the nation's most densely populated piece of real estate.

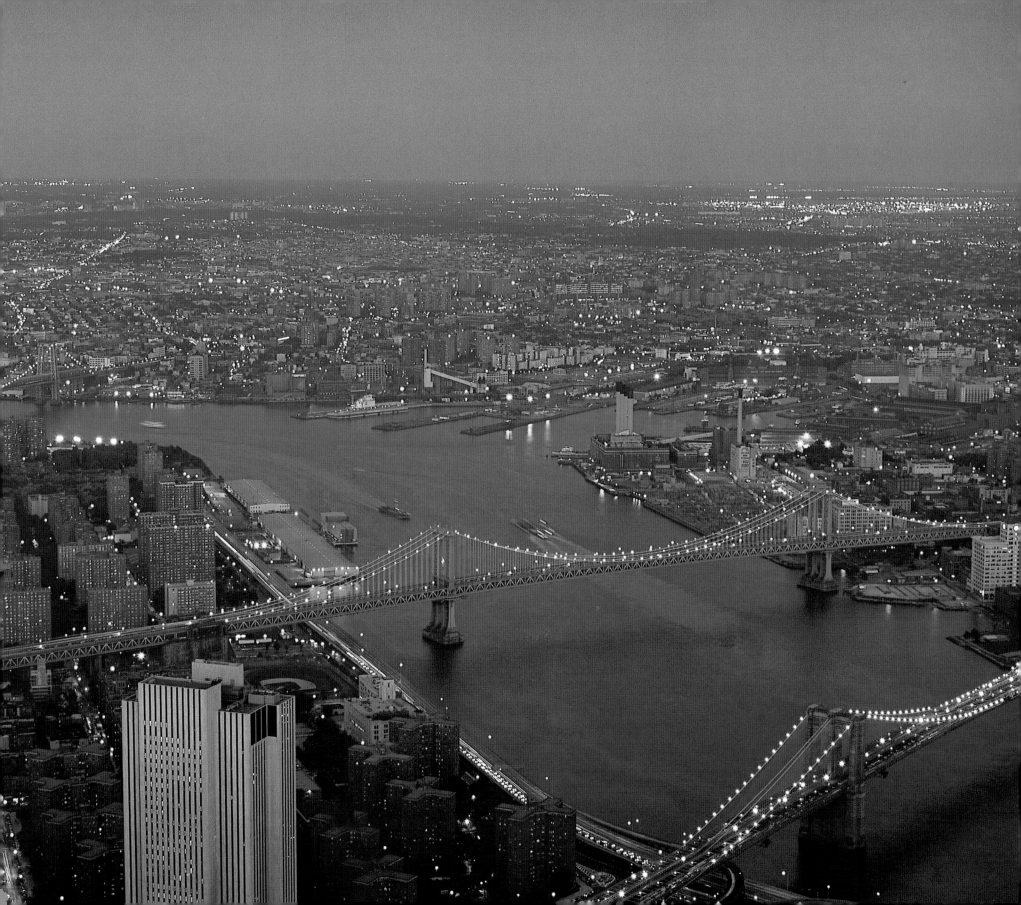

BELOW: An impromptu music festival in New York's Washington Square Park.

OPPOSITE TOP: Central Park, designed by Frederick Law Olmstead in the late 1800s, is still delighting New Yorkers and visitors to the city.

OPPOSITE BOTTOM: Winter in Central Park includes a turn on the Wollman Skating Rink, foreground.

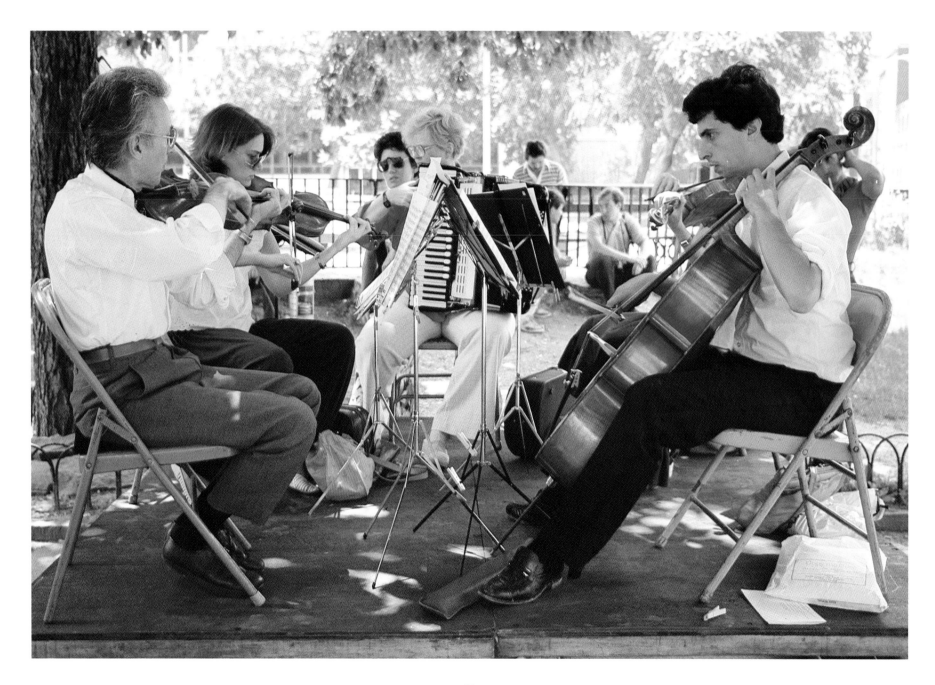

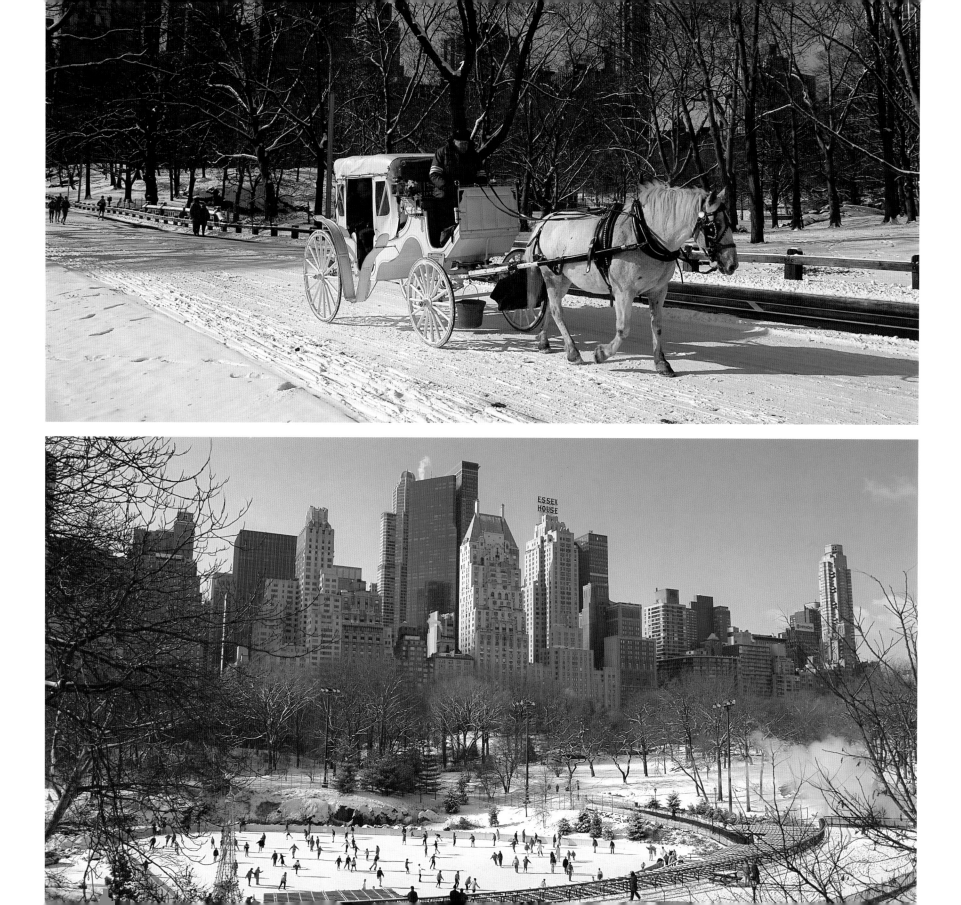

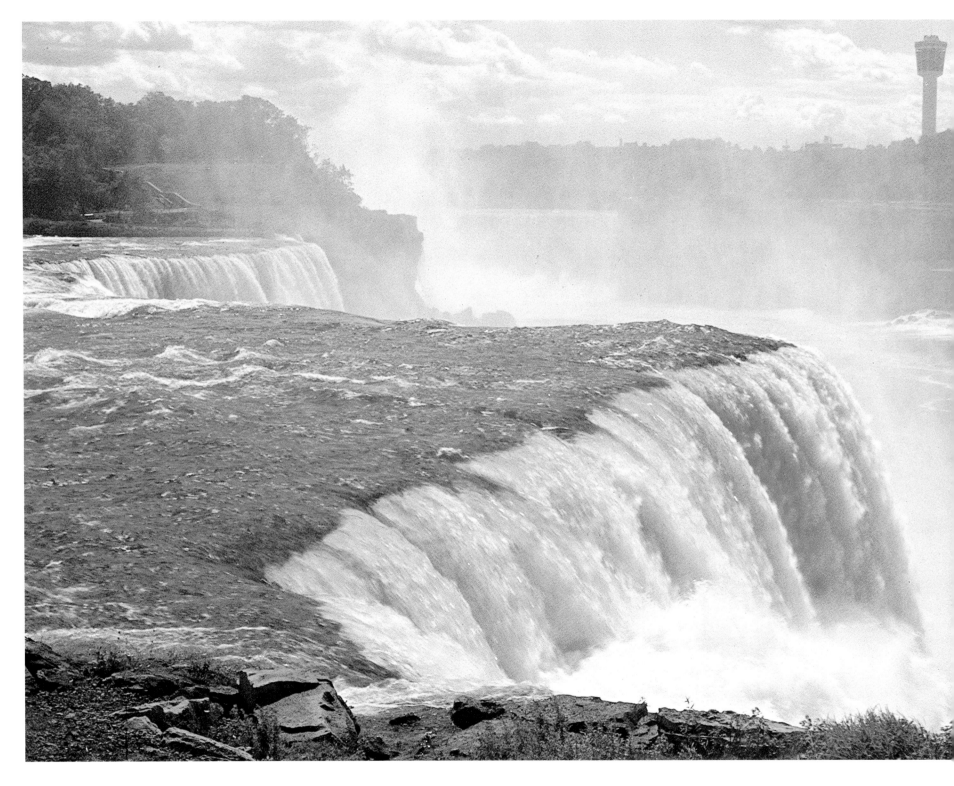

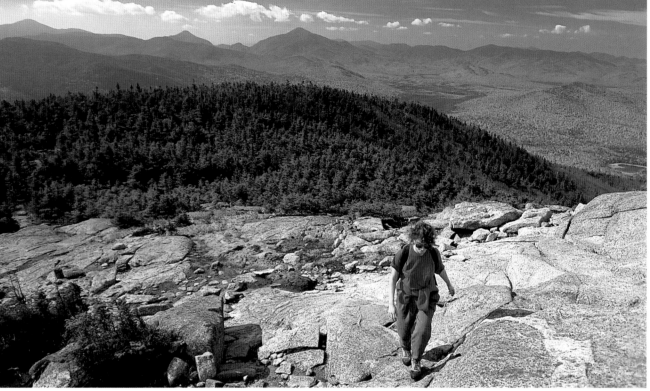

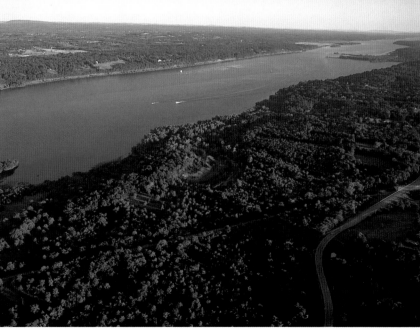

FAR LEFT: Thunderous Niagara Falls, more than a thousand feet wide on the American side, plummet from a height of almost 200 feet. In the distance is Niagara Falls, Ontario, Canada.

ABOVE: Cascade Mountain, in New York's rugged Adirondack Mountains.

LEFT: New York's great Hudson River, some 15 miles south of the state capital at Albany. The Hudson is navigable by ocean vessels from the Atlantic Ocean to Albany, some 150 miles.

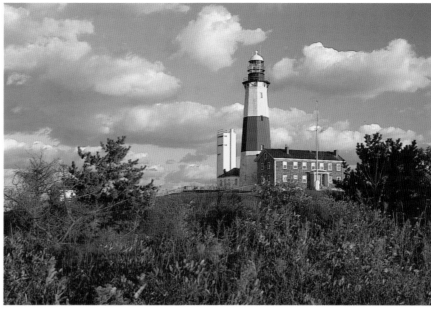

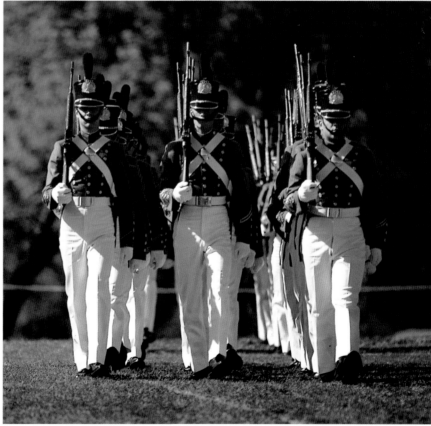

OPPOSITE: Skaneateles Lake in the Finger Lakes region of upstate New York.

ABOVE: Along a country road in western New York's Erie County.

TOP RIGHT: Montauk Light, at the eastern extremity of 120-mile Long Island.

RIGHT: Cadets drill at New York's West Point, above the Hudson River north of New York City. West Point has been the site of the United States Military Academy since 1802.

RIGHT: A breathtaking view of the Palisades along the Hudson, from New Jersey's State Line Lookout.

OPPOSITE: The symmetrical outline of a New Jersey farm is apparent from the air. While a number of farms operate in this state, New Jersey is the most densely settled and the most highly urbanized state in America.

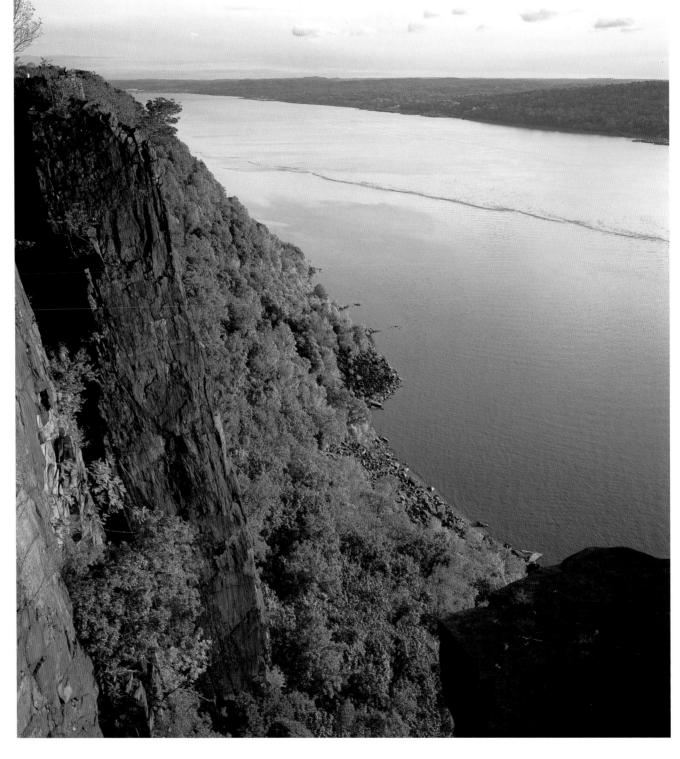

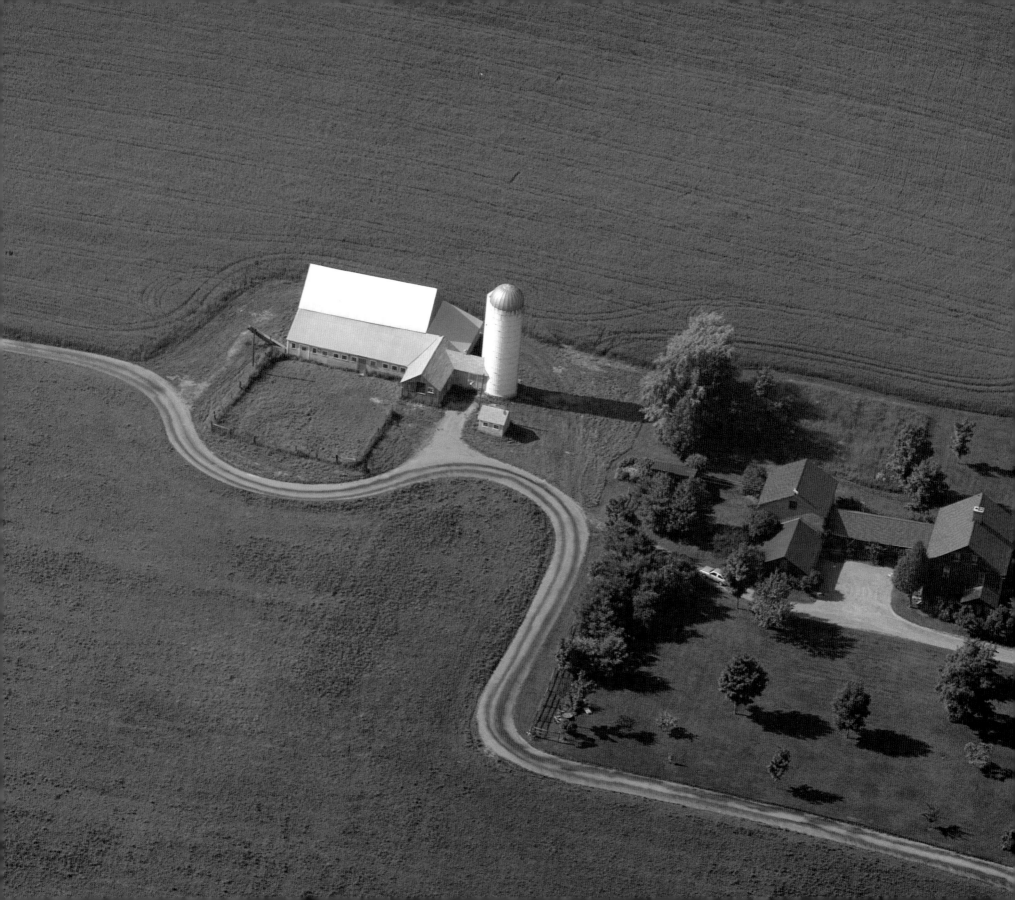

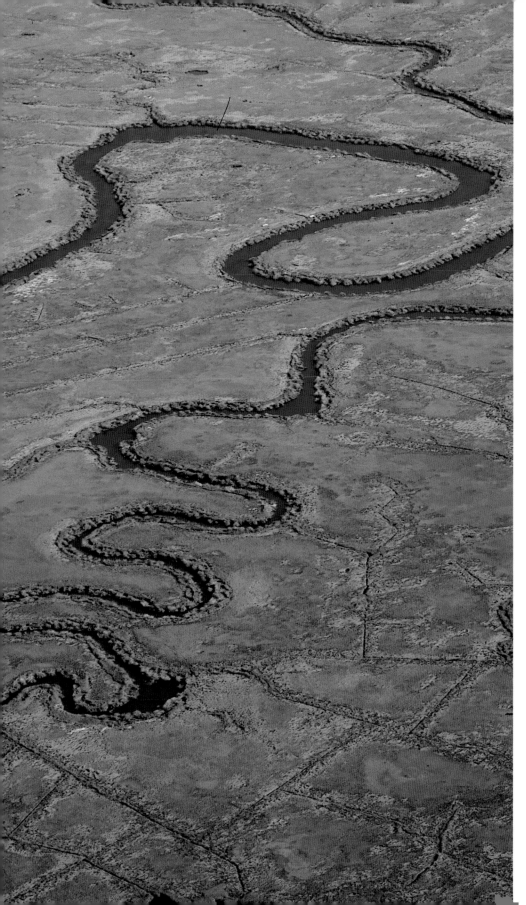

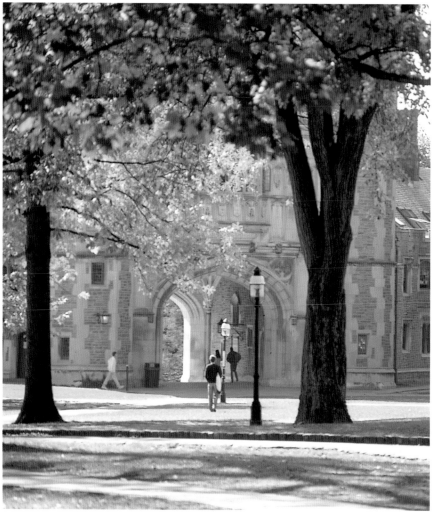

LEFT: A river meanders through New Jersey's marshes.

ABOVE: The serene campus of Ivy League Princeton University, at Princeton, New Jersey. Founded in 1746 as the College of New Jersey, at Elizabeth, it was moved in 1756 to Princeton, where it has become one of the country's outstanding institutions of higher education.

OPPOSITE TOP: Cape May, long a popular seaside resort on the Jersey shore.

OPPOSITE BOTTOM: Atlantic City's boardwalk has never been busier since New Jersey legalized gambling here.

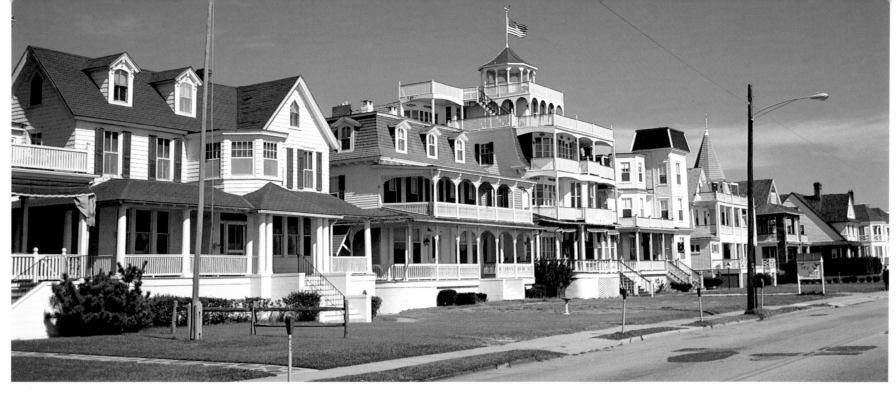

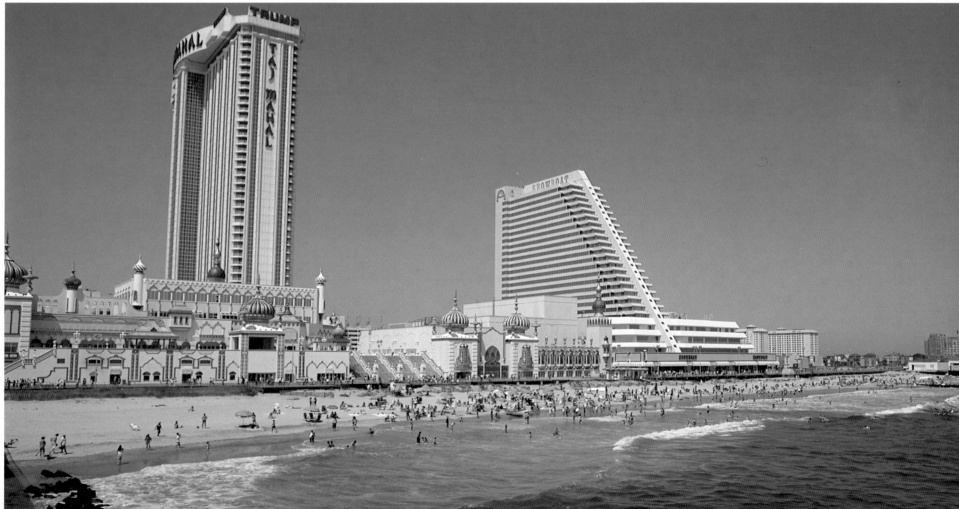

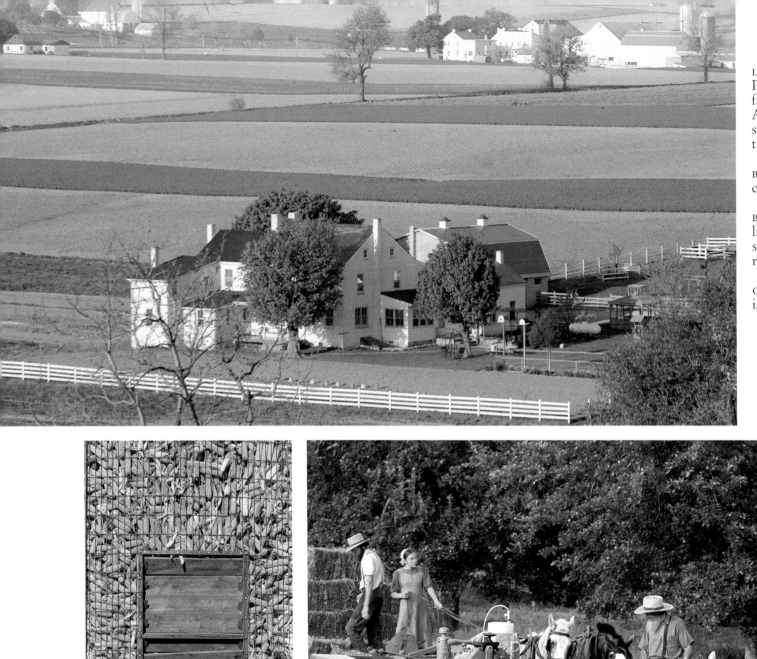

LEFT: Lancaster County, Pennsylvania, is a venerable farming region settled by the Amish, an Anabaptist sect that separated from the Mennonites in the late 17th century.

BOTTOM LEFT: A Lancaster County corncrib.

BELOW: Amish beliefs allow a limited use of modern technology, so the horse still has an important role in community life.

OPPOSITE: A well-kept Amish farm is ready for winter.

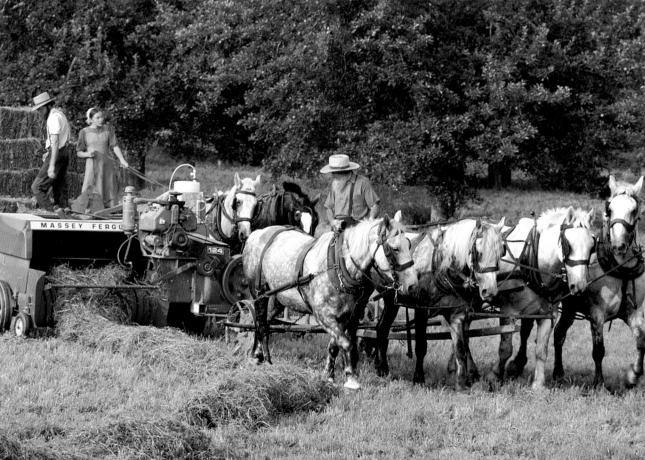

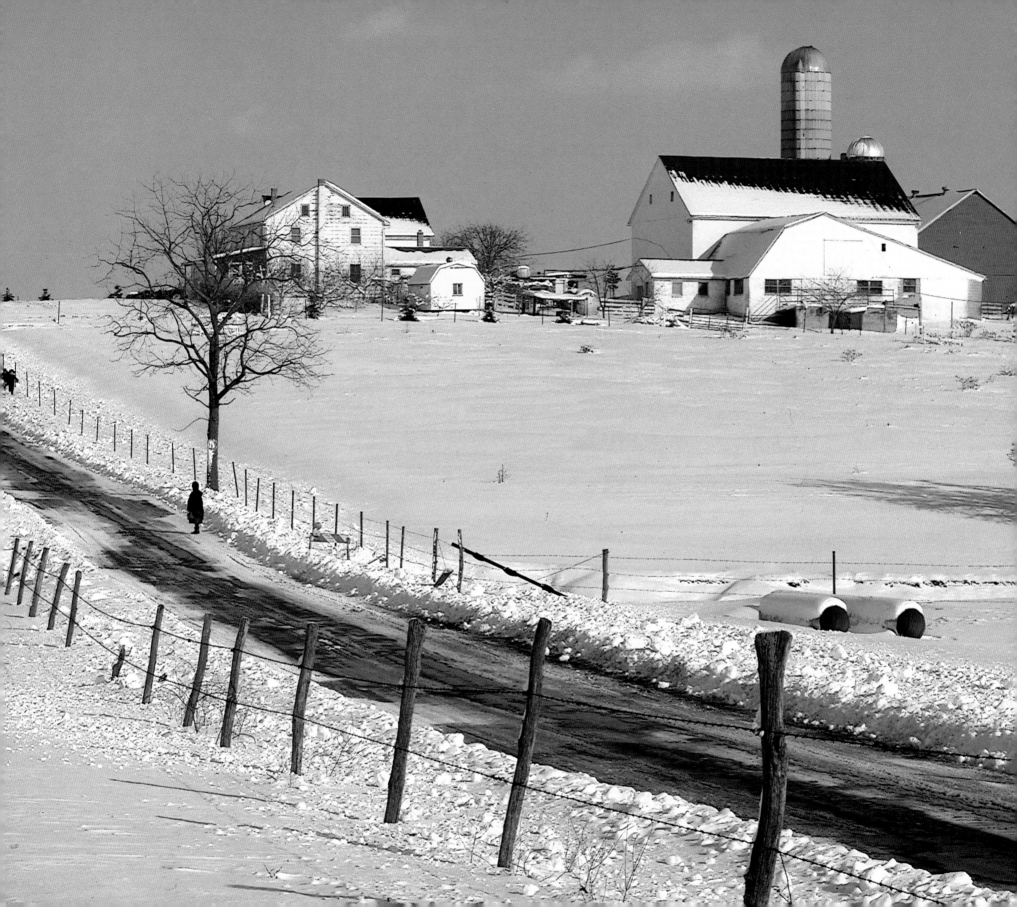

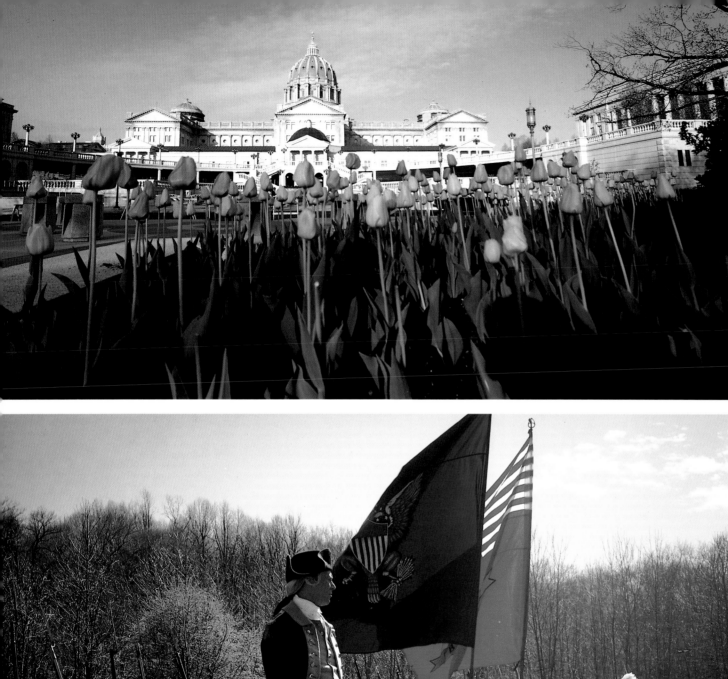

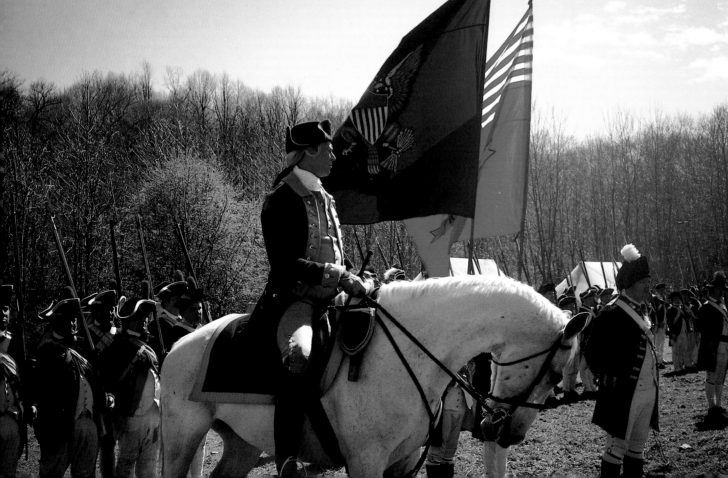

LEFT: The state capitol building in Harrisburg, Pennsylvania.

BOTTOM LEFT: On location at Valley Forge, Pennsylvania, actor Barry Bostwick portrays George Washington in a television show about the revolutionary commander.

OPPOSITE: The old Bobbin House Tavern in Gettysburg recalls Pennsylvania's Colonial days.

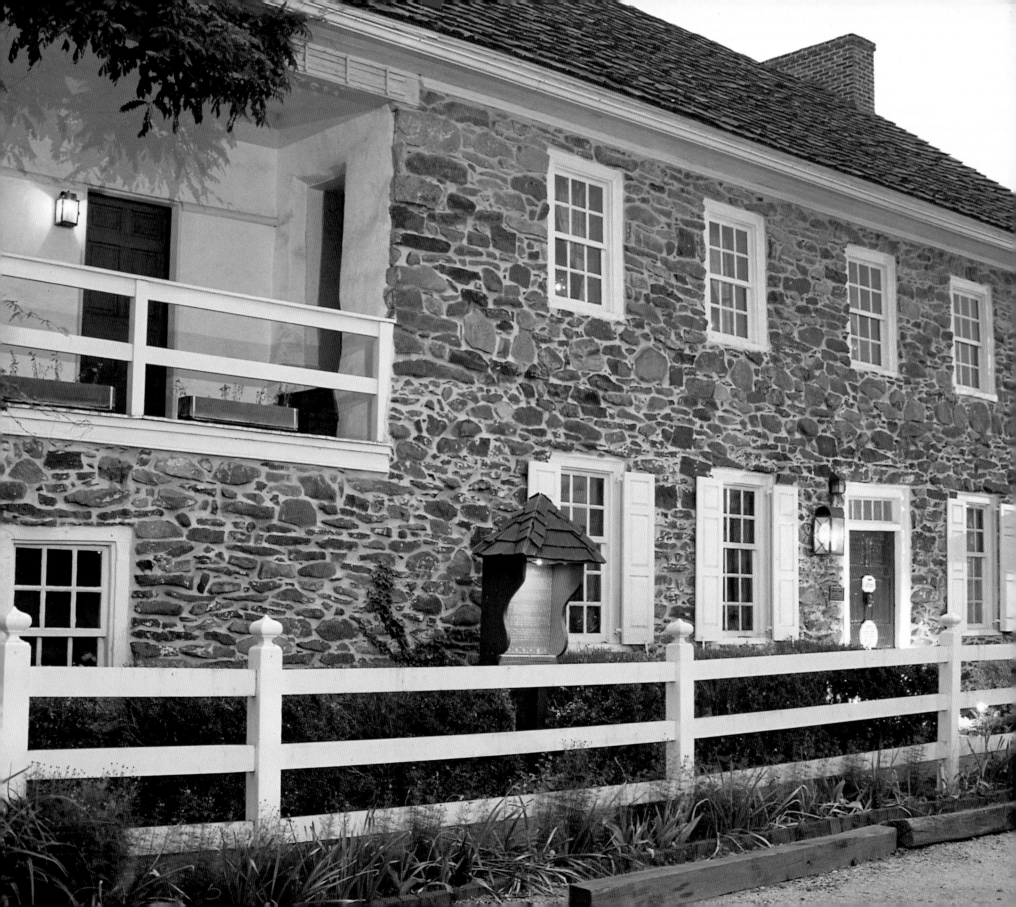

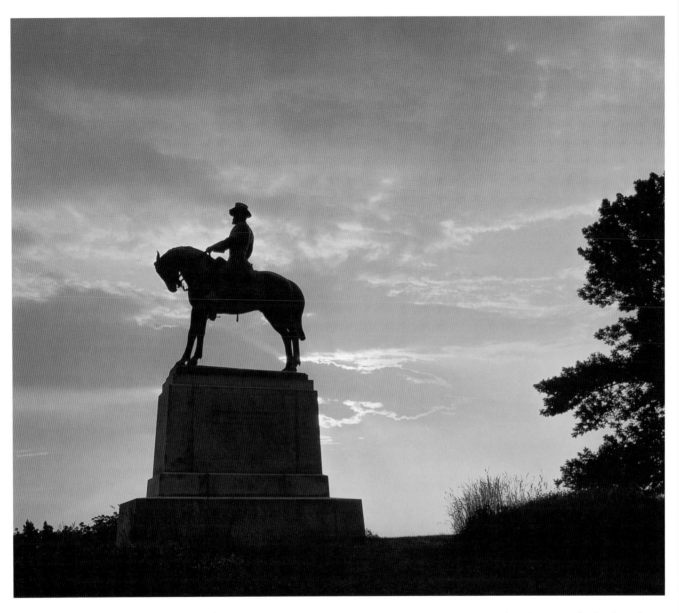

ABOVE: A striking view of the Civil
War monument at Gettysburg
National Military Park.

RIGHT: A rejuvenated Pittsburgh
lights up the night where the
Allegheny and Monongahela rivers
meet to form the Ohio.

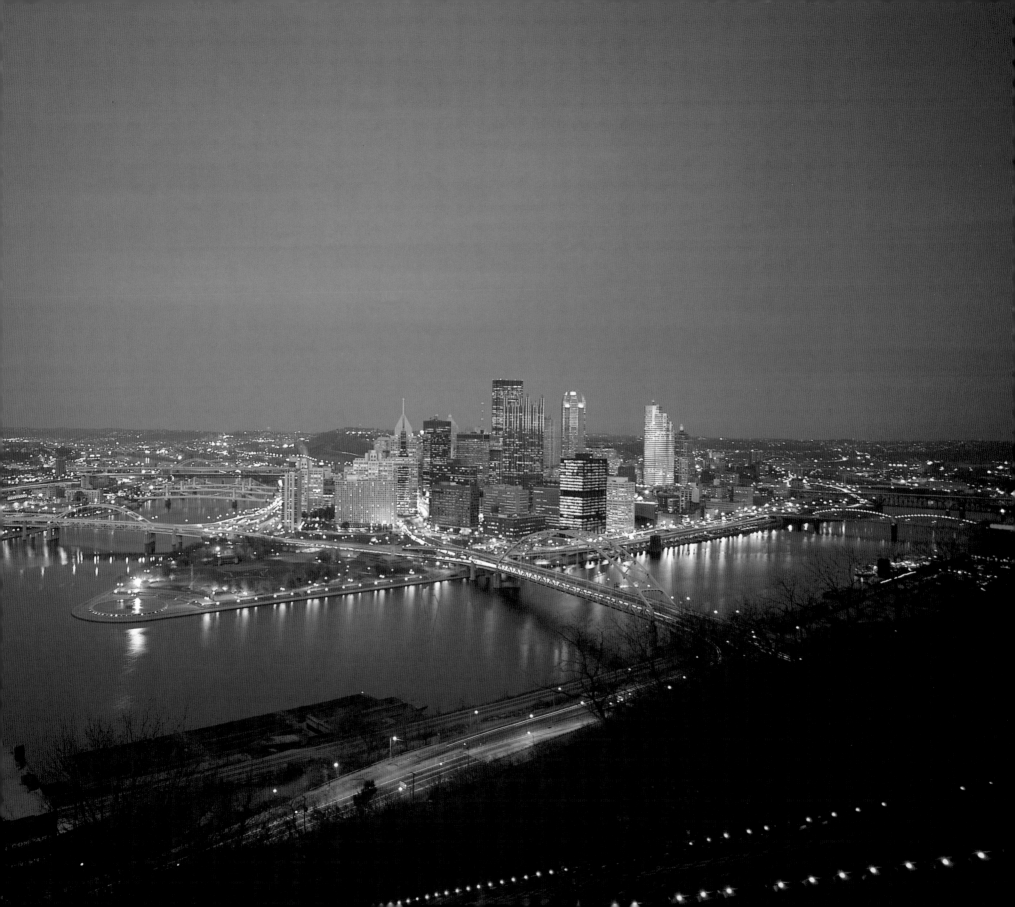

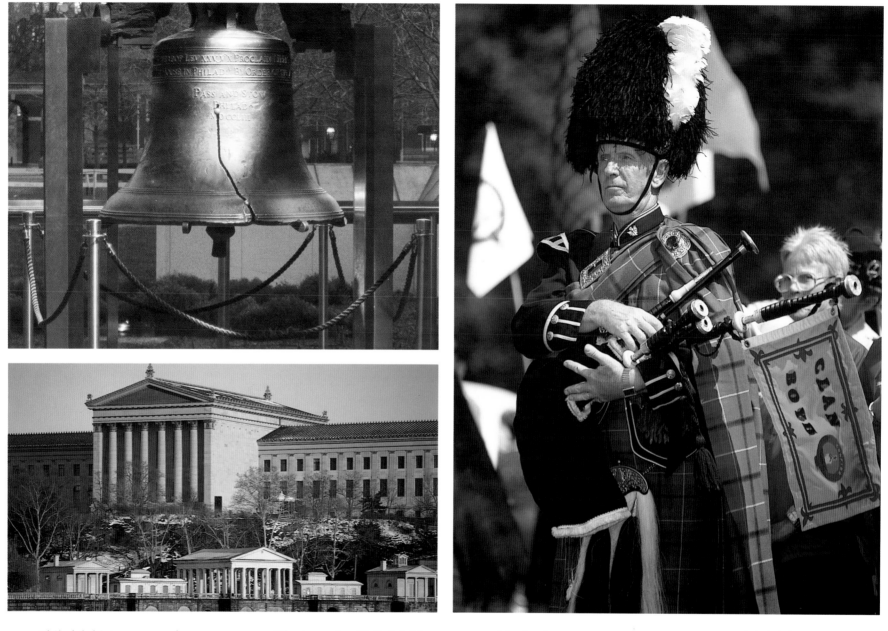

TOP: Philadelphia's renowned Liberty Bell, herald of American independence.

ABOVE: The imposing Philadelphia Museum of Art, on the Schuylkill River.

ABOVE: Much of western Pennsylvania was settled by immigrants from Scotland. Here the town of Ligonier celebrates its heritage at the annual Scottish Highland Games.

OPPOSITE: Philadelphia claims "the oldest street in the United States": Elfreth Alley.

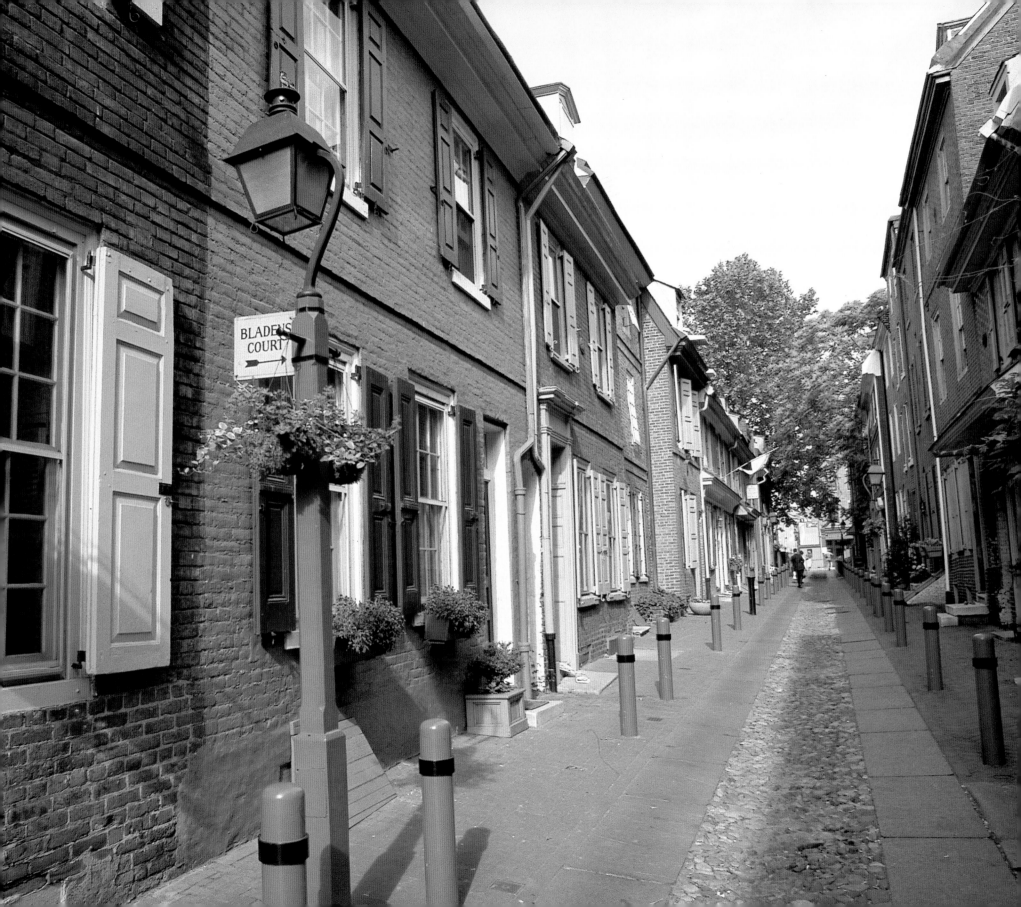

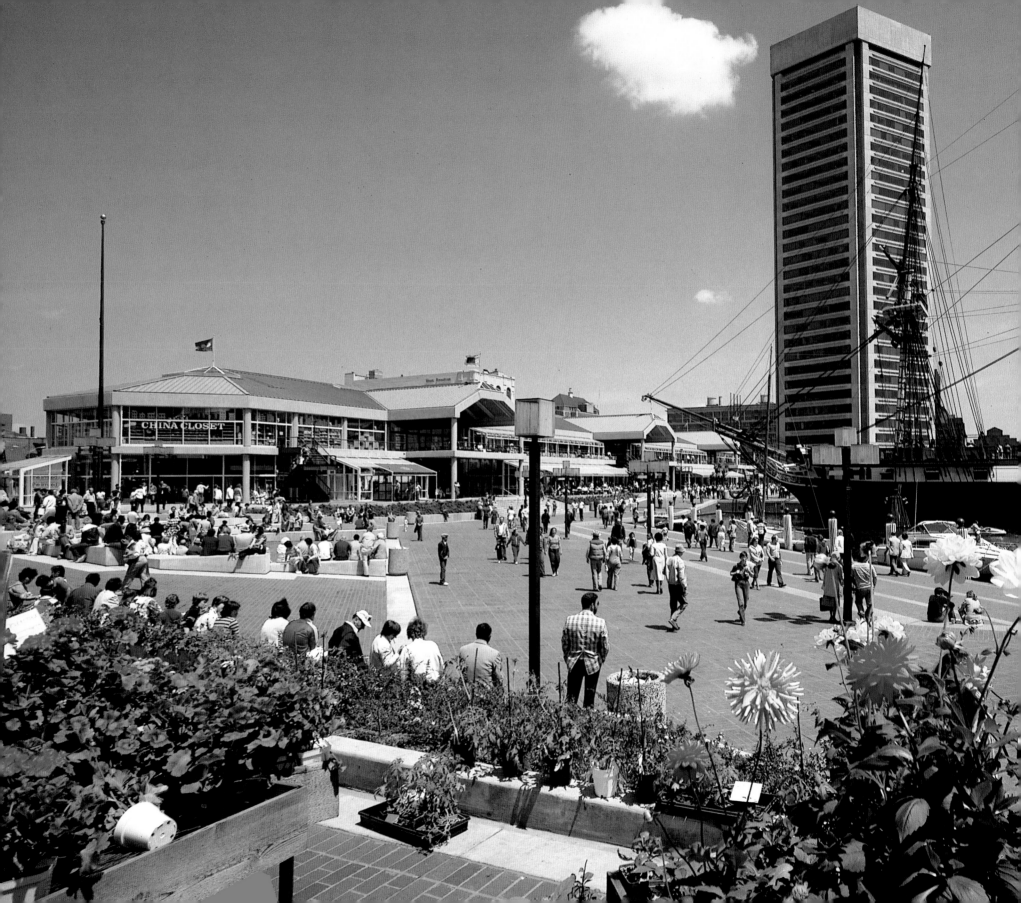

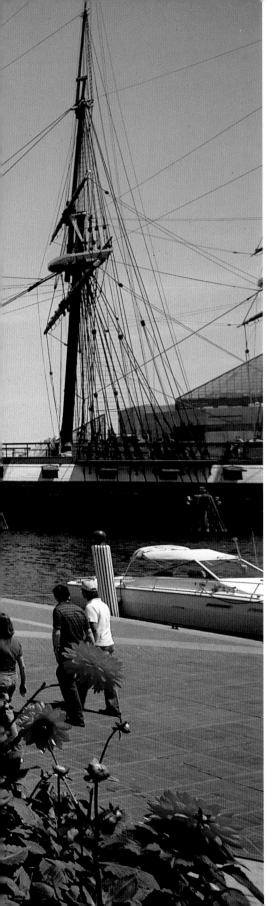

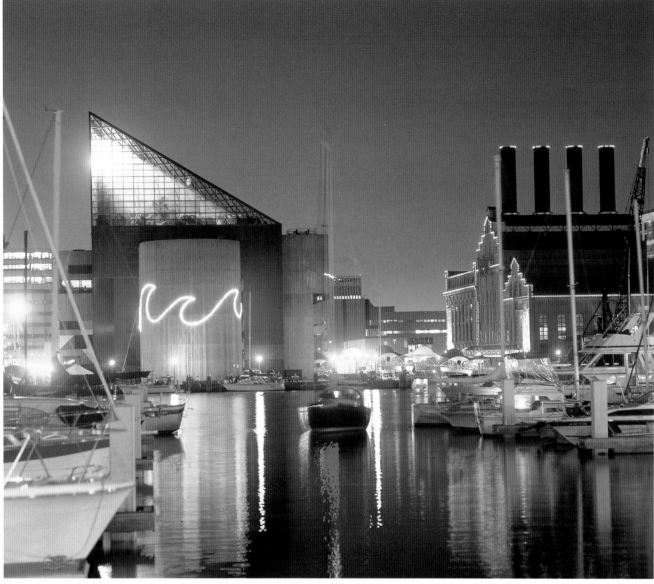

LEFT: Baltimore's impressive new Harborplace testifies to the importance of Maryland's historic port.

ABOVE: Baltimore's brightly lighted Inner Harbor, one of the scenes of a major urban redevelopment project for the downtown area.

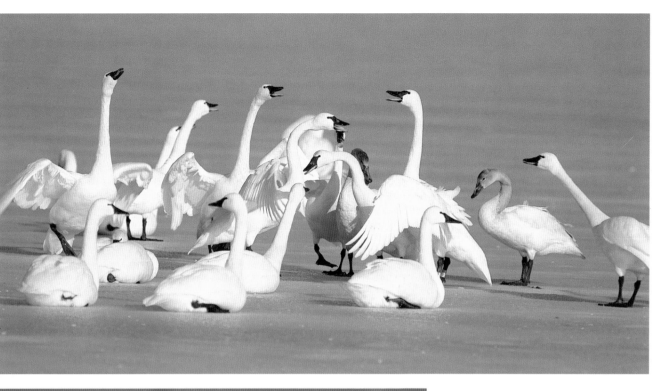

FAR LEFT: St. Michaels, Talbot County, Maryland, where woods and water meet.

ABOVE: Tundra swans winter on the Choptank River, on Maryland's eastern shore, near Cambridge.

LEFT: The sun highlights marsh plants at Maryland's Sandy Point, on the Chesapeake Bay.

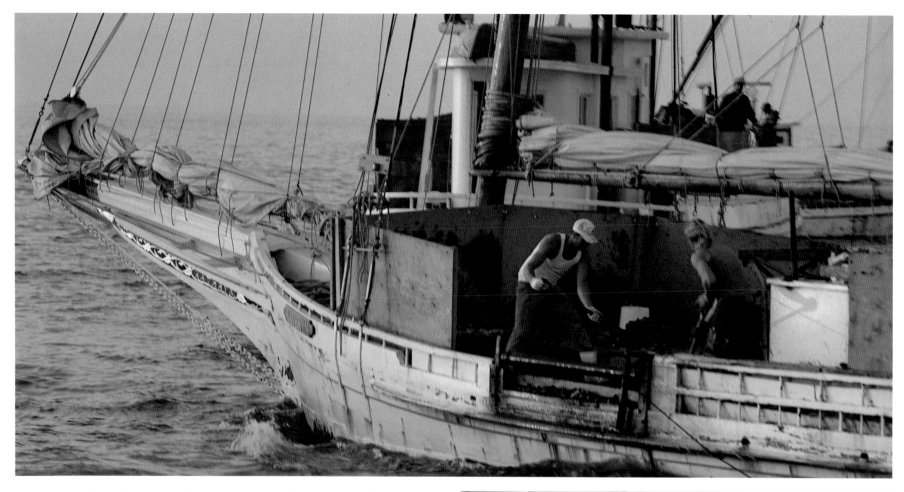

ABOVE: Dredging for oysters in the Chesapeake Bay, Maryland. Part of this great inlet of the Atlantic is in Virginia.

RIGHT: Chesapeake crabs are in demand at Sandy Point's Seafood Fest, in Pickerell, Maryland.

OPPOSITE: The busy harbor at Annapolis, Maryland, site of the United States Naval Academy.

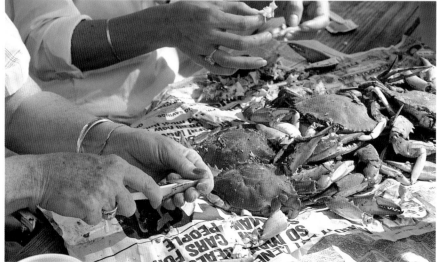

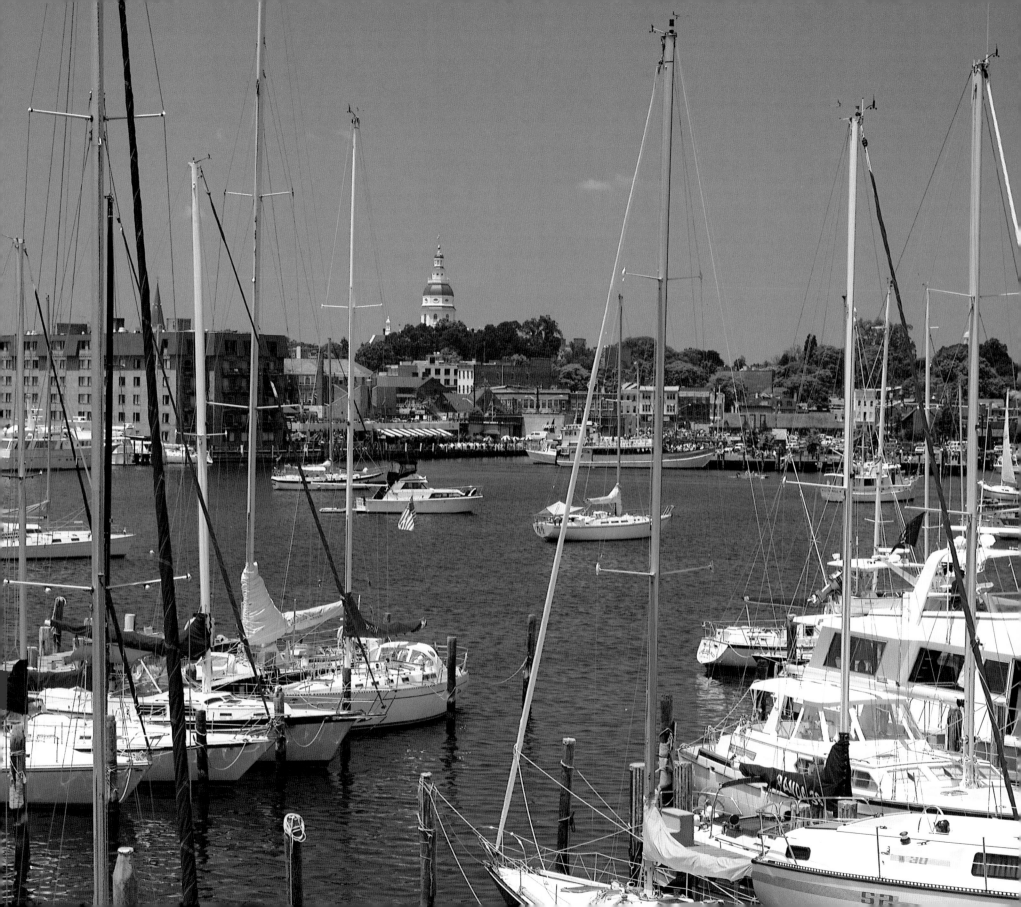

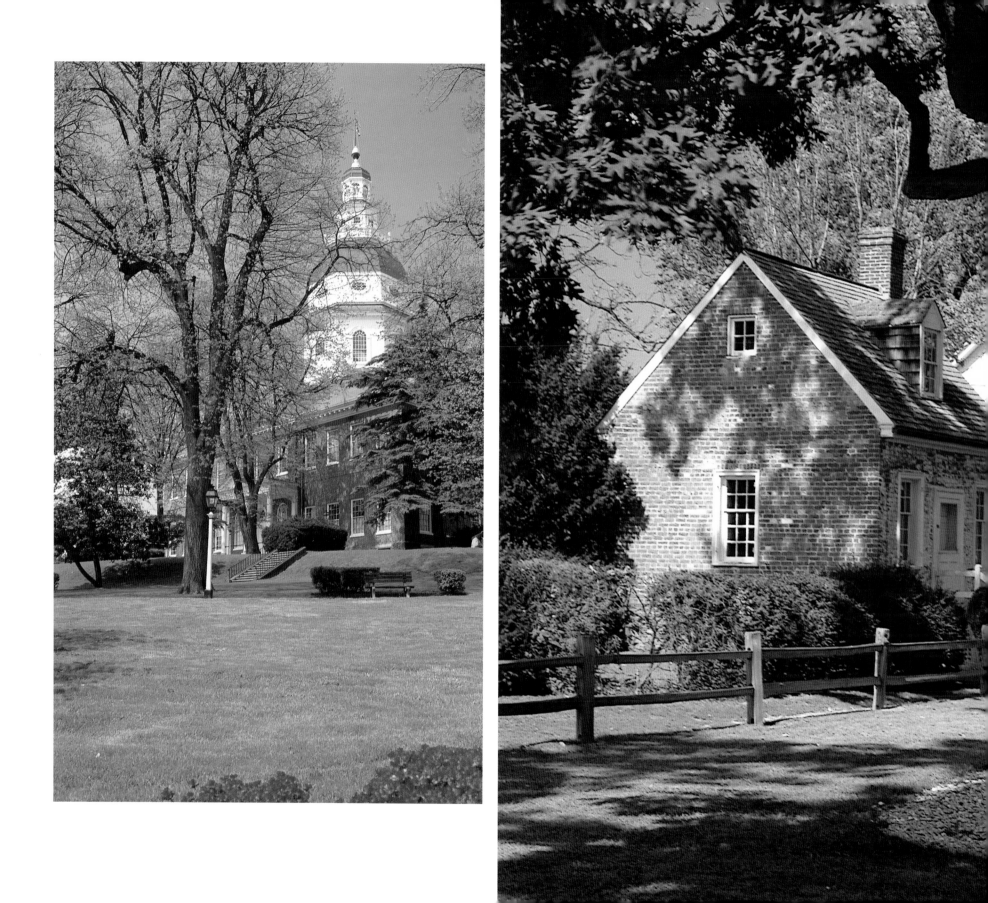

OPPOSITE: Maryland's state capitol in Annapolis, a gracious monument to the Federal style. Begun in 1772 and first used by the legislature in 1780, it is the oldest state capitol still in use.

CENTER: An ancient oak has a place of honor in the Maryland town of Wye. The town is known for the Wye Oak, which is 400 years old and one of the largest white oaks in the country.

ABOVE: A colorful catamaran sails Maryland's Chester River.

BELOW: The sidewalk in front of townhouses in Wilmington, Delaware, is graced by a carpet of spring petals.

RIGHT: Thousands of snow and Canada geese rendezvous at Delaware's Bombay Hook National Wildlife Refuge.

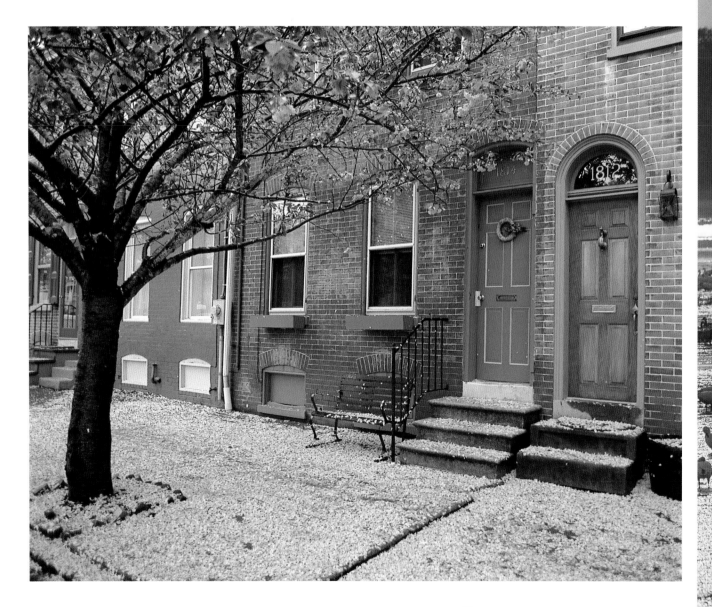

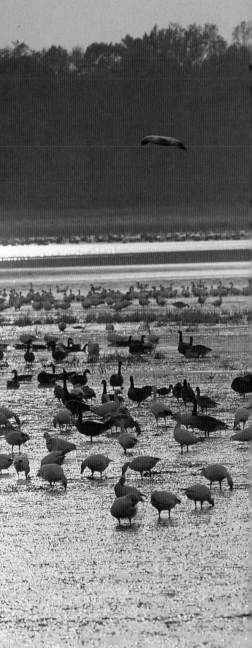

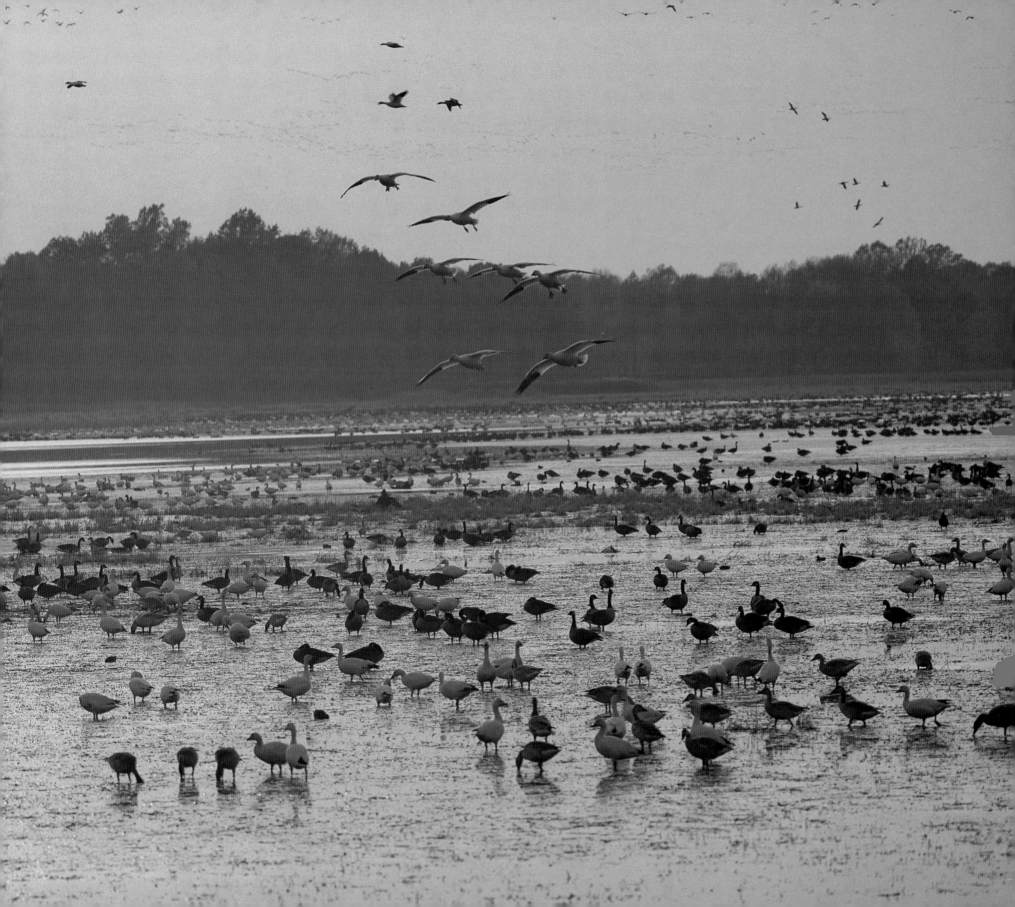

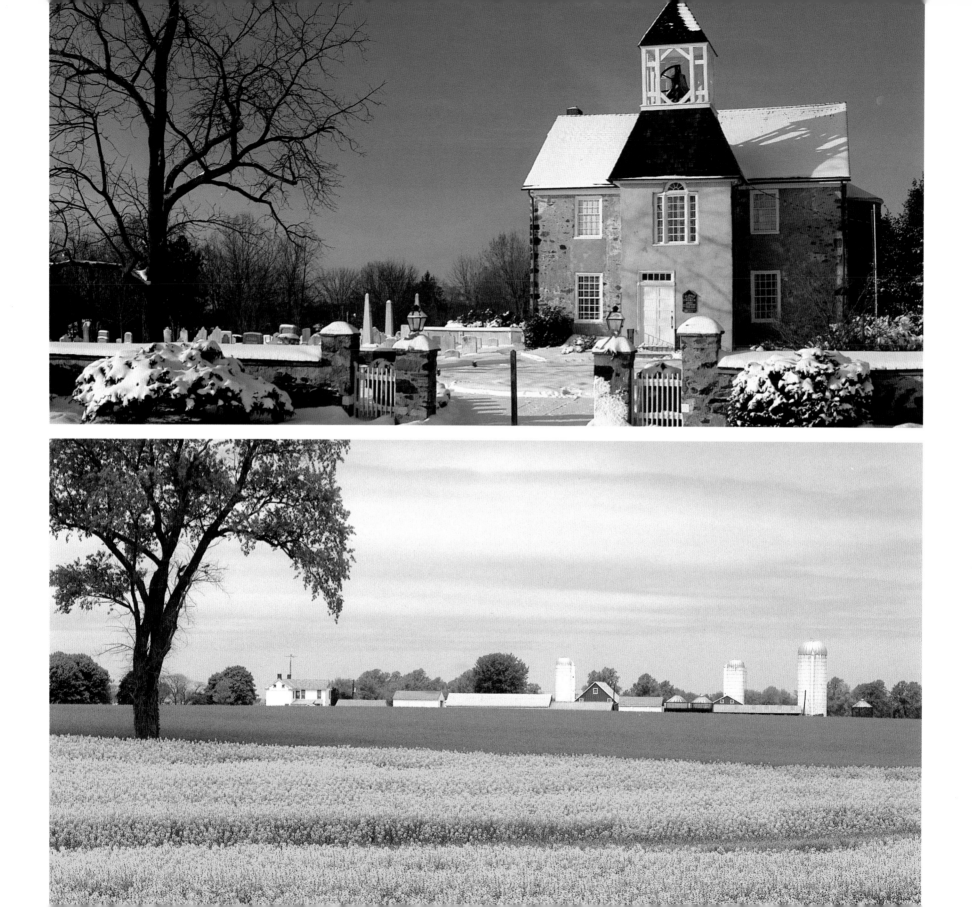

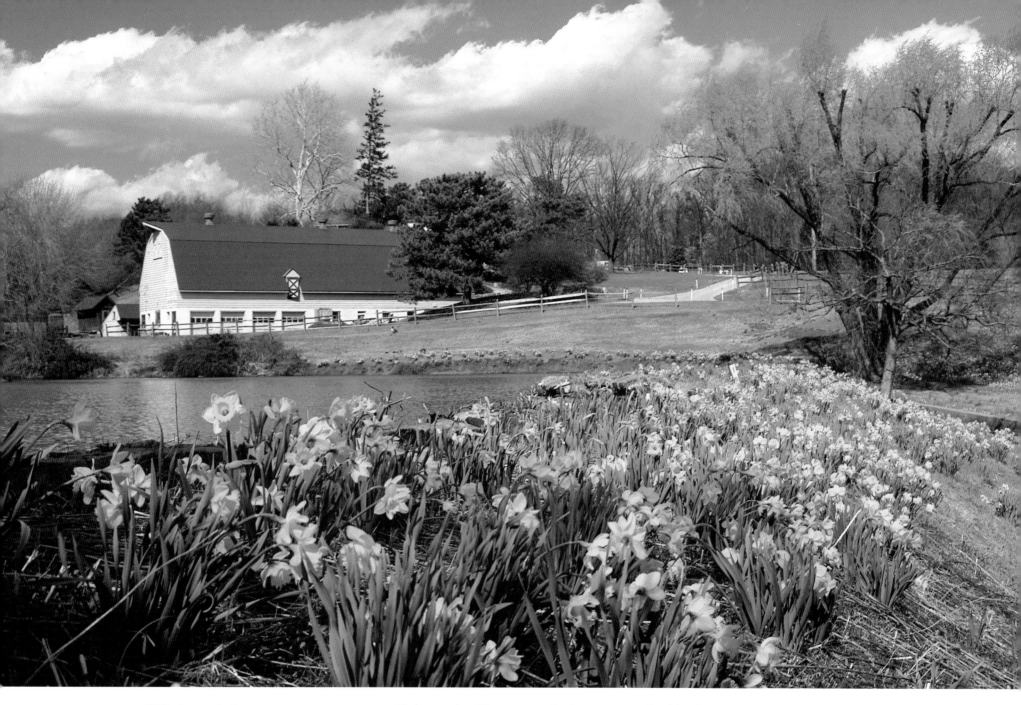

OPPOSITE TOP: Wilmington's St. James Episcopal Church was built in 1820.

OPPOSITE BOTTOM: Delaware is still farmed intensively, although it is best known for its manufacturing.

ABOVE: Spring comes to Rockland, Delaware, with "a host of golden daffodils."

RIGHT: America's best-loved statesman is spruced up for visitors to the Lincoln Memorial in Washington, D.C.

BELOW: A somber testament: The Vietnam War Memorial.

OPPOSITE: The soaring Washington Monument – 555 feet tall – pierces the sky above the nation's capital. The cornerstone was laid in 1848 with the same trowel George Washington had used to lay the cornerstone of the Capitol.

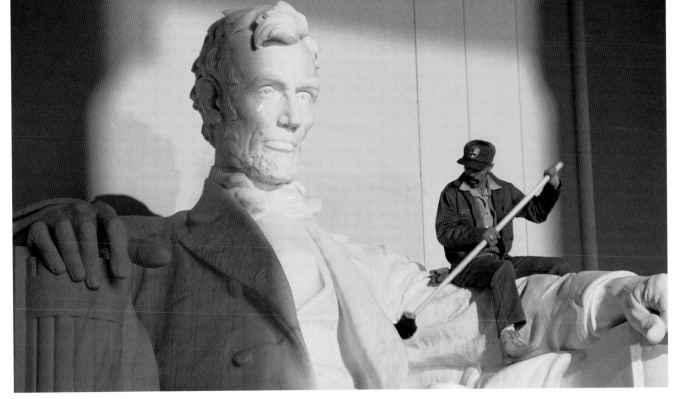

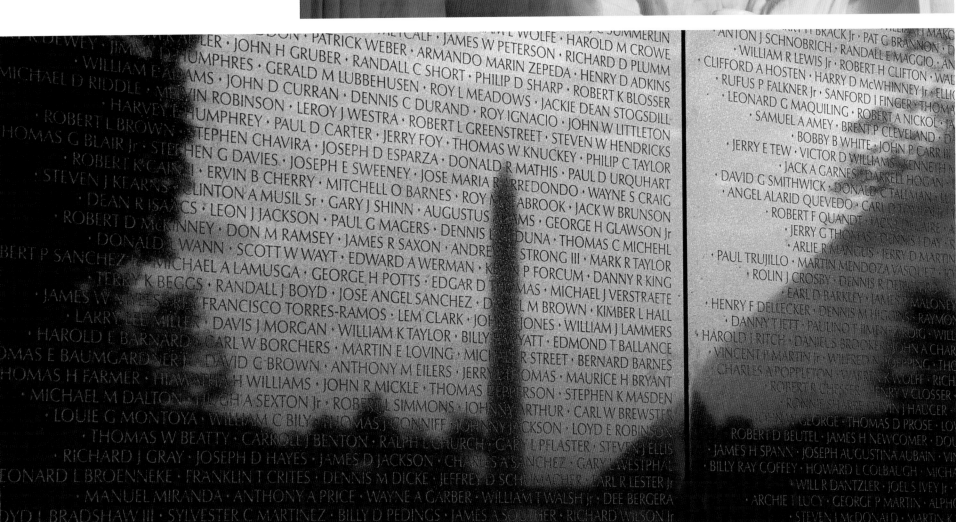

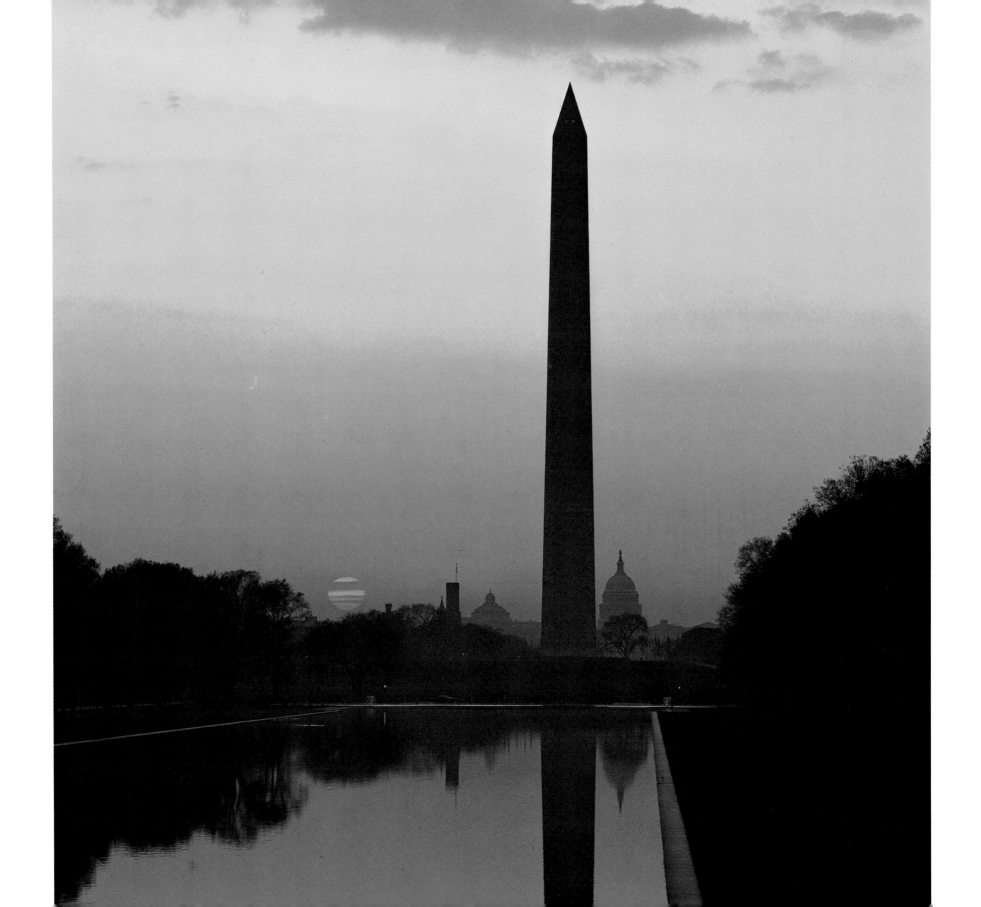

RIGHT: The stately United States Capitol building by night.

BELOW: Washington's annual Cherry Blossom Parade brings out the Old Guard (the Third Infantry).

FAR RIGHT: The White House, completed in 1800, has been home to every American president since John Adams.

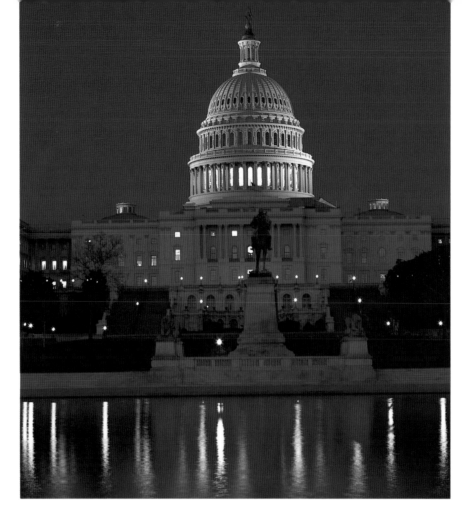

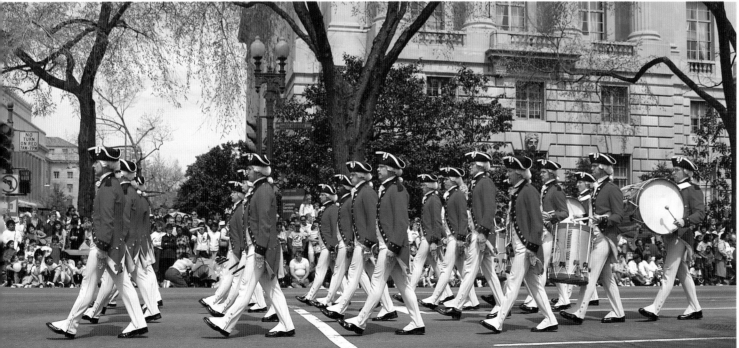

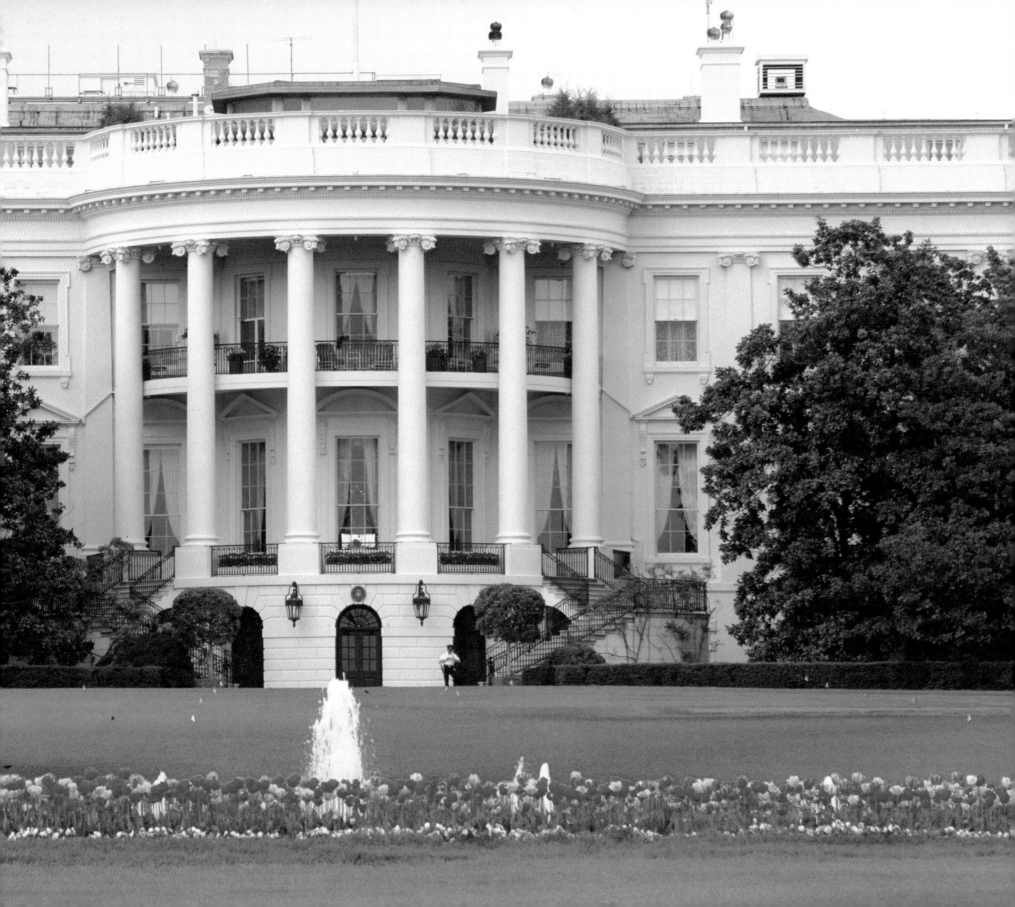

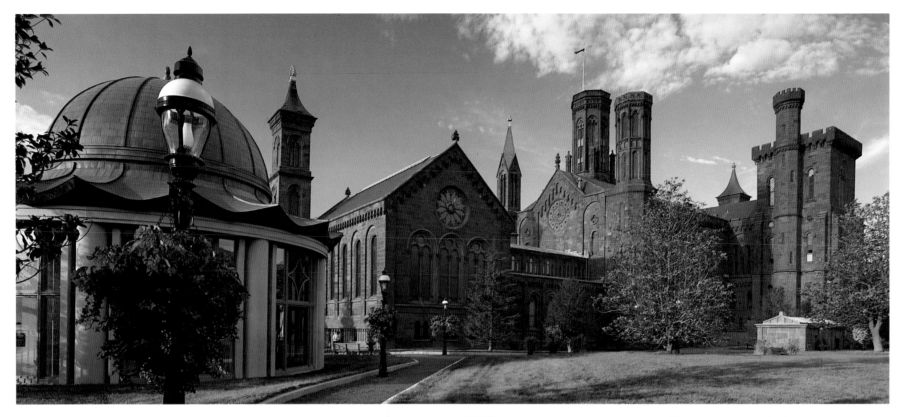

ABOVE: The Enid Haupt Garden at the Smithsonian Institution – the museum of America. Its collection is so extensive that parts of it have never been displayed.

OPPOSITE: Cherry blossoms frame the Jefferson Memorial at the Tidal Basin.

RIGHT: A brick-paved street in Georgetown, Washington's oldest residential section, lined with charming houses and shops.

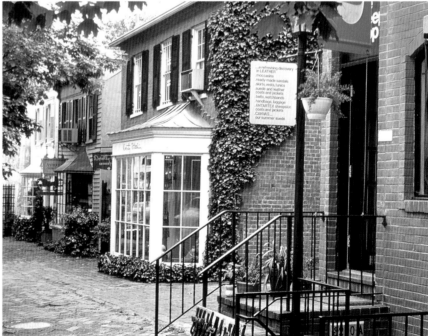

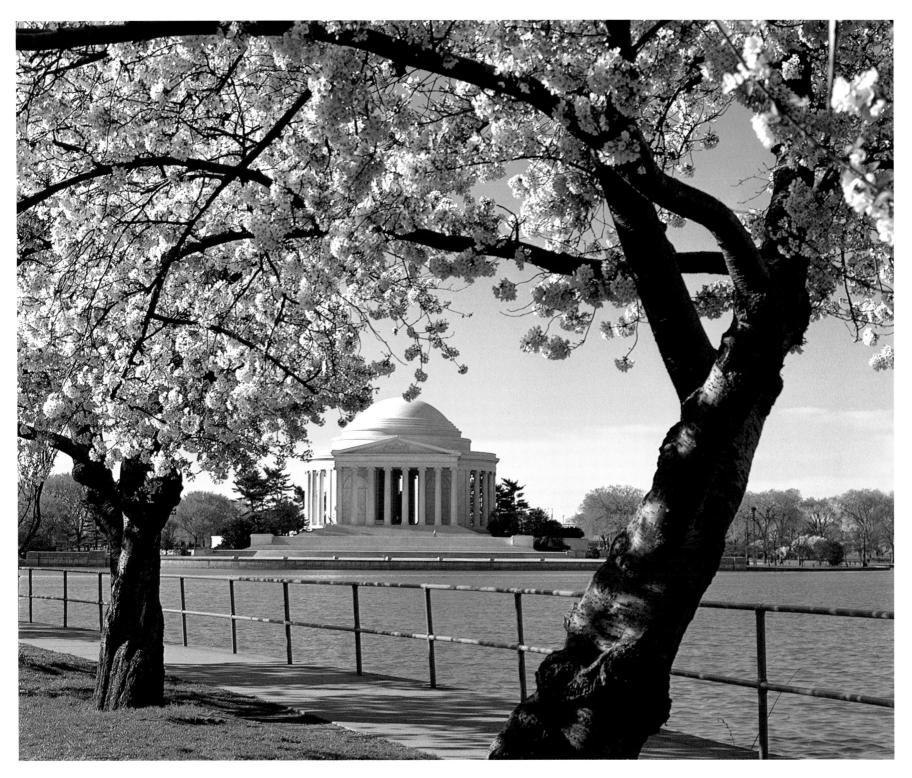

THE SOUTH

The twelve states of the American South are rich in history, natural beauty, and human resources. The Southern way of life is more relaxed than that of colder Northern climates, and people live in close proximity to their natural surroundings. There are many things to enjoy in this region that includes North Carolina, South Carolina, Georgia, Kentucky, Virginia, West Virginia, Florida, Alabama, Mississippi, Louisiana, Arkansas, and Tennessee.

This was the first part of the United States to be settled by Europeans, but until the last few decades it was sparsely populated in comparison to other areas. Now the growing attractions of the Sun Belt are drawing many Americans southeastward, not only for Florida vacations, but to make new homes and businesses in a flourishing region. Such modern cities as Atlanta, Charleston, Mobile, Nashville, Miami, and New Orleans offer countless amenities, while the natural beauty of Atlantic shorelines and islands, mountain ranges such as the Ozarks and the Great Smokies, antebellum plantations and beautiful gardens in year-round bloom exert their own kind of fascination.

Many kinds of animals and plants are protected in such refuges as Everglades National Park, Cherokee National Forest, and the Okefenokee Swamp on the Georgia-Florida border. Alligators prowl these waters, and long-legged water birds nest and feed. The South has great stands of live oak, long-leaf pine, rhododendron, azalea, palm and palmetto. Magnolias gleam with an iridescent beauty, and night-blooming jasmine perfumes the air. Hibiscus of red and pink, swaying water grasses, and brightly colored wildflowers beautify the landscape.

Side by side with the gleaming skyscrapers and bustling harbors of the region's cities are enduring monuments to the past: tiny pioneer cabins, riverboats, Civil War memorials, old sailing ships – the many threads that tie this region into the fabric of American history.

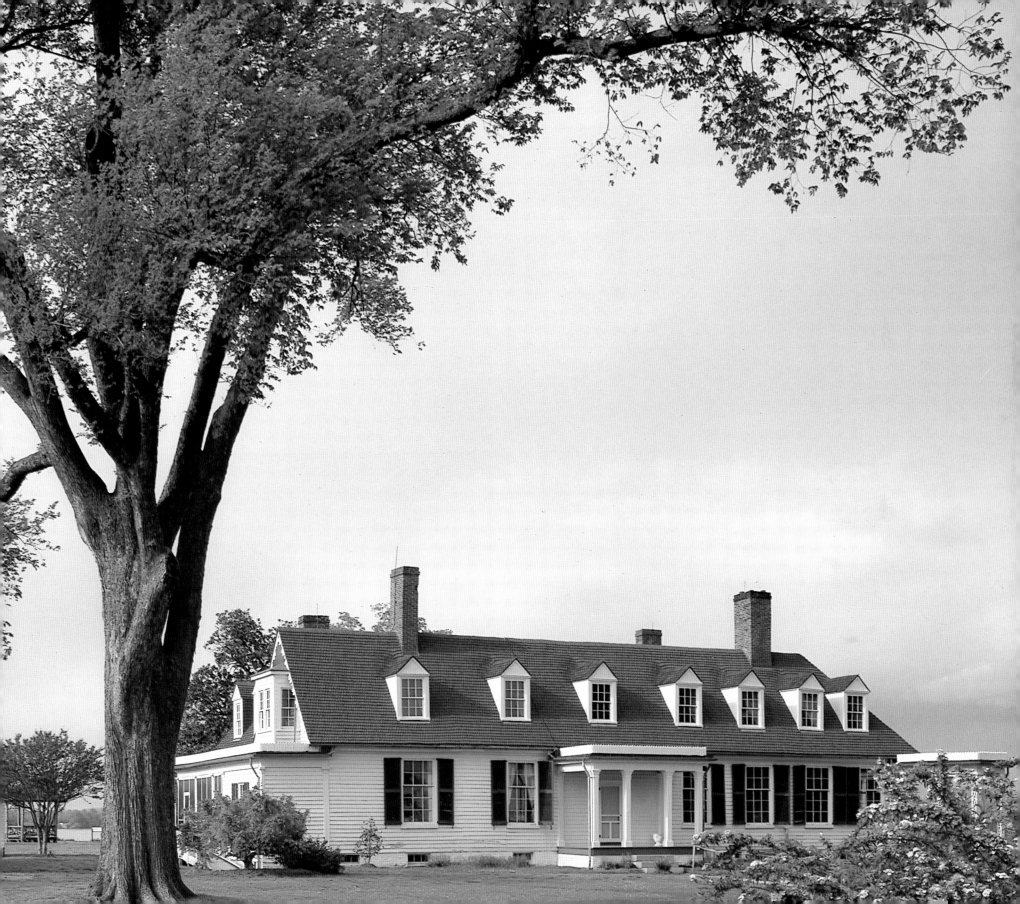

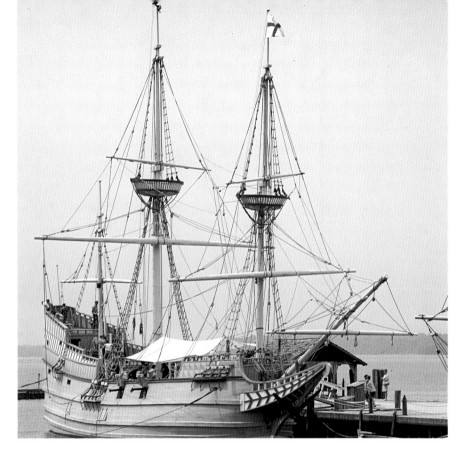

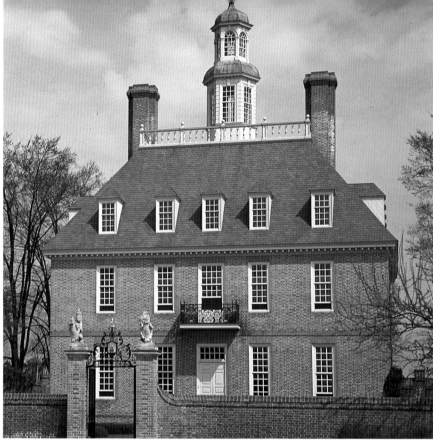

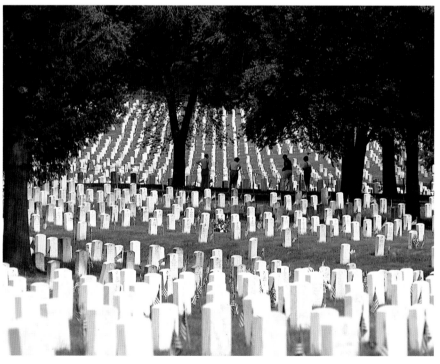

ABOVE: Virginia's Jamestown Festival Park preserves replicas of the sailing ships that brought English settlers to the state in 1607.

TOP RIGHT: The restored Georgian-style Governor's Palace that housed the governors of Virginia, at Colonial Williamsburg.

RIGHT: Arlington National Cemetery honors the nation's war dead, both famous and obscure, including the Unknown Soldier.

OPPOSITE: Monticello was designed and built by Thomas Jefferson beginning in 1769. This classic building of American architecture is one of the most beautiful estates in Virginia. The future president and governor of Virginia lived here for more than 50 years.

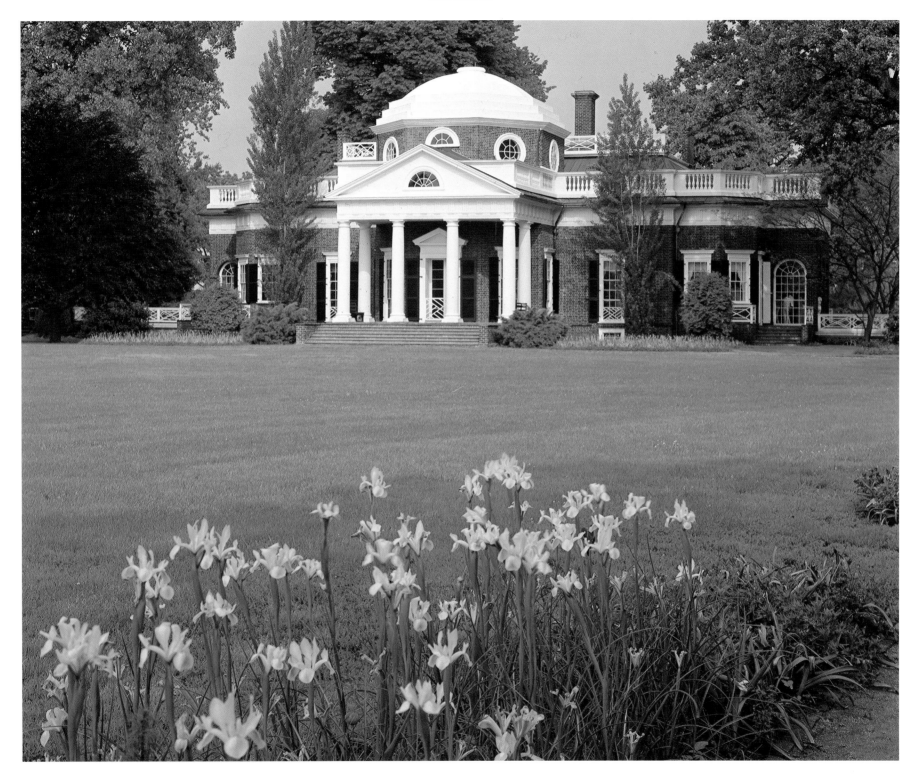

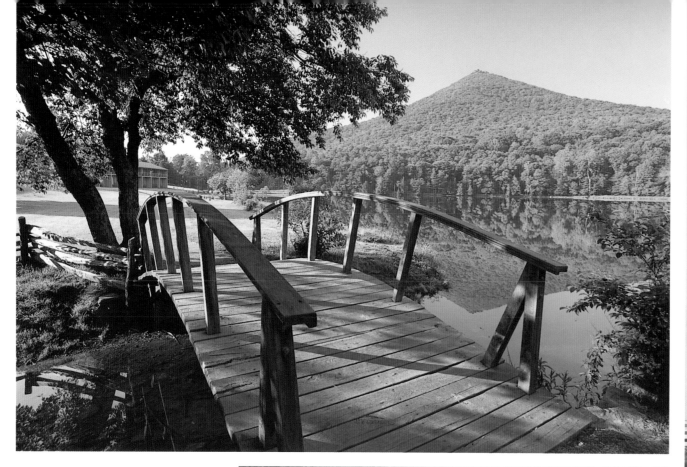

ABOVE: The peaks of Otter Lodge along the Blue Ridge Parkway. Virginia's Blue Ridge Parkway opens the door to a scenic paradise. Extending for almost 500 miles through three states, the Parkway links the Shenandoah National Park, the Blue Ridge Mountains, and the Great Smoky Mountains National Park.

RIGHT: The luxuriant Norfolk Botanical Gardens, at Norfolk, Virginia.

FAR RIGHT: The city of Richmond today.

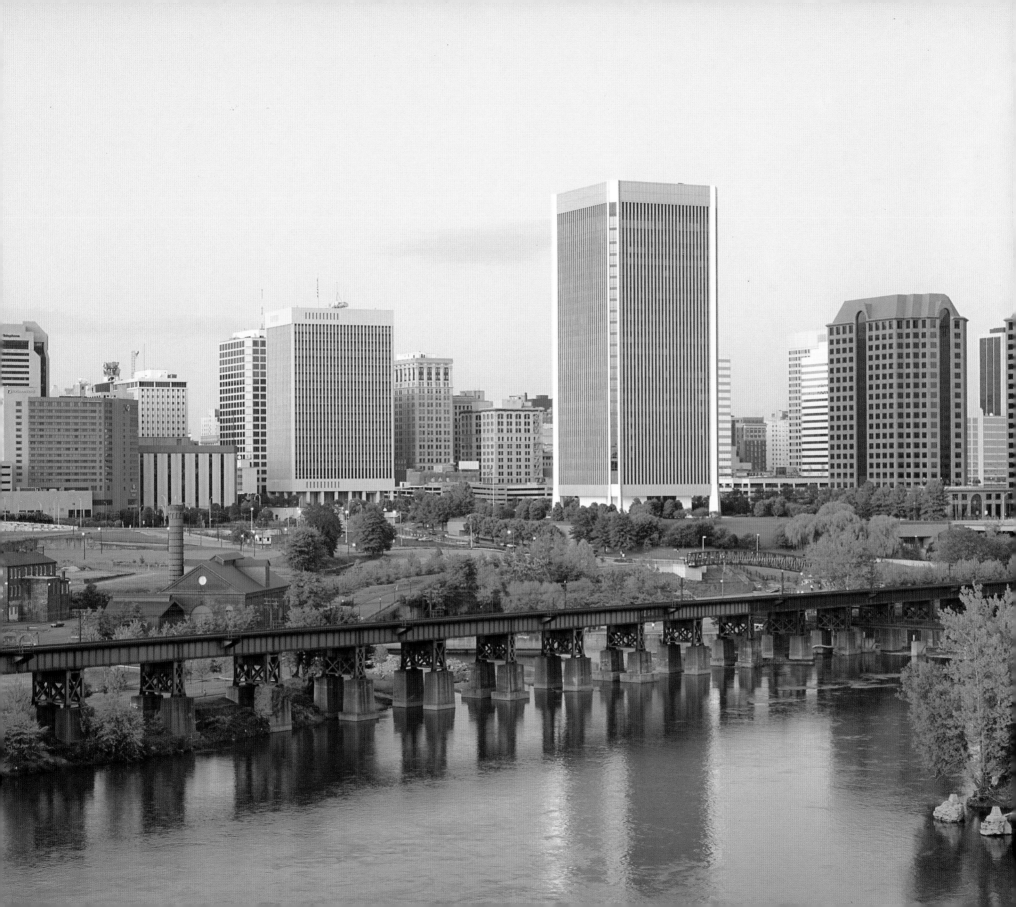

LEFT: Graceful water plants at Lake Phelps, North Carolina – part of the Dismal Swamp National Wildlife Refuge.

BELOW: South Nags Head, North Carolina, has secluded beaches and warm breezes off the Atlantic.

RIGHT: A spectacular aerial view of North Carolina's Outer Banks. This 100-mile stretch of narrow peninsulas and islands off the mainland also holds National Seashore beaches and sand dunes.

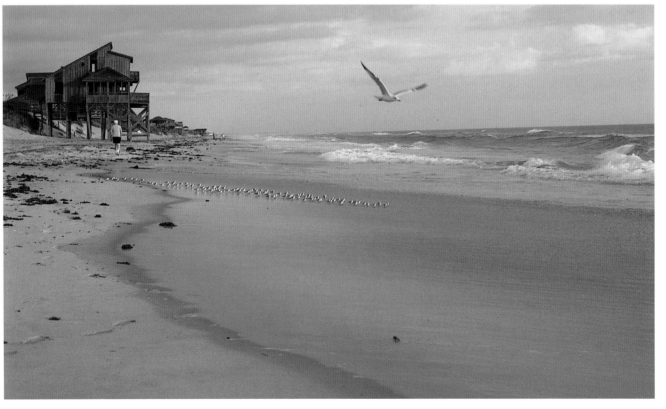

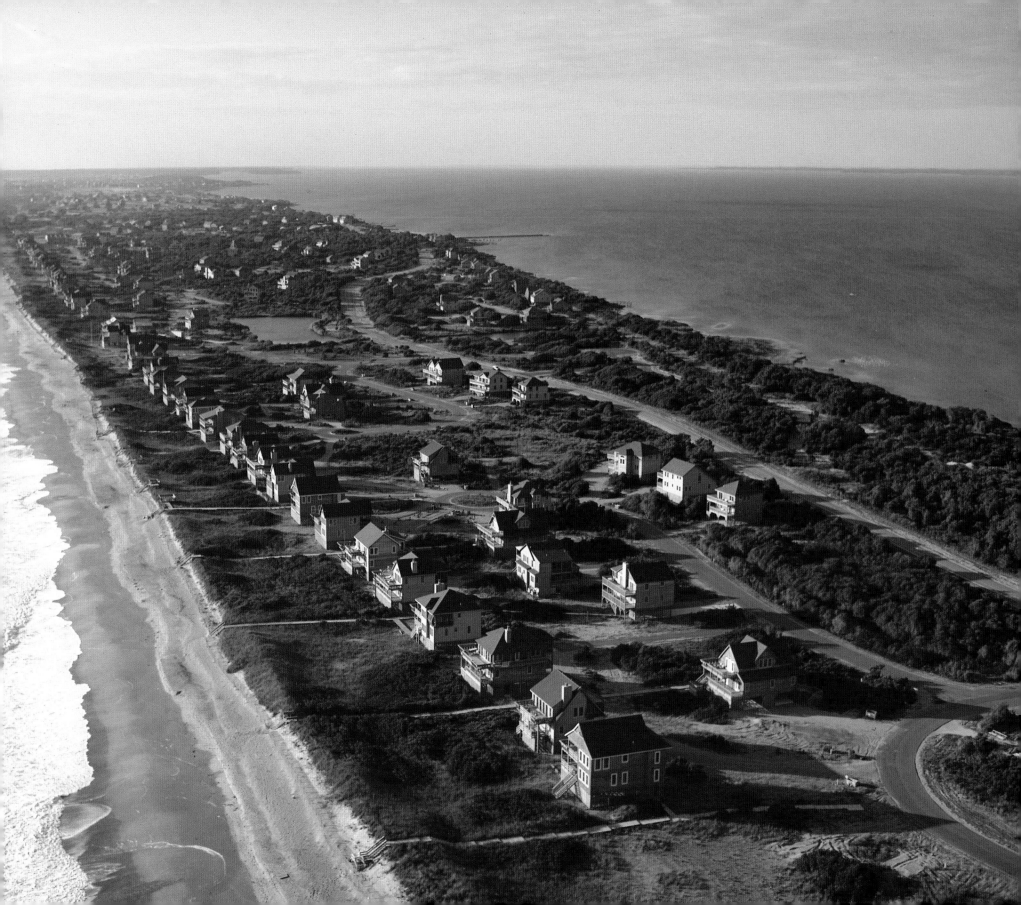

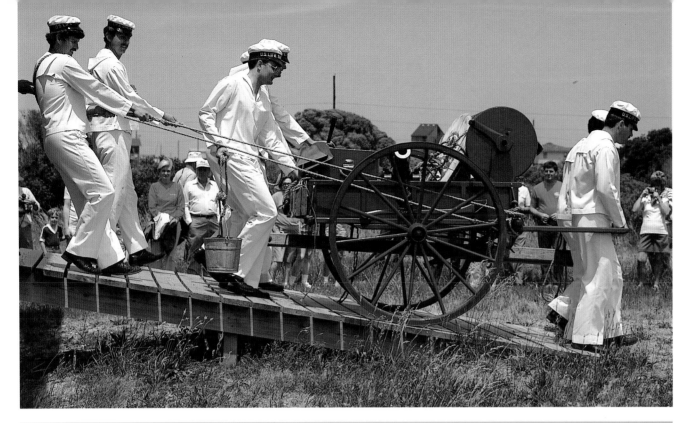

LEFT: Lifeguards train for rescue work in the Outer Banks, North Carolina.

BOTTOM LEFT: The Wright Brothers National Memorial at Kitty Hawk, North Carolina, commemorates the pioneers of aviation. Orville Wright's 12-second flight on December 17, 1903, was the first powered airplane flight.

OPPOSITE: The Avenue of Oaks at Magnolia Plantation and Gardens, Charleston, South Carolina. The 50-acre gardens are at the heart of this 500-acre estate.

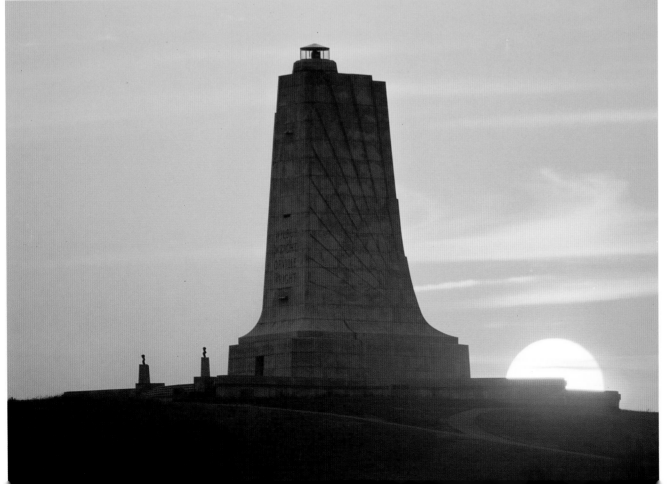

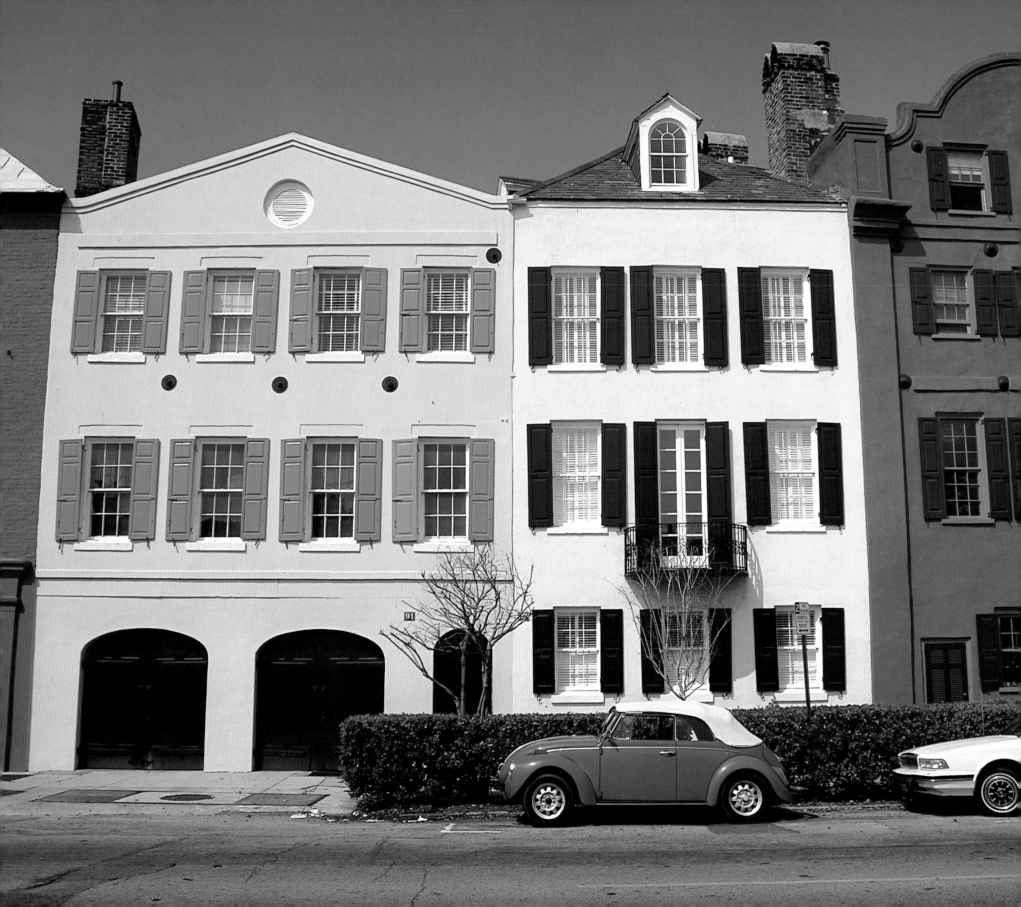

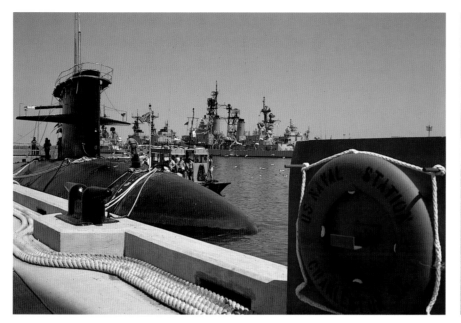

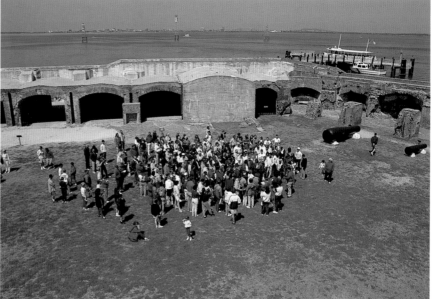

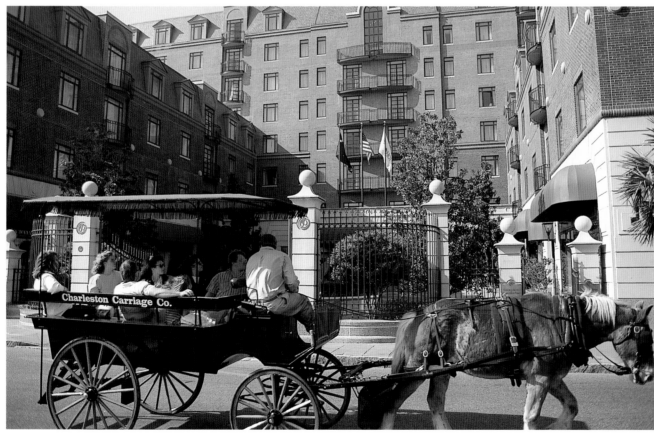

OPPOSITE: Rainbow Row is the name for this part of Charleston's East Bay Street, with its historic row houses.

TOP LEFT: The naval station at Charleston Harbor, an important port since Colonial times.

LEFT: Horse-drawn carriages tour Charleston's historic district.

ABOVE: Fort Sumter, on an island in Charleston Harbor, saw the first shots of the Civil War exchanged. It is now a National Monument.

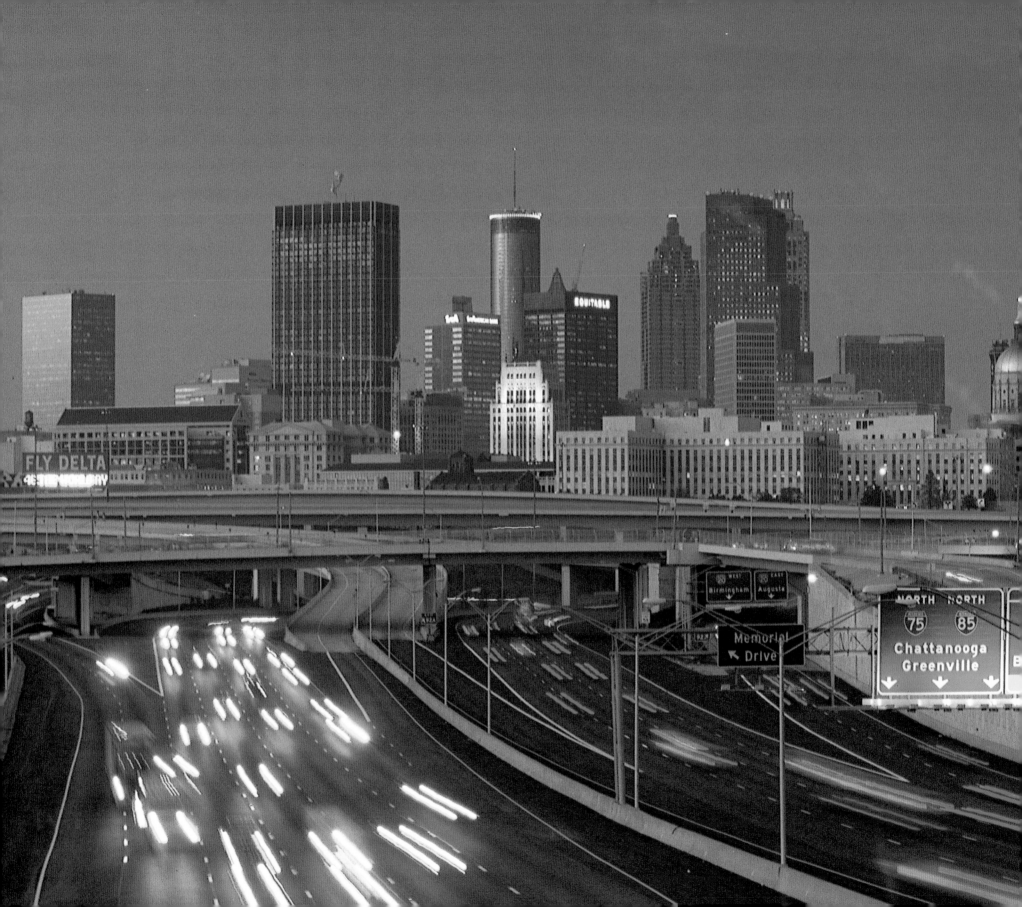

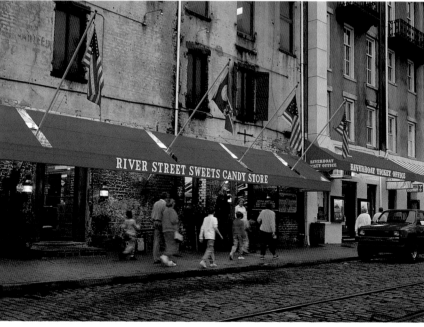

FAR LEFT: A panoramic view of Atlanta, Georgia, at dusk.

ABOVE: Sleek skyscrapers in downtown Atlanta's Peachtree Center.

LEFT: Historic River Street in the gracious old city of Savannah, Georgia.

111

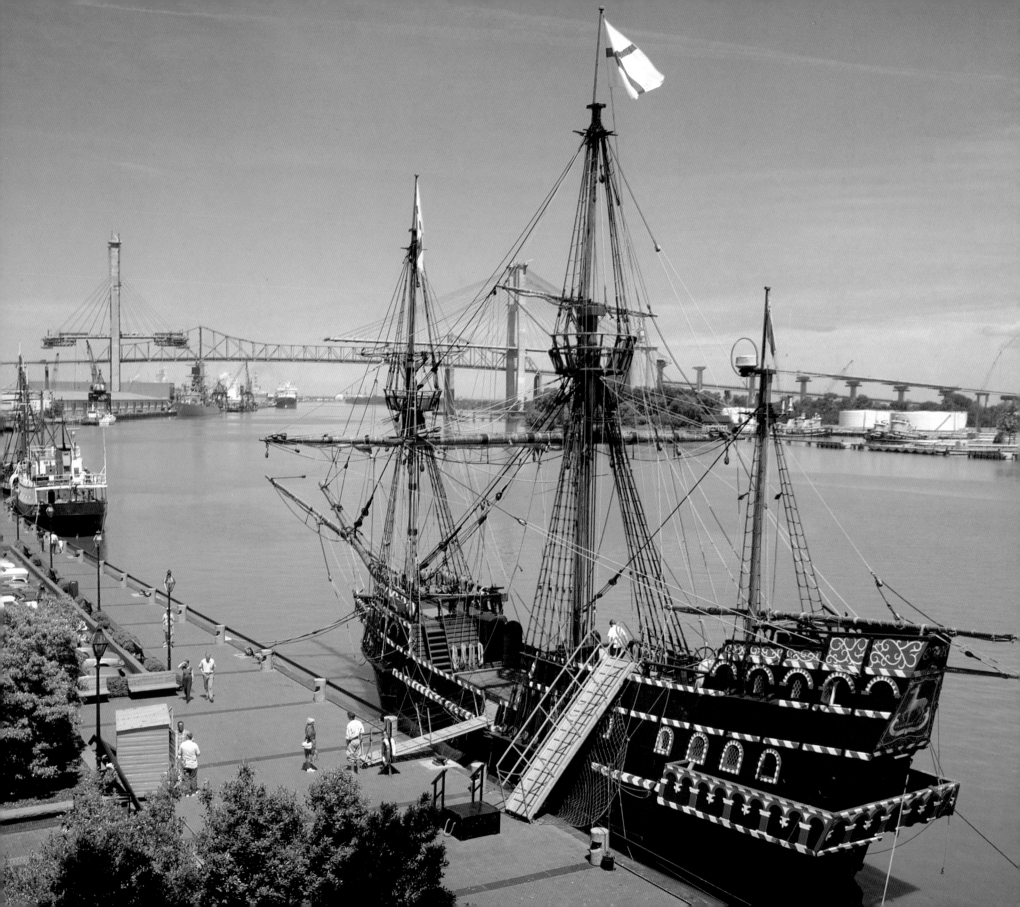

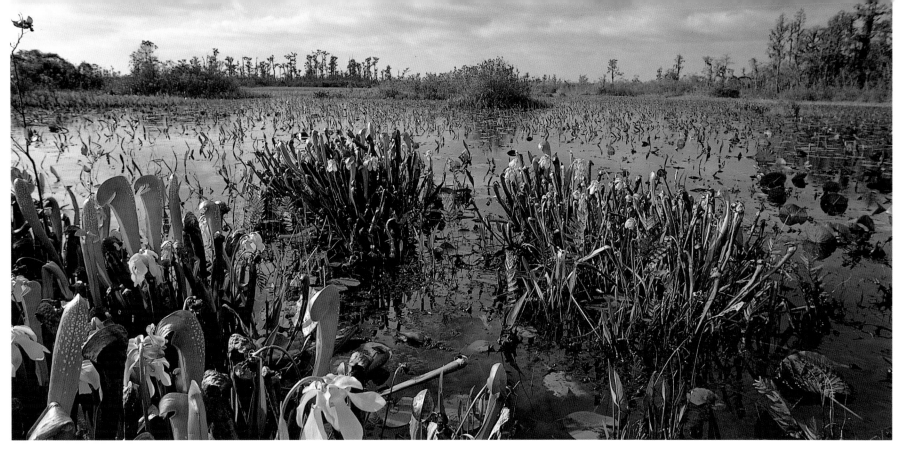

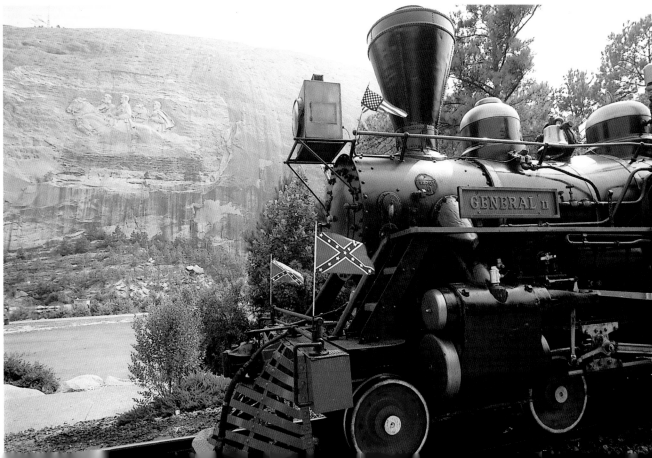

OPPOSITE: Savannah history is preserved along its riverfront. Savannah today is the fastest-growing port on the South Atlantic coast.

ABOVE: Goldenclub flourishes in the Okefenokee Swamp of Georgia, which extends into northern Florida.

LEFT: A Civil War-era train tours the Stone Mountain war memorial in Georgia, where reliefs of Confederate President Jefferson Davis, General Robert E. Lee, and General "Stonewall" Jackson, each on horseback, are carved into the rockface. It took more than 50 years and three sculptors to complete the monument.

RIGHT: In colorful Key West, Florida, people gather at Mallory Square to watch the spectacular tropical sunset.

BELOW: Downtown Miami as seen from Brickell Avenue.

OPPOSITE: Luxury hotels line the shores of Miami Beach, an island off the city of Miami. One of several causeways that connect Miami Beach to Miami can be seen in the distance.

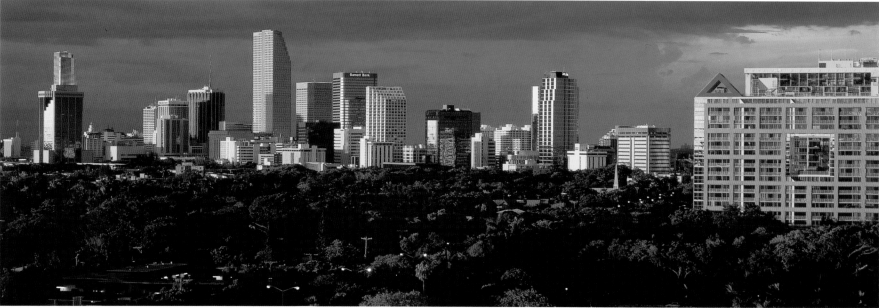

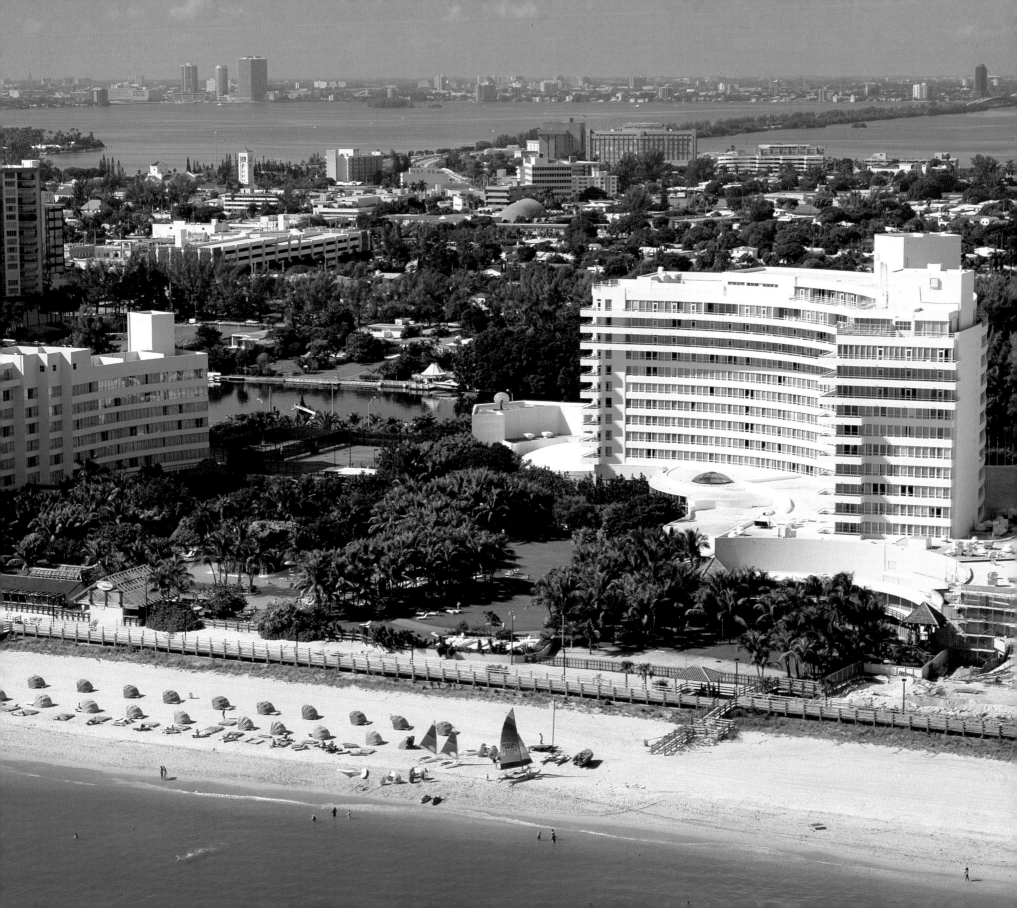

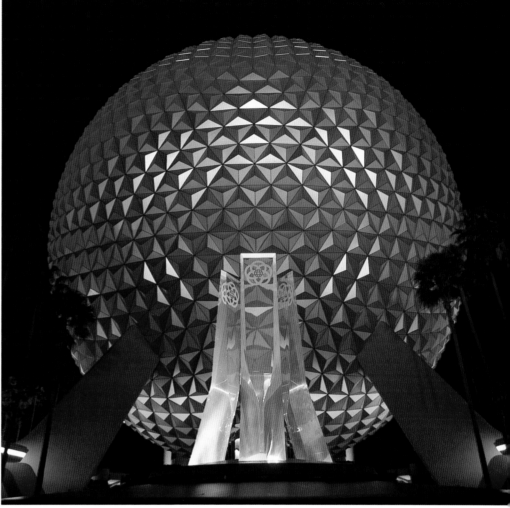

OPPOSITE: Sunset over Ocean Drive in the Historic Art Deco District of Miami Beach.

ABOVE LEFT: The Python, at the Busch Gardens recreational complex in Tampa, Florida.

LEFT: A Saturn V rocket displayed at the Kennedy Space Center in Cape Canaveral – one of Florida's biggest attractions.

ABOVE: Spaceship Earth, the geodesic dome at Disney's EPCOT Center in Orlando.

ABOVE: The popular show featuring Shamu the whale, at Orlando's Sea World.

RIGHT: An alligator watches for prey in the Florida Everglades.

FAR RIGHT: Vast fields of sugar cane in eastern Florida, near Lake Okeechobee.

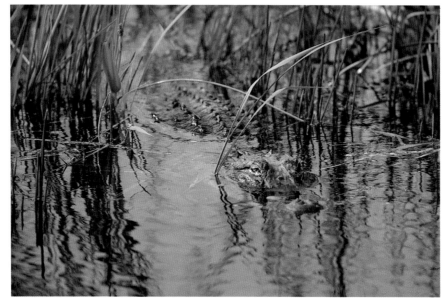

RIGHT: Oak Knoll Bed & Breakfast, along West Virginia's scenic Route 60.

BOTTOM RIGHT: Fall colors near Rainelle, West Virginia, which is still largely a rural state, best known for its mining industry.

OPPOSITE: The Glade Creek Grist Mill in Babcock State Park in West Virginia.

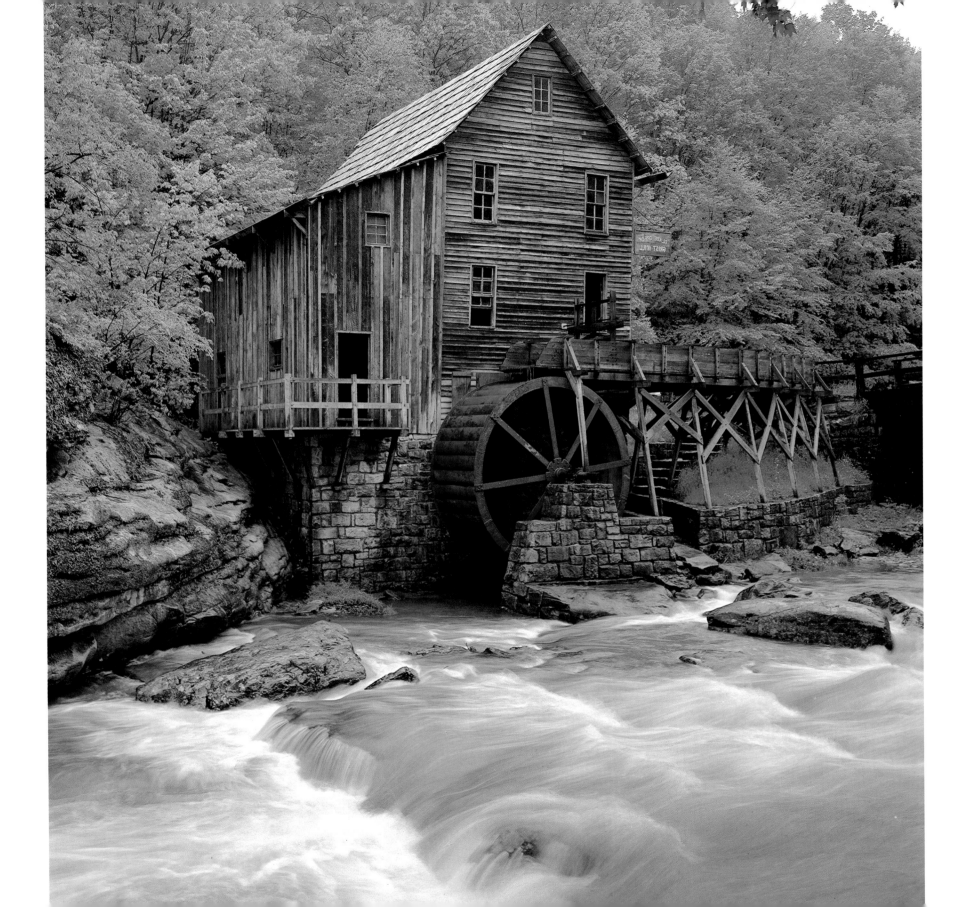

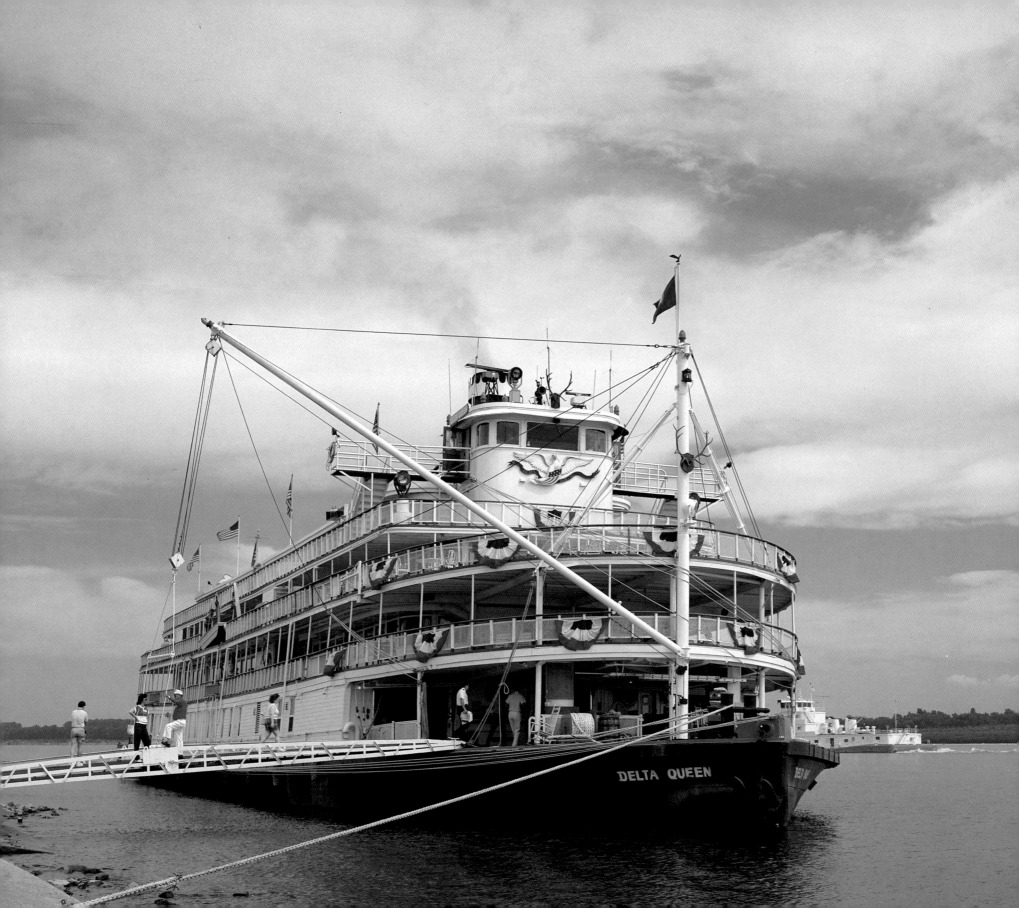

OPPOSITE: The *Delta Queen* riverboat, in Paducah, Kentucky, recalls an older time.

ABOVE: The *Belle of Louisville* takes the long Ohio River route to the Mississippi, where nostalgic riverboat cruises are a popular vacation activity.

LEFT: The ancient Mammoth Cave of Kentucky, only part of which has been explored.

ABOVE: Abraham Lincoln's boyhood home: Knob Creek Farm, in Hodgenville, Kentucky.

RIGHT: The Shakers are gone from their village at Pleasant Hill, Kentucky, but their simple artifacts recall generations of fidelity to work and worship.

OPPOSITE: Splendid Kentucky thoroughbreds graze on one of the state's many fine breeding farms.

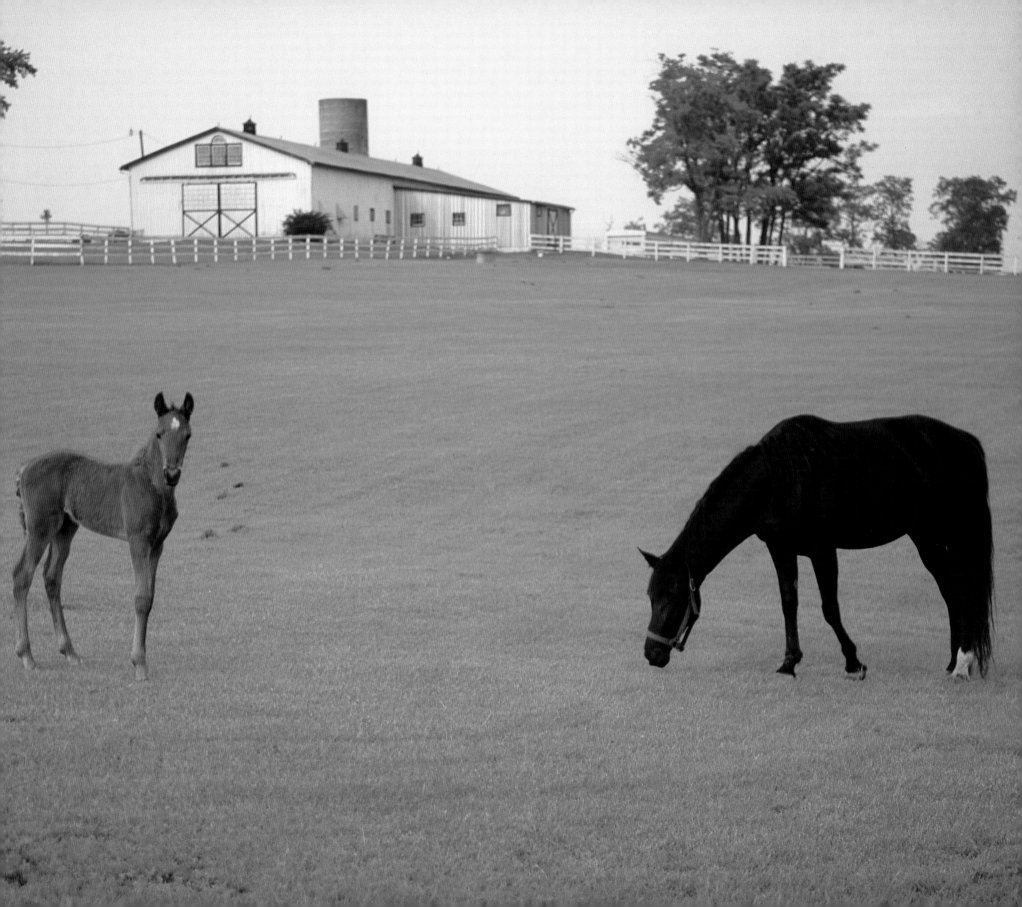

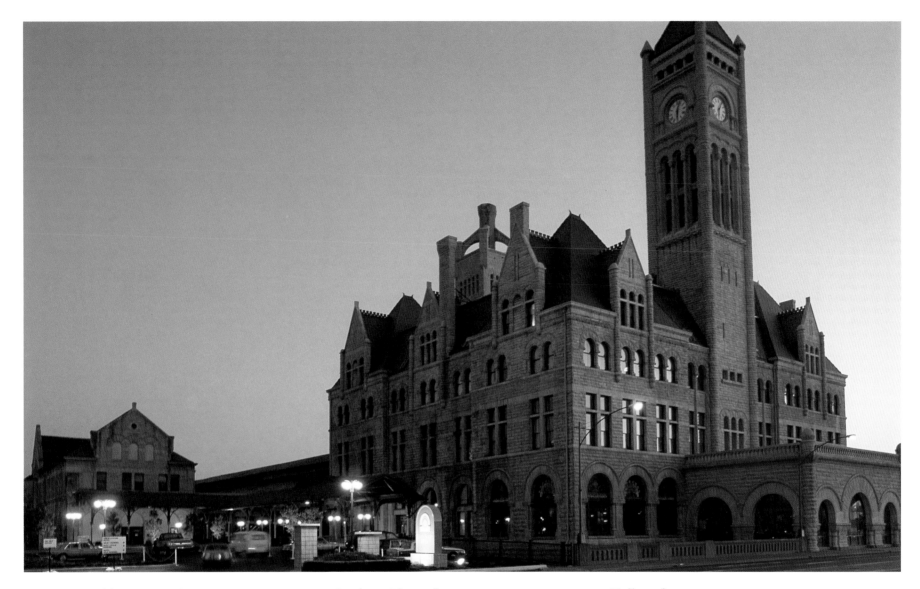

ABOVE: The old Union Station – now a hotel – in Nashville, Tennessee, was once the most splendid railroad depot in the South. The original stained glass and detailed woodwork and plasterwork are still here.

OPPOSITE TOP: Lookout Mountain, a Civil War battleground that rises steeply above Chattanooga, Tennessee. Lookout Mountain is in Chattanooga National Military Park, the nation's oldest park of its kind.

OPPOSITE BOTTOM LEFT: Folk crafts such as weaving are still part of life in the Great Smoky Mountains of Tennessee and North Carolina. Here, a woman demonstrates her craft at the Pioneer Farmstead.

OPPOSITE BOTTOM RIGHT: Downtown Nashville, Tennessee, under a cloudless sky.

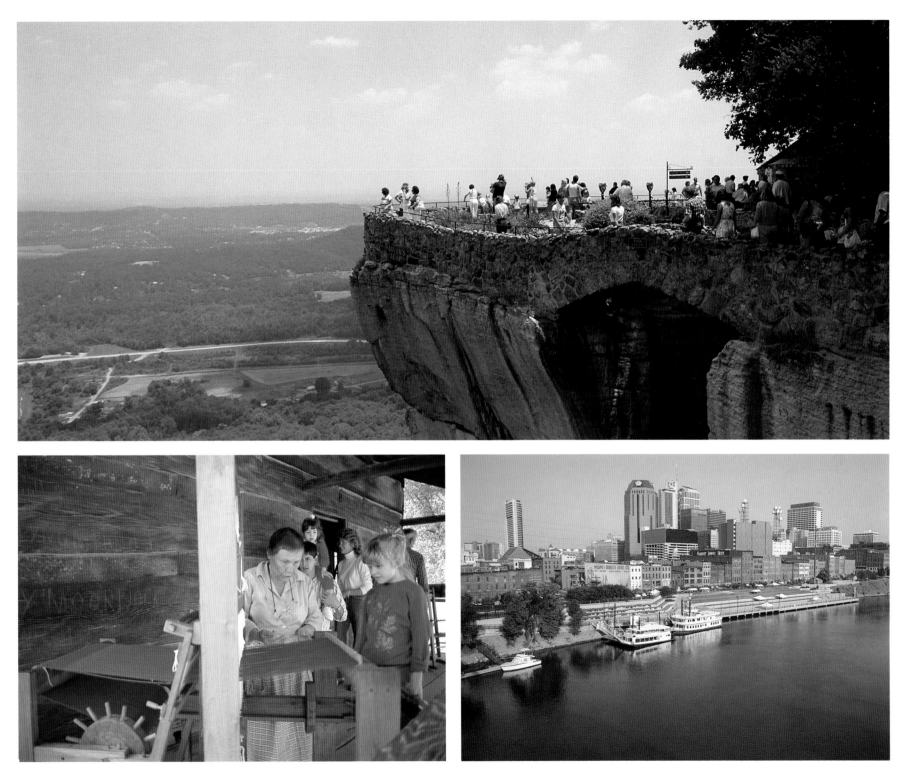

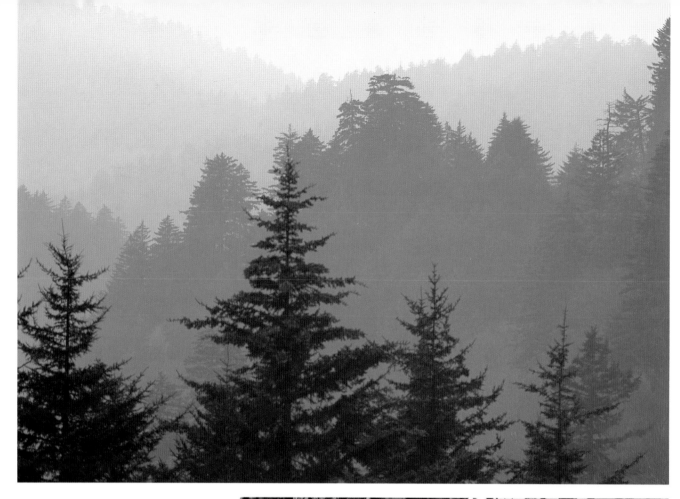

ABOVE: Day's end at Newfound Gap, in the incomparable Great Smoky Mountains National Park.

RIGHT: The restored Carter Shields Cabin, a typical pioneer homestead in the Great Smoky Mountains.

FAR RIGHT: Tennessee woodlands near the town of Spencer.

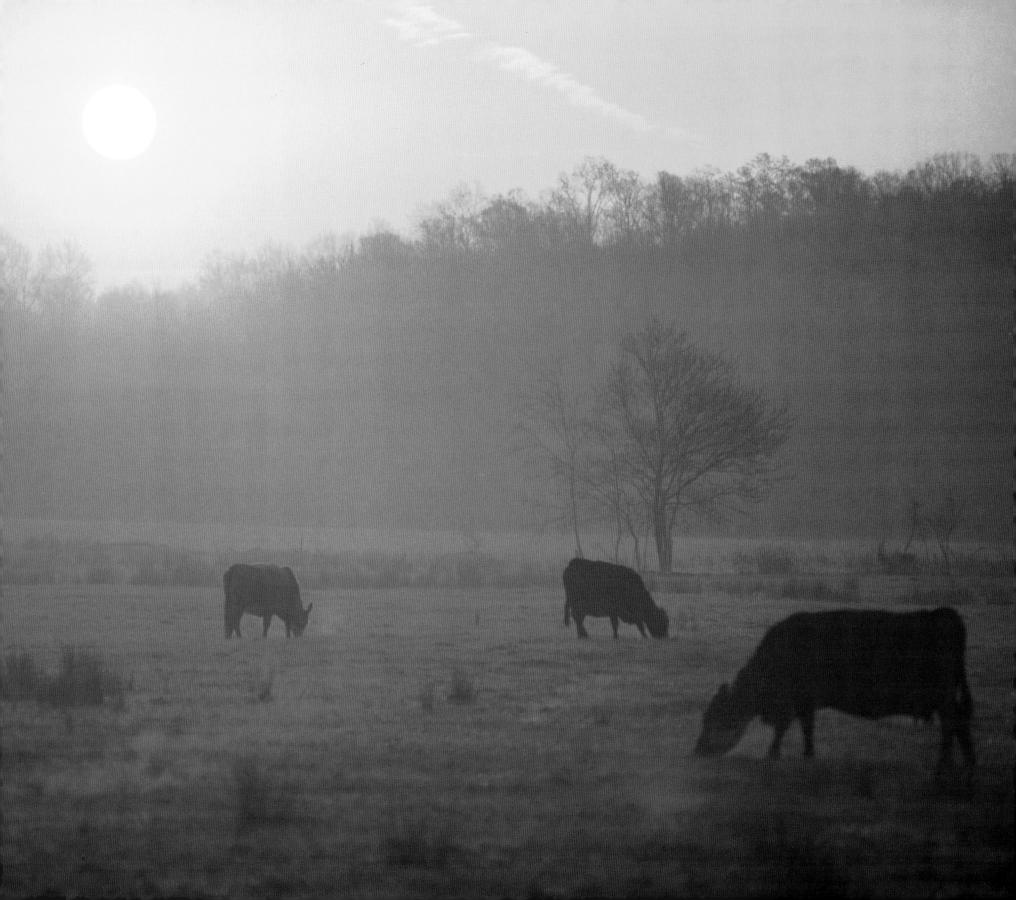

RIGHT: Bellingrath Estate and Gardens, one of Mobile, Alabama's, stately homes, landscaped with thousands of flowering azaleas.

BELOW: One of the many cotton fields along Alabama's Natchez Trace.

FAR RIGHT: The landmark Pope's Tavern, built in 1830, in Florence, Alabama. This one-and-a-half-story building served as a tavern and as a hospital for both Confederate and Union troops during the Civil War.

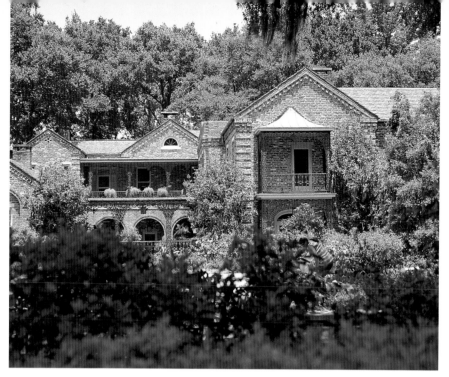

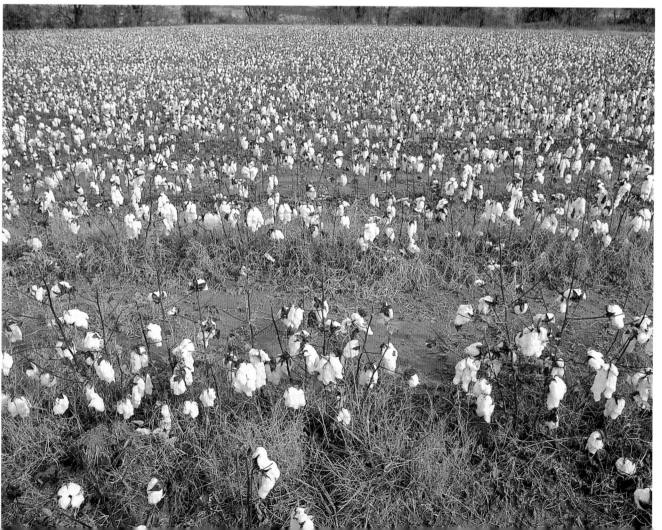

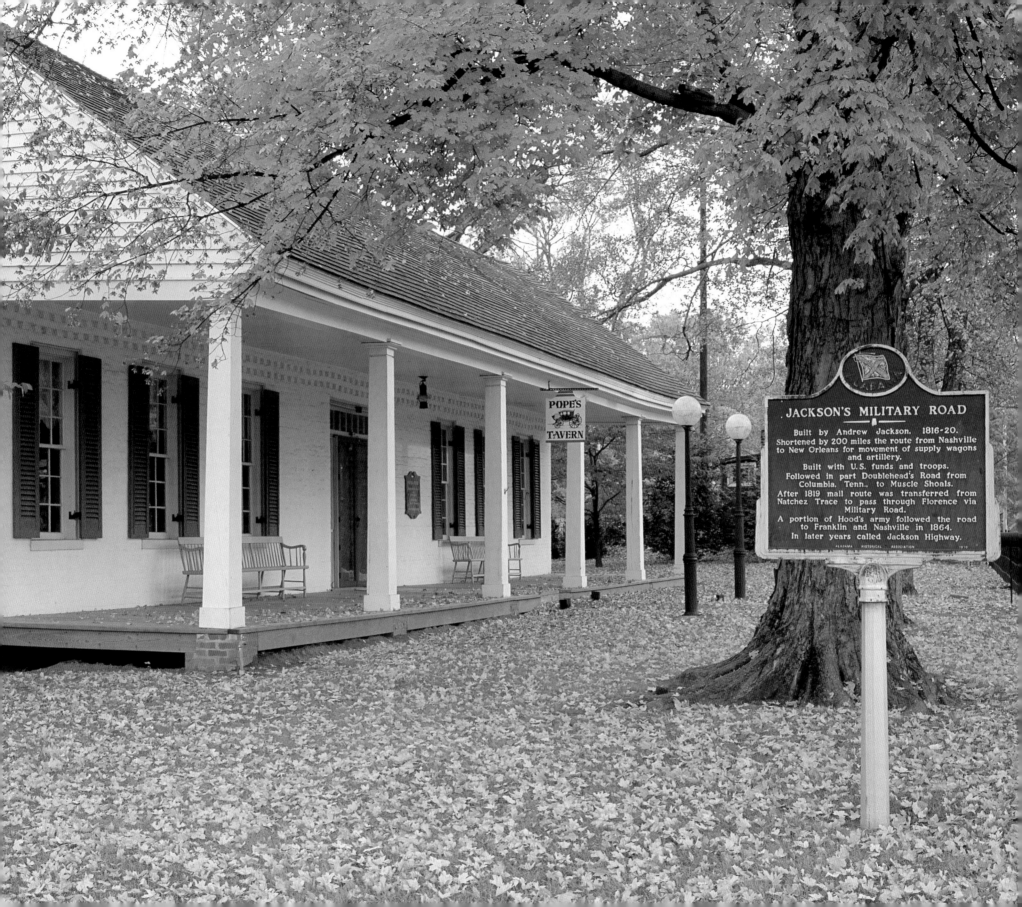

JACKSON'S MILITARY ROAD

Built by Andrew Jackson. 1816-20.
Shortened by 200 miles the route from Nashville
to New Orleans for movement of supply wagons
and artillery.
Built with U.S. funds and troops.
Followed in part Doublehead's Road from
Columbia. Tenn., to Muscle Shoals.
After 1819 mail route was transferred from
Natchez Trace to pass through Florence via
Military Road.
A portion of Hood's army followed the road
to Franklin and Nashville in 1864.
In later years called Jackson Highway.

ALABAMA HISTORICAL ASSOCIATION 1970

POPE'S
TAVERN

RIGHT: An interior view of elegant Stanton Hall, a former plantation in Natchez, Mississippi.

BELOW: D'Evereux House (1840), another gracious antebellum manor in Natchez.

BELOW RIGHT: The Colonel J. Drane House in Mississippi was a Confederate officer's home.

OPPOSITE: Neoclassical Stanton Hall, built in 1857, is typical of the great estates that cotton built along the Mississippi.

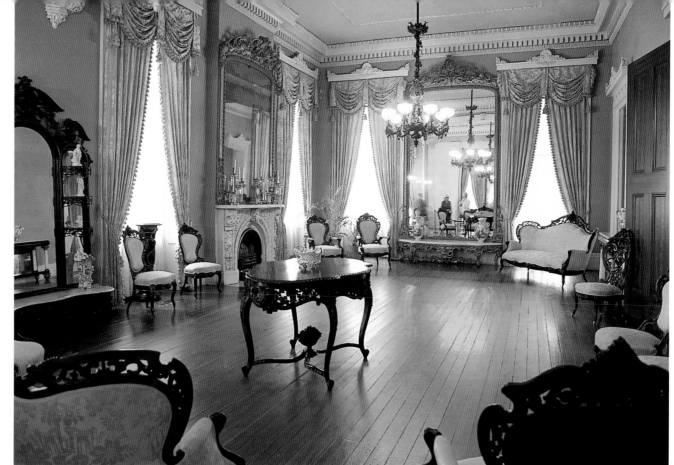

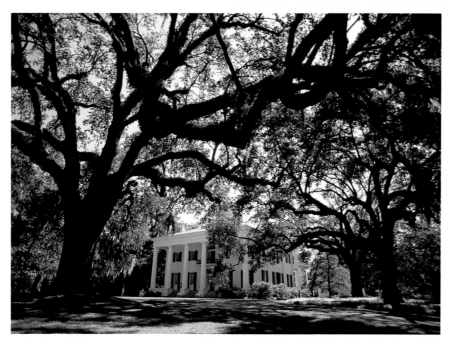

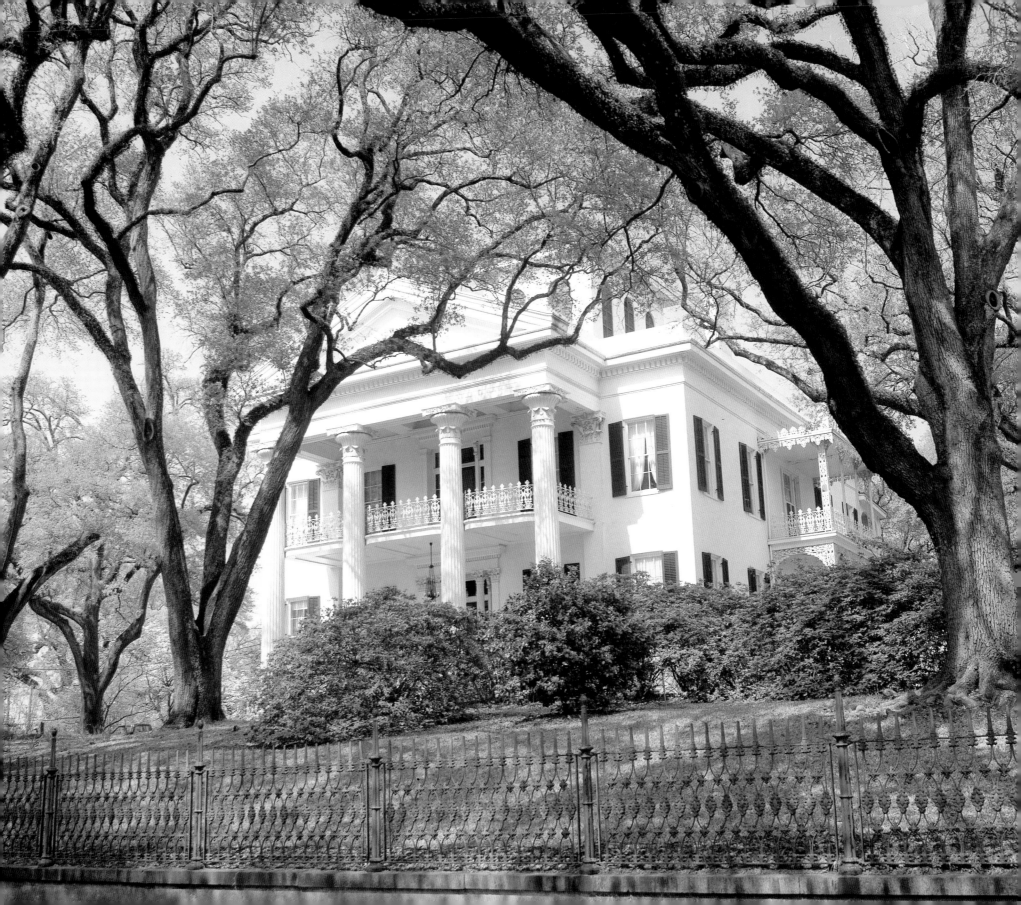

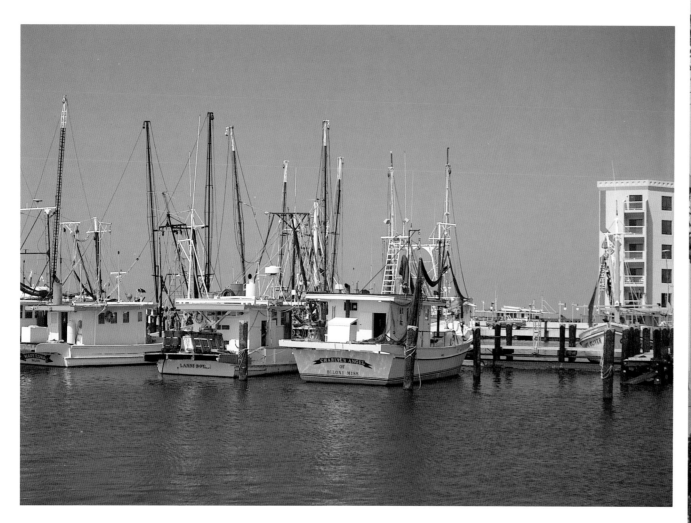

ABOVE: Shrimp boats ply the Gulf of Mexico from the harbor at Biloxi, Mississippi, a popular resort.

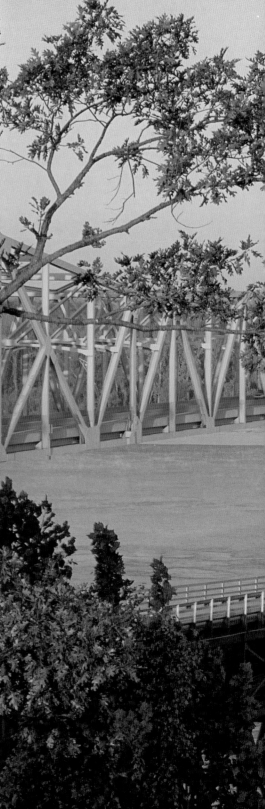

RIGHT: The bridge over the Mississippi at Vicksburg, scene of a critical Civil War action that hastened the collapse of the South.

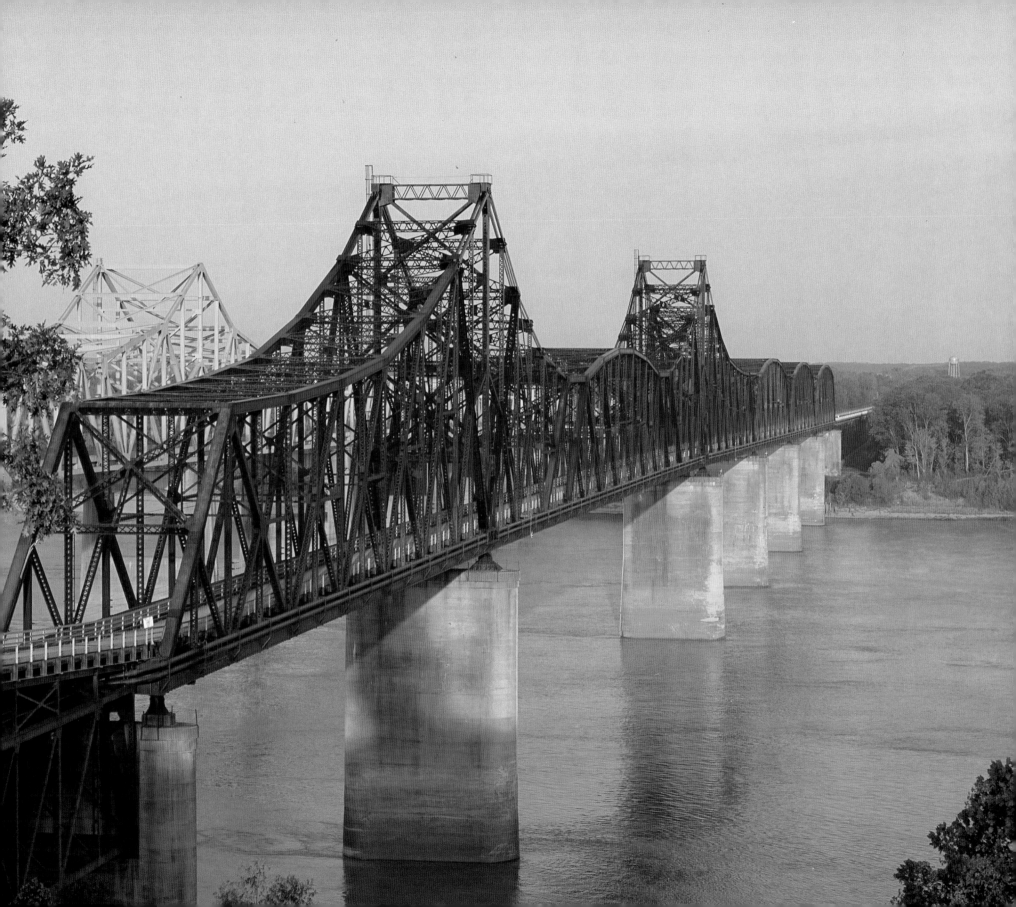

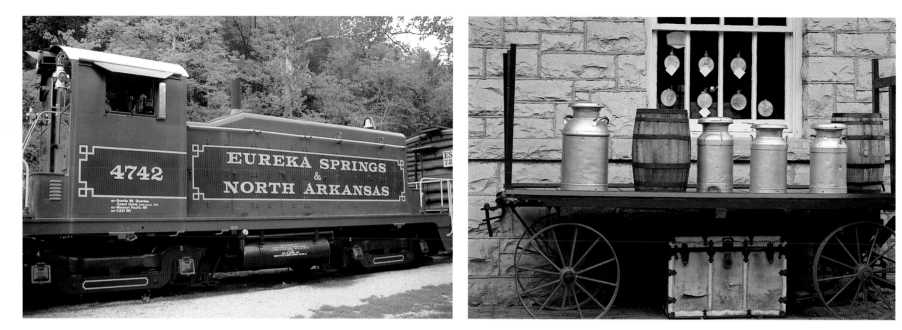

ABOVE: A classic train at Eureka Springs, one of the popular hot-springs resorts in Arkansas.

ABOVE RIGHT: An old-fashioned baggage cart preserved at Eureka Springs.

RIGHT: A country music show will always find an audience in Arkansas, which prides itself on its folk-culture heritage.

OPPOSITE: The 19th-century Quapaw Bath House at luxurious Hot Springs, Arkansas.

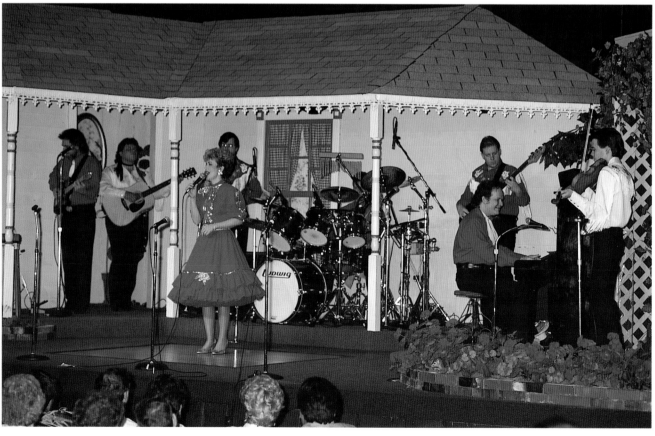

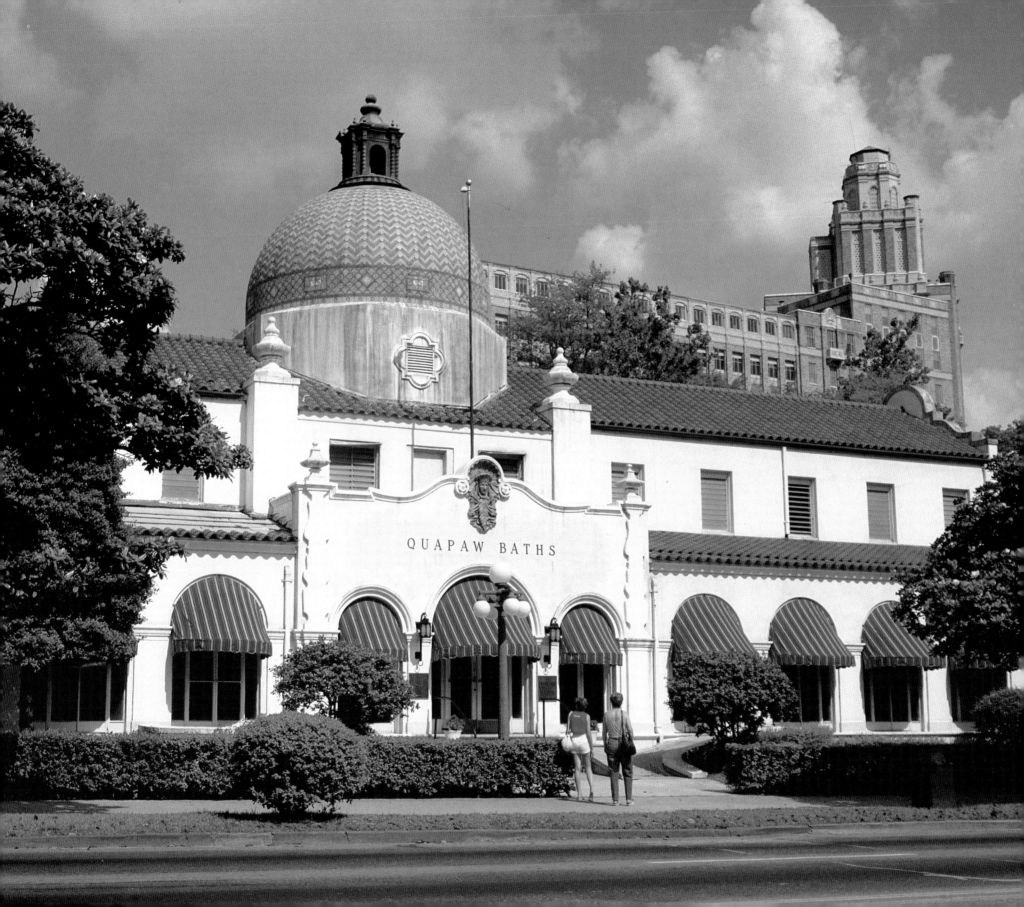

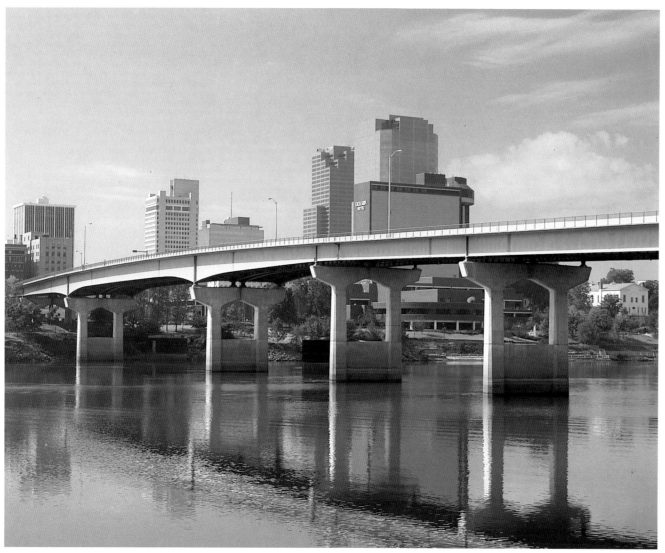

ABOVE: The flourishing city of Little Rock, on the Arkansas River. There really was a little rock in the vicinity, which served as an Arkansas River landmark beginning in 1722, when the French explorer Bénard de la Harpe searched the area.

RIGHT: The delightful Victorian house called "Rosalie," in Eureka Springs, Arkansas.

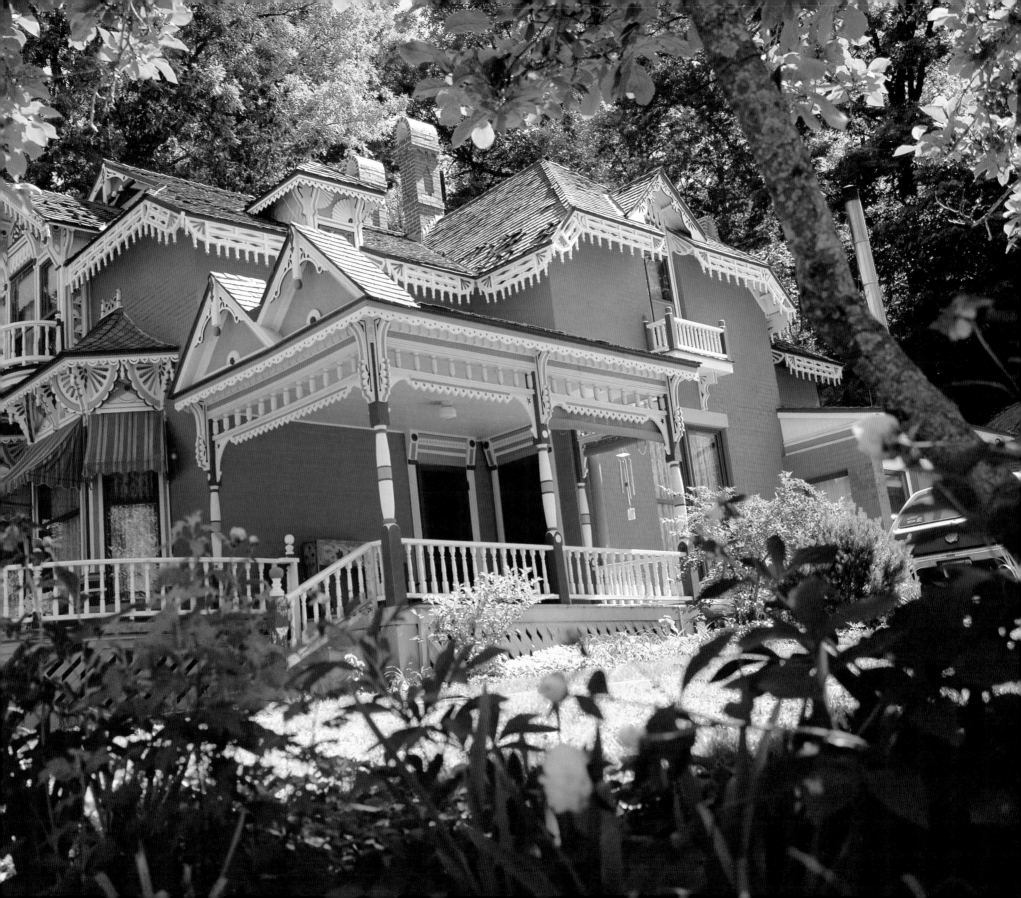

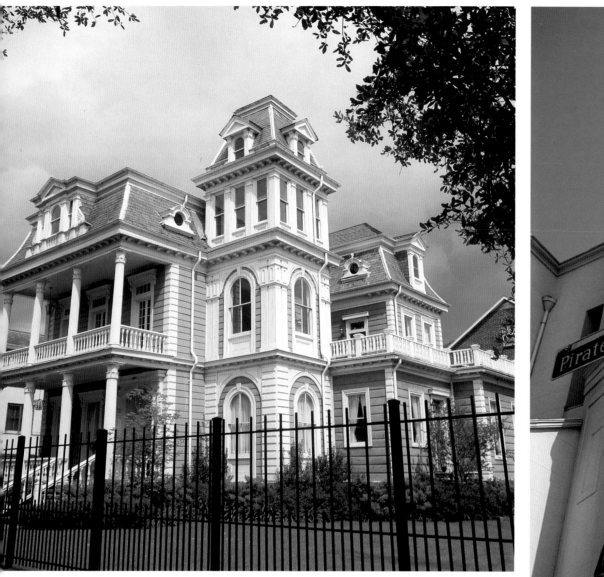

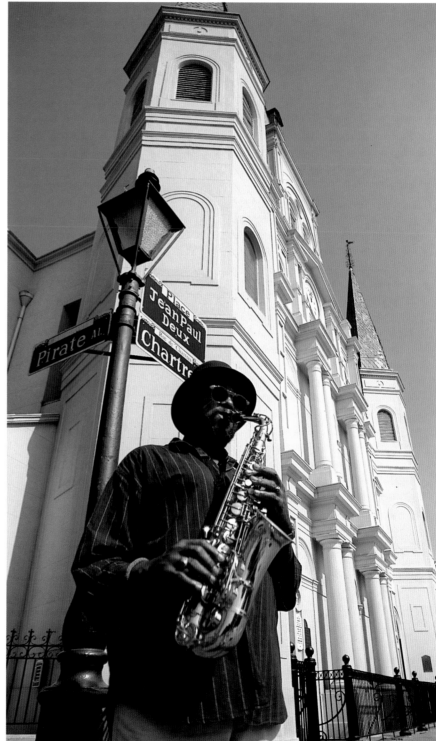

ABOVE: Historic houses are one of New Orleans' many attractive features. Here, the Hernandez House on St. Charles Avenue.

RIGHT: Jazz musicians congregate in St. Louis Square, at New Orleans' Roman Catholic cathedral.

OPPOSITE: Details of the grillwork balconies in the old French Quarter of New Orleans.

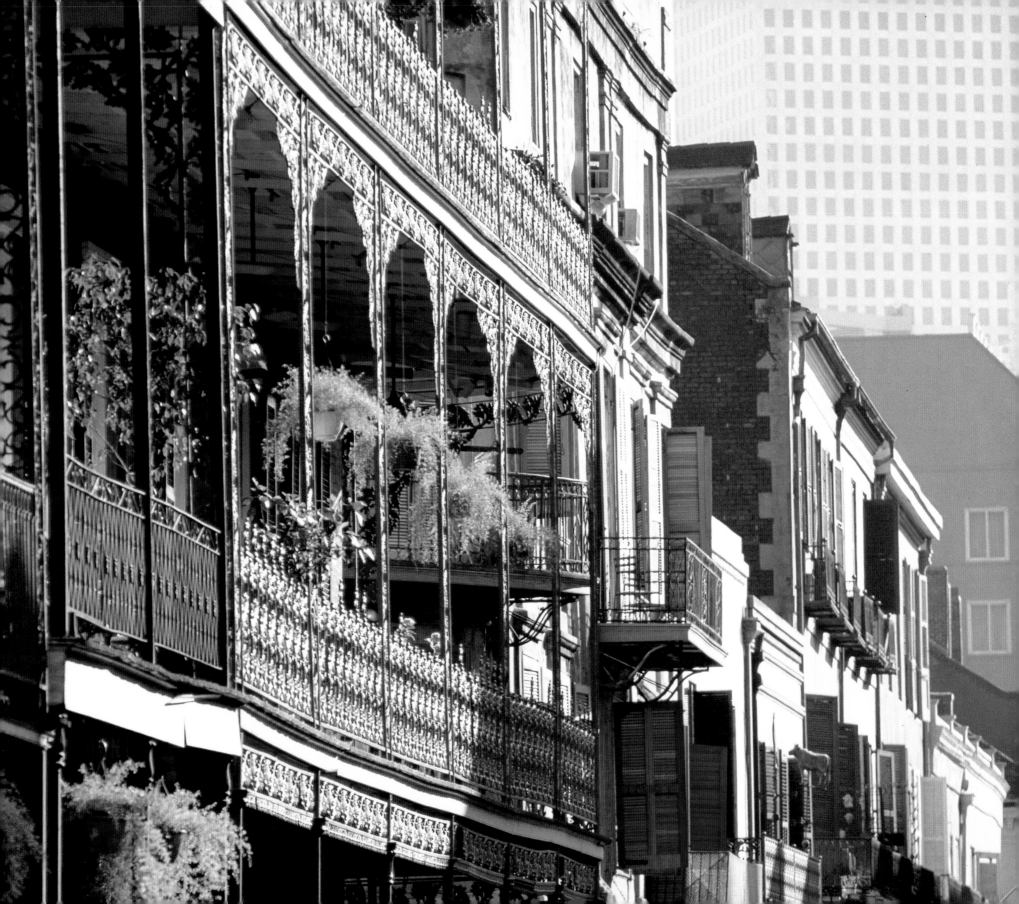

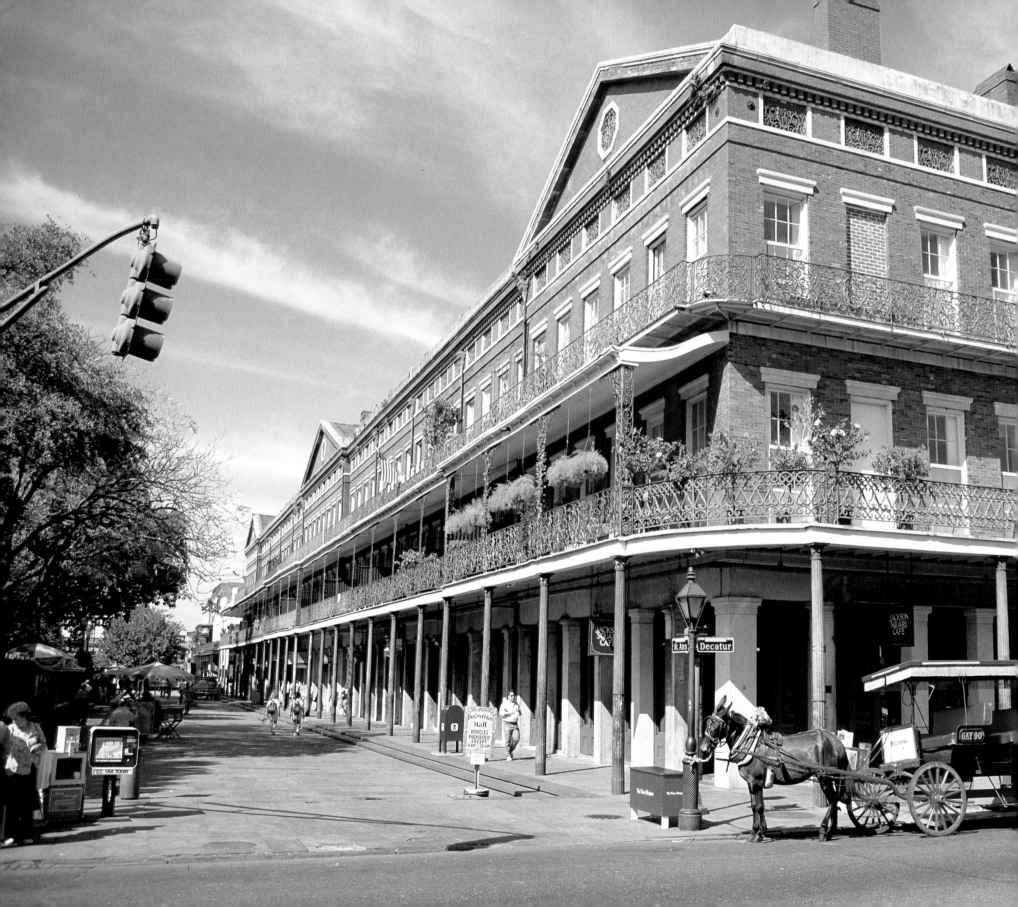

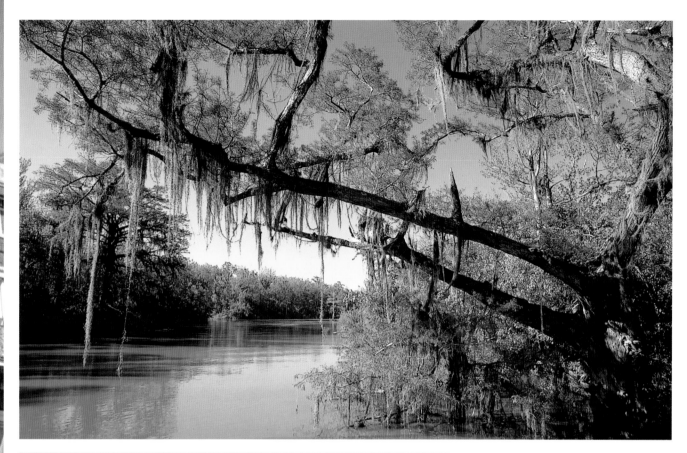

FAR LEFT: A famous corner in the French Quarter: Decatur and St. Ann streets. The Quarter's basic plan has not changed since 1718, when the first successful settlement was established.

ABOVE: Spanish moss drapes the trees in Louisiana's swampy bayou country. The bayous are famous as the home of Louisiana's Cajuns, descendants of French Acadians expelled by the British in the 1750s.

LEFT: A bayou frog at home in duckweed.

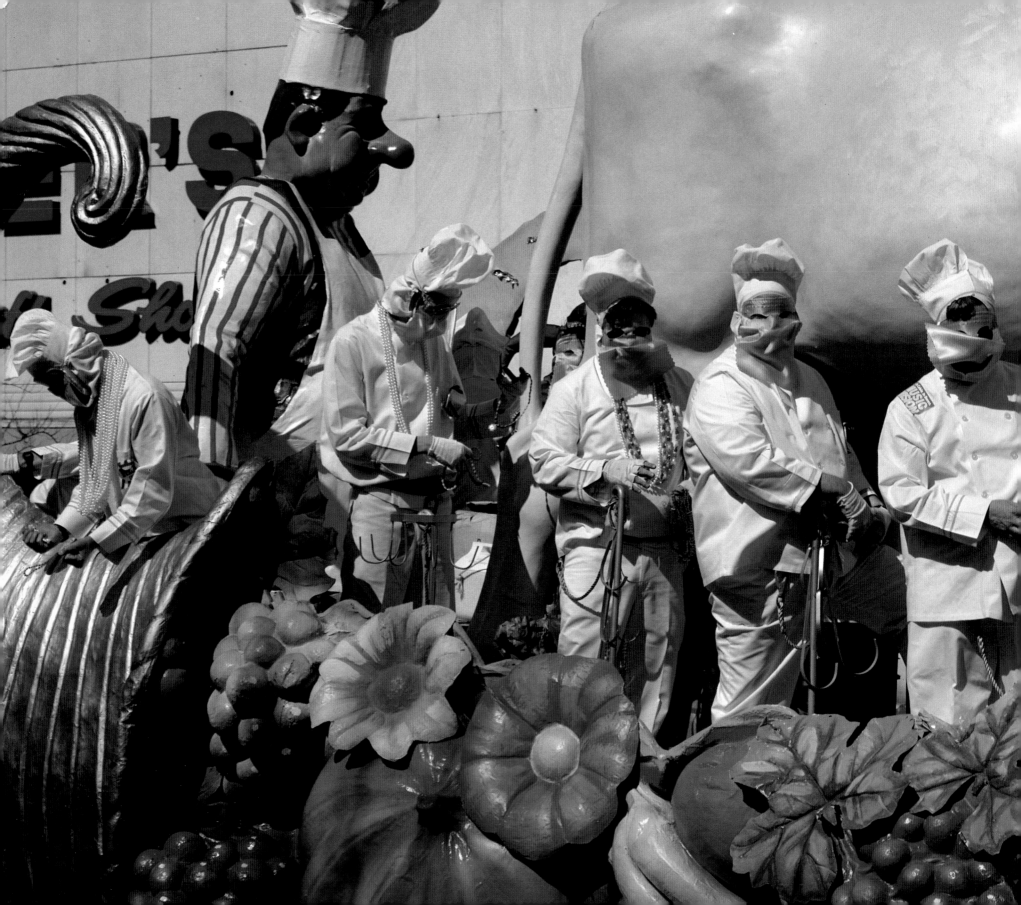

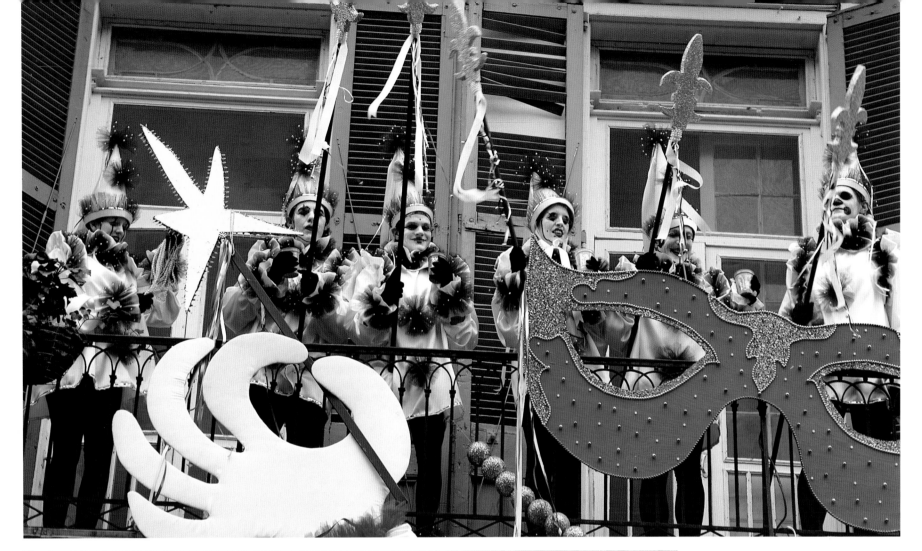

OPPOSITE: Members of the Krewe of Rex ride by on their elaborate float to cheers from the crowd.

ABOVE: Mardi Gras revelers crowd a French Quarter balcony in New Orleans.

LEFT: The incomparable Mardi Gras parade, held on the Tuesday before Ash Wednesday. All of New Orleans is there, along with thousands of visitors.

THE MIDWEST AND THE PLAINS

OPPOSITE: Morning comes to an Iowa farm in sailing clouds etched in gold.

Perhaps the most surprising feature of the New World to early settlers who crossed the Appalachians was the vast expanse of prairie and plains to the west. Toward the north were rolling hills and forest that had a familiar look to emigrants from the East, but their extent and diversity were new and inviting. Nothing could have prepared them for the size and depth of the freshwater seas called the Great Lakes, between the north-central United States and Canada. These lakes – Superior, Huron, Erie, Ontario, and Michigan – would become essential to the trade and commerce of the newly settled Midwest, which attracted European immigrants from Scandinavia, Germany, France, and many other nations.

In time, twelve states were formed from this region: Ohio, Indiana, Illinois, Michigan, Wisconsin, Minnesota, Iowa, Missouri, North Dakota, South Dakota, Nebraska, and Kansas. They were important for a variety of reasons, from their rich farmlands and pasturelands to such robust new cities as Chicago, Indianapolis, Minneapolis, St. Paul, Kansas City, St. Louis, Detroit, Milwaukee, Cleveland, and Des Moines. The people who settled here were enterprising and community-minded, and these qualities still characterize the region today.

In terms of natural resources, the Midwest is a bountiful source of oil and natural gas, coal, and fresh water. Iron ore from the northern ranges supplies the nation's steel industry. Manufacturing has become increasingly important, side by side with the agricultural economy based on wheat, corn, rye, oats, flaxseed, soybeans, sugar, fruit, livestock, and dairies. The region is equally rich in natural beauty.

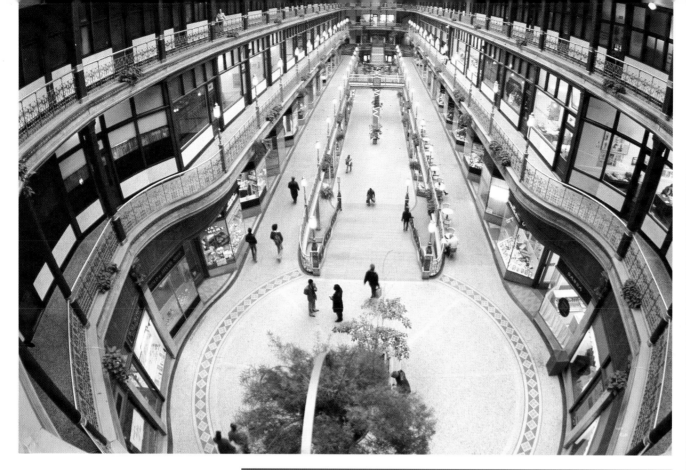

ABOVE: Cleveland's Old Arcade, five stories high, was the first skylighted mall, constructed in 1890.

RIGHT: Columbus, the capital of Ohio, on the banks of the Scioto River.

FAR RIGHT: Columbus by night, from across the river. It is one of ten major cities in the state.

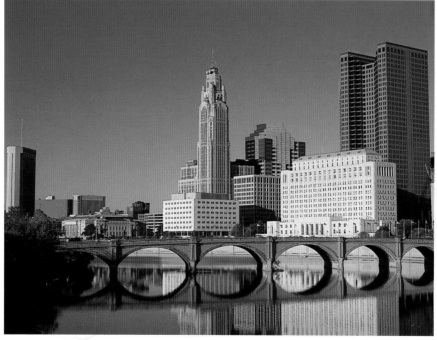

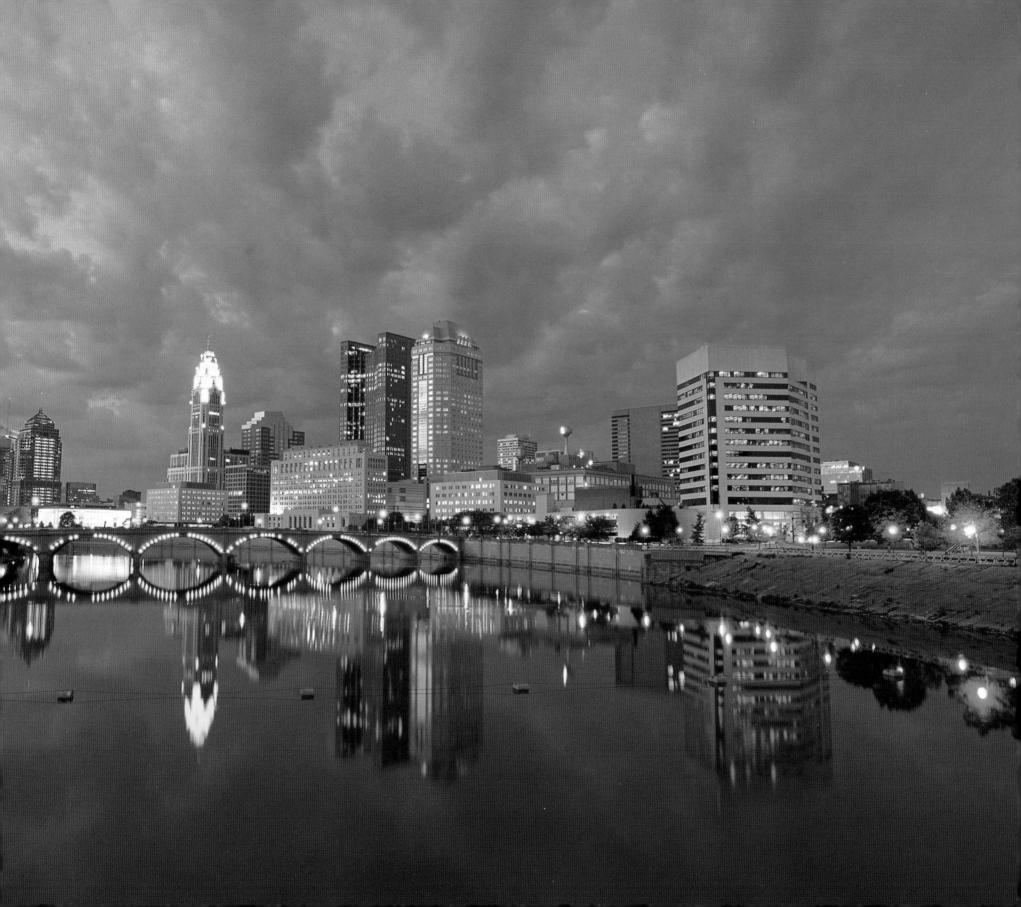

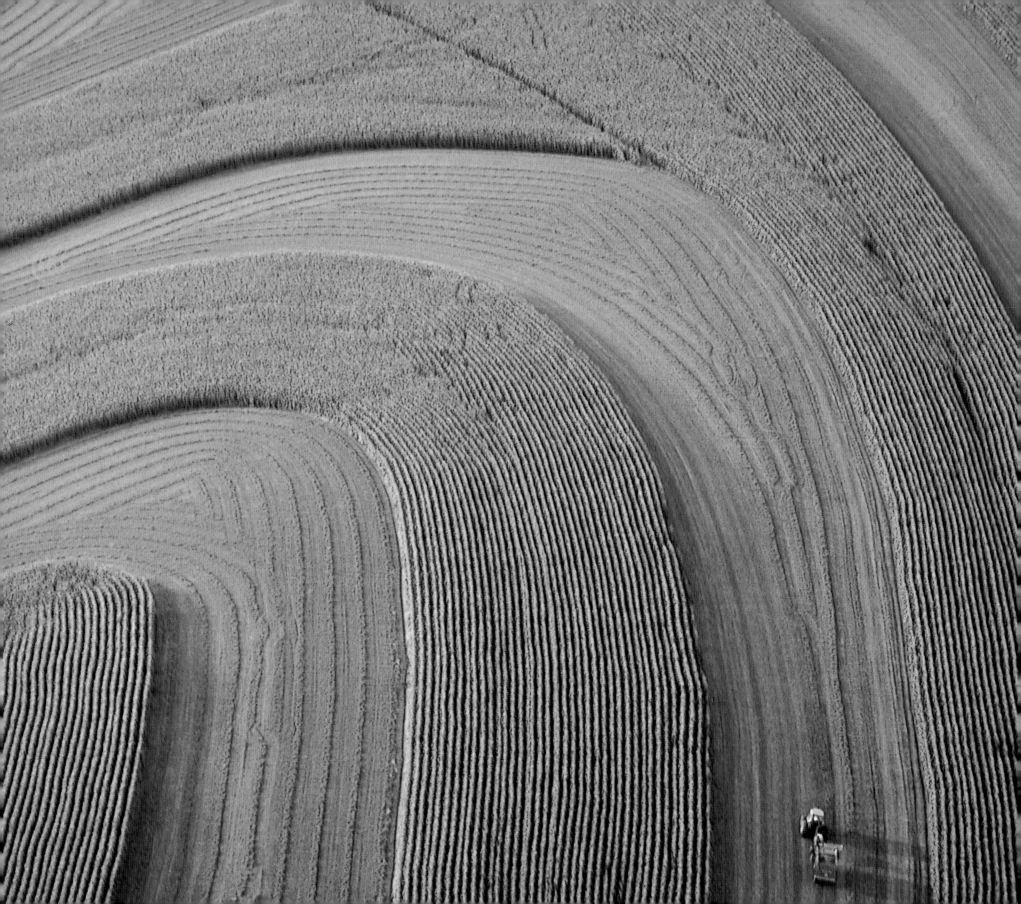

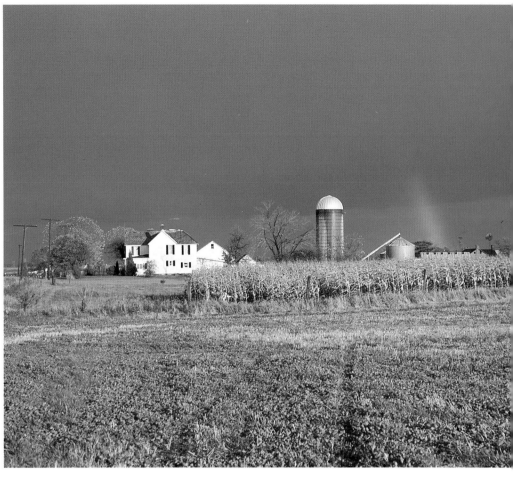

OPPOSITE: An aerial view of contour farming.

LEFT: An Ohio farm field bordered by wildflowers.

ABOVE: Part of a rainbow cracks through a dark, lowering sky over a farm on the plains of Ohio.

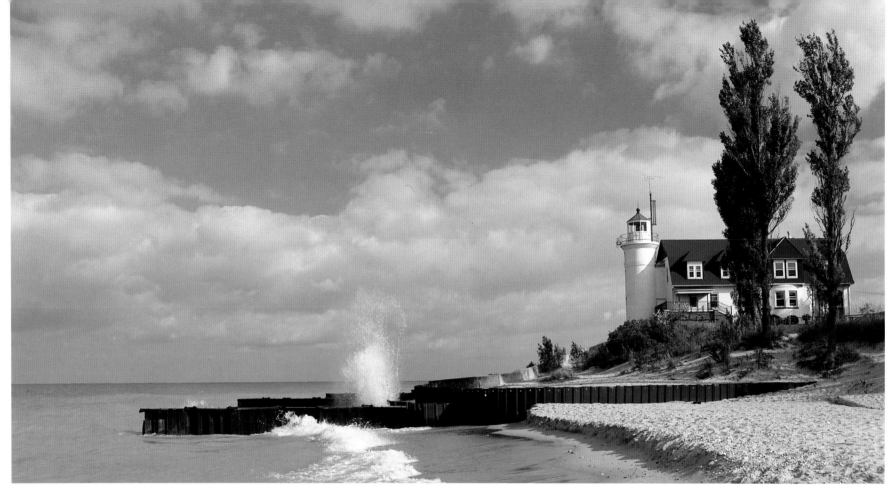

ABOVE: Point Betsie Lighthouse, built in 1858, on the shores of vast Lake Michigan.

RIGHT: The *Queen of Shiawassee*, the pride of Chesaning, Michigan's annual Showboat Festival. This vessel is an authentic paddleboat of 19th-century vintage.

OPPOSITE: The Mackinac Bridge spans Michigan's Straits of Mackinac, connecting Lakes Huron and Michigan.

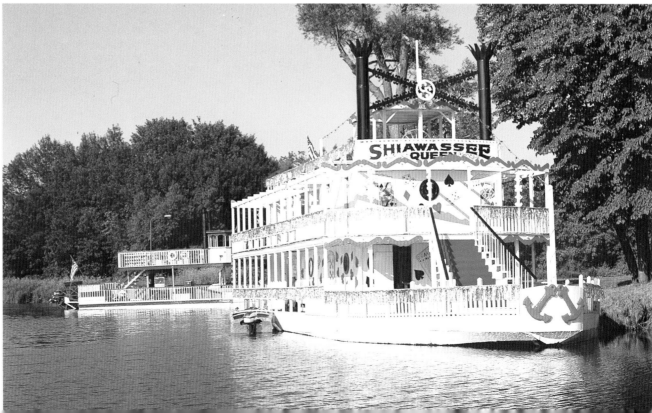

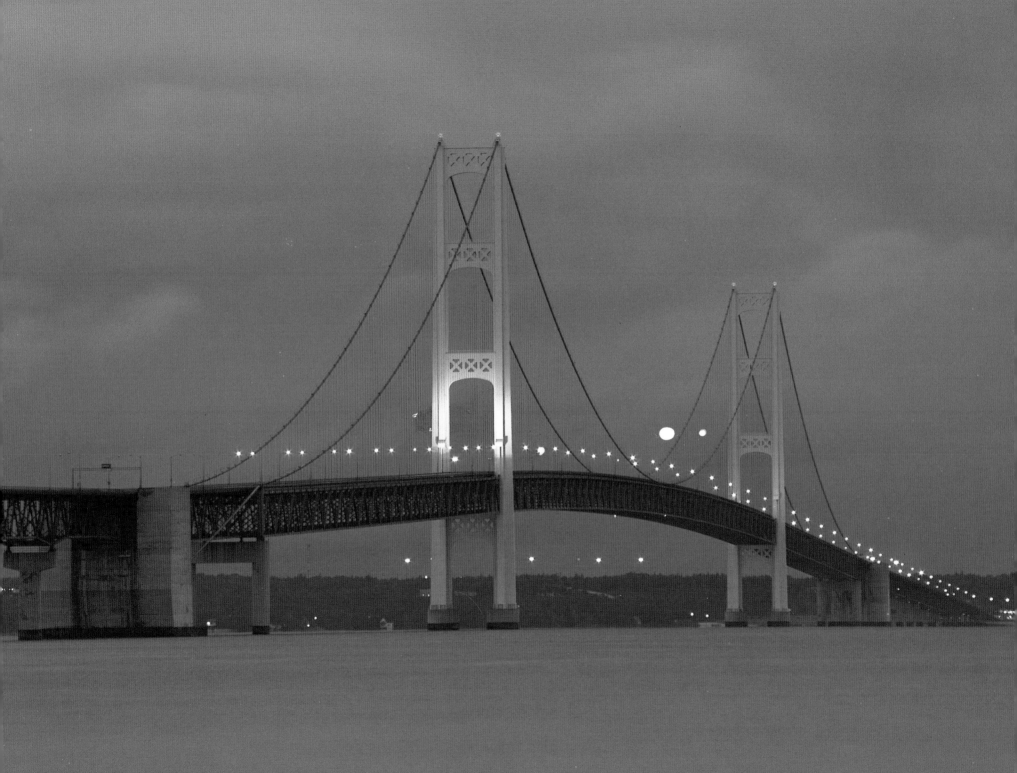

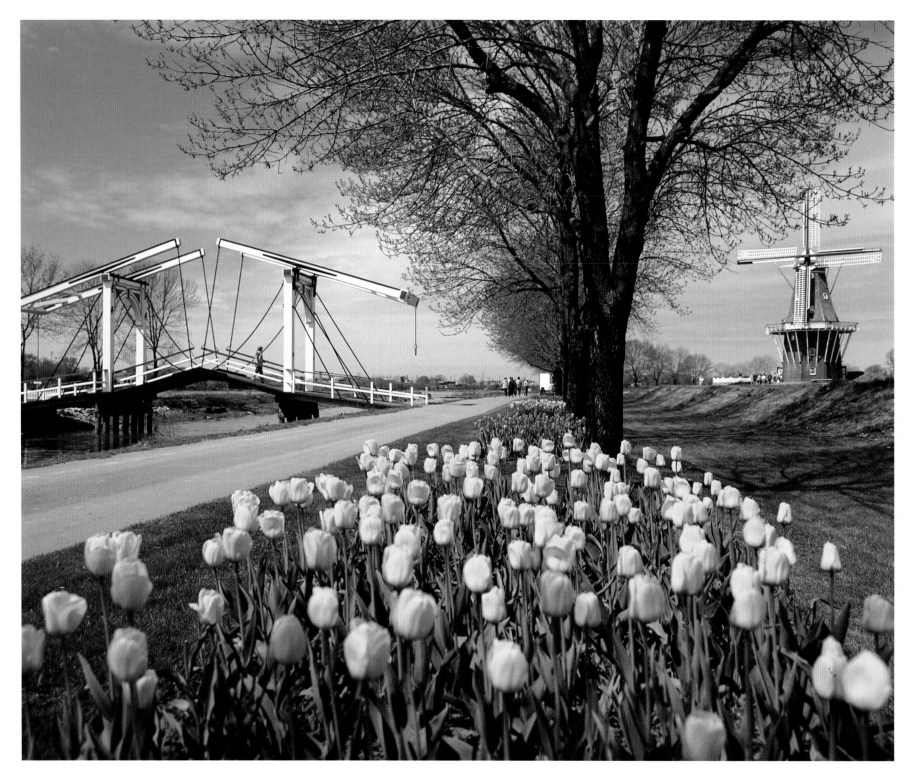

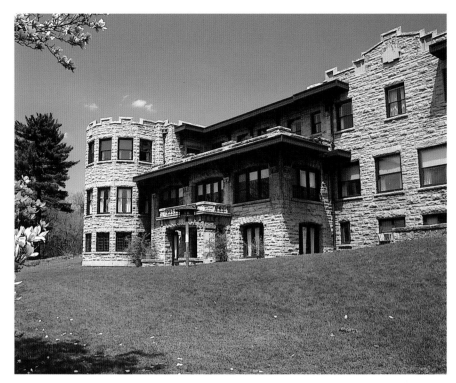

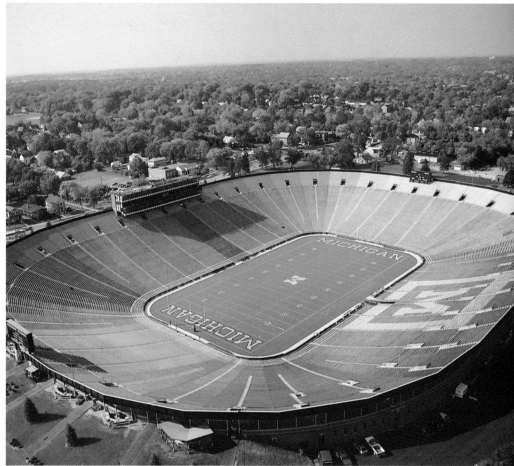

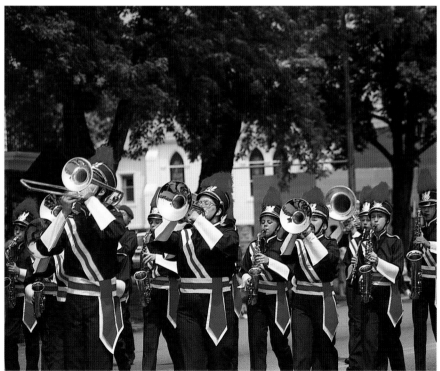

OPPOSITE: The DeZwaan Windmill at Windmill Island Municipal Park pays tribute to the Dutch heritage of Holland, Michigan.

ABOVE LEFT: The imposing Henry Ford estate, Fair Lane, was built in 1914 on the River Rouge in Dearborn, Michigan.

LEFT: The Fourth of July parade in Durand, Michigan, brings out the band.

ABOVE: The nation's largest college football stadium: the University of Michigan, Ann Arbor.

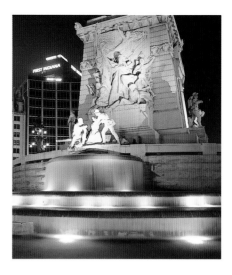

TOP LEFT: The author of *A Girl of the Limberlost*, Gene Stratton Porter, lived in this roomy cedar-log house near Geneva, Indiana, for 20 years.

BOTTOM LEFT: President Benjamin Harrison's Indianapolis home is preserved as a state memorial.

ABOVE: The Soldiers' and Sailors' Monument in Indianapolis, Indiana, part of the nation's heartland.

RIGHT: The College Life Institute in Indianapolis, Indiana.

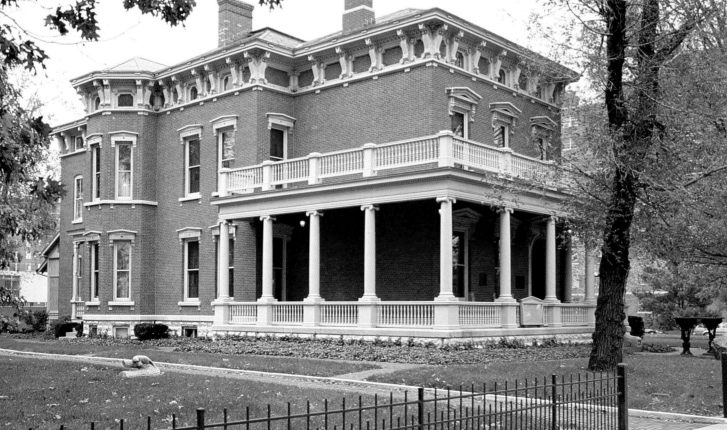

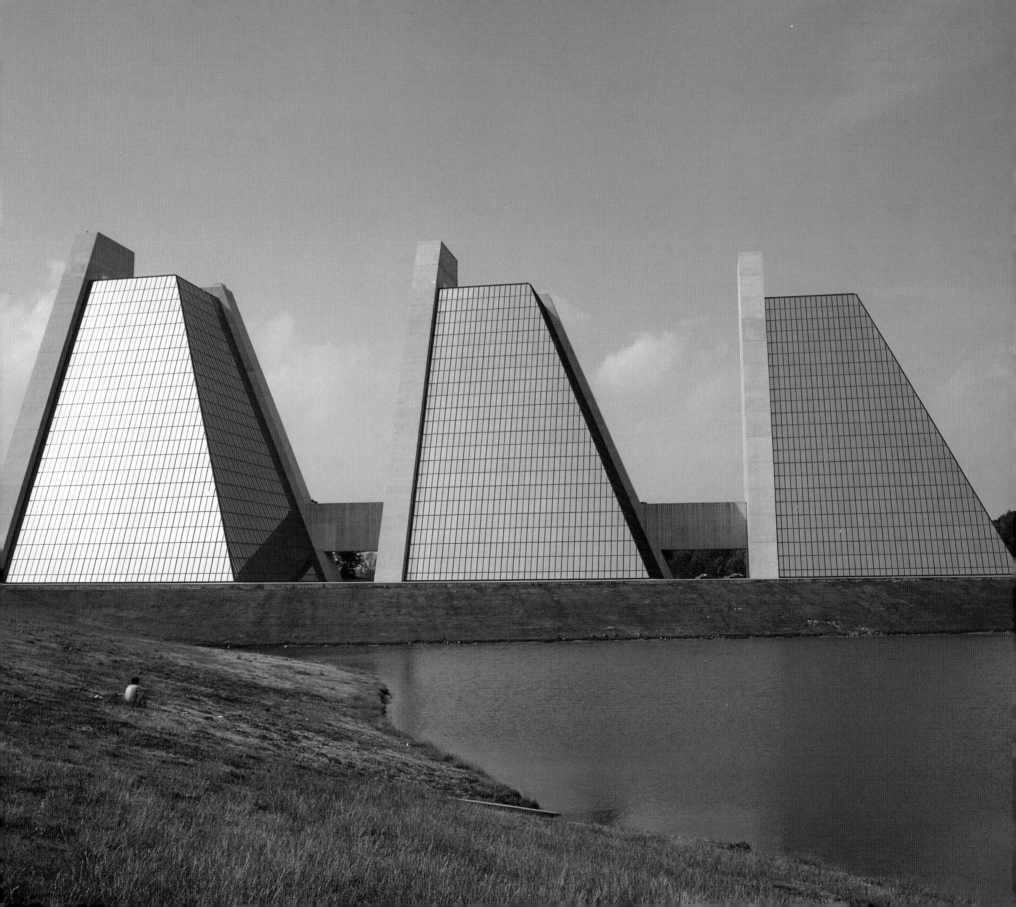

RIGHT: A Wisconsin cornfield at mid-summer.

BELOW: A large dairy farm in southern Wisconsin. About 80 percent of Wisconsin was covered in forest in the 1700s. Widespread logging cleared the land for wheat farming, which in turn gave way to dairy farming after chinch bugs destroyed the wheat crop.

FAR RIGHT: The country's greatest river, the Mississippi, winds south from La Crosse, Wisconsin, to the Gulf of Mexico.

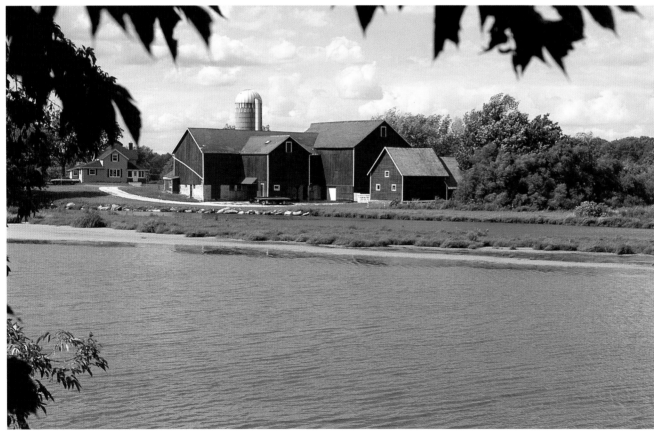

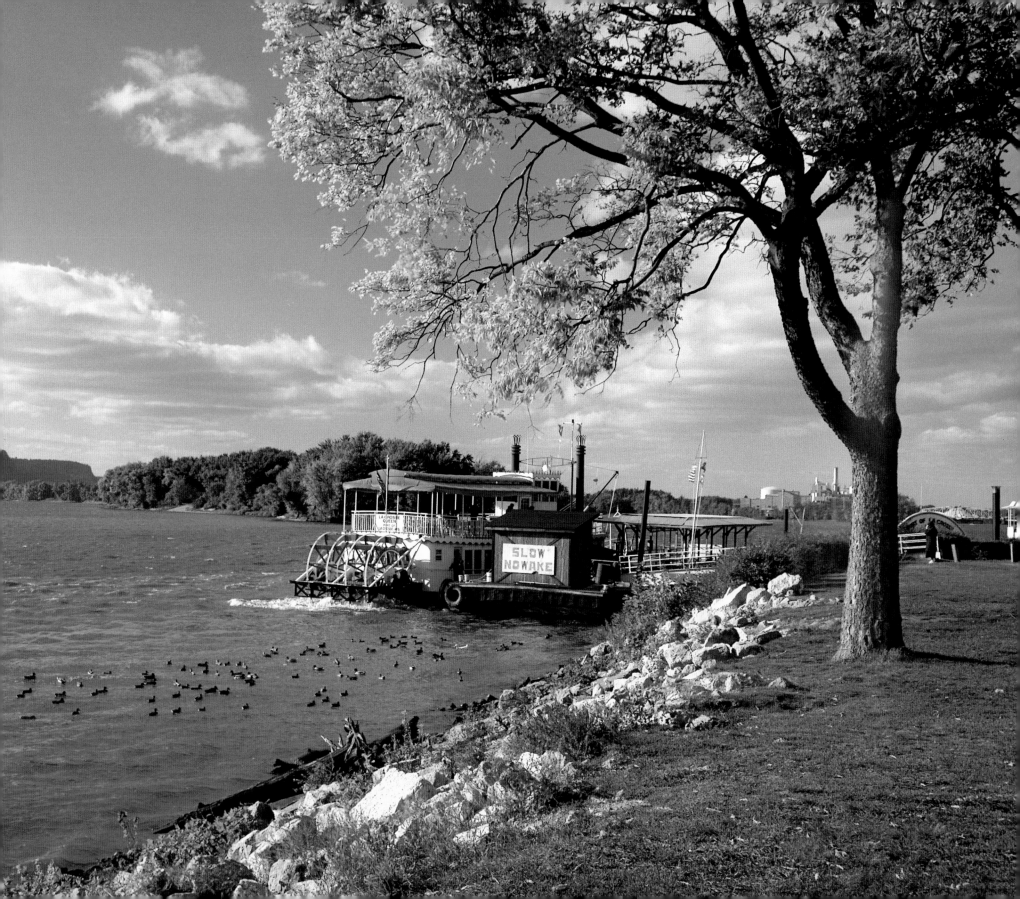

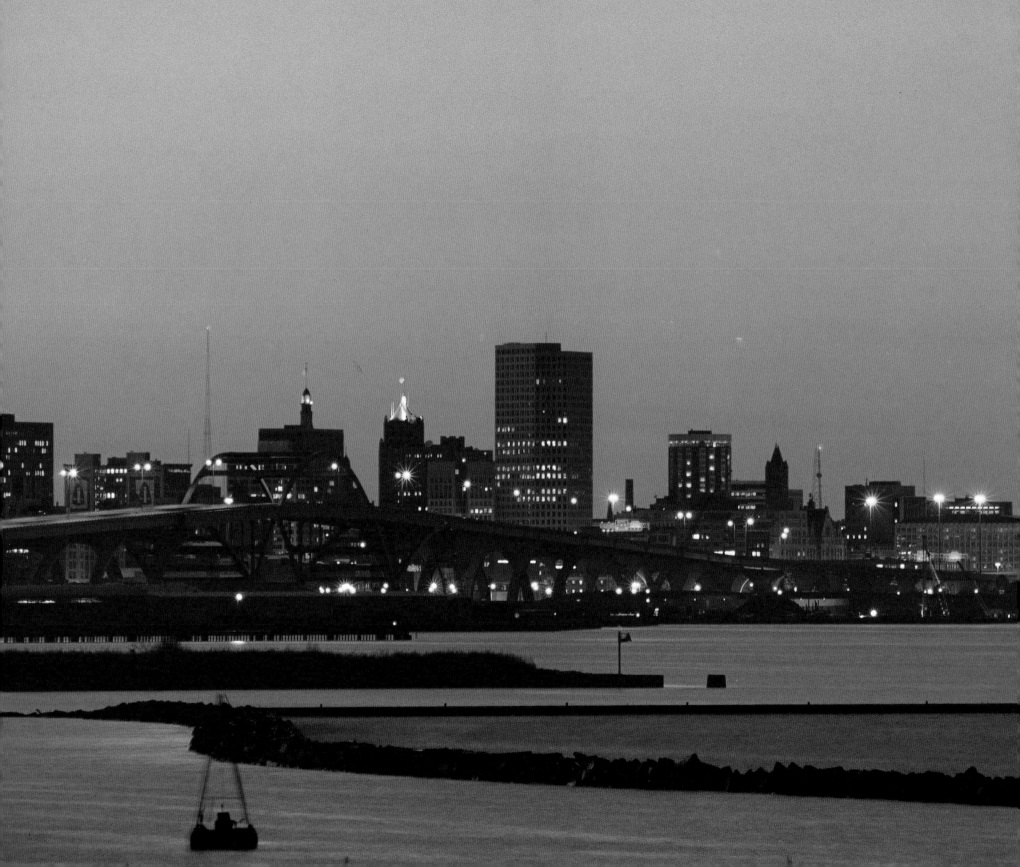

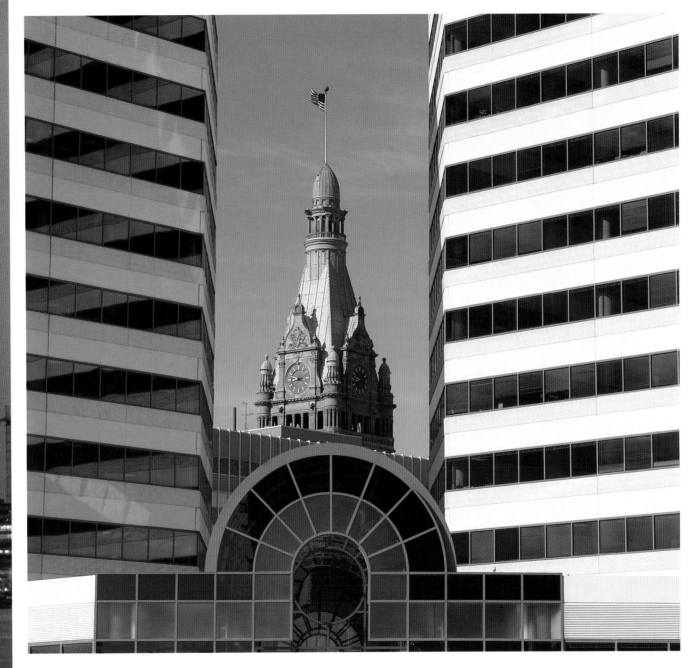

LEFT: Milwaukee, Wisconsin: one of the Midwest's most progressive and prosperous cities.

ABOVE: Milwaukee's City Hall, framed by the contemporary Plaza East Building.

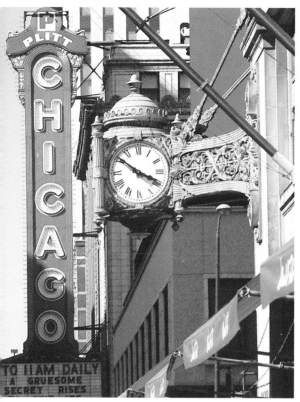

ABOVE: The famous clock of Marshall Field's department store on State Street in Chicago, Illinois.

RIGHT: Chicago has come a long way from its origins as a frontier town and railroad crossing to the West.

OPPOSITE TOP RIGHT: Chicago's imposing skyline at dusk.

OPPOSITE BOTTOM RIGHT: Exuberant Buckingham Memorial Fountain brightens the Chicago night.

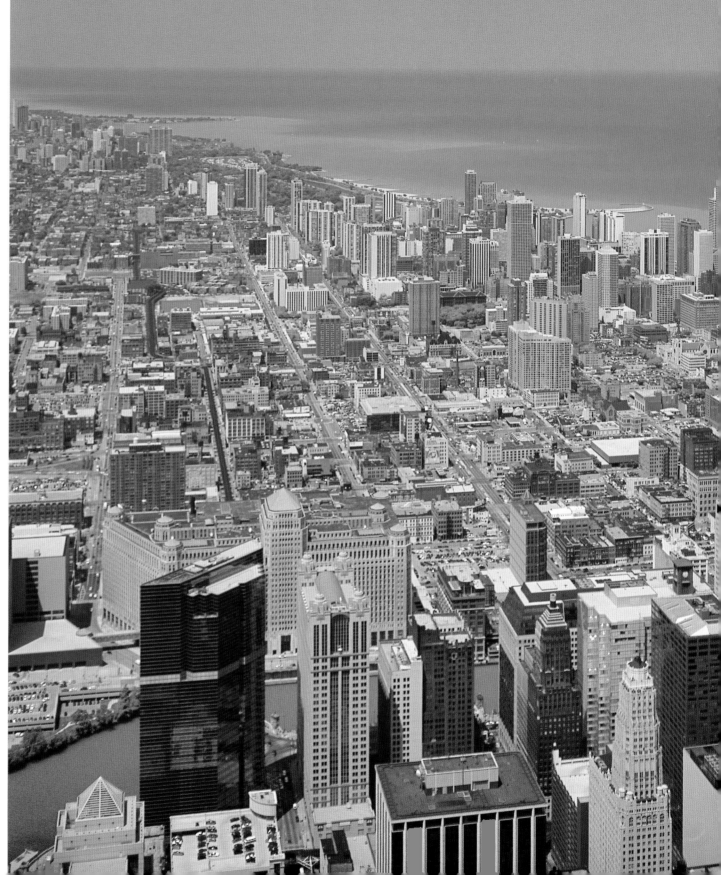

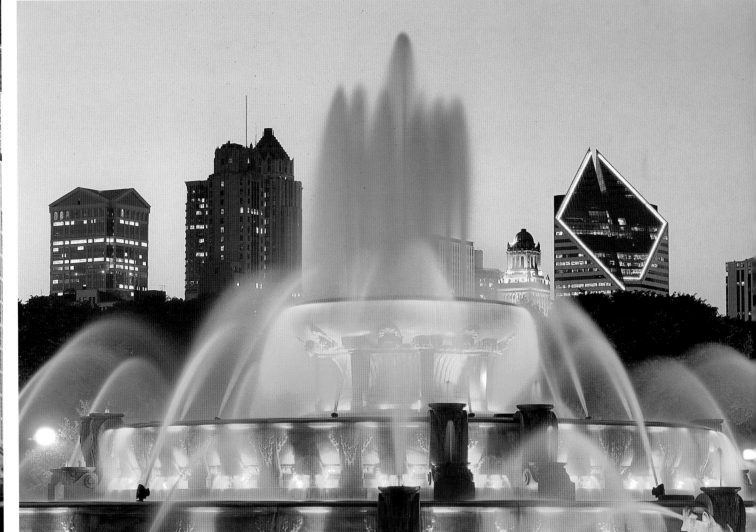

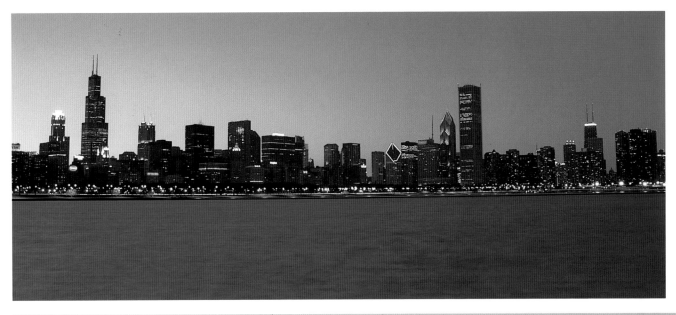

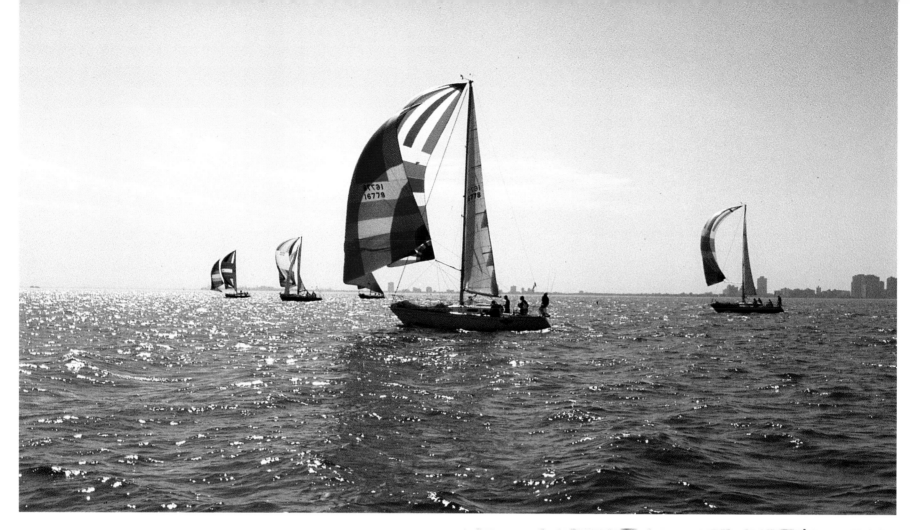

ABOVE: The annual Chicago-to-Mackinac race on Lake Michigan.

RIGHT: A vendor at Wrigley Field, longtime home of the Chicago Cubs. Built in 1914, it is one of the country's last classic ballparks.

OPPOSITE: Abraham Lincoln's home in Springfield, Illinois, the state capital.

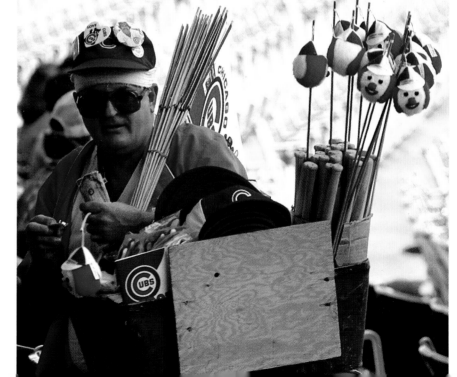

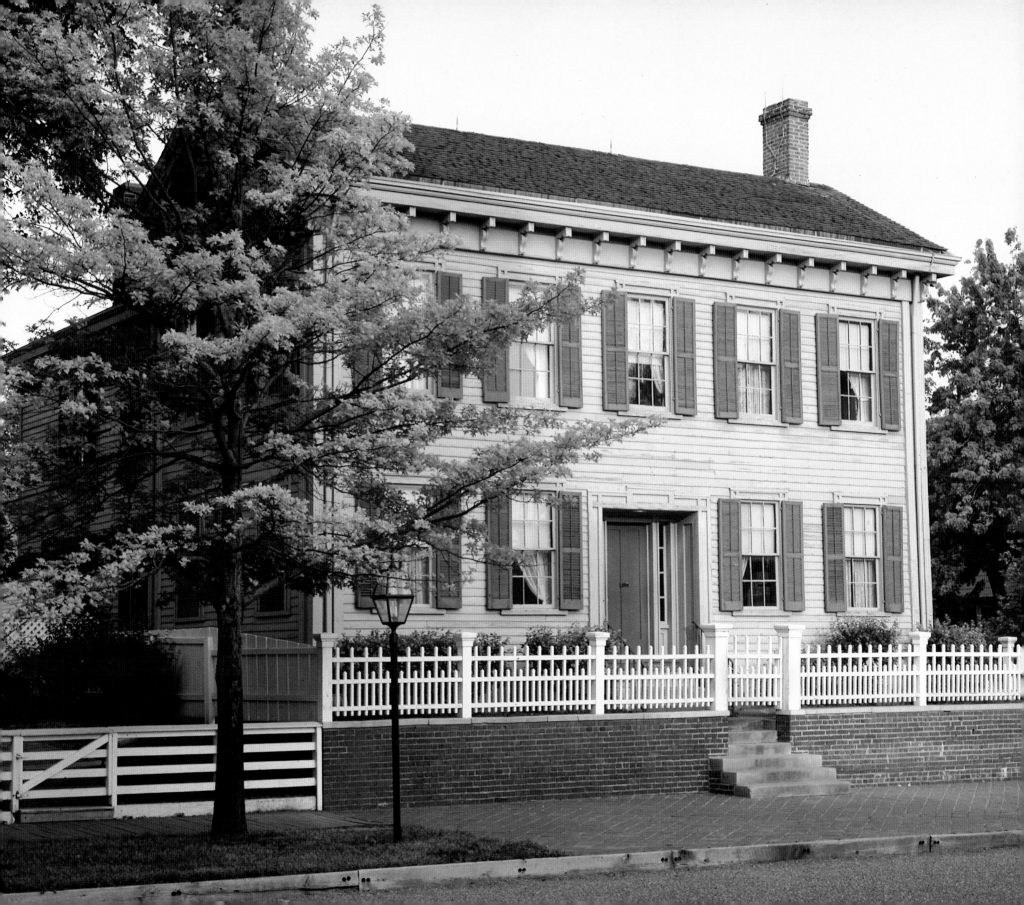

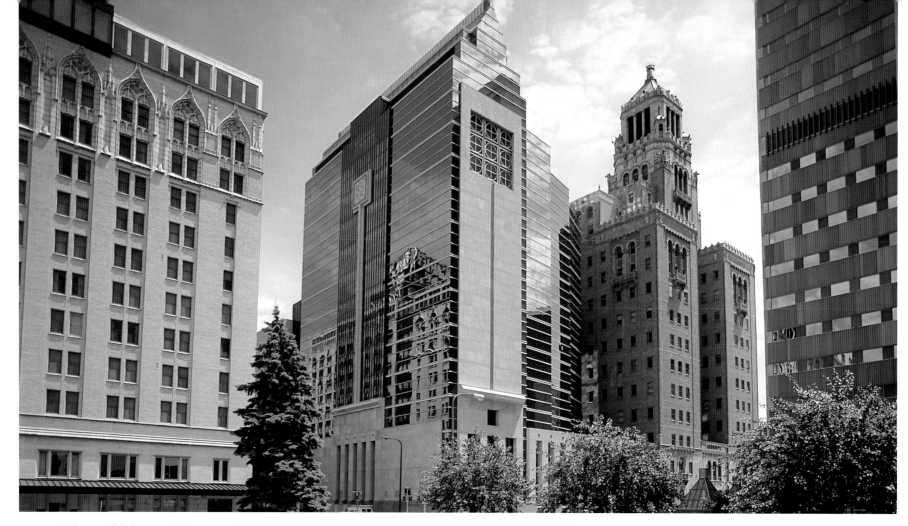

ABOVE: The world-famous Mayo Clinic, in Rochester, Minnesota.

RIGHT: Minnesota's state capitol in St. Paul, called, with Minneapolis, the Twin Cities.

OPPOSITE: The Conservatory in St. Paul's 443-acre Como Park, which includes a zoo and a large lake.

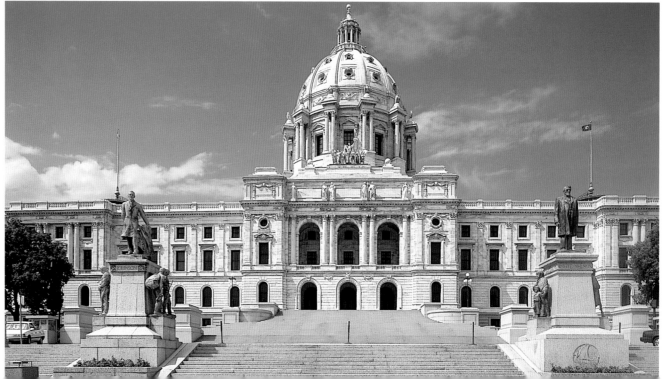

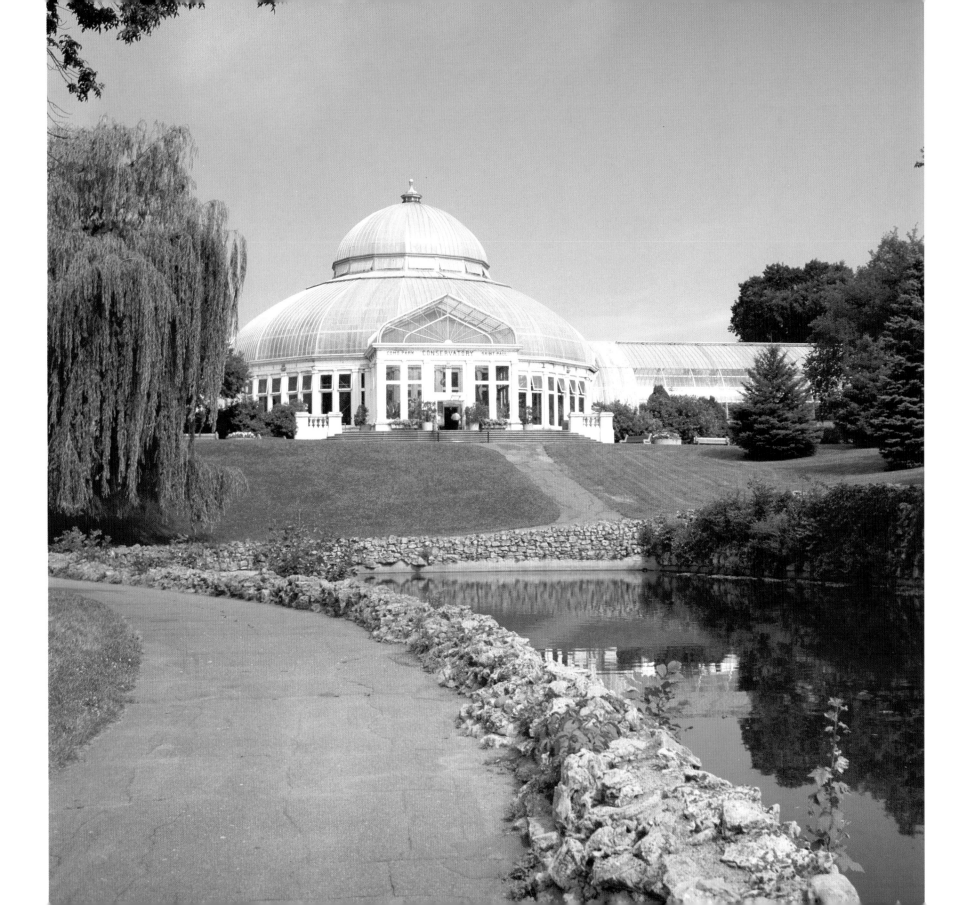

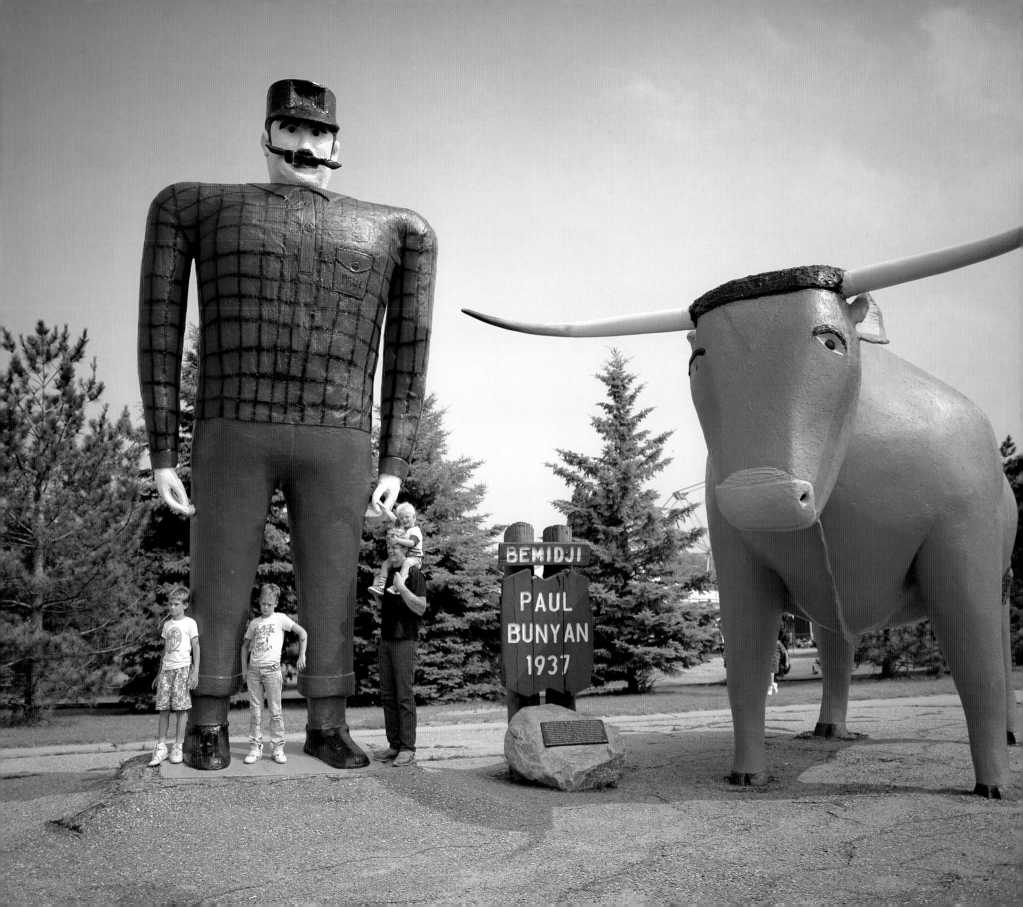

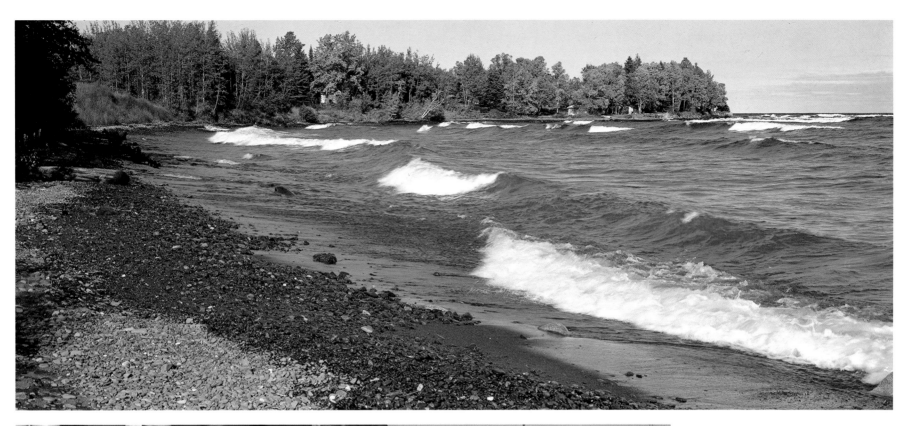

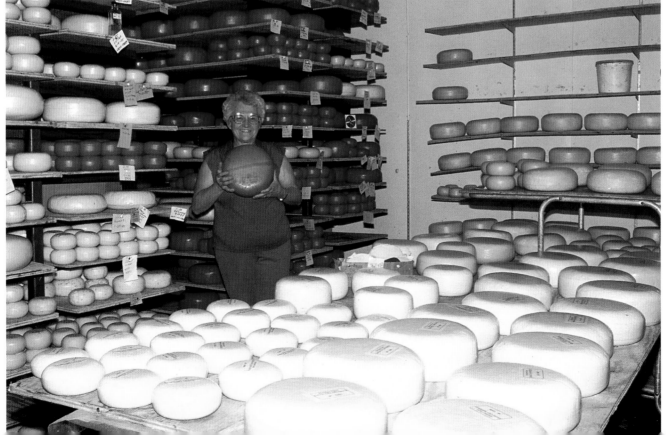

OPPOSITE: Giant figures of legendary lumberman Paul Bunyan and Babe, the blue ox, tower over Bemidji, Minnesota.

ABOVE: Lake Superior, 31,800 square miles in extent, rolls in to a Minnesota shore.

LEFT: Aged cheddar cheese is one of Minnesota's famous dairy products.

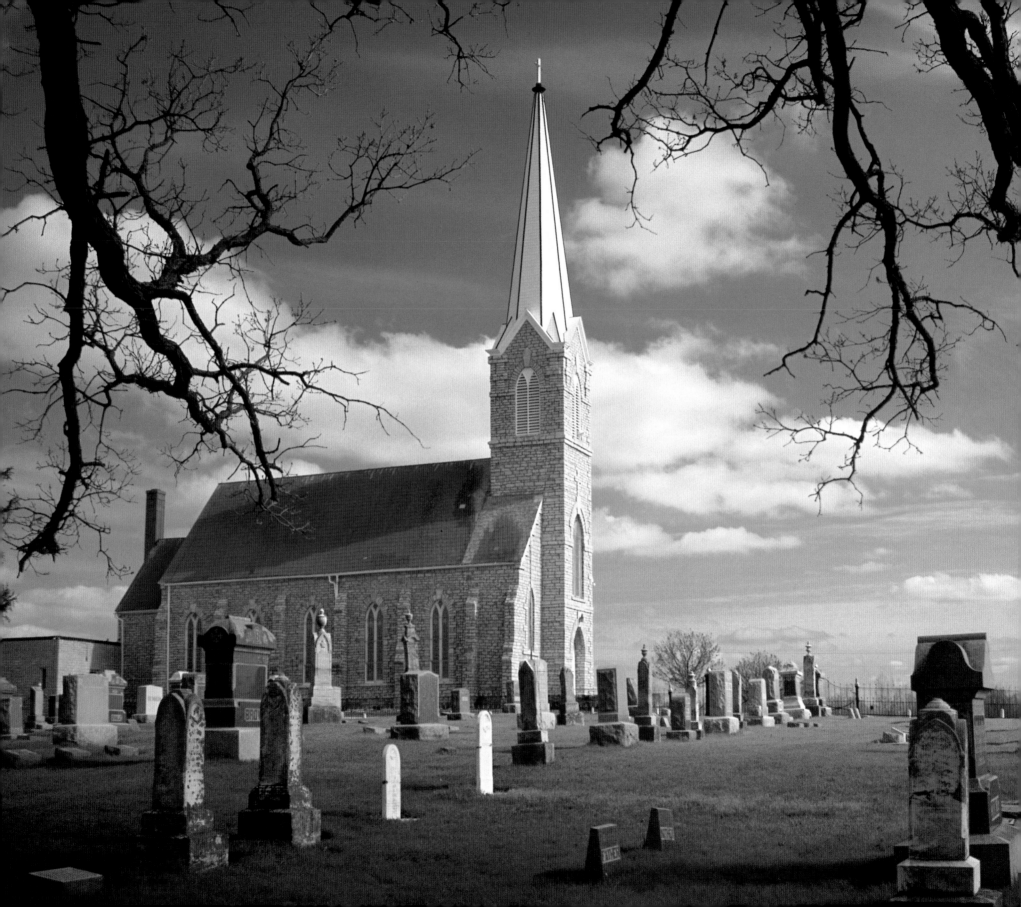

LEFT: Simplicity is the keynote of venerable Washington Prairie Church, in northeastern Iowa.

BELOW: Iowa's imposing state capitol in Des Moines overlooks the Des Moines River.

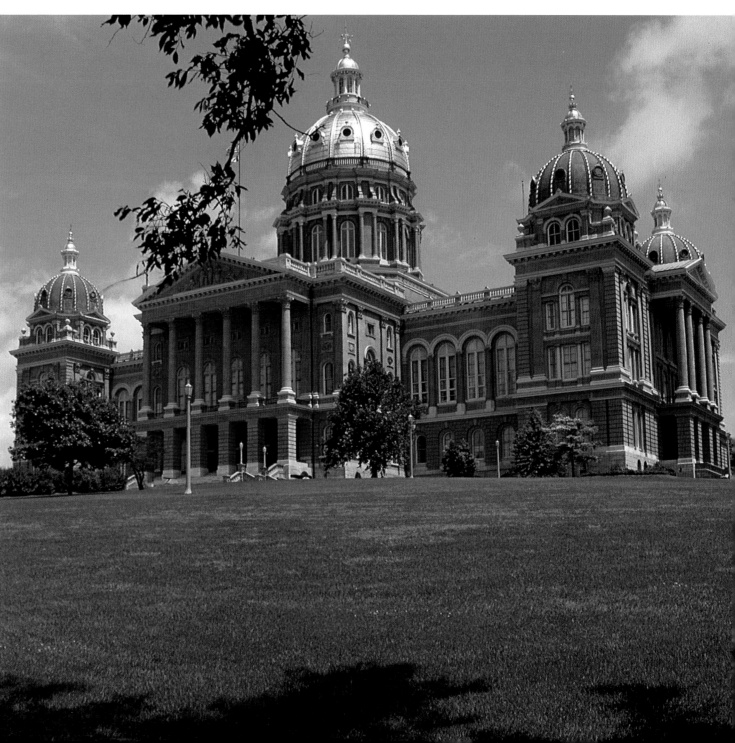

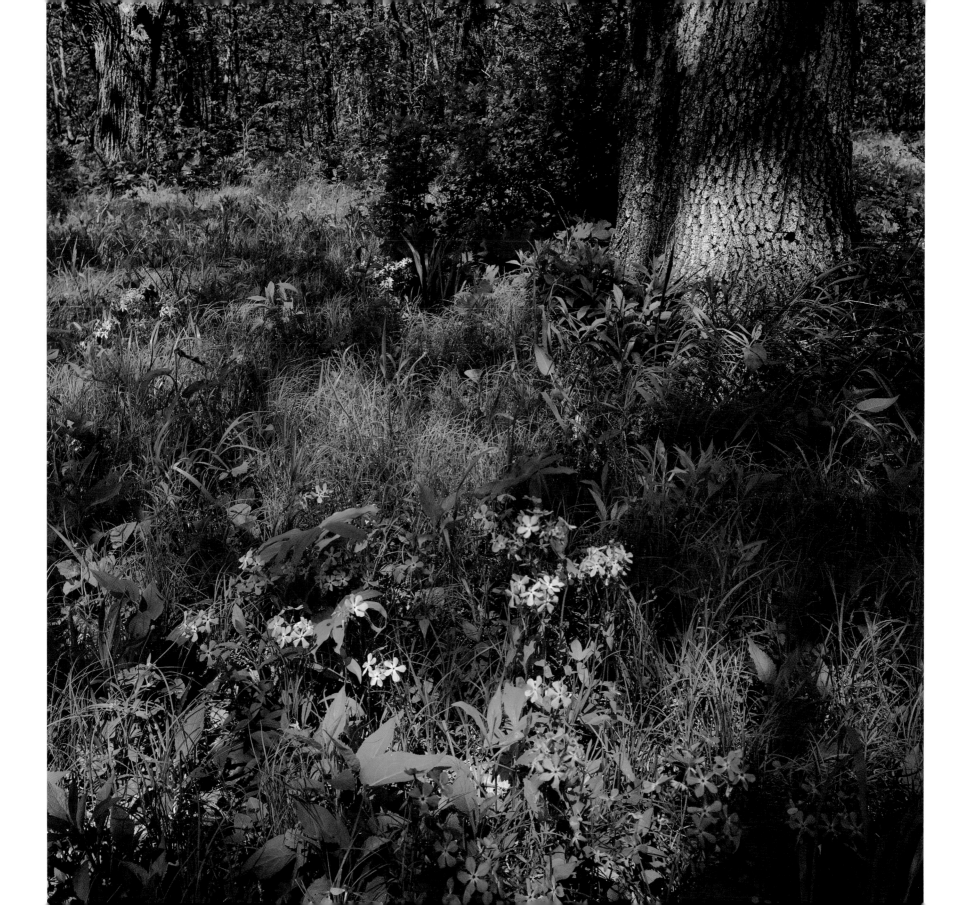

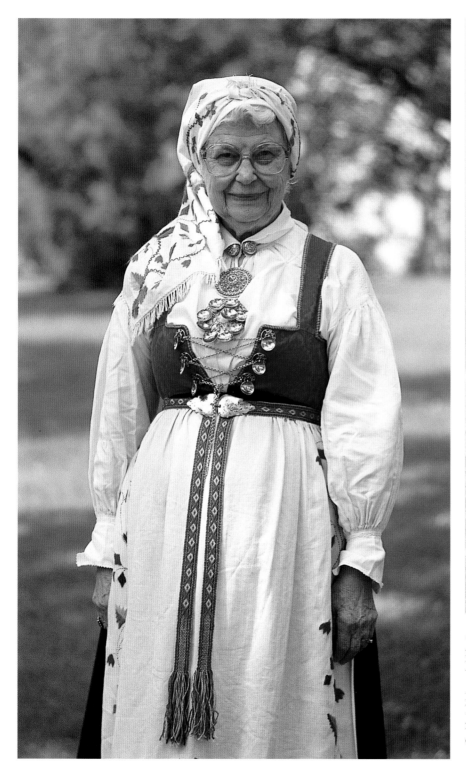

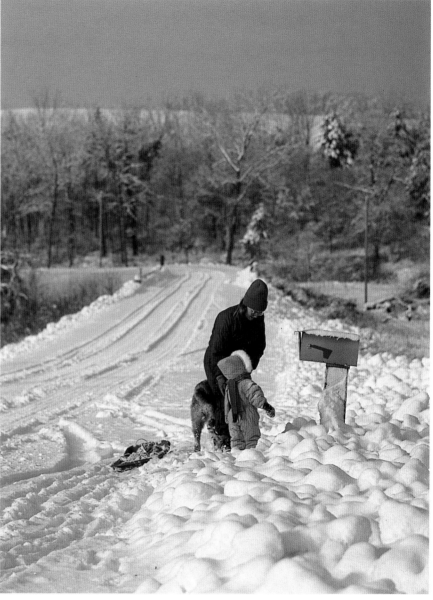

OPPOSITE: Wild phlox dots the forest in Palisades-Kepler State Park, Iowa.

LEFT: Decorah, Iowa, celebrates its Norwegian origins in an annual festival of traditional food and dress.

ABOVE: An Iowan mother and daughter trek through the snow to get their mail.

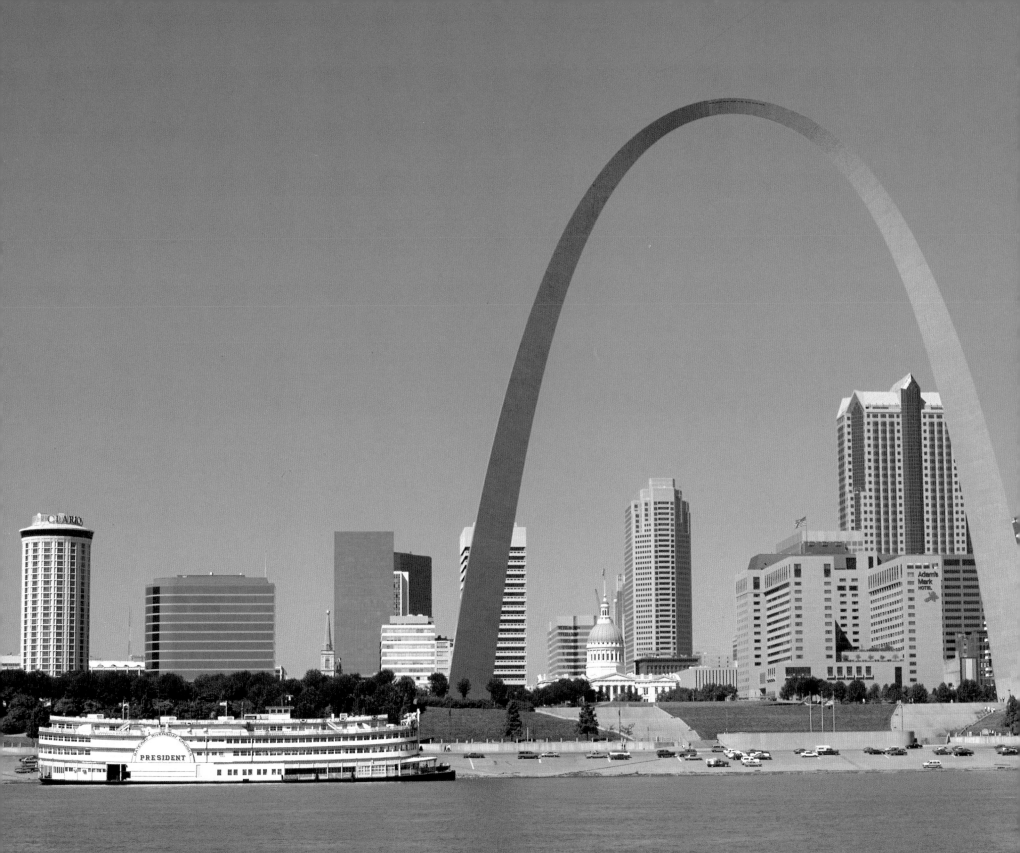

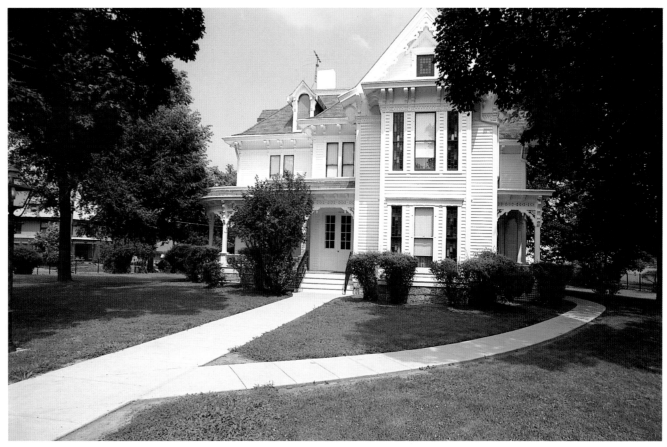

FAR LEFT: St. Louis, Missouri, Gateway to the West, with the great arch that commemorates the city's place in frontier history.

ABOVE: The home of President Harry S. Truman in Independence, Missouri.

LEFT: Mark Twain's boyhood home in Hannibal, Missouri.

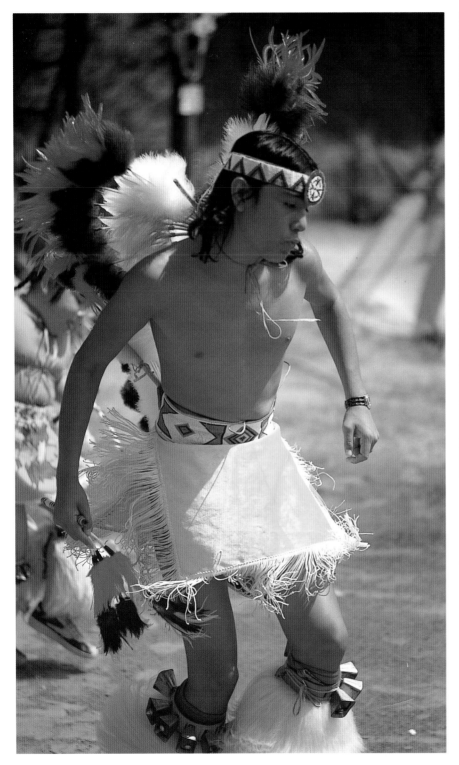

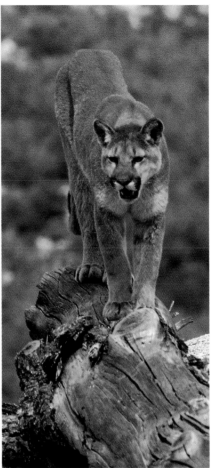

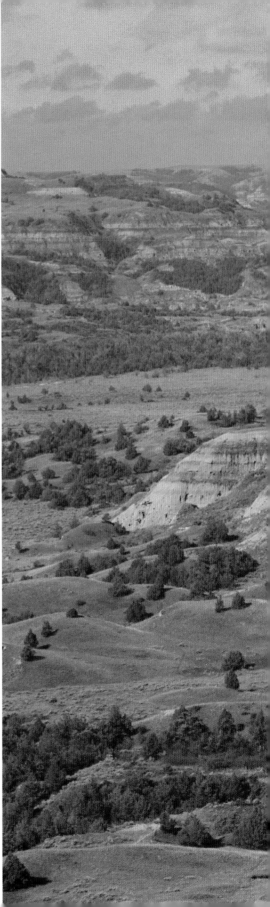

LEFT: Sioux Indians perform a tribal dance on a North Dakota reservation.

ABOVE: Mountain lions still roam in the wilds of North Dakota.

RIGHT: Striated rock formations in North Dakota's Theodore Roosevelt National Park.

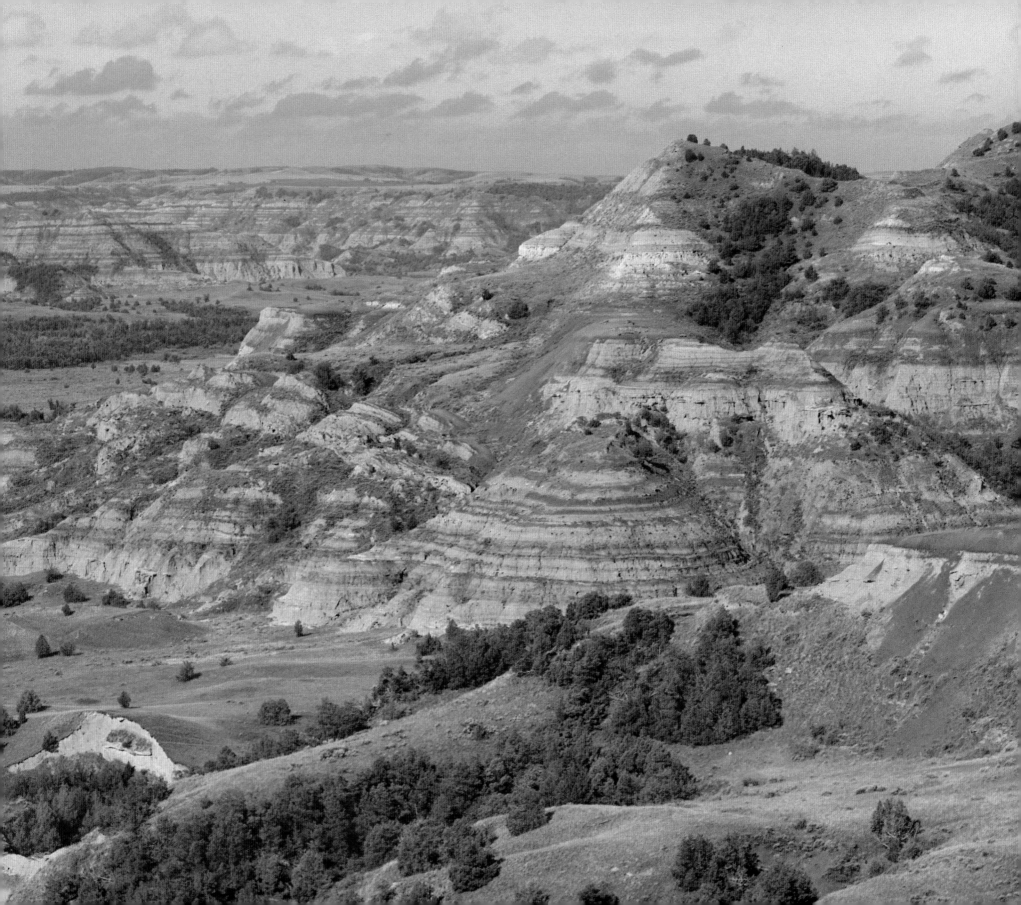

RIGHT: Custer State Park in South Dakota's Black Hills, with sheer Harney Peak in the foreground.

BELOW: Rising abruptly from the Dakota plains, the weird spires and deep ravines of the Badlands have fascinated geologists and paleontologists. The region is rich in fossils.

OPPOSITE: South Dakota's clay Badlands were the bane of travelers westward bound.

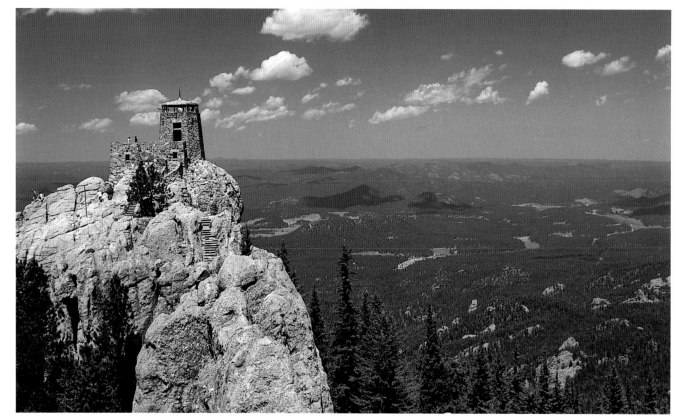

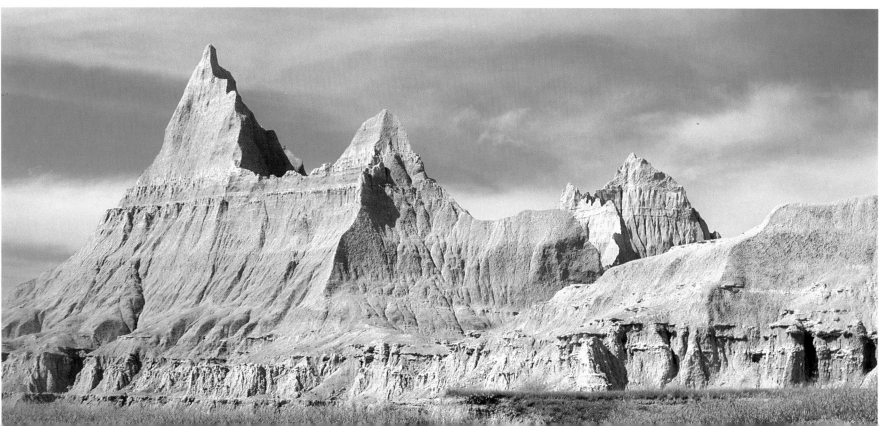

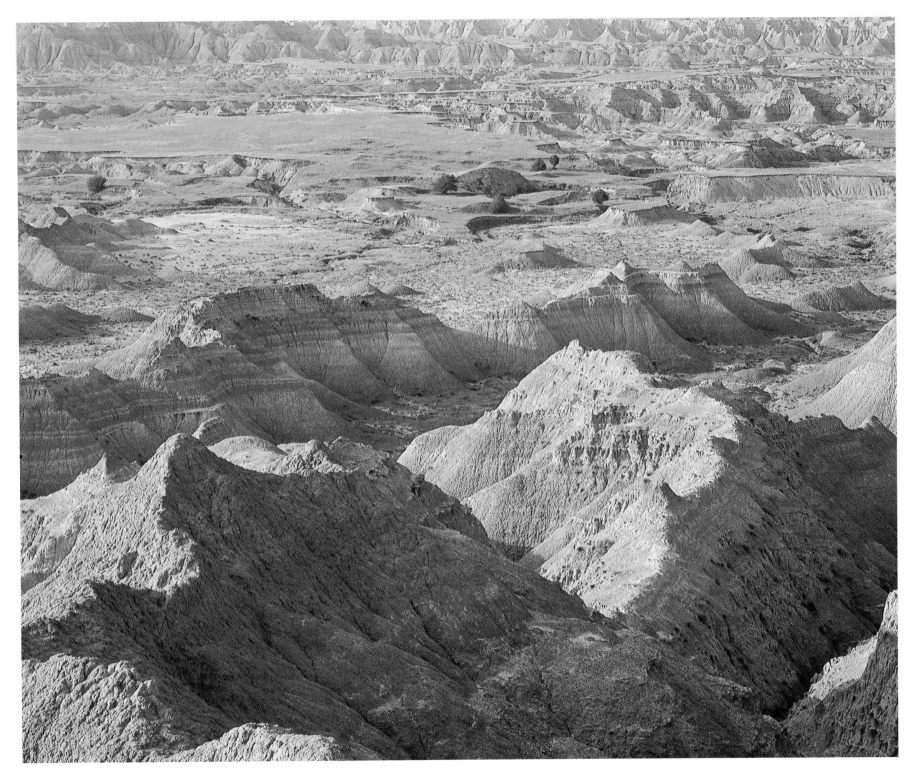

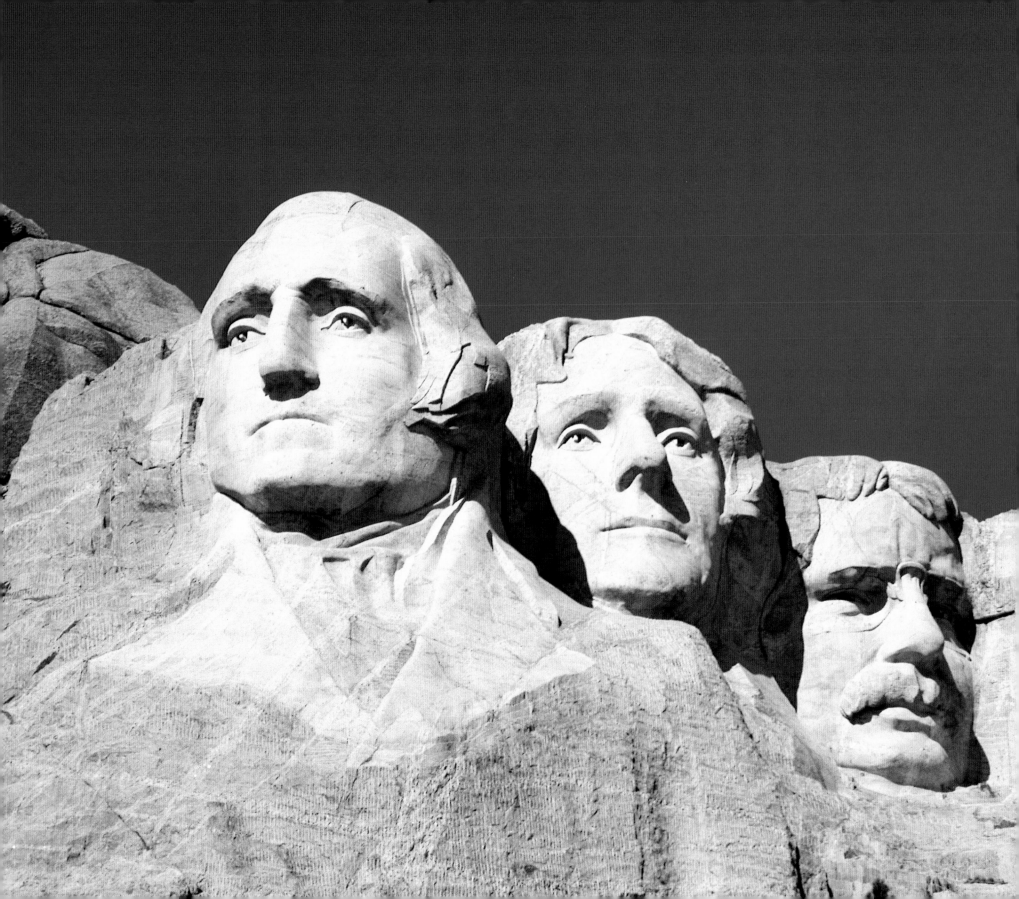

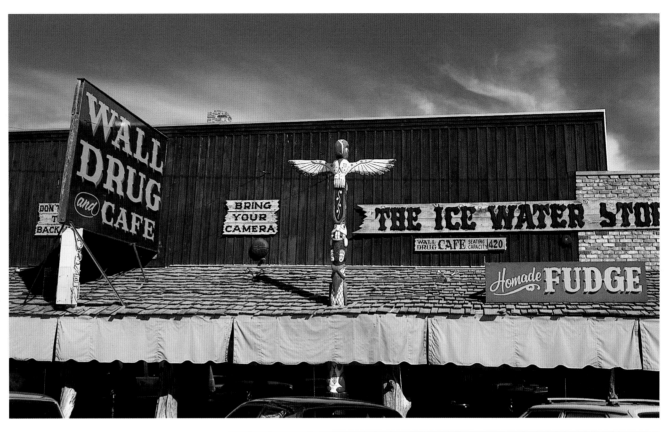

LEFT: The immense carvings made by Gutzon Borglum on South Dakota's Mount Rushmore depict Presidents George Washington, Thomas Jefferson, Theodore Roosevelt and Abraham Lincoln.

ABOVE: Small towns such as Wall, South Dakota, recall the region's sturdy pioneer heritage. Wall Drug Store, which became famous in 1936 when its owners advertised free ice water along the highway, attracts thousands of tourists during the summer.

RIGHT: The grandiose Corn Palace in Mitchell, South Dakota, pays tribute to one of the state's biggest crops.

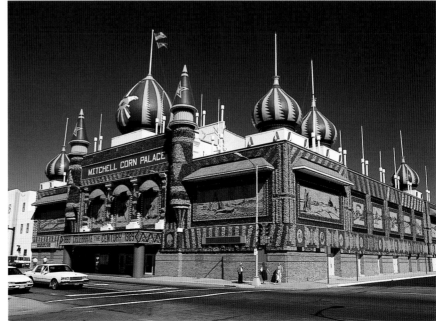

181

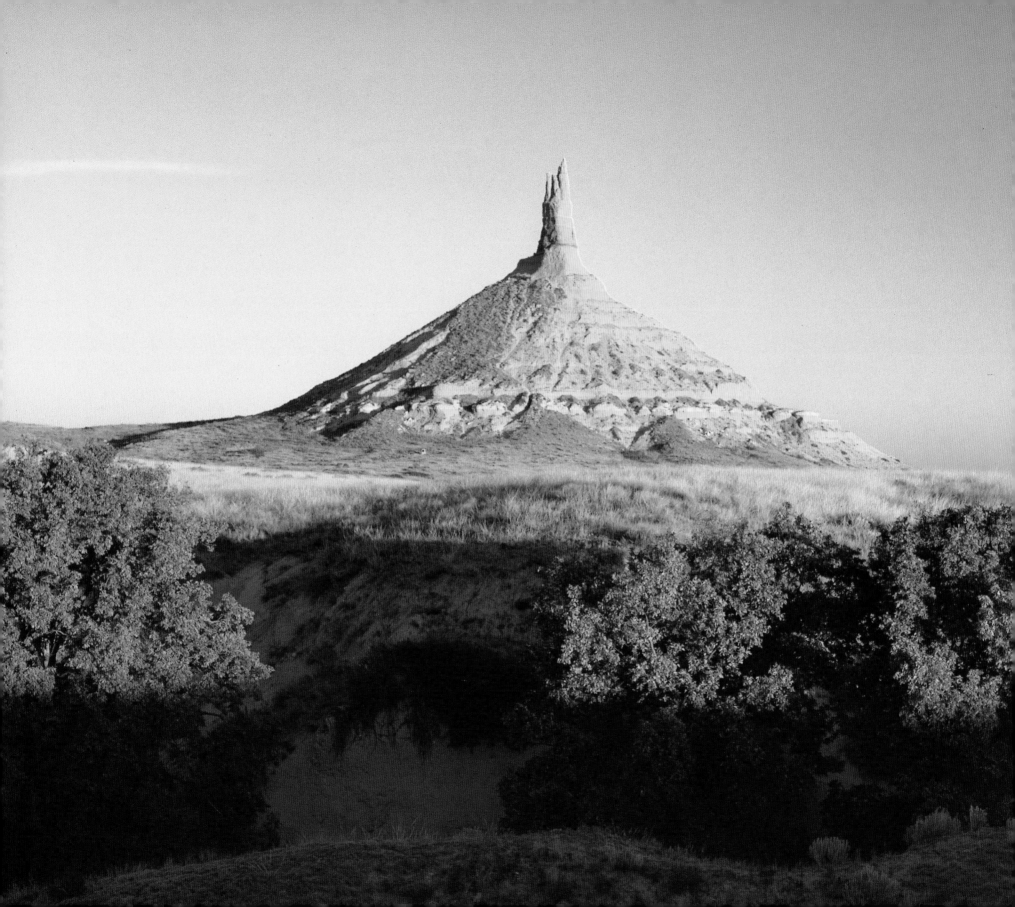

OPPOSITE: Chimney Rock, Nebraska, a major landmark along the Oregon Trail.

RIGHT: Tiny Immaculate Conception Church in Sioux County, Nebraska.

BELOW: Nebraska's Sand Hills are windblown sand dunes covered with prairie grass that span thousands of square miles in the northwestern part of the state.

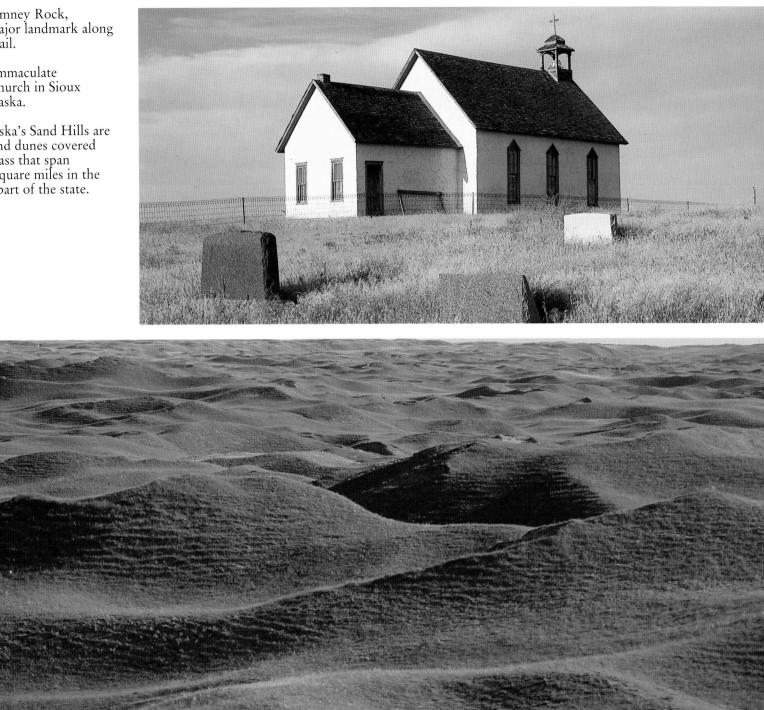

RIGHT: The Kansas state capitol in Topeka, was built in stages between 1866 and 1903.

BELOW: The scenic Red Rock region of Kansas.

OPPOSITE: Kansas City takes its stand on the plains of Kansas, where it plays a vital role in the state's agricultural economy.

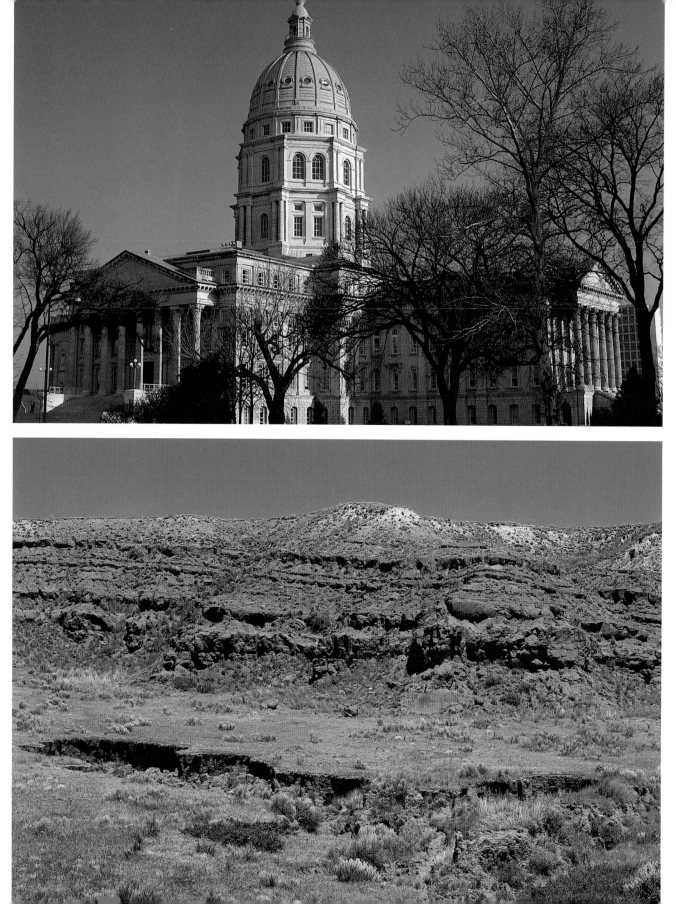

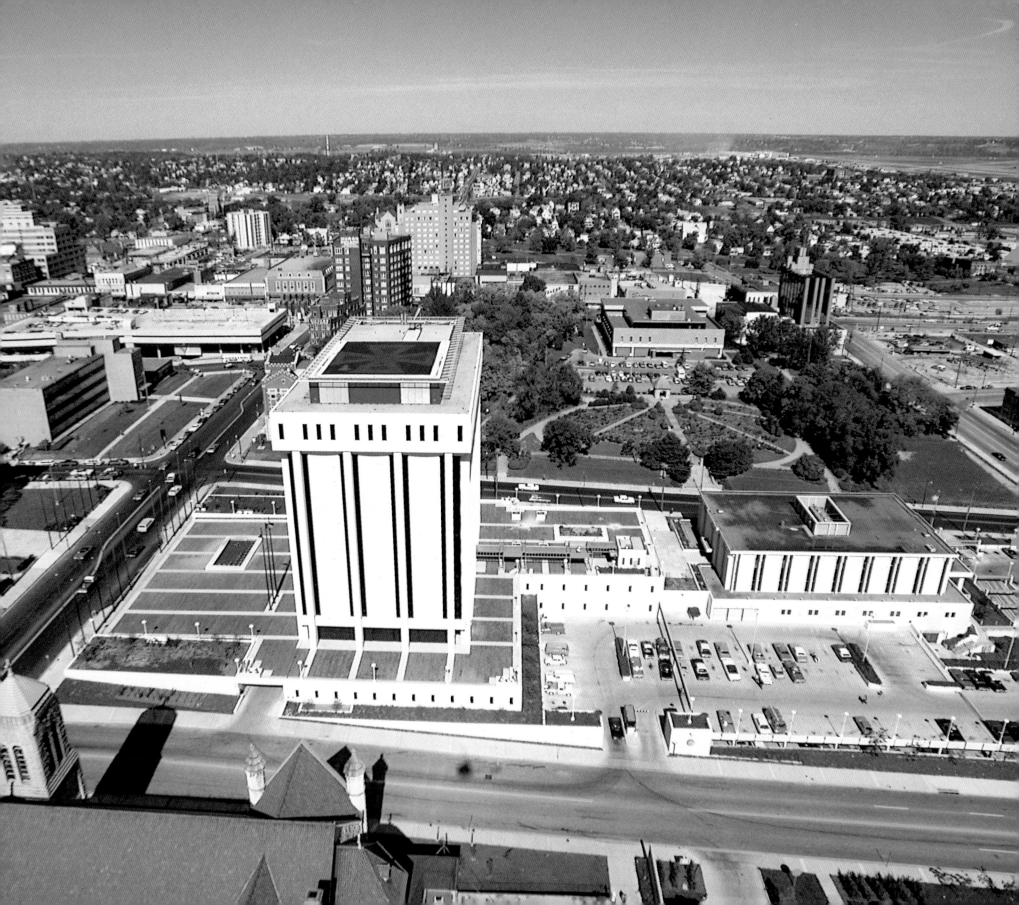

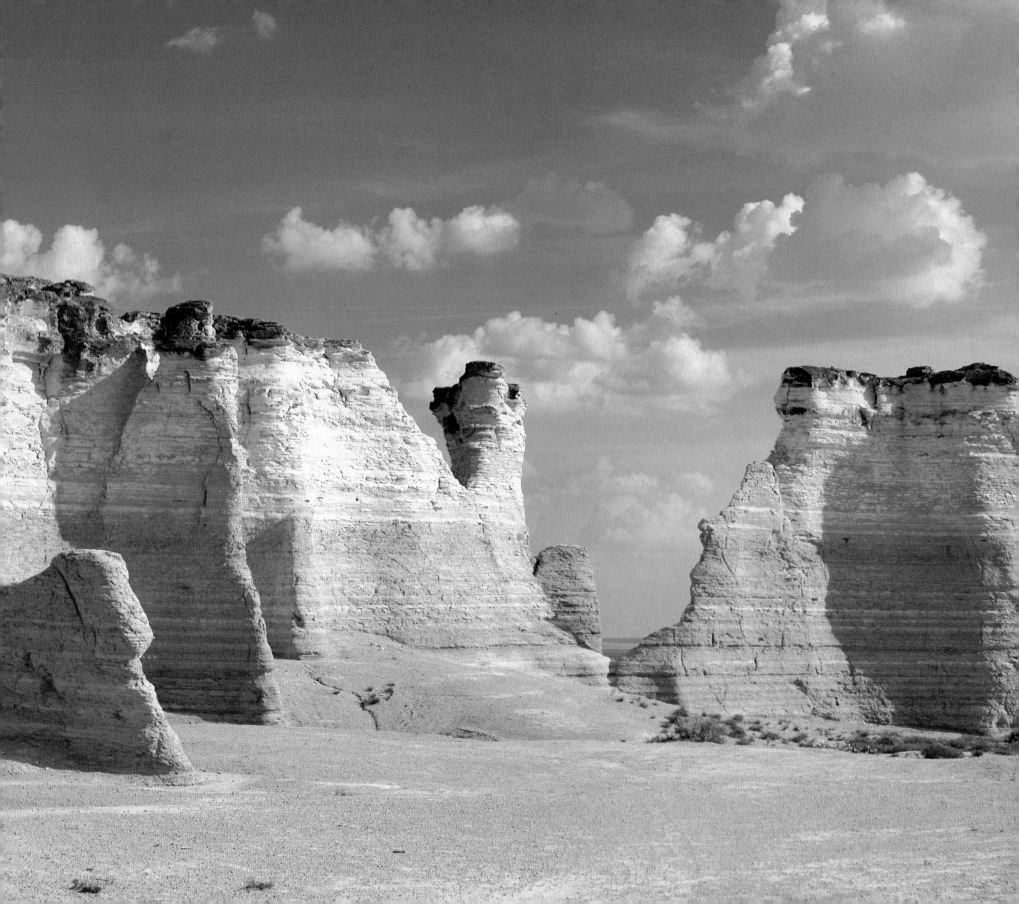

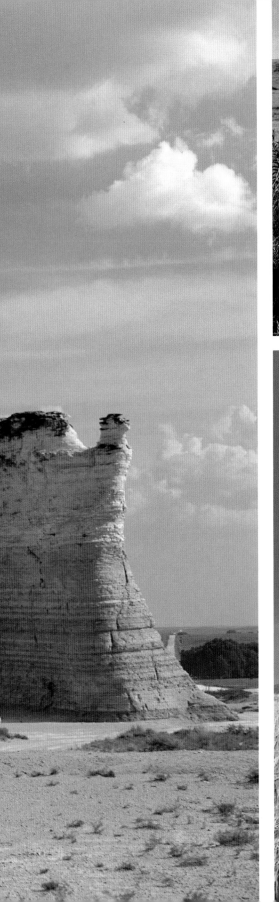

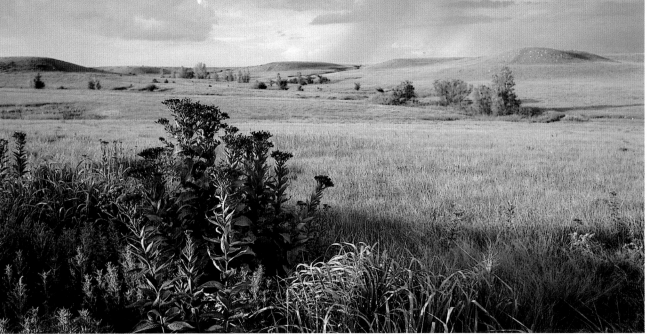

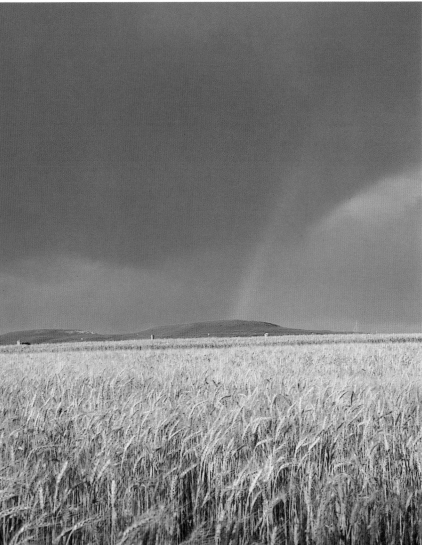

FAR LEFT: In Kansas, ancient chalk bluffs have been eroded into fantastic shapes by wind and weather.

ABOVE: Prairie conservation has become important to the Plains states, as seen at the Konza Prairie Research Natural Area near Manhattan, Kansas. Konza preserves the largest remaining tall-grass prairie in America.

LEFT: A field of Kansas wheat under a stormy sky.

THE SOUTHWEST AND SOUTHERN CALIFORNIA

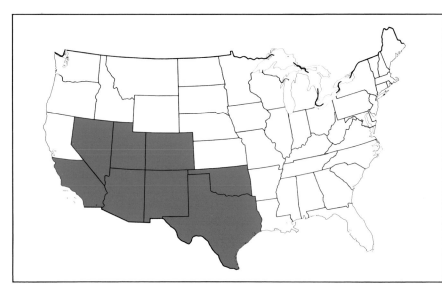

OPPOSITE: Sunset over the Grand Canyon in Arizona. This world-famous gorge, cut by the Colorado River, is more than a mile deep, 4 to 18 miles wide, and more than 200 miles long.

The American Southwest has thousands of square miles of deserts and canyons, red rocks and sand dunes that give it a unique character. Oklahoma, Texas, New Mexico, Arizona, Nevada, Utah, Colorado, and Southern California share features of geography and climate found nowhere else in the country.

The great American deserts include White Sands National Monument in southern New Mexico, Arizona's Painted Desert, and California's Mojave, north of Baja. This region once lay beneath the Pacific Ocean. Its first inhabitants were the Anasazi, who built cliff dwellings in what is now northern Arizona, New Mexico, Utah, and Colorado. The Hohokam irrigated the desert and made it productive, and the Mogollon hunted and farmed.

Uplift and erosion formed the weirdly beautiful stone formations of Bryce and Zion canyons in Utah. The Grand Canyon started out as a plain with a shallow river running through it. The plain was lifted up by subterranean forces, and the river – the Colorado – ran faster, cutting a great chasm up to 18 miles wide and more than a mile deep. Its 200-mile course is now one of the world's natural wonders. The Rocky Mountains, which form the Continental Divide, extend for more than 3,000 miles from New Mexico to Alaska.

Of course, the Southwest and Southern California region contains more than awe-inspiring wilderness. It is also the great cities of Los Angeles, Denver, Phoenix, Salt Lake, Tulsa, Dallas, Santa Fe, Las Vegas, and Houston. It includes thousands of square miles of the nation's richest farmland, oil fields, offshore islands, the incomparable Pacific Coast, thriving commerce and industry, and millions of people who wouldn't live anywhere else.

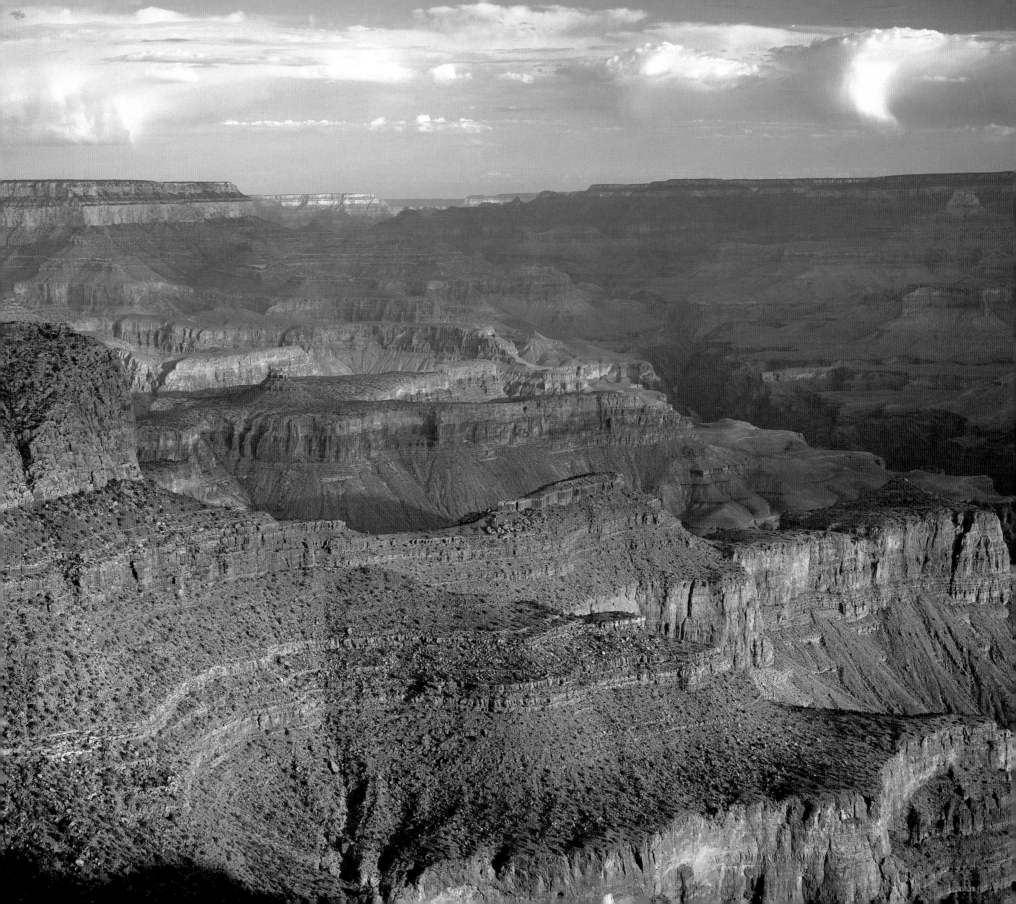

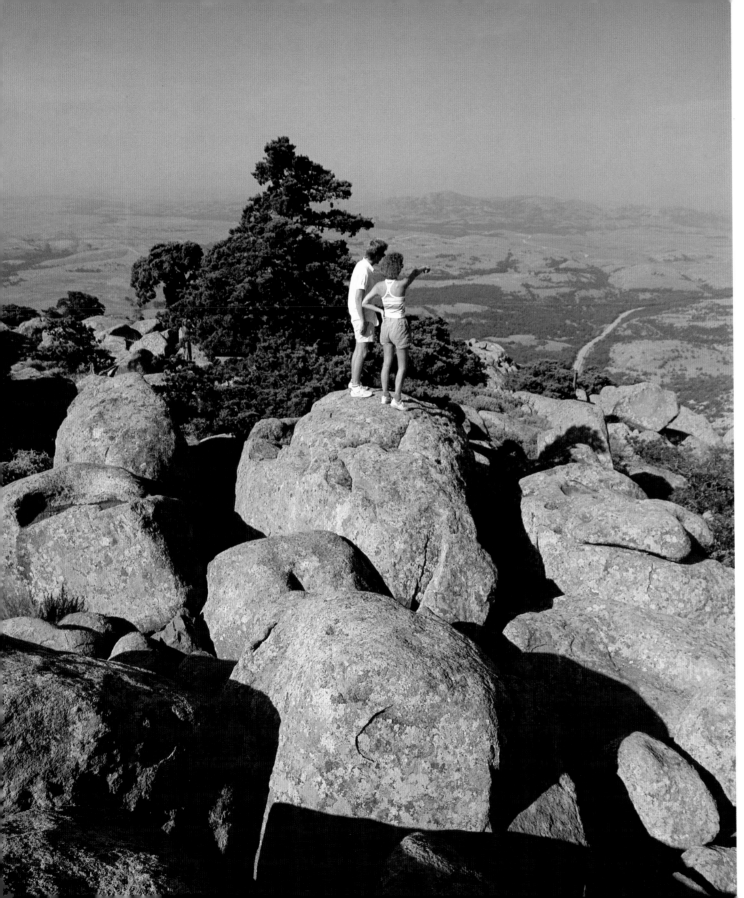

LEFT: Hardy climbers overlook Oklahoma's Wichita Mountains.

OPPOSITE TOP LEFT: The state capitol building in Oklahoma City, once part of the huge, nearly unmapped tract known as Indian Territory.

OPPOSITE BOTTOM LEFT: Oklahoma Indians in traditional dress for the annual Frontier City celebration in Oklahoma City.

OPPOSITE TOP RIGHT: Myriad Gardens strike a colorful note in Oklahoma's capital.

OPPOSITE BOTTOM RIGHT: A mule hitched to a parking meter makes sense in Norman, Oklahoma.

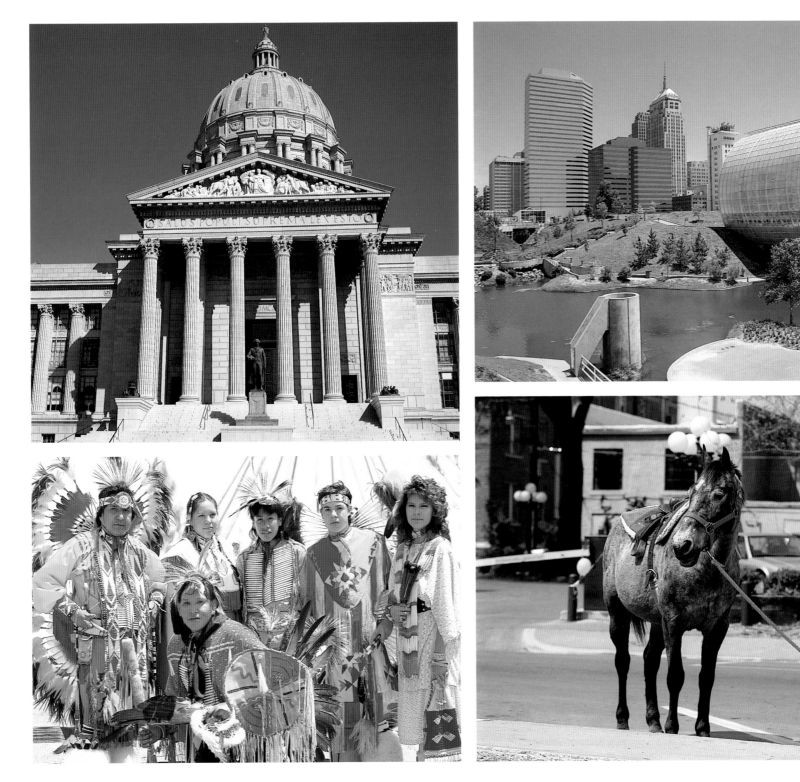

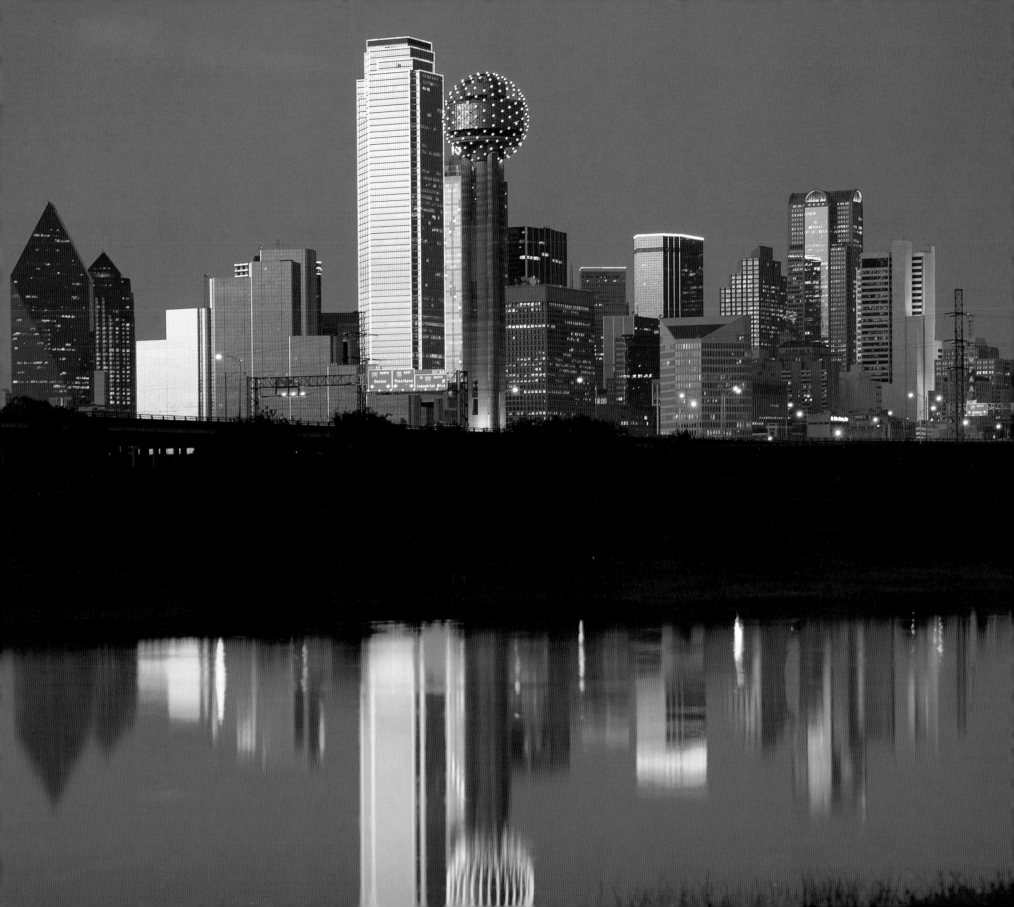

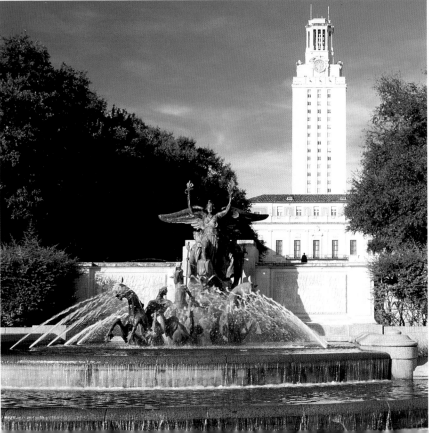

OPPOSITE: The Dallas skyline by night.

ABOVE: Gleaming Dallas skyscrapers are headquarters for southwestern commerce and industry, from oil to exotic produce.

LEFT: The 307-foot tower of the University of Texas, in downtown Austin, the state's first North American settlement, when this region belonged to Mexico.

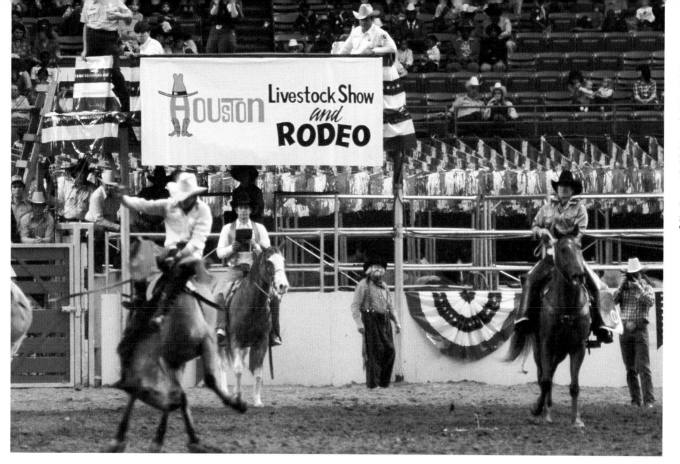

LEFT: Houston keeps up the tradition of Texas cowboys and ranchers with its popular rodeo and livestock show.

BELOW: The fishing town of Kemah Seabrook, in Galveston County, on the Gulf of Mexico.

OPPOSITE: A drilling rig is silhouetted against the south Texas sky.

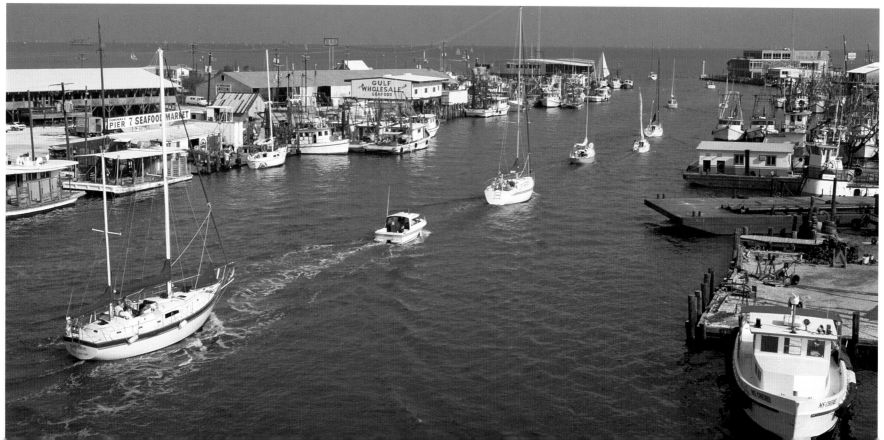

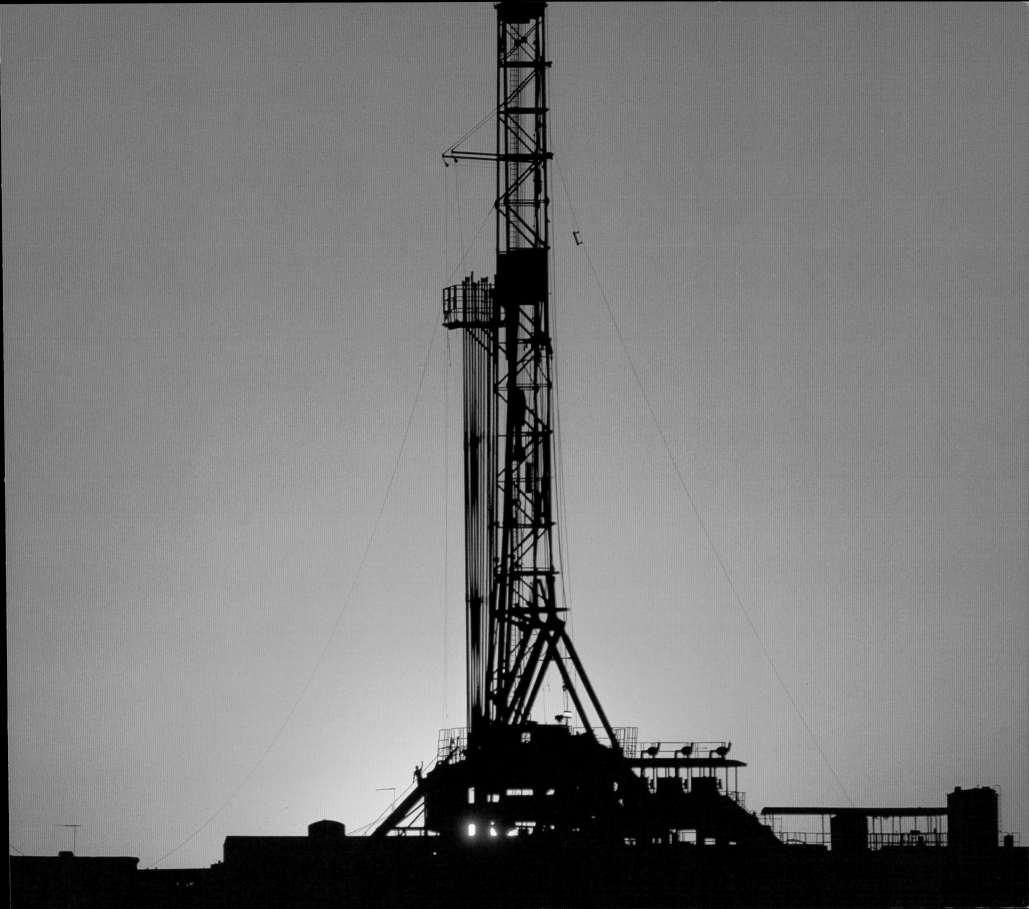

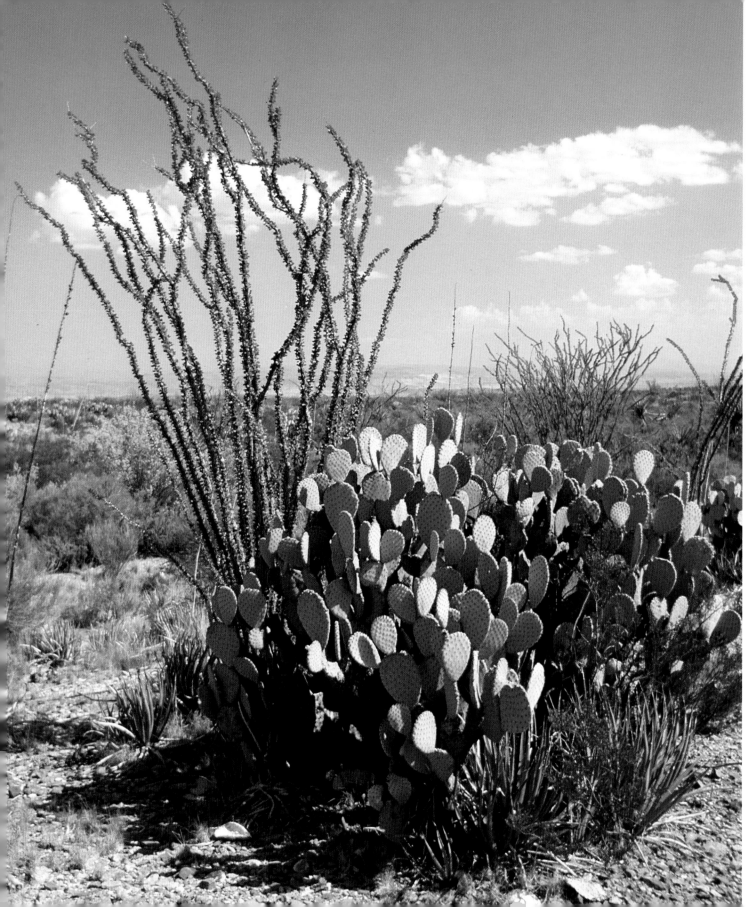

LEFT: Exotic, water-hoarding plants hold their own on the stony soil of the Big Bend region, near Casa Grande Mountain, Texas.

OPPOSITE TOP: The guest house at the King Ranch in Kingsville, Texas. This is the world's largest privately owned ranch, established in 1853.

OPPOSITE BOTTOM LEFT: The reconstructed Alamo in San Antonio, scene of the famous battle between Mexican general Santa Anna and Texas settlers in 1836.

OPPOSITE BOTTOM RIGHT: A cattle roundup in Victoria, Texas.

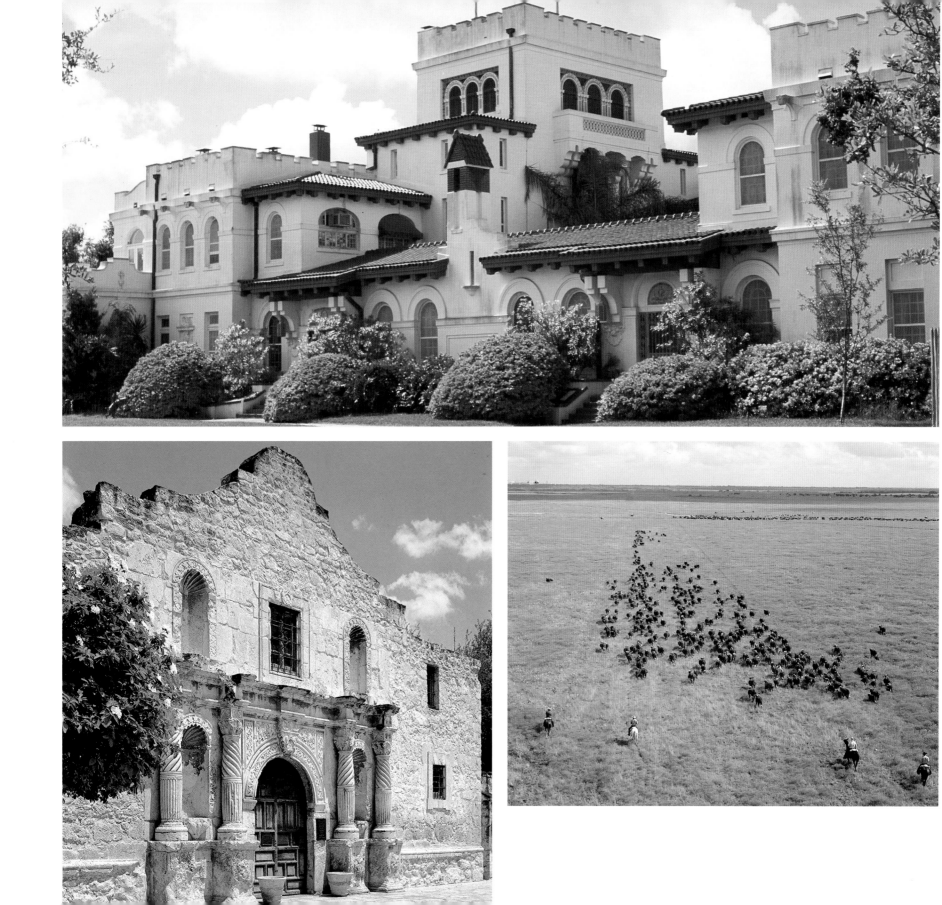

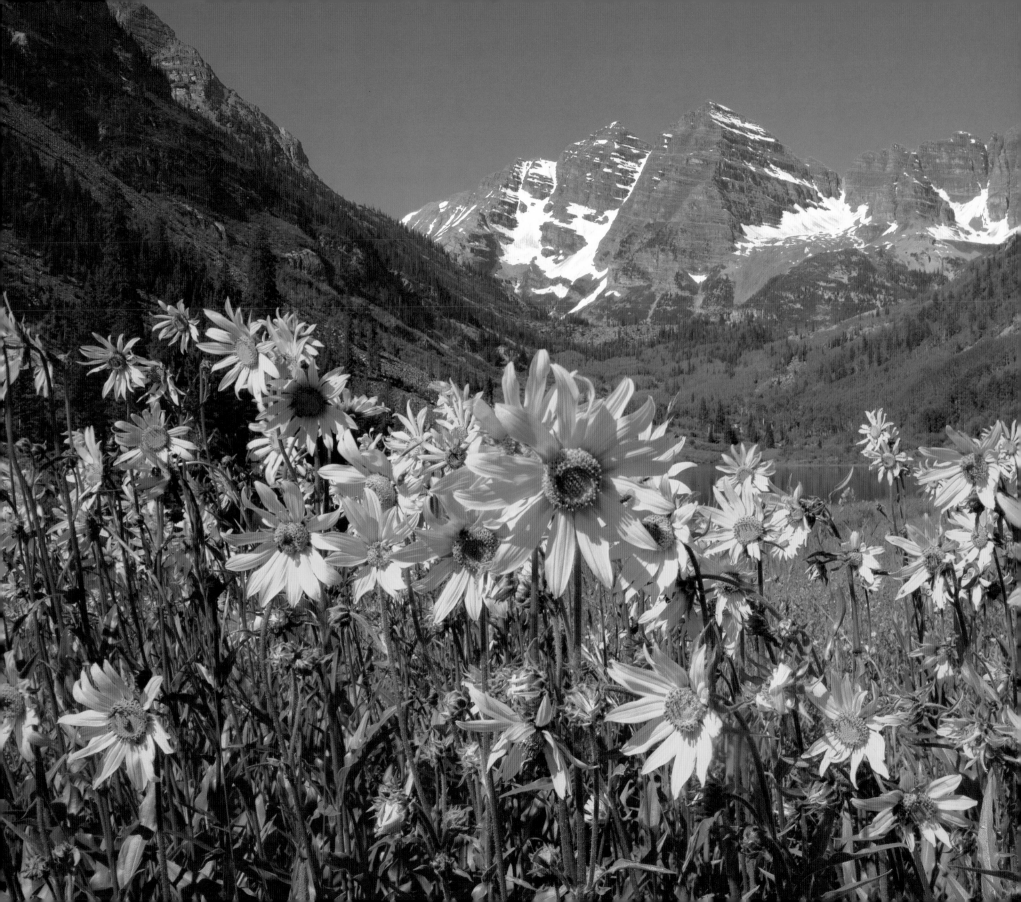

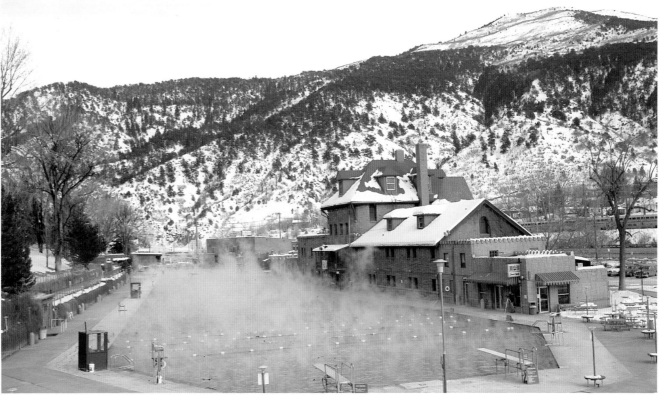

FAR LEFT: In Colorado's White River National Forest, the Elk Mountains provide the backdrop for dazzling sunflowers.

ABOVE: A pool formed by hot springs at Glenwood Springs, Colorado.

LEFT: Aspen, Colorado, is a popular resort for skiing vacations.

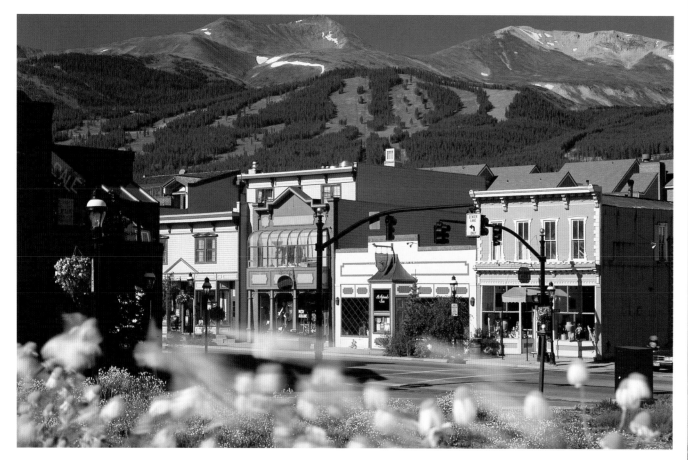

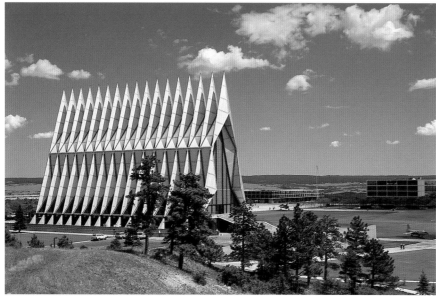

ABOVE: Breckenridge, Colorado, recalls the state's history, when 19th-century mining camps sprang up to become the nucleus of permanent settlements.

LEFT: The chapel at the United States Air Force Academy in Colorado Springs.

RIGHT: The impressive Denver County Building, lighted up for the holidays.

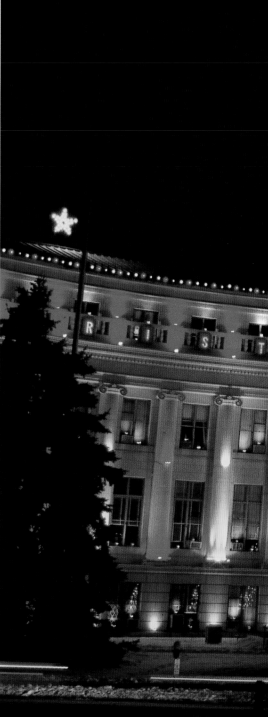

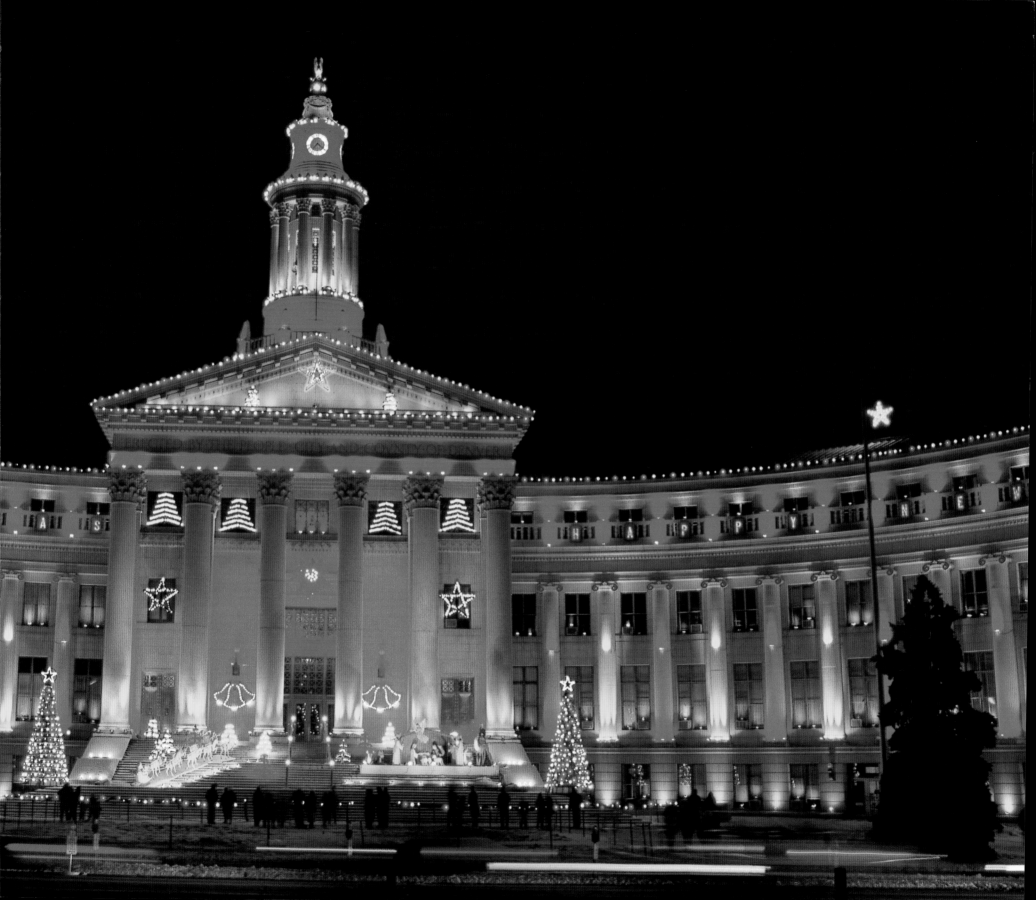

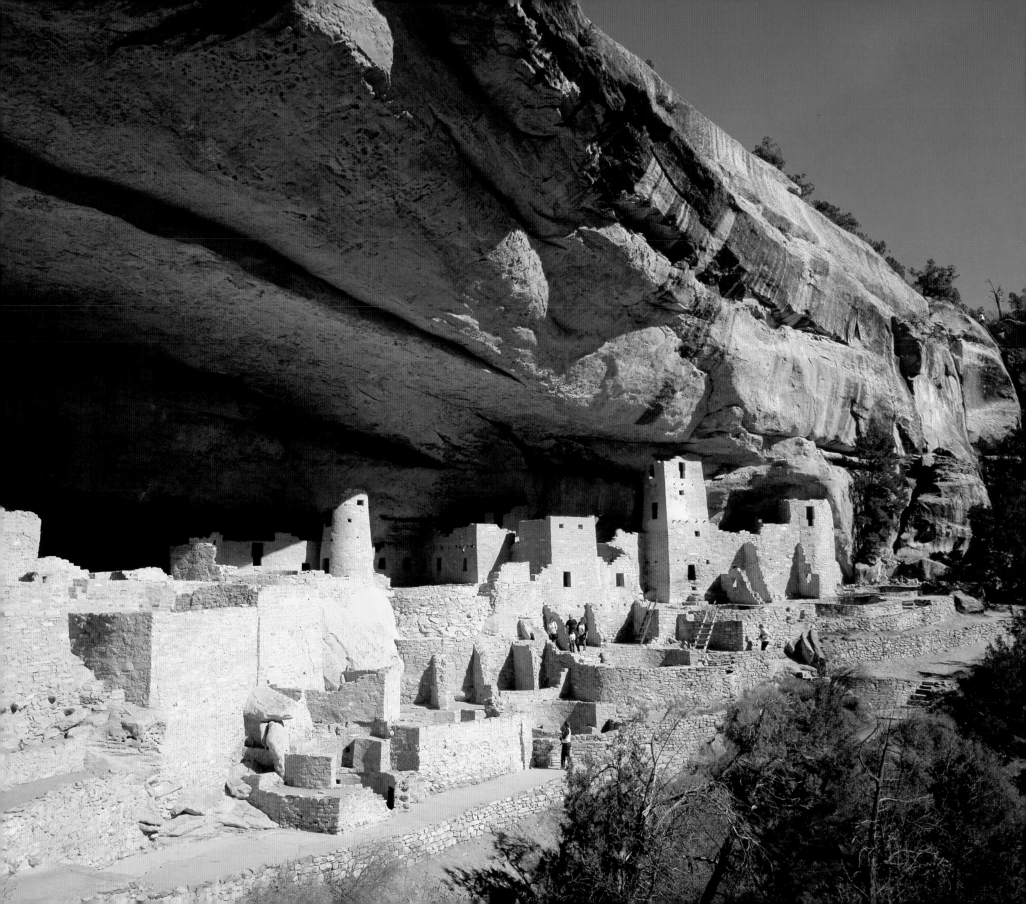

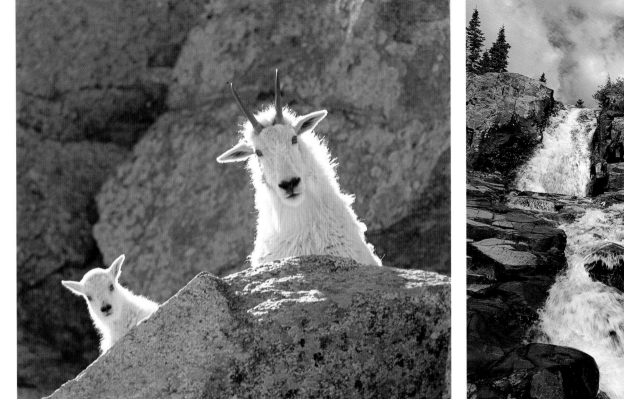

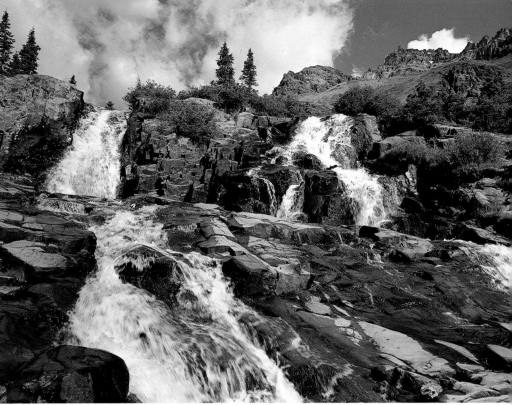

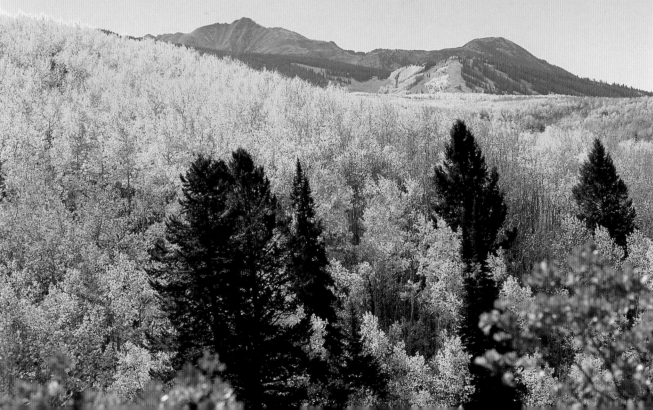

OPPOSITE: Pre-Columbian cliff dwellings at Colorado's Mesa Verde.

TOP LEFT: Rocky Mountain goats on the heights of Mount Evans, Colorado.

LEFT: Fall comes to Snowmass, Colorado, in a blaze of color.

ABOVE: Twin Falls, in the Colorado Rockies near Ouray, surrounded by the San Juan Mountains.

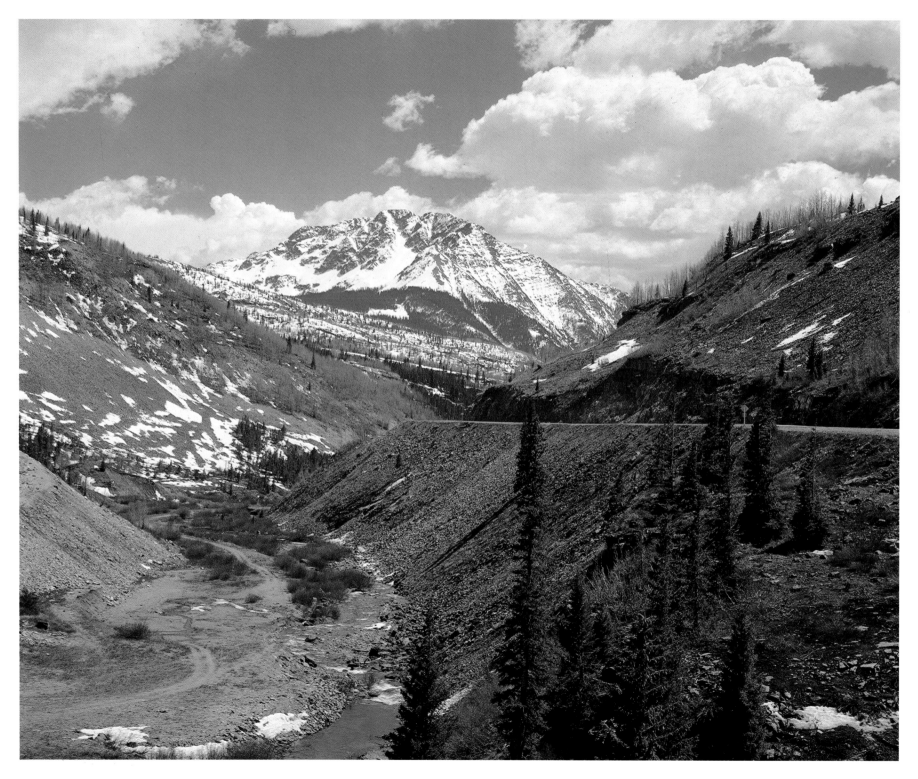

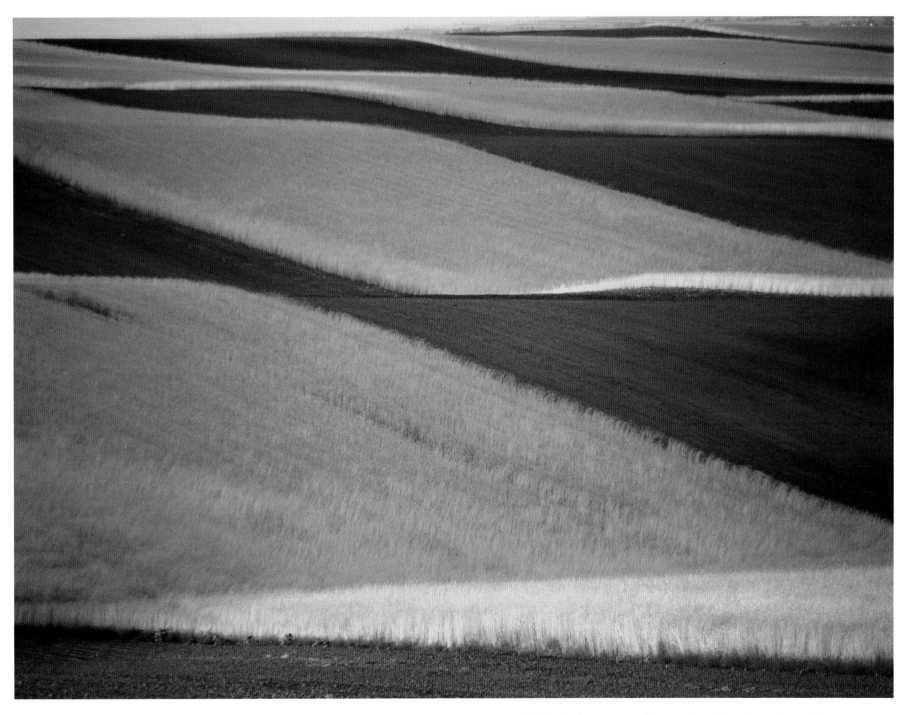

OPPOSITE: An austere Rocky Mountain valley overlooked by the Needle Mountains, perpetually frosted in snow because of their great altitude.

ABOVE: A field of wheat in Boulder, Colorado, where short, hot summers hasten the growth of crops under a deep blue bowl of sky.

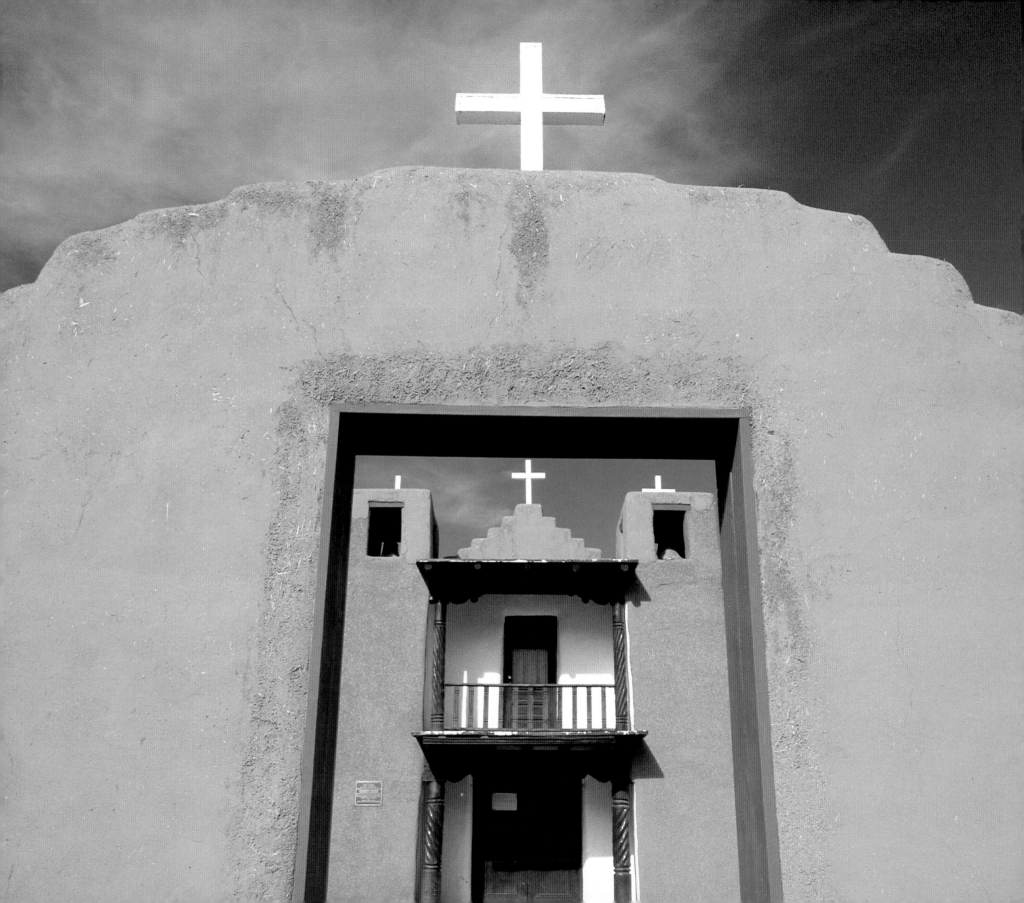

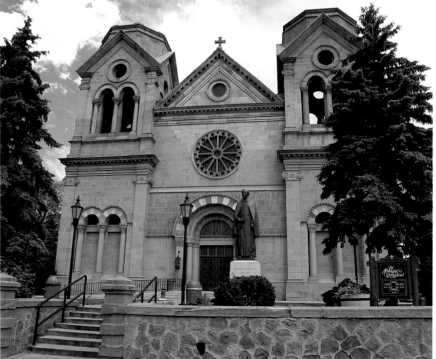

OPPOSITE: The Spanish-mission-style church at old Taos Pueblo, New Mexico.

FAR LEFT: Santa Fe, New Mexico's, Old Town combines its Mexican heritage with the trappings of contemporary culture.

ABOVE: The Spanish Colonial church in Santa Fe's Old Town.

LEFT: Still life in Santa Fe.

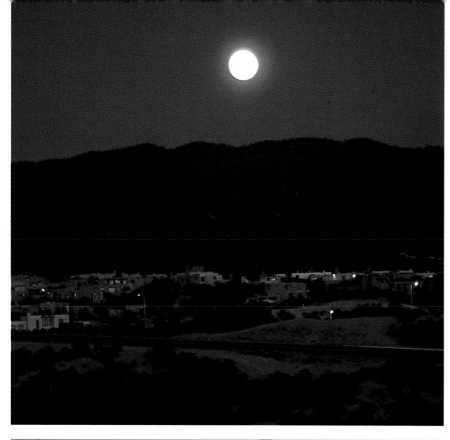

LEFT: Moonlit Santa Fe, New Mexico's capital and the oldest seat of government in the United States. The Sangre de Cristo Mountains are in the background.

BELOW: The adobe pueblo at Taos, built on a plateau for protection and continuously occupied for hundreds of years.

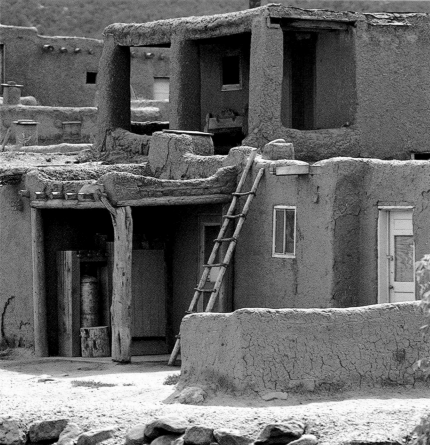

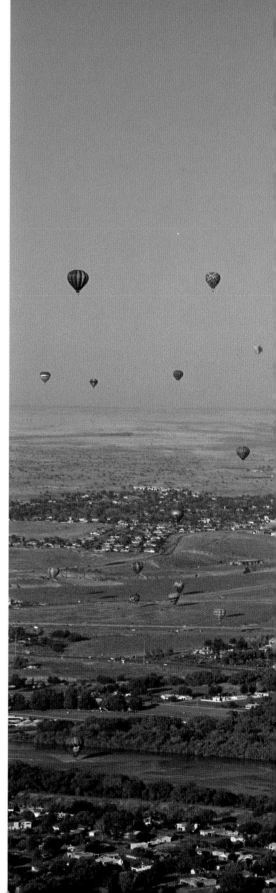

RIGHT: The colorful Balloon Festival over Albuquerque, New Mexico.

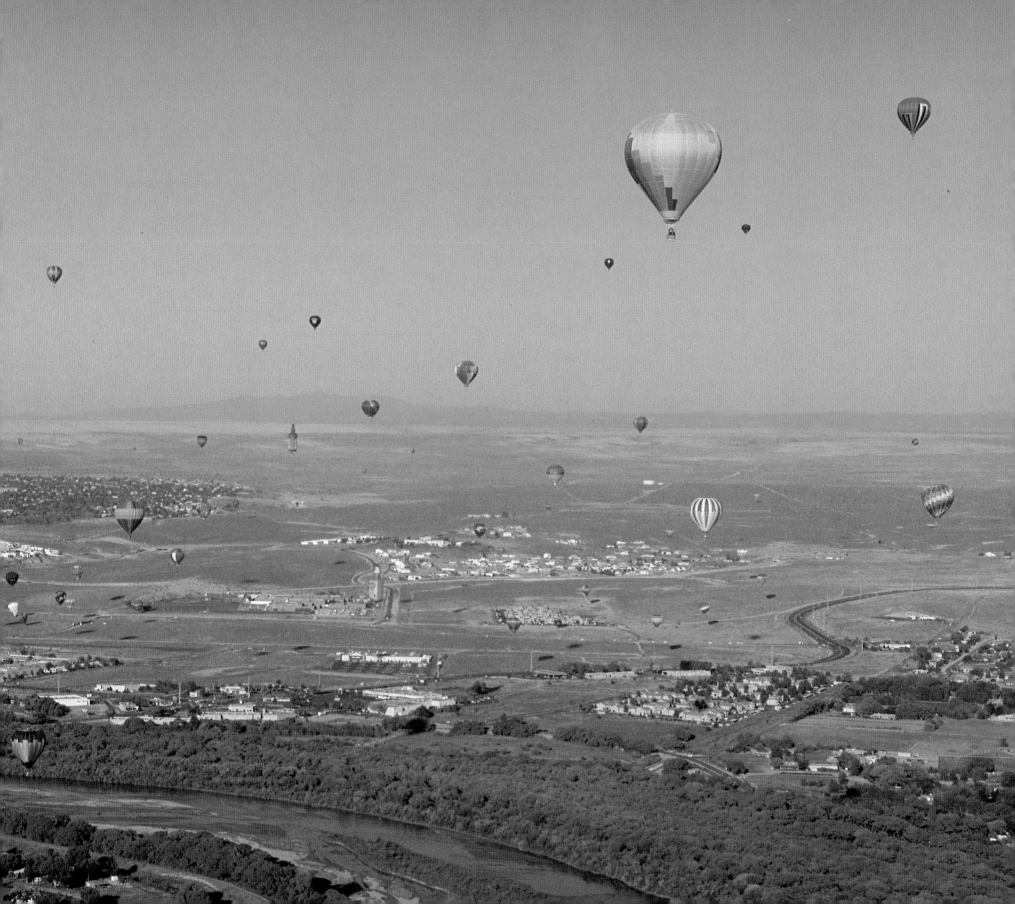

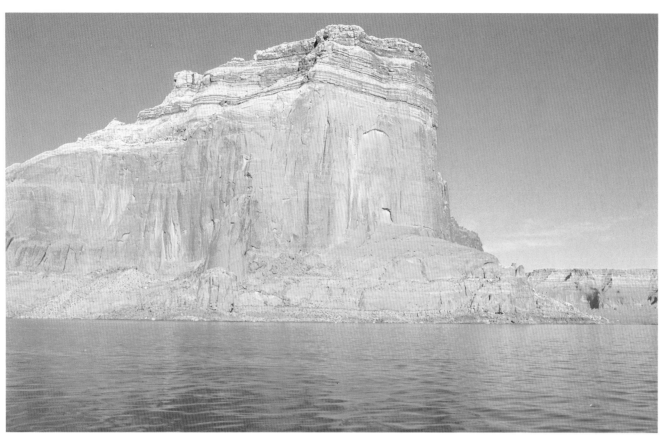

LEFT: Lake Powell, in southeastern Utah, overlooked by the region's sheer cliffs of red sandstone.

BELOW: The 1,500-square-mile Great Salt Lake yields some 40,000 tons of salt per year.

OPPOSITE: The Mormon Temple in Salt Lake City, Utah, settled by members of the Church of Jesus Christ of Latter-Day Saints who came west to escape persecution for their beliefs.

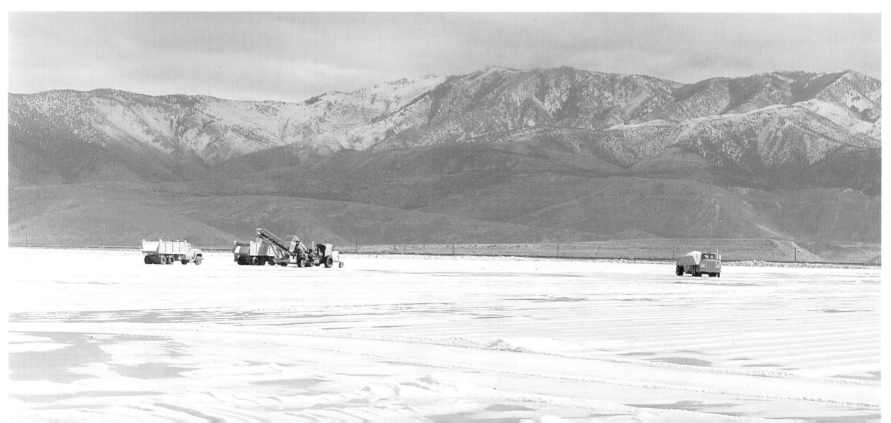

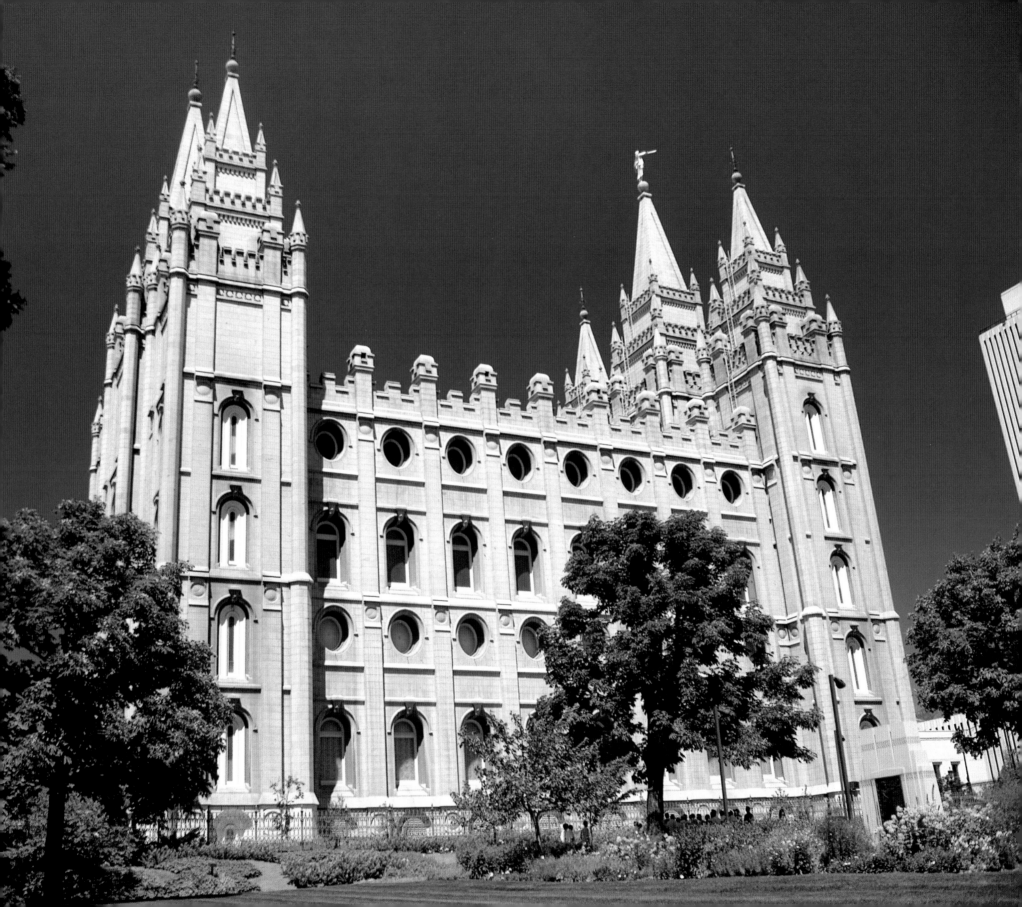

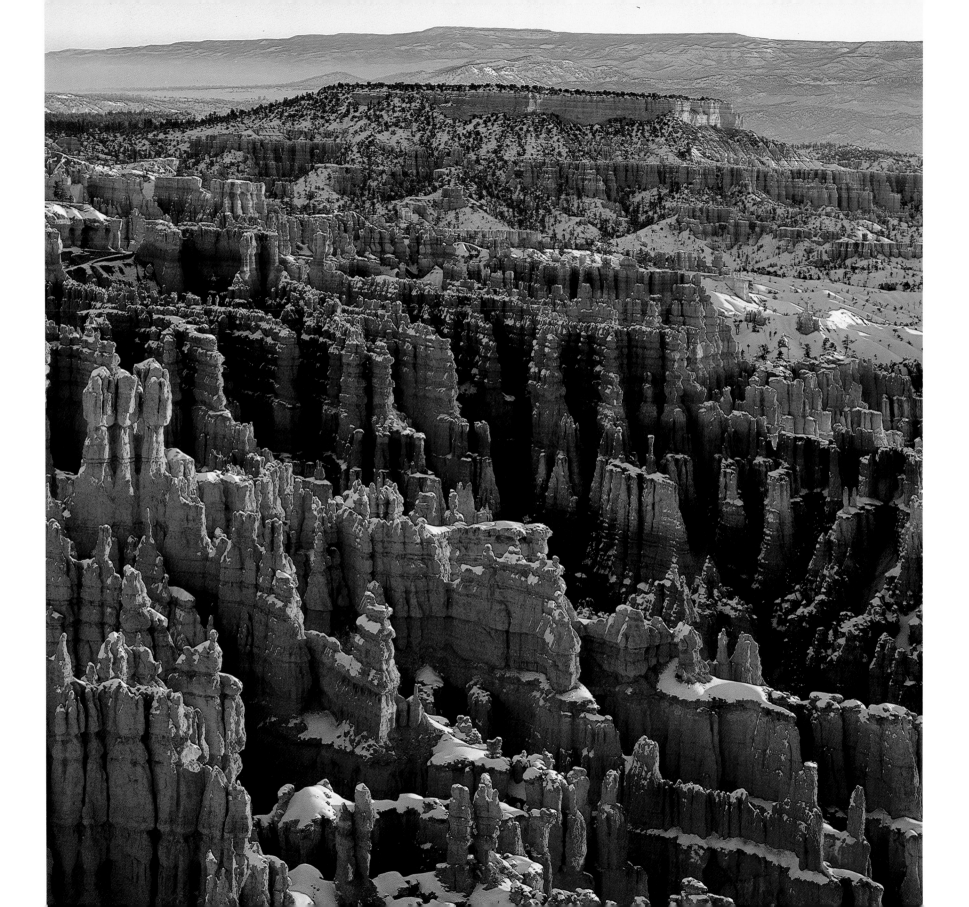

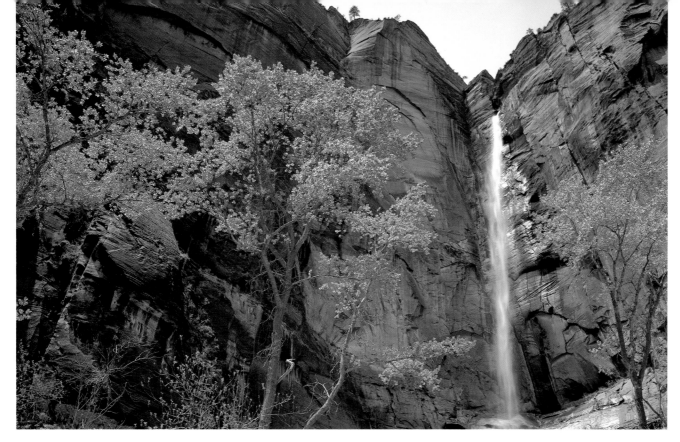

OPPOSITE: Rainbow-colored Bryce Canyon, Utah, with the fantastic pinnacles of the Silent City backed by the great plateau called Boat Mesa.

LEFT: A spectacular waterfall in Utah's Zion National Park, with cottonwood trees in the foreground.

BELOW: Zion Canyon's West Temple. The walls of Zion Canyon were carved by the Virgin River, cutting its way through the Markagunt Plateau.

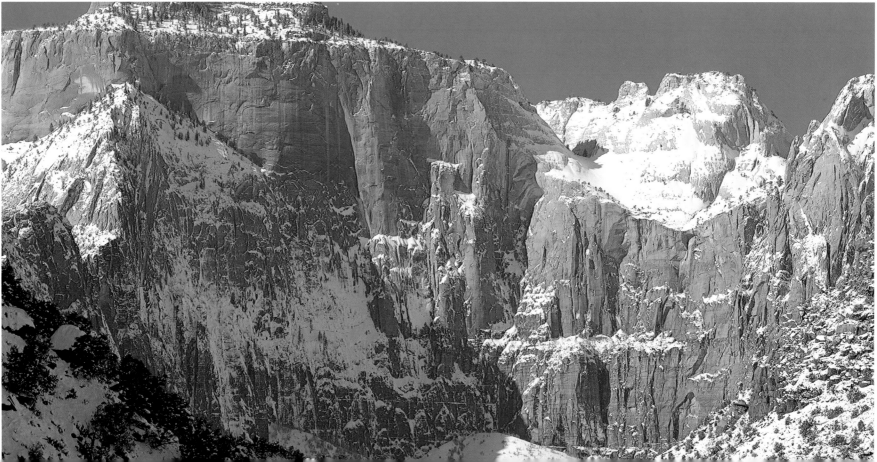

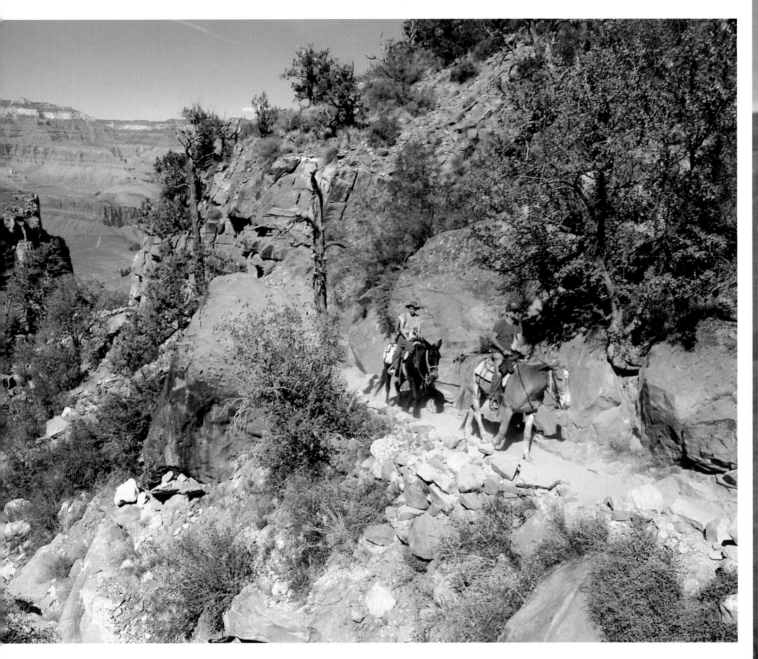

ABOVE: A heart-stopping mule ride down a narrow trail into the Grand Canyon in Arizona.

RIGHT: The Grand Canyon from the West Rim Drive at sunset.

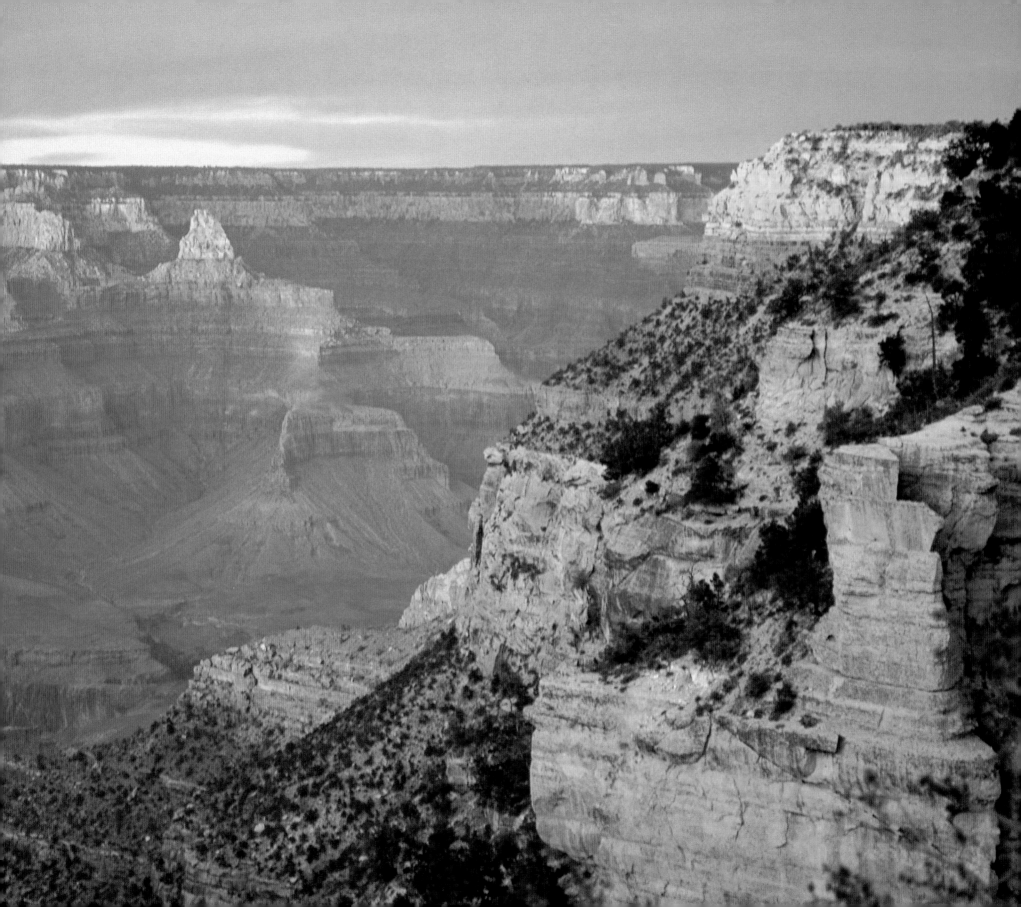

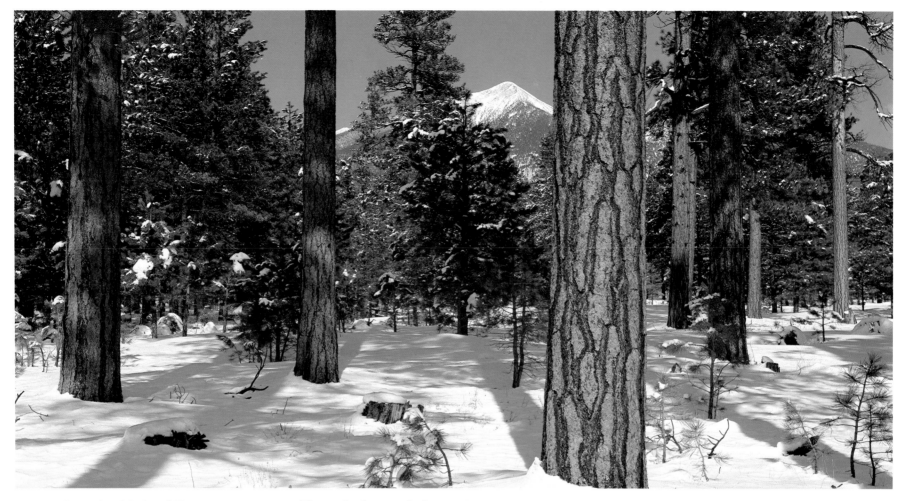

ABOVE: Coconino National Forest, near Flagstaff, Arizona, backed by the 12,000-foot San Francisco Peaks.

OPPOSITE: The eerie shapes of Blue Mesa, Arizona, once a floodplain, as seen in its banded buttes and mesas.

RIGHT: Trees turned to stone by eons of mineral action, in Petrified Forest National Park, near Holbrook, Arizona.

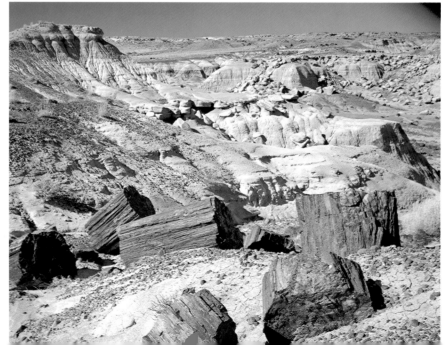

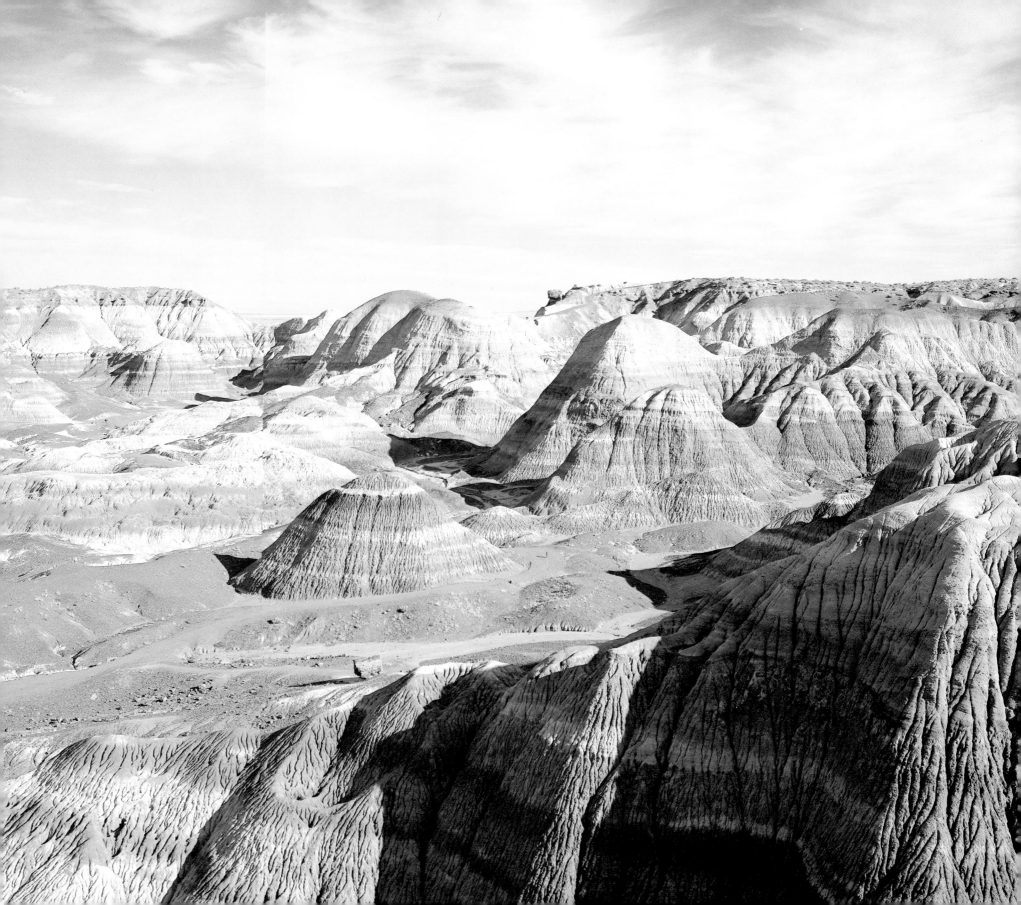

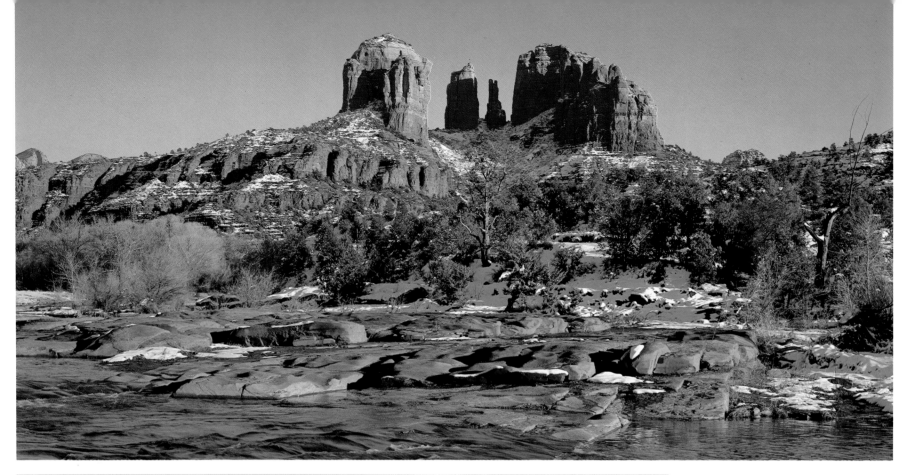

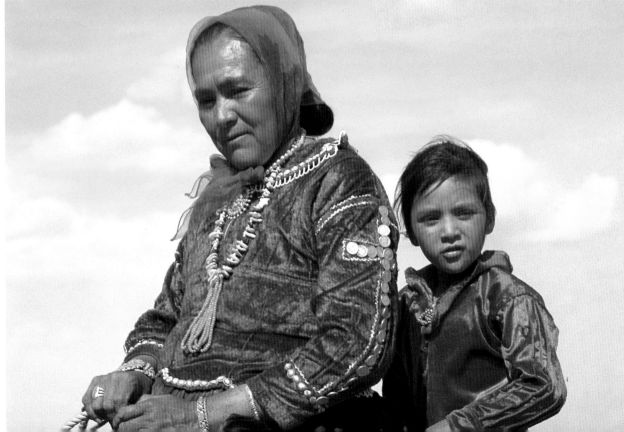

ABOVE: Red Rock Crossing, near Sedona, Arizona, has been the setting for many a Western movie.

LEFT: A Navajo woman and child in traditional dress, with the turquoise jewelry shaped by tribal craftsmen.

OPPOSITE: Sandstone monoliths and spires stud Monument Valley, on the Utah-Arizona border. This region is part of an extensive Navajo reservation.

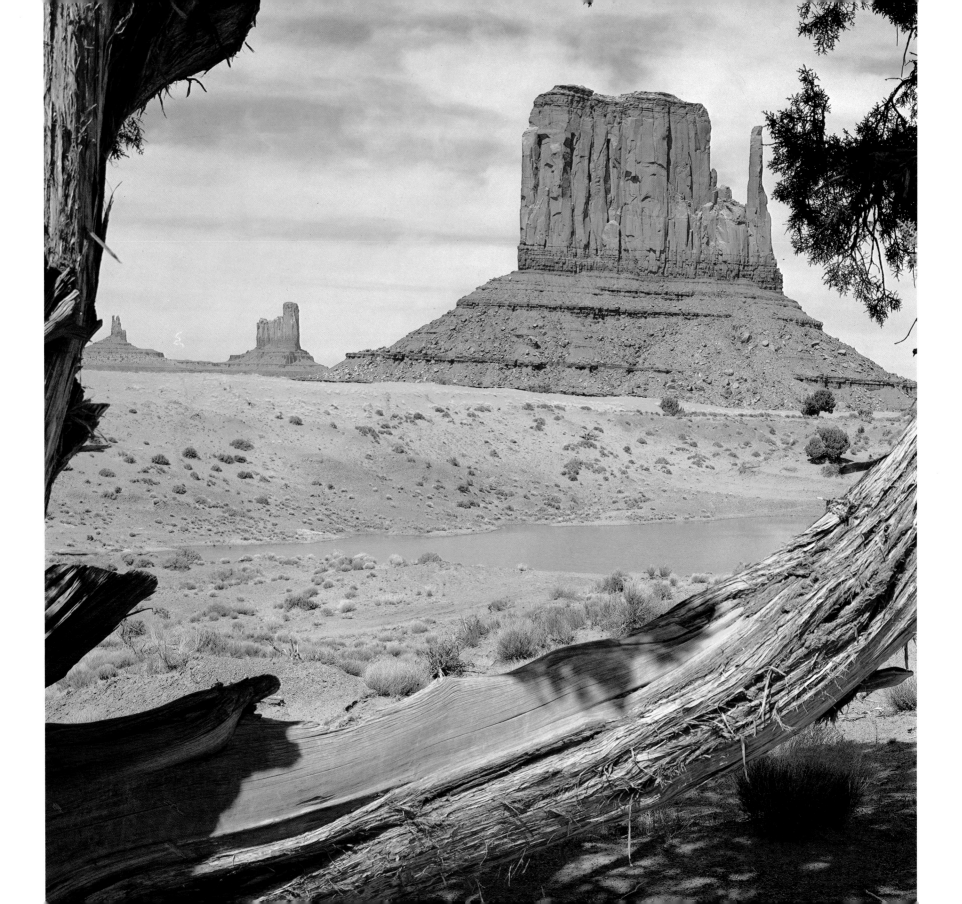

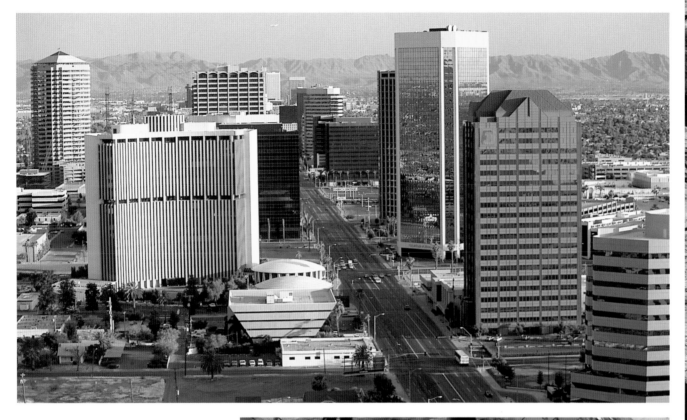

ABOVE: The high-rise buildings of metropolitan Phoenix.

RIGHT: Navajo rugs on display at an Arizona trading post.

FAR RIGHT: An adventurous kayaker braves Arizona's Havasu Canyon.

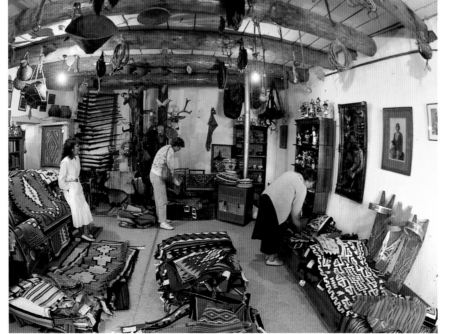

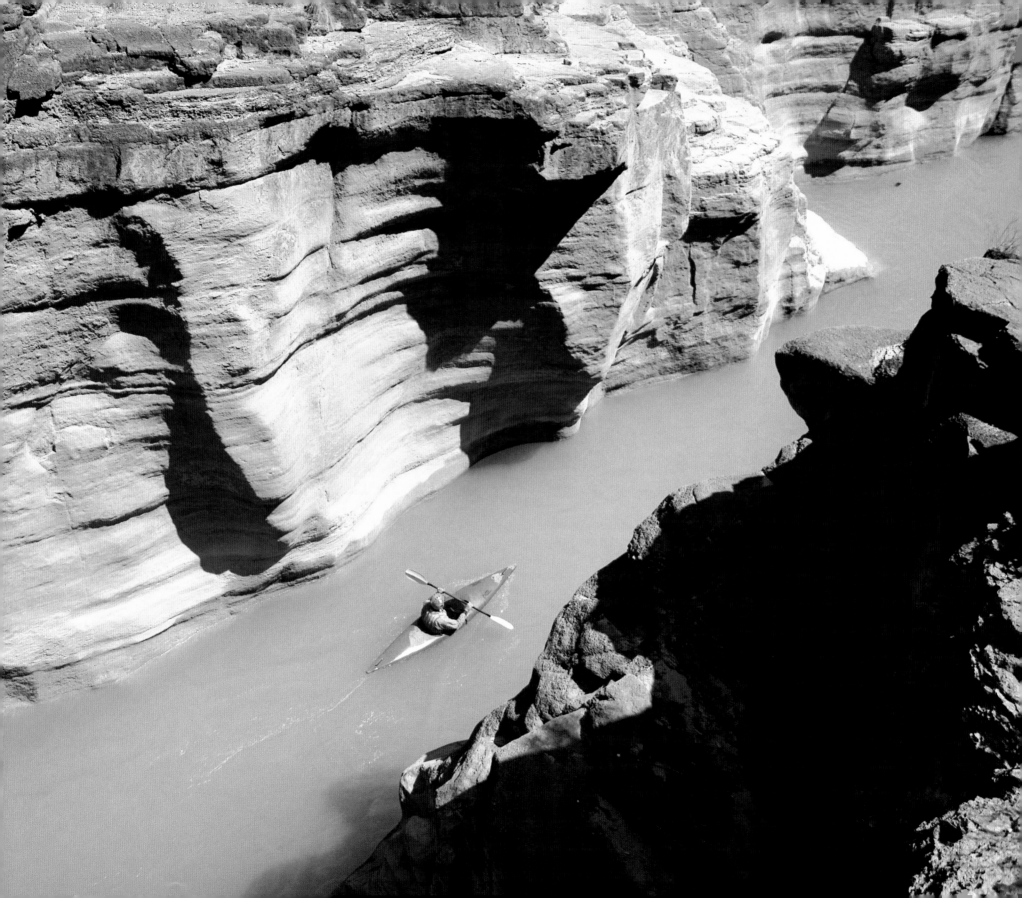

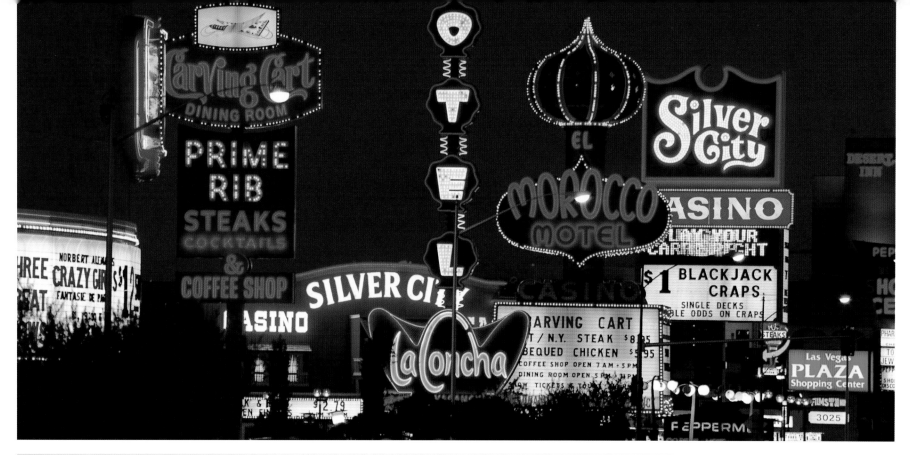

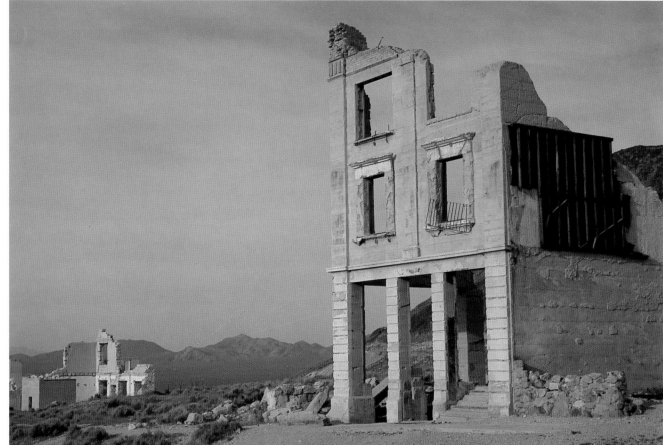

OPPOSITE: A panoramic view of Reno, Nevada, ringed by mountains.

ABOVE: Glittering Las Vegas, Nevada, with its luxury hotels and casinos springing from the desert.

LEFT: The Nevada ghost town of Rhyolite recalls the boom-and-bust days of frontier mining in this arid region.

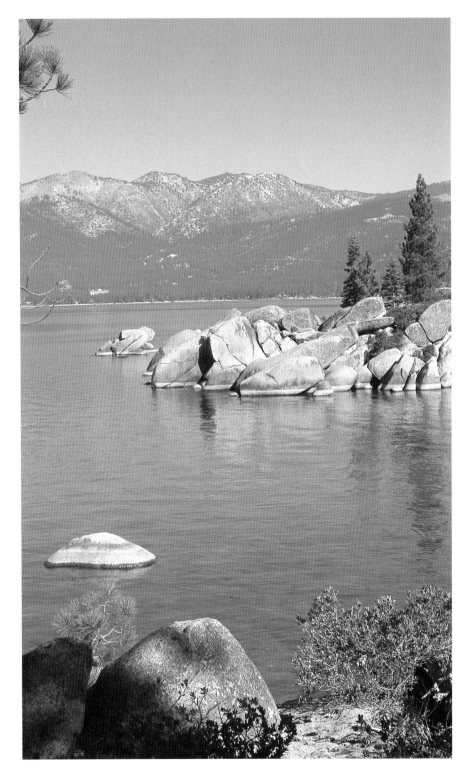

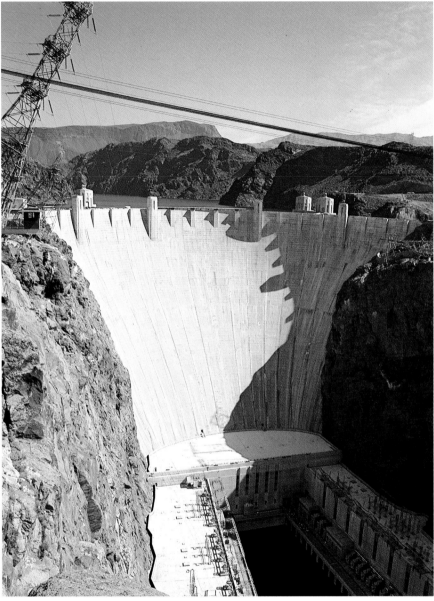

LEFT: Lake Tahoe, Nevada – one of the world's most spectacular freshwater lakes – is an expensive summer and winter resort in a unique natural setting.

ABOVE: Hoover Dam, near Las Vegas – the world's largest concrete dam – brings water to the desert.

OPPOSITE: Sagebrush and wildflowers mark the site of Berlin, a Nevada ghost town.

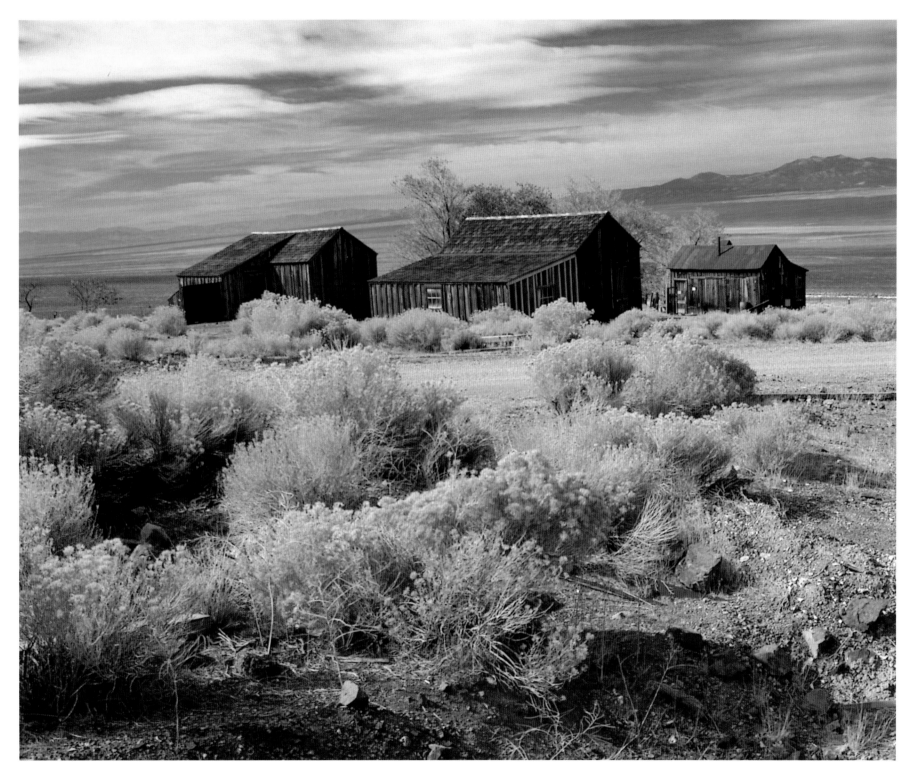

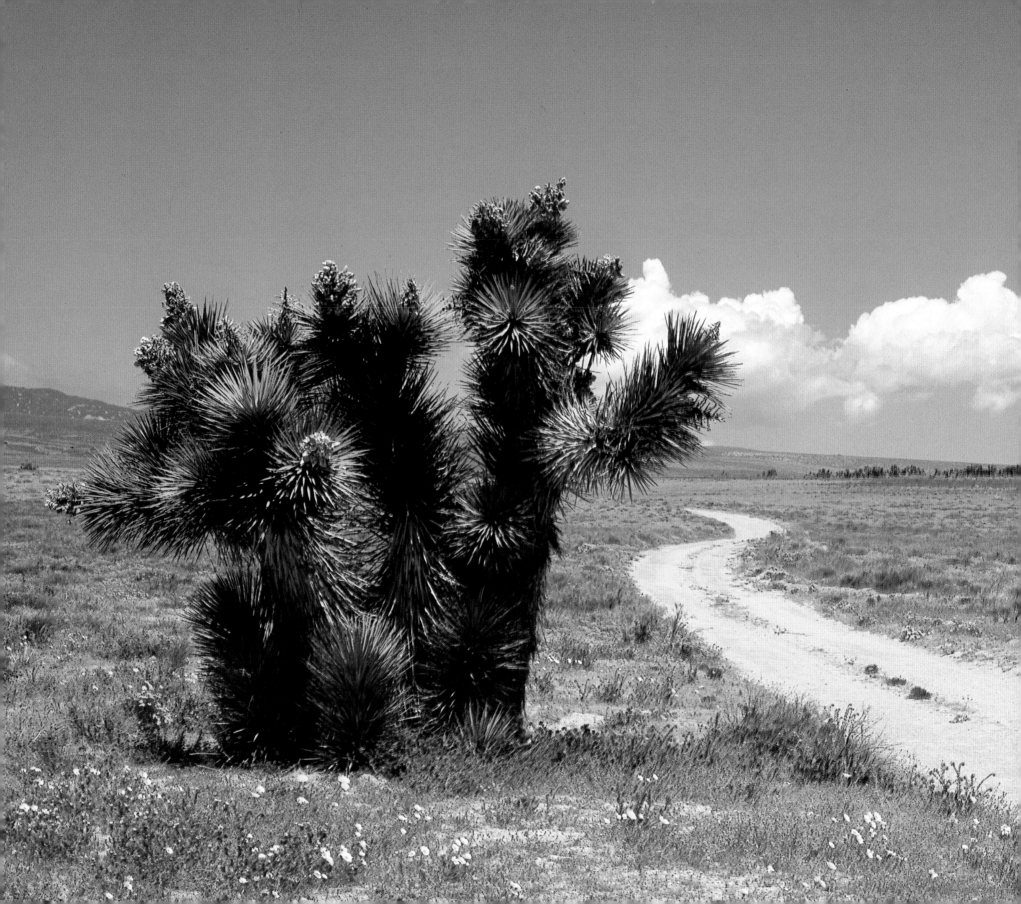

LEFT: The Tehachapi Mountains of Southern California, as seen near the town of Gorman.

RIGHT: Ancient sequoias crowned by fog in California's Sequoia National Park. These gigantic trees are found only on the Pacific Coast.

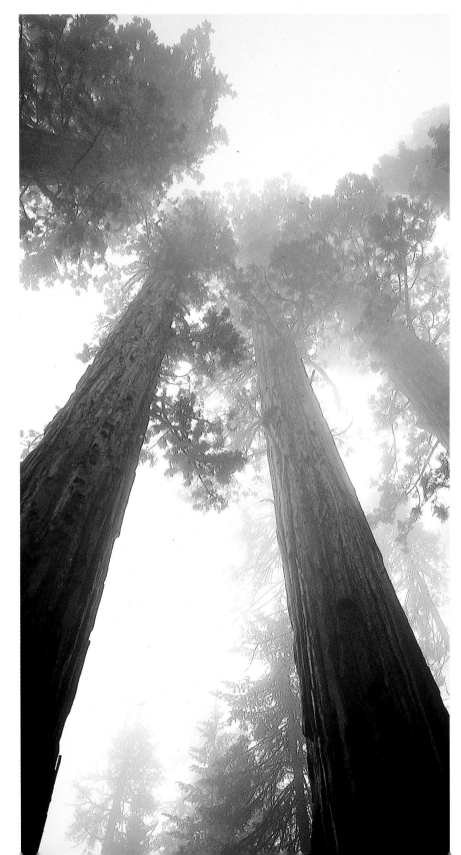

RIGHT: Sprawling Los Angeles, the nation's largest city. The official city alone covers almost 465 square miles, but when taking the Los Angeles lowlands area into account, the total urban area approaches five times that figure.

BELOW: Outdoor concerts are held at the Hollywood Bowl.

BELOW RIGHT: The mission church of San Diego de Alcalá, the first of the 21 missions established by the Spanish in what is now the state of California.

OPPOSITE: The huge sign that has dominated the Hollywood Hills since the 1920s, announcing the film capital of the world.

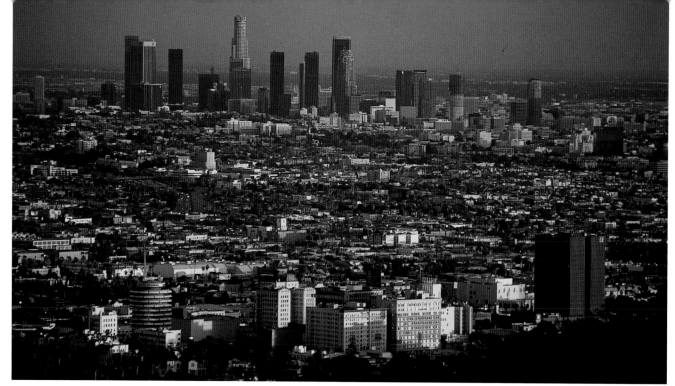

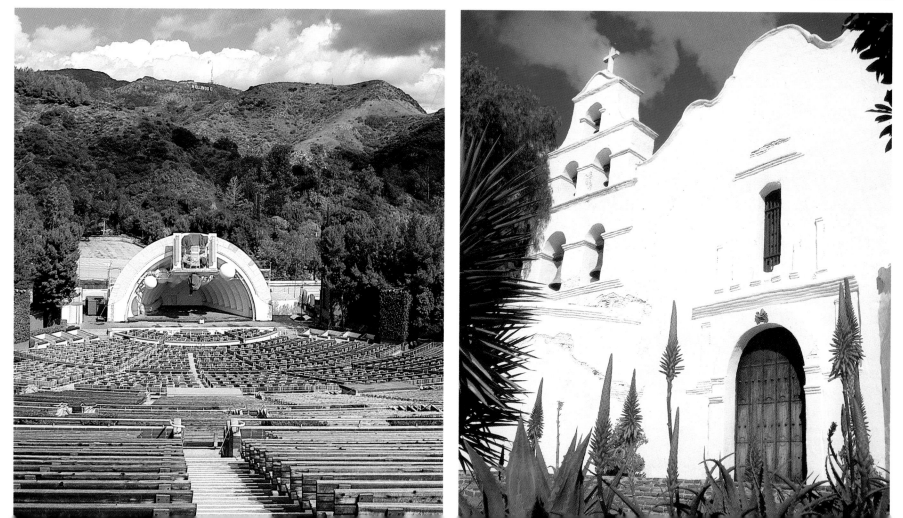

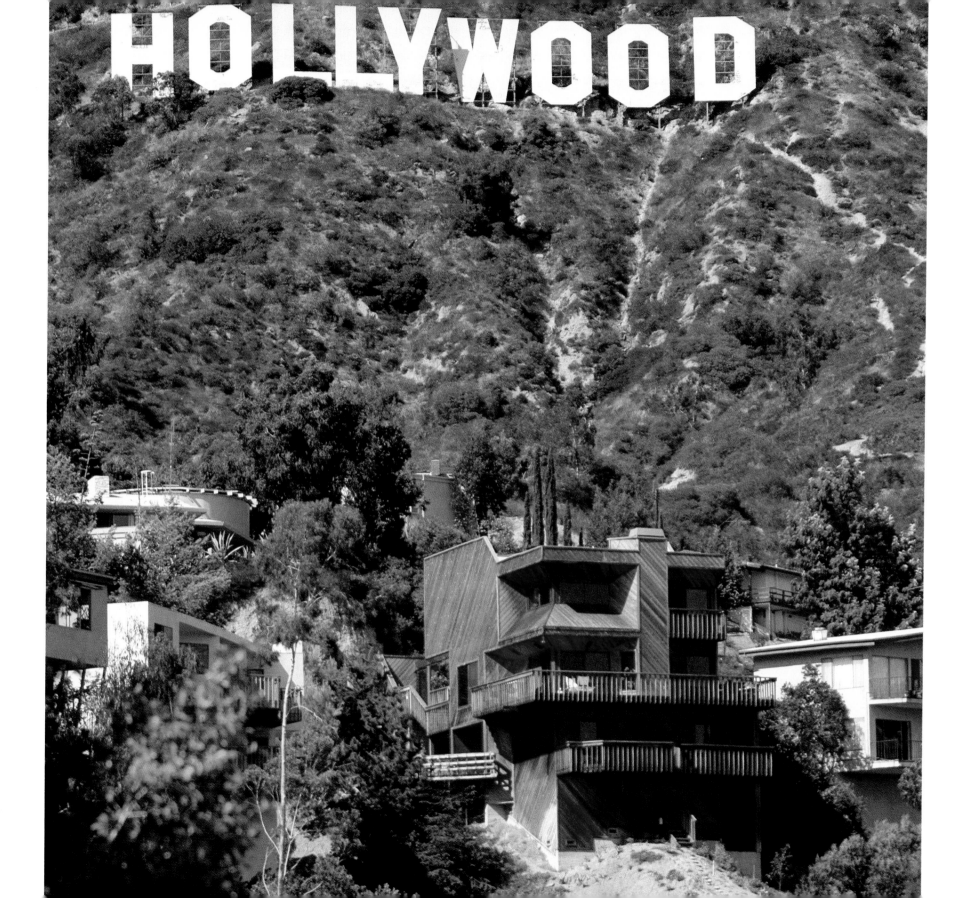

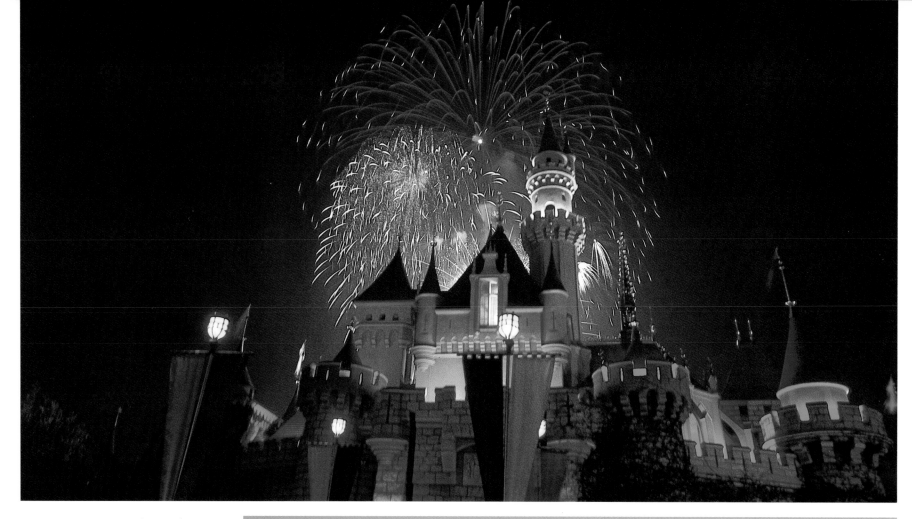

ABOVE AND RIGHT: Fireworks over the fantasy kingdom of Disneyland, connected to the Disneyland Hotel by monorail: Anaheim, California.

OPPOSITE: The mosaic-tiled pool at Hearst Castle, built as part of the fabulous complex of San Simeon by newspaper publisher William Randolph Hearst. San Simeon was so extensive that some of the people who worked there in Hearst's day had never left the property where they were born and raised.

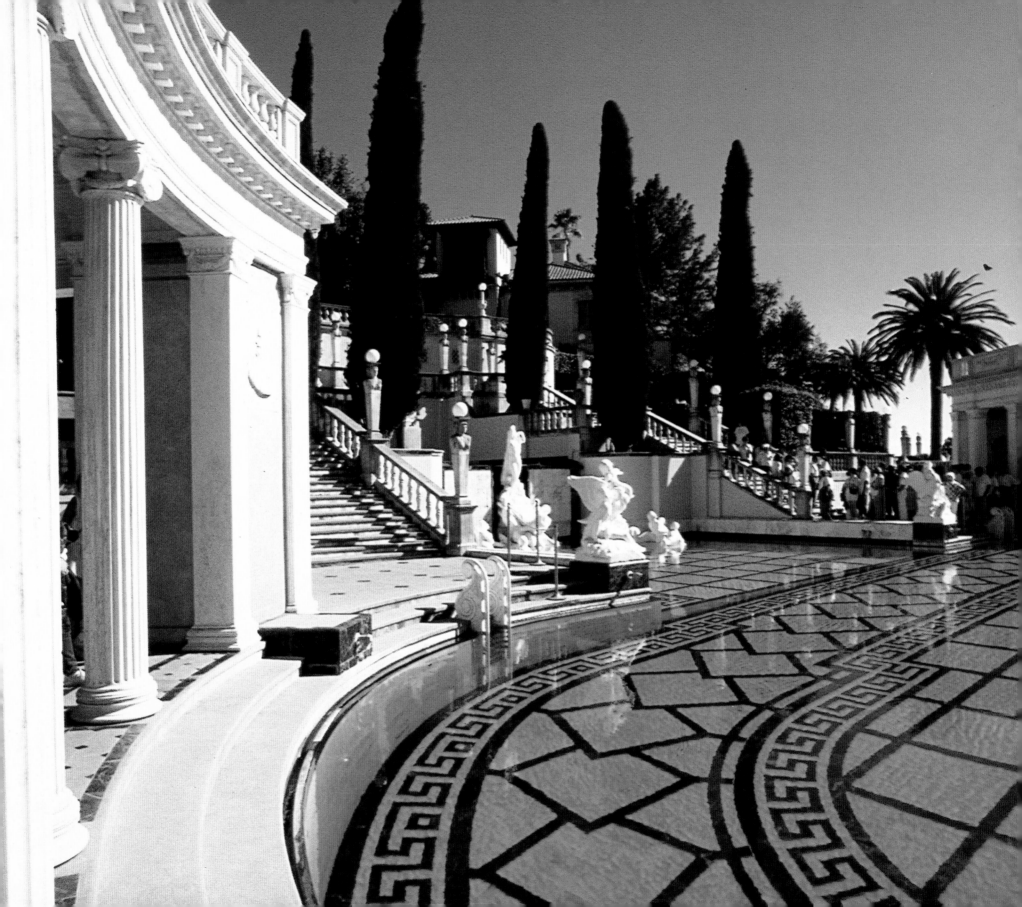

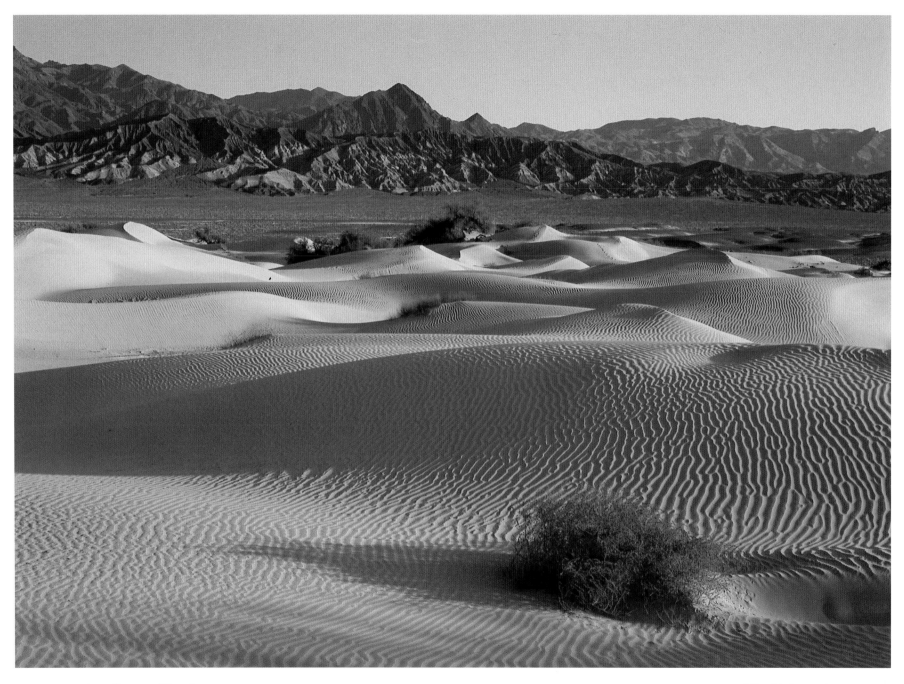

ABOVE: Death Valley, California, the hottest place in the nation and a formidable obstacle to early settlers from the East.

OPPOSITE: The highway between Carmel and Monterey, California, passes Pebble Beach and some of the state's most spectacular scenery.

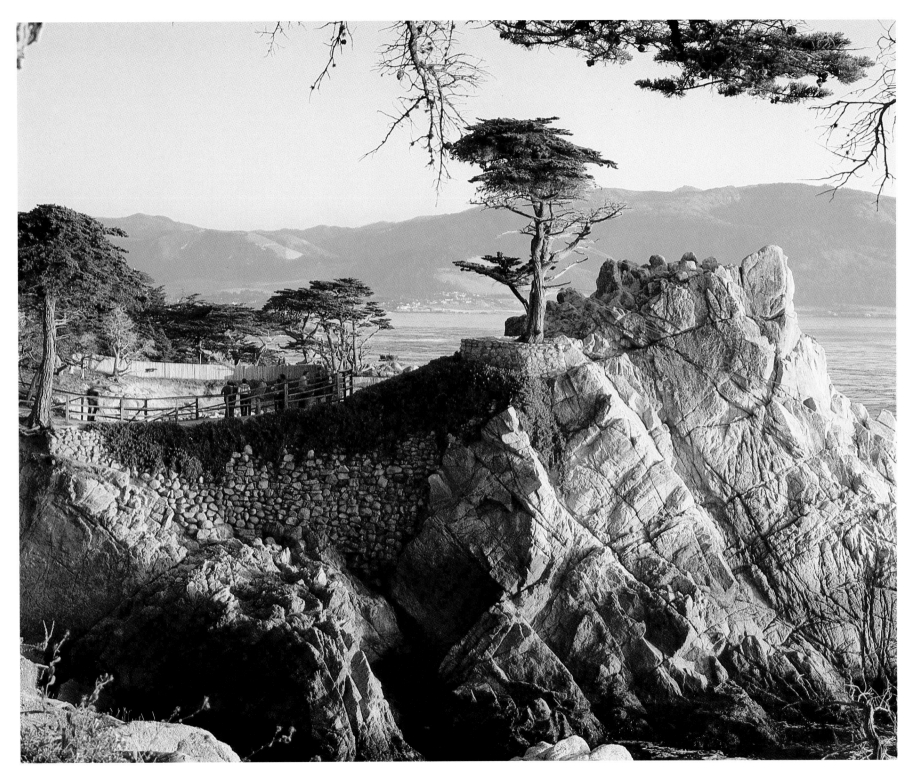

THE NORTHWEST AND NORTHERN CALIFORNIA

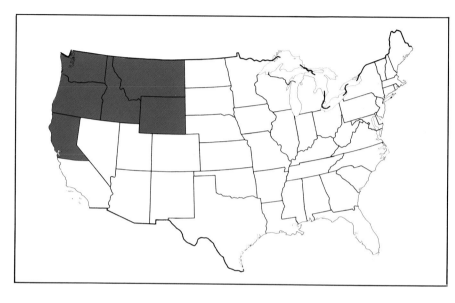

OPPOSITE: The Grinnell Glacier Trail in Glacier National Park, Montana, a wilderness of incredible beauty.

This diverse region shares a coast on the Pacific, the world's largest ocean, which contributes to the temperate climate here. Warm winds and currents provide ample rainfall to the farmlands, forests, and cities west of the Cascade Range. East of the mountains, the climate is drier, giving rise to the extensive cattle ranges of eastern Oregon and Washington, Montana, Wyoming, and Idaho. Much of this land is still wilderness – forests, mountains, and such deep blue lakes as Oregon's incomparable Crater Lake, in the cone of an ancient volcano.

On the Oregon coast, the West's greatest river, the Columbia, empties into the Pacific. Fantastically eroded sea stacks rise from the coastal waters, and bluff headlands dominate the shoreline. Surf and silence reign on the beautiful beaches of Northern California as night closes in and tidal pools fill up with brightly colored crabs, starfish, and mollusks. Pacific waters form the Puget Sound in Washington – a great inland sea with a long shoreline dotted with innumerable inlets and estuaries. Boats are a major form of transportation here, and great container ships from the Far East dock in these waters.

The great redwood forests of Northern California give place to major cities, including San Francisco and Oakland, where the high price of real estate includes unsurpassed views and cultural amenities from opera to art museums. National parks of the Northwest include Washington's Olympic Peninsula, Montana's Glacier National Park, the vast Yellowstone, which covers parts of three states, Oregon's Crater Lake, and the Grand Teton National Park in Wyoming.

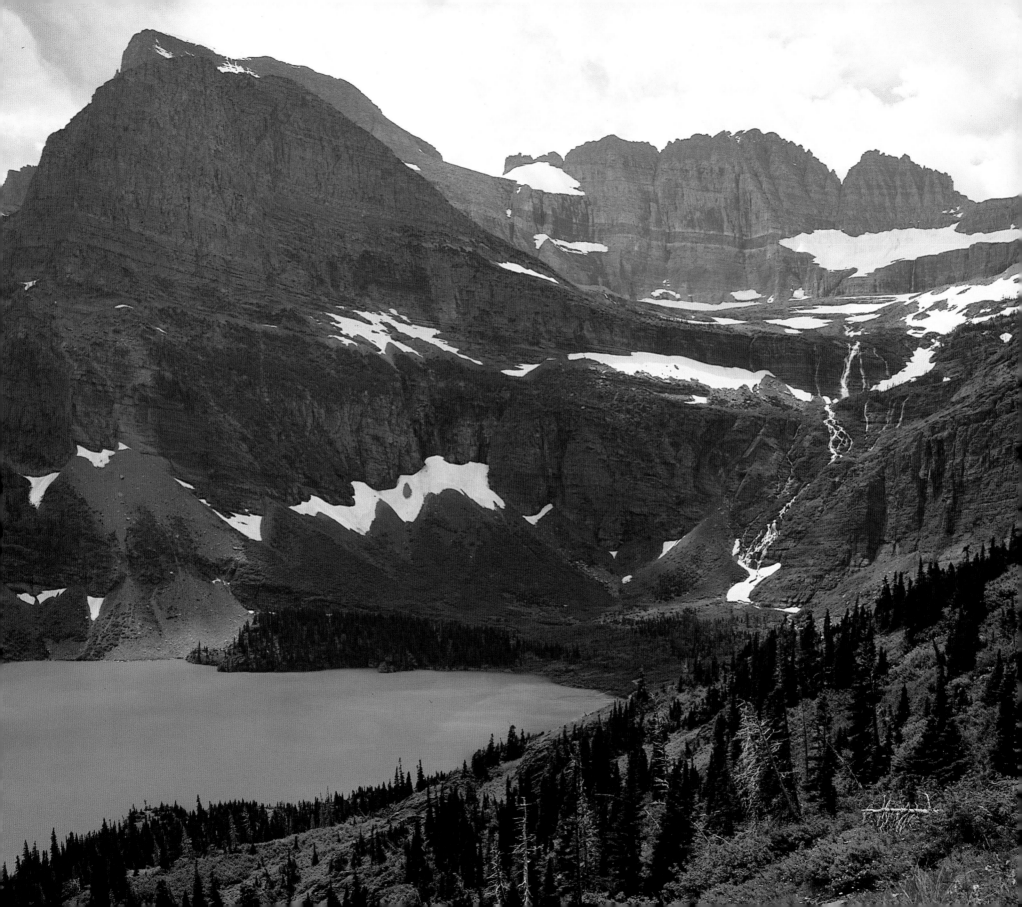

BELOW: A farm near Ronan, Montana, enjoys an idyllic setting.

RIGHT: Wintering cattle are fed by horse-drawn sleigh near Avon, Montana.

OPPOSITE: A primitive log cabin in Montana's snow-clad Rocky Mountains.

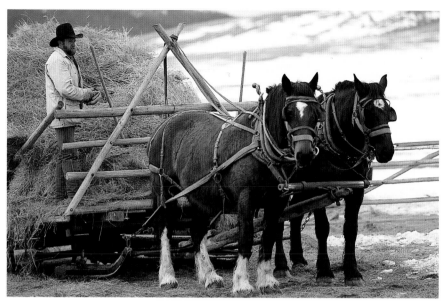

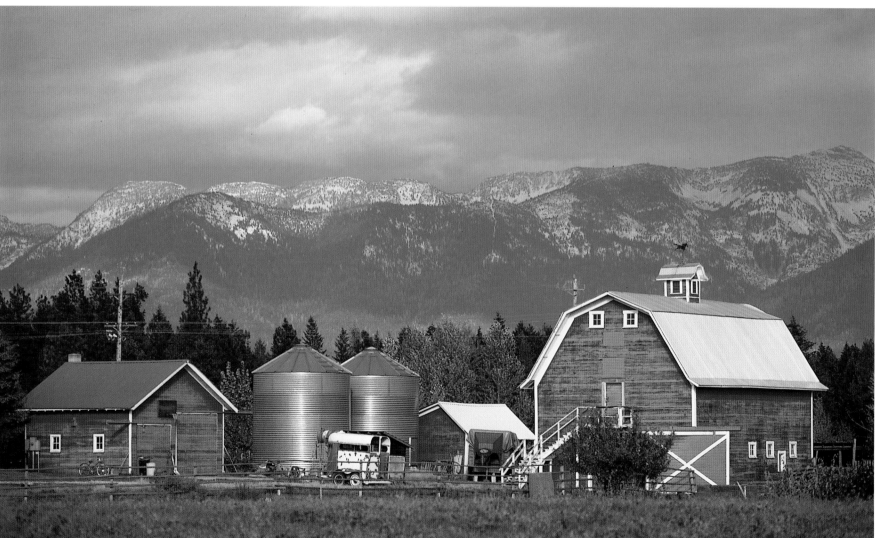

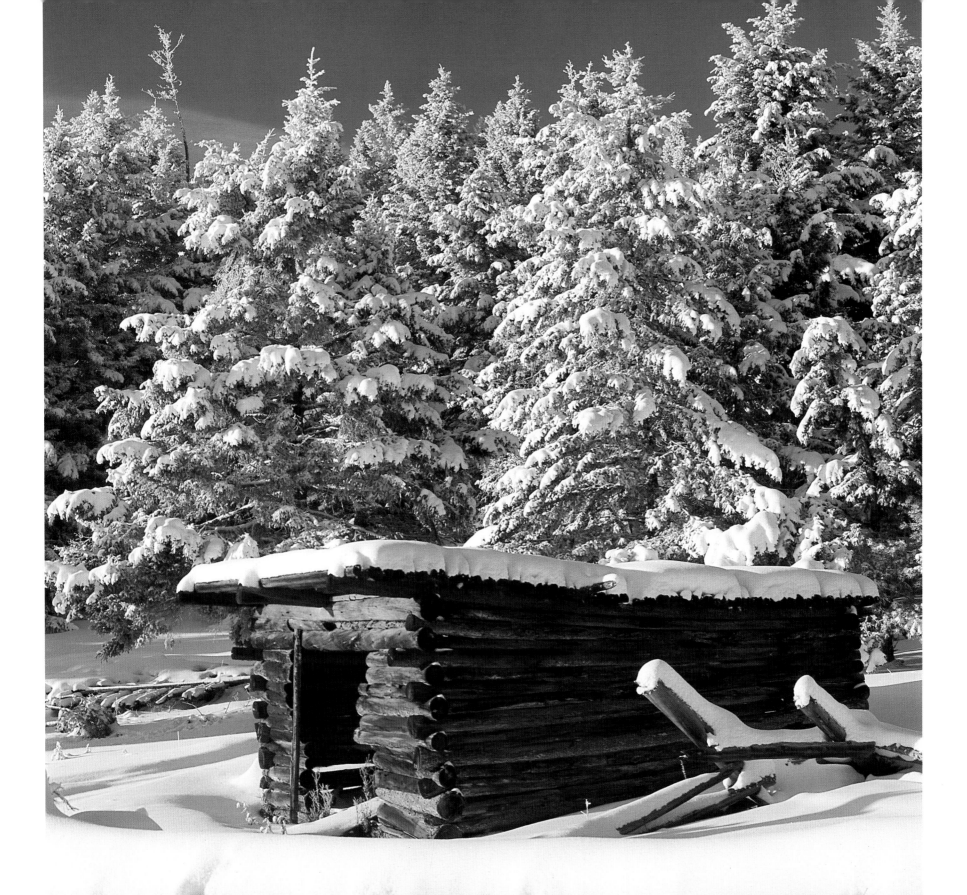

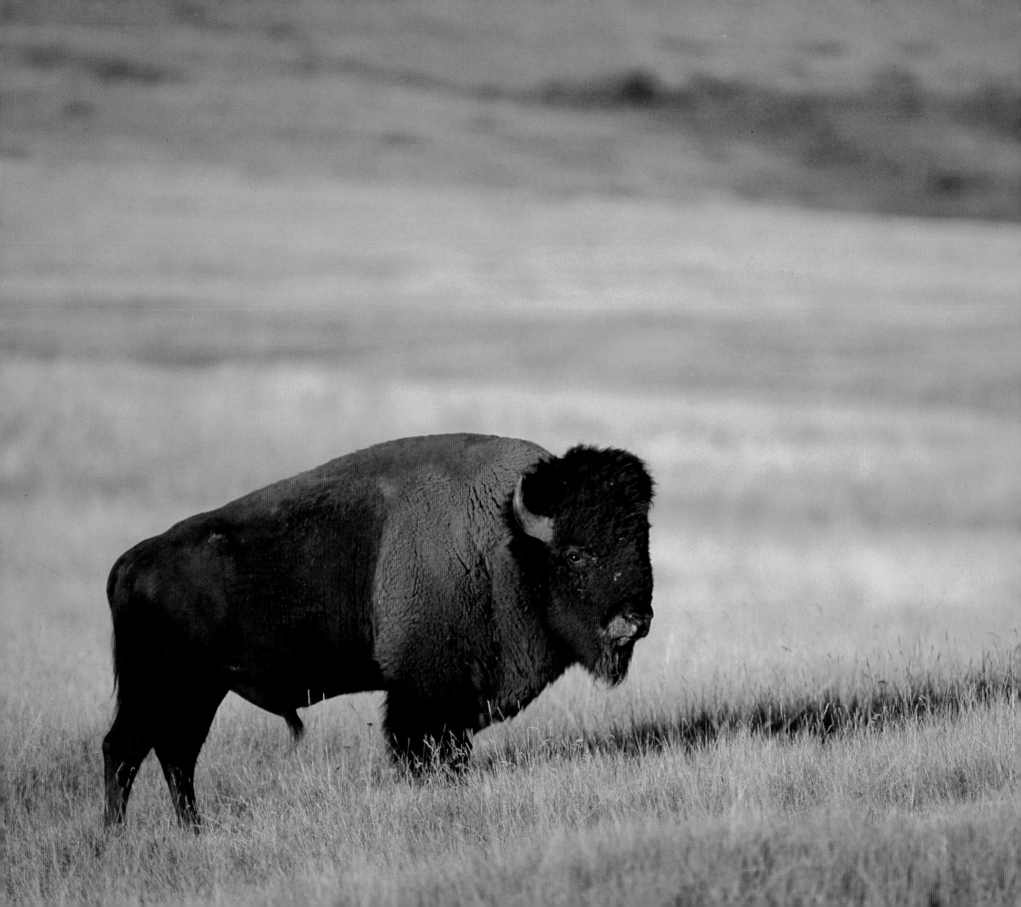

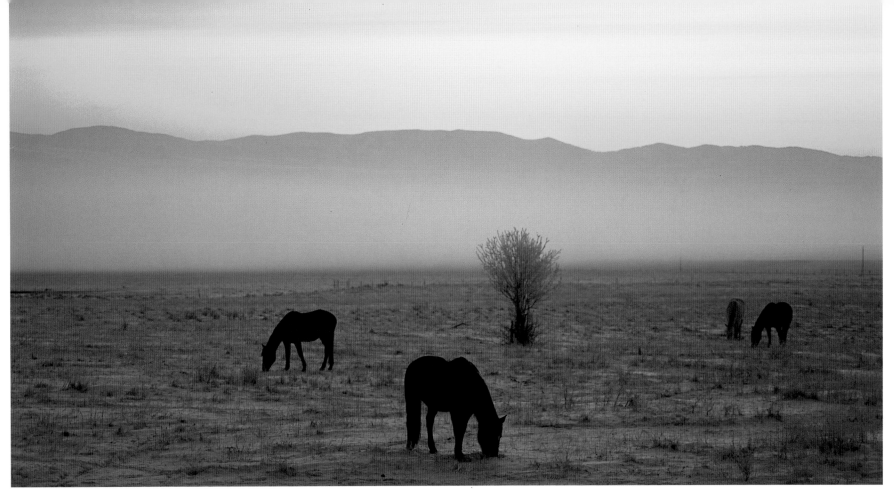

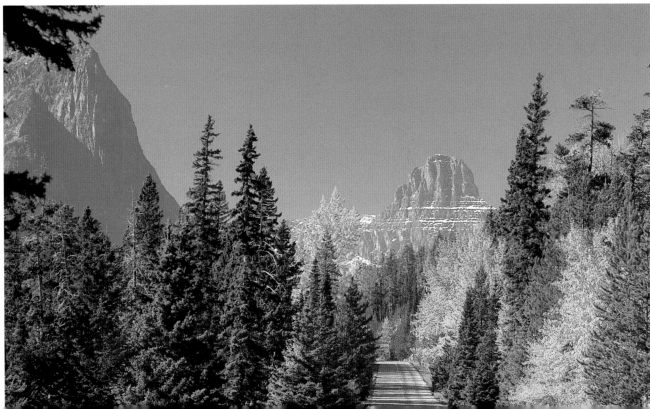

OPPOSITE: The buffalo resumes its rightful place on the Montana plains at the National Bison Refuge.

ABOVE: Grazing horses near the "Twin Silos" of remote Townsend, Montana.

LEFT: A breathtaking view of Glacier National Park, a haven for western wildlife.

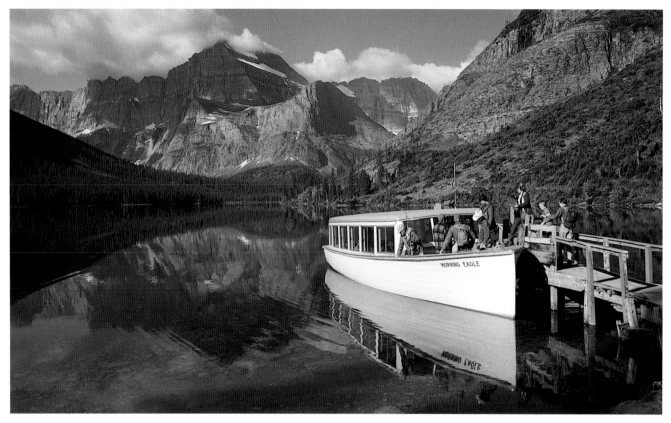

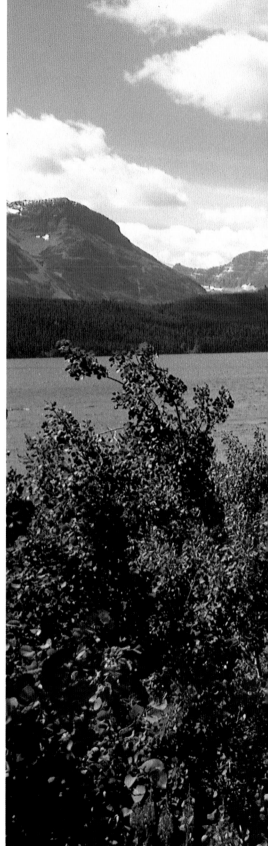

ABOVE: A guided tour of one of the many serene lakes in Glacier National Park.

RIGHT: McDonald Lake, rimmed by the Montana Rockies.

FAR RIGHT: Glacier National Park extends north to the Canadian Rockies.

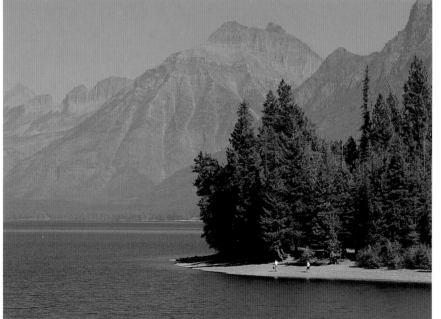

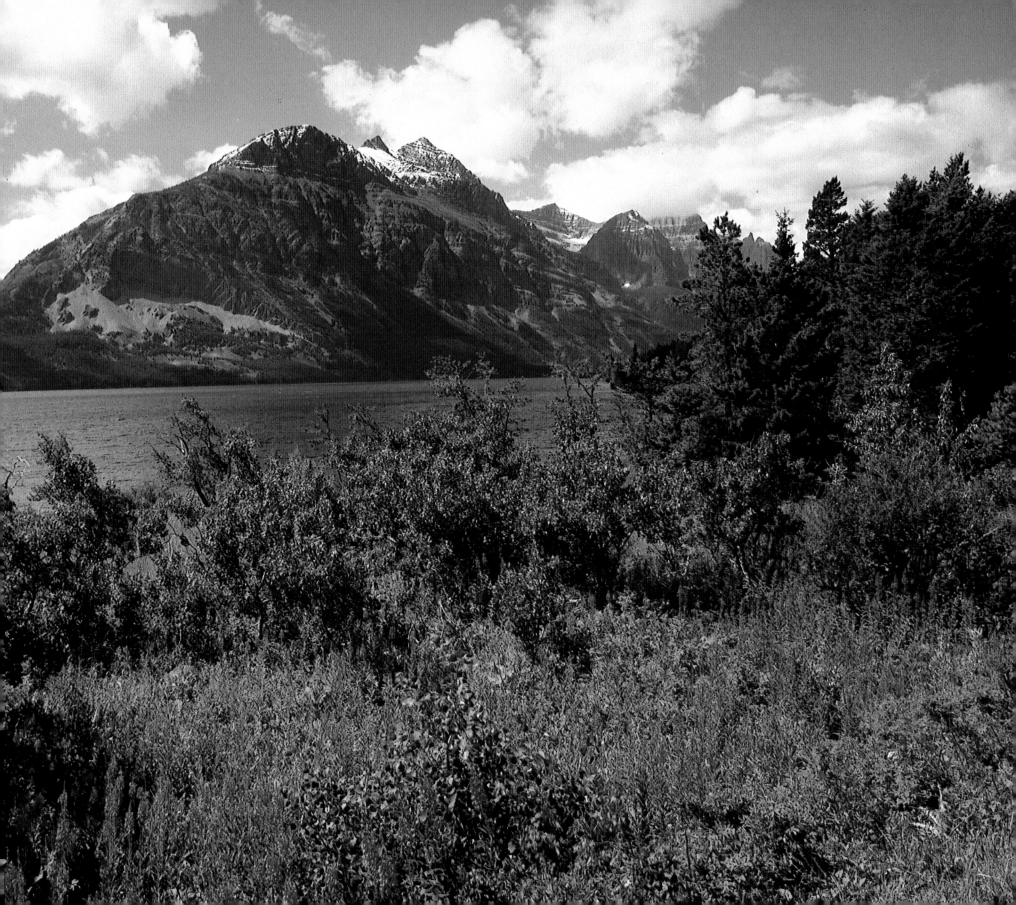

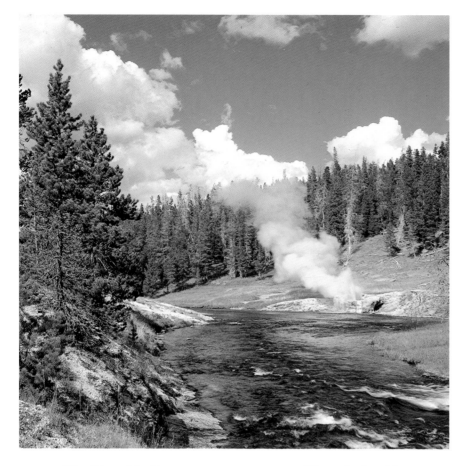

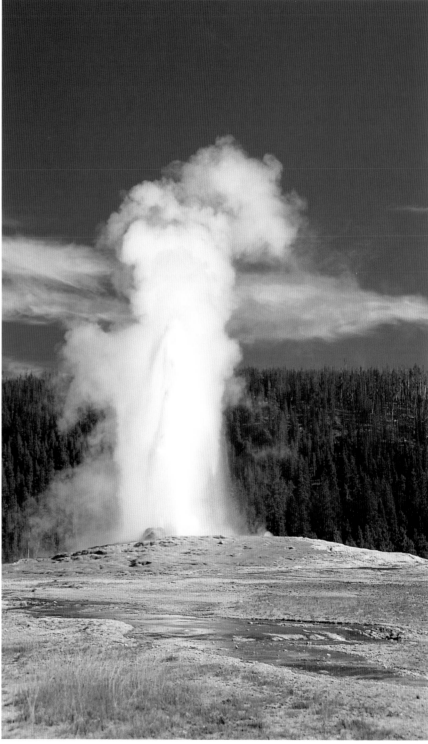

ABOVE: The Riverside Geyser erupts in the Wyoming section of Yellowstone National Park.

OPPOSITE: Wyoming's wide-open spaces include the spectacular Grand Teton range.

RIGHT: Old Faithful, the best-known geyser in Yellowstone National Park, Wyoming. Old Faithful erupts on an average of every 71 minutes, although this can vary from 33 to 148 minutes.

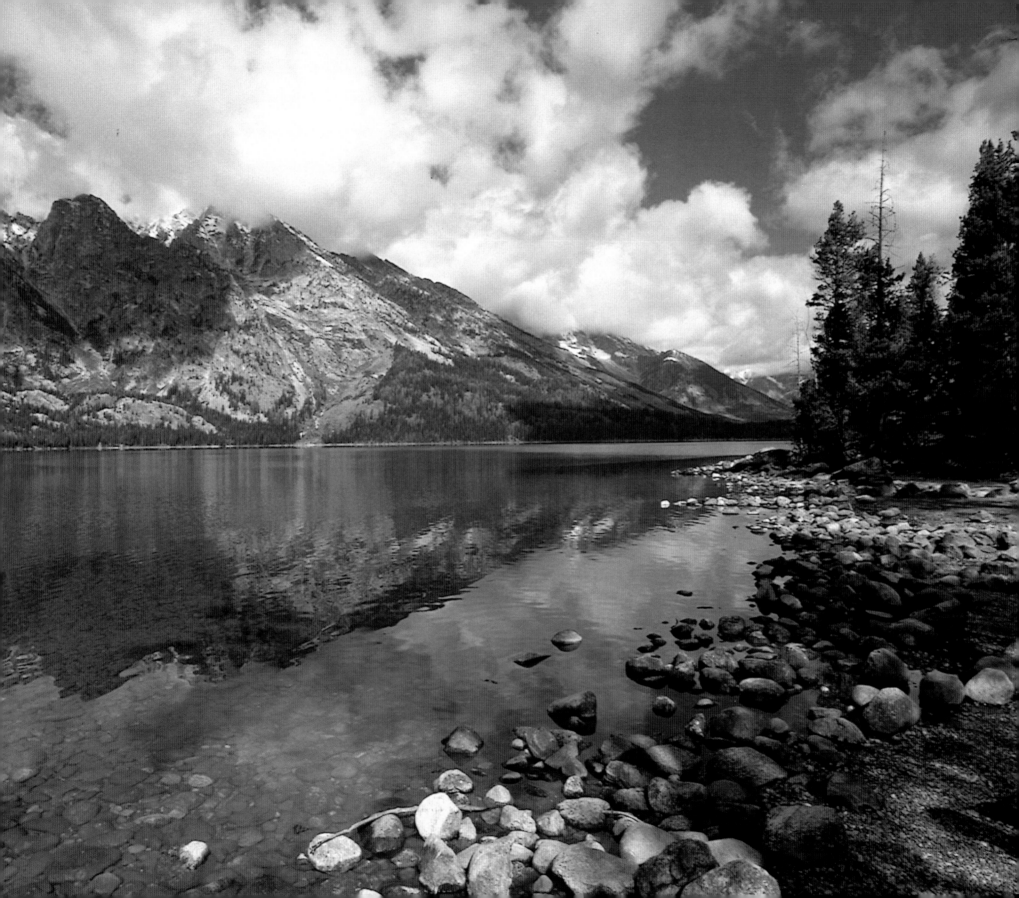

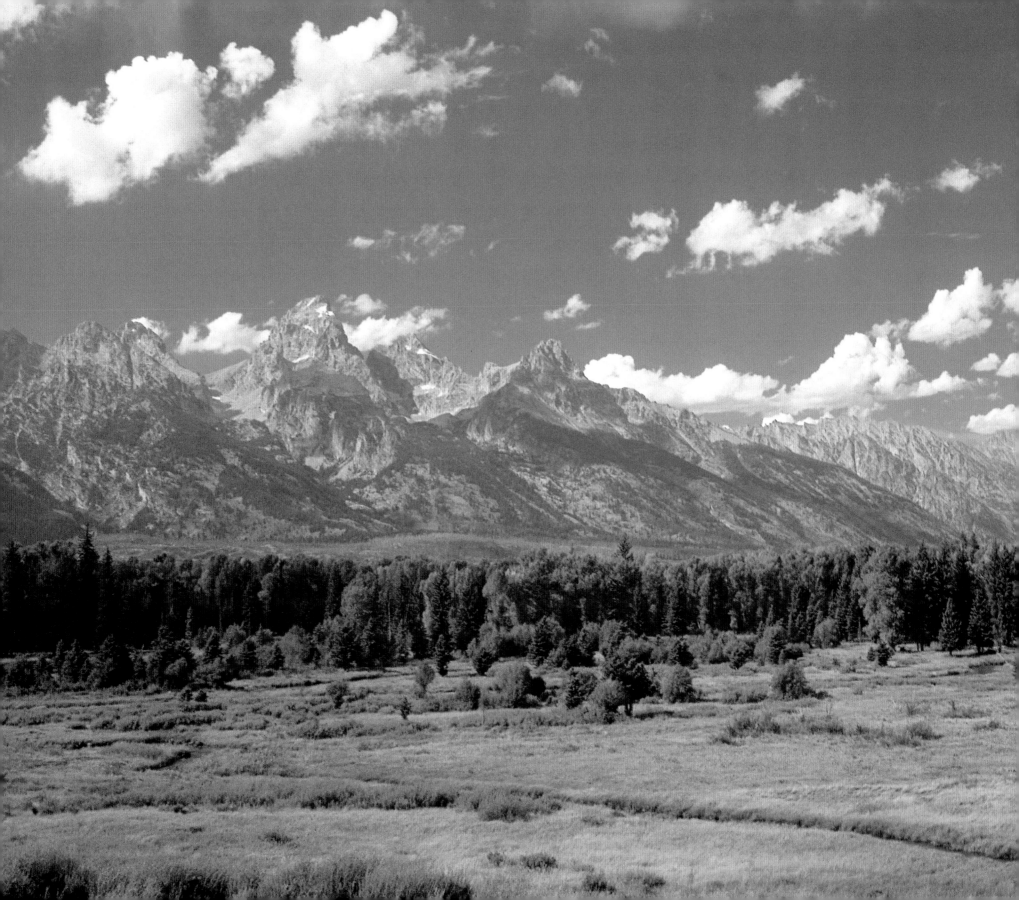

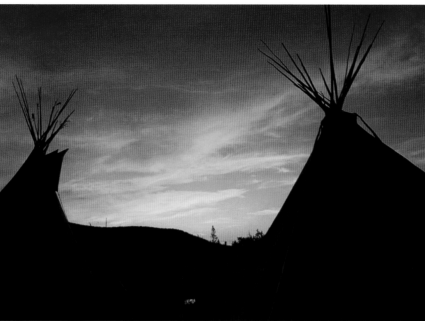

FAR LEFT: The Grand Tetons rise steeply from the surrounding plains, without the foothills that characterize the Rockies.

LEFT: Tepees are silhouetted against a brilliantly colored sky at sunset on Wyoming's Wind River Reservation.

BELOW: Jackson Lake, Wyoming, in the shadow of stone mountains.

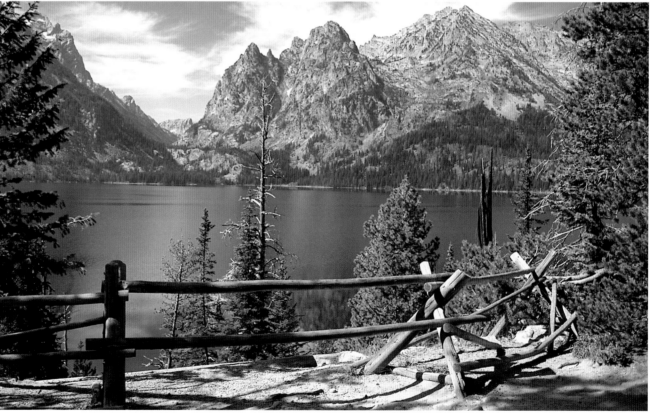

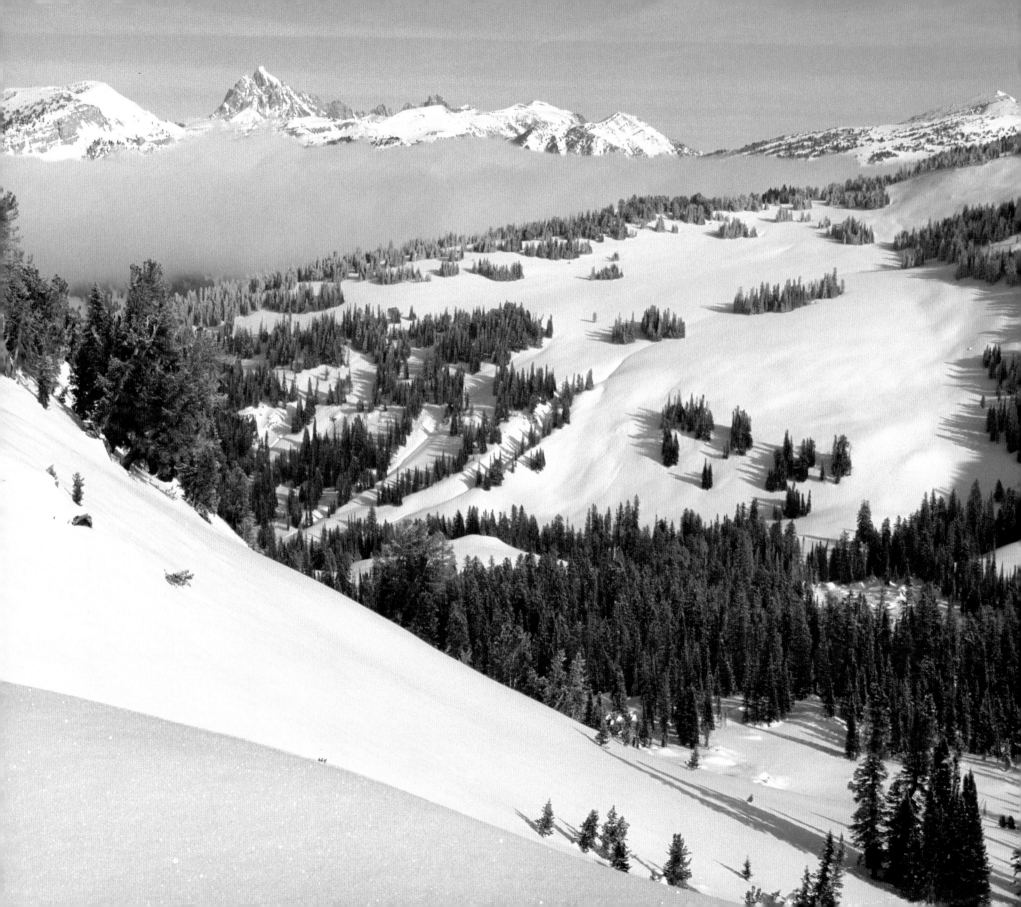

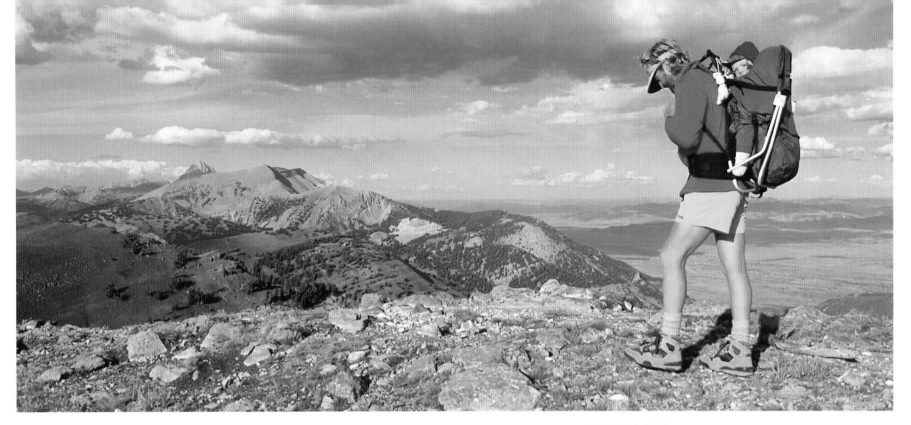

OPPOSITE: Looking north from Taylor Basin to the Grand Tetons of Wyoming.

ABOVE: A sturdy hiker backpacking his son reaches Glory Peak, at Jackson Hole, Wyoming.

LEFT: Rafting the Snake River from Moose, Wyoming. The Snake extends far into Idaho.

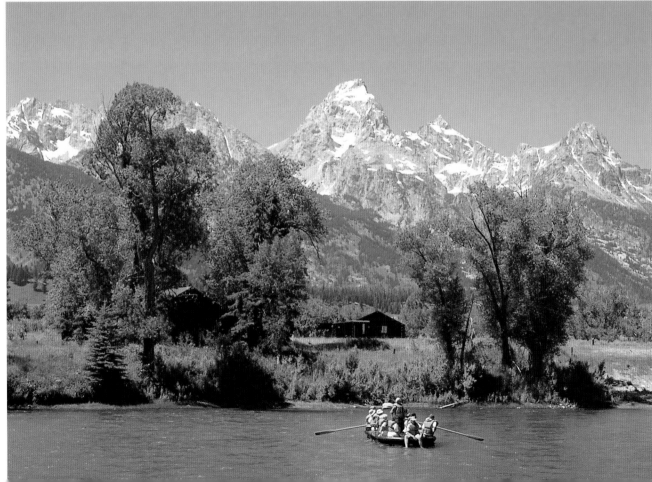

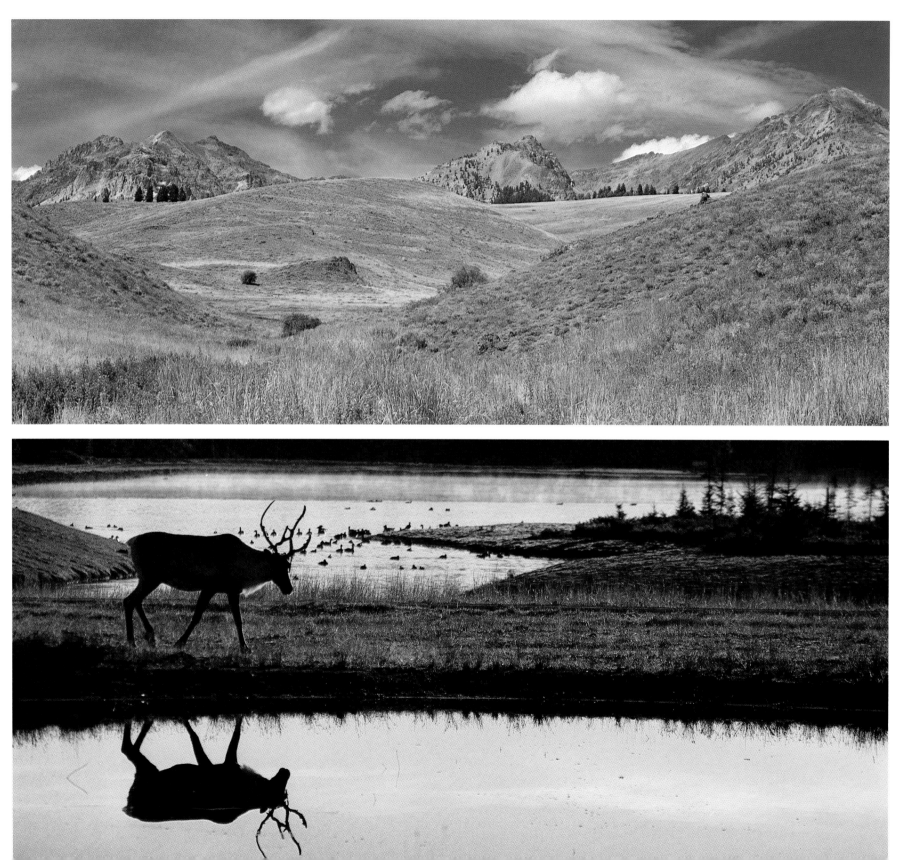

OPPOSITE TOP: The jagged peaks of Idaho's Sawtooth Mountains.

OPPOSITE BOTTOM: Woodland caribou are common in northern Idaho.

ABOVE: Winter in the foothills near Boise, Idaho.

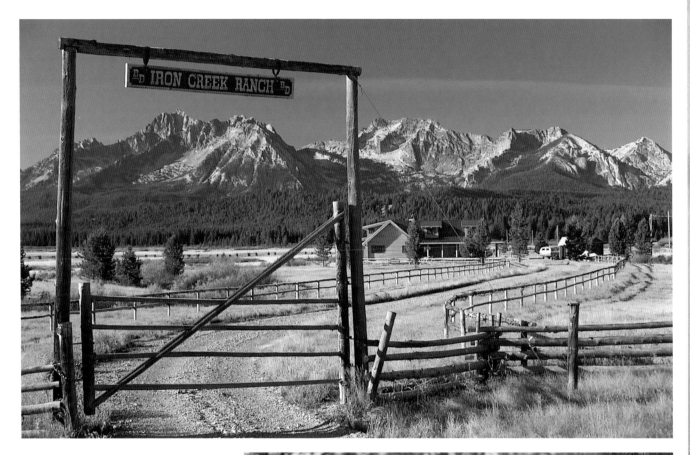

ABOVE: A cattle ranch near Stanley, Idaho.

RIGHT: A Twin Falls farmer feeds his dairy cattle. Livestock are vital to Idaho's economy.

FAR RIGHT: Magic Valley, in south-central Idaho's Snake River Plain.

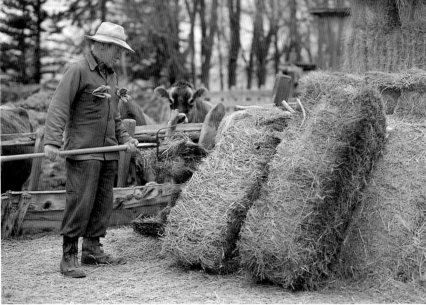

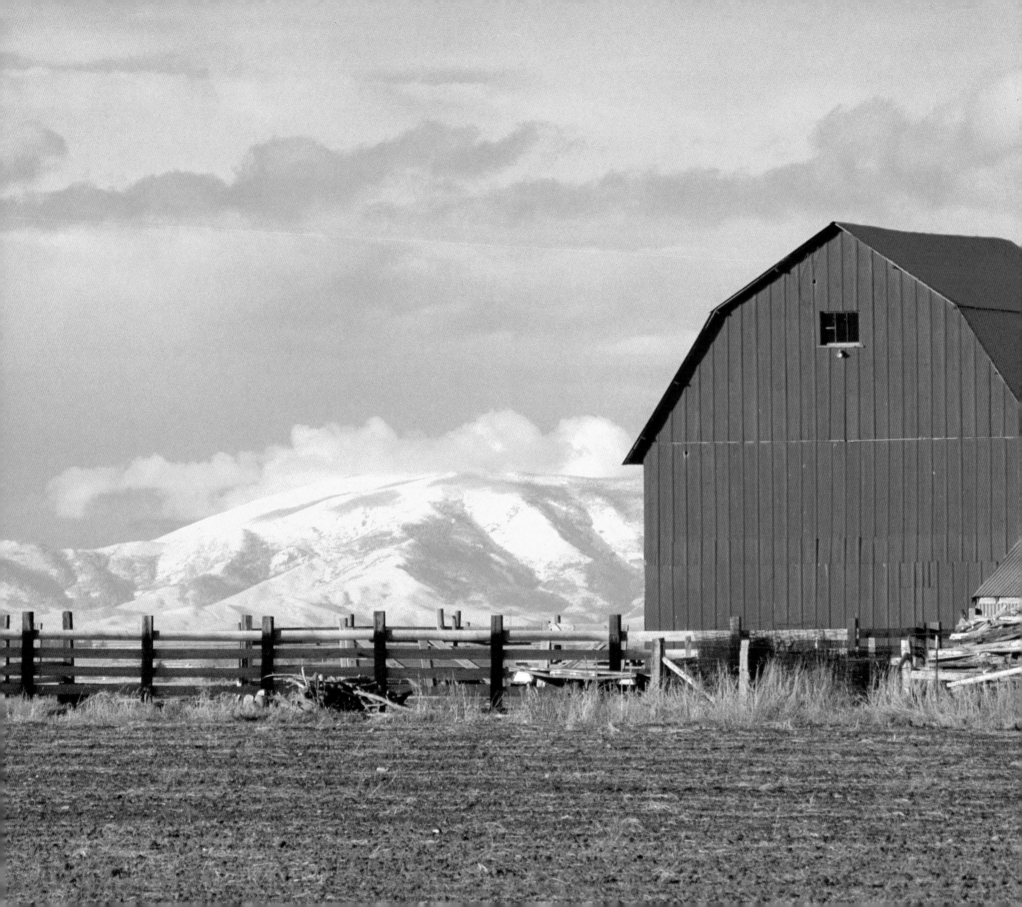

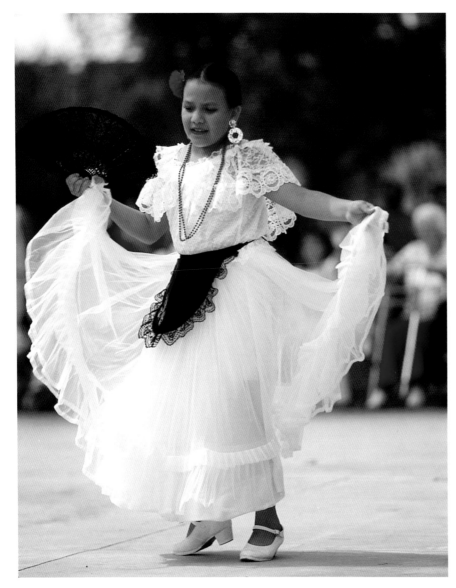

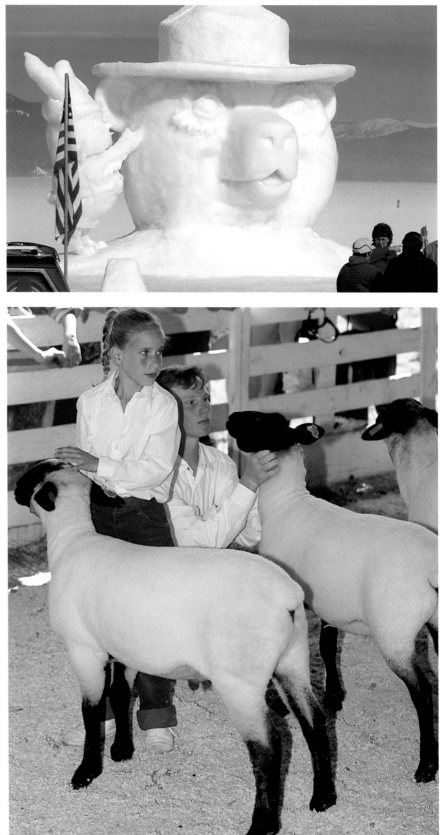

ABOVE: An Hispanic girl in traditional dress at a cultural festival in Twin Falls, Idaho.

TOP RIGHT: An ice sculpture of vigilant Smokey the Bear at McCall, Idaho's, annual Winter Festival.

RIGHT: Members of the 4-H Club show their sheep at the Twin Falls County Fair.

OPPOSITE: Summer is a gentle season in the mountains of central Idaho. Here are two participants at the Mountain Man Rendezvous.

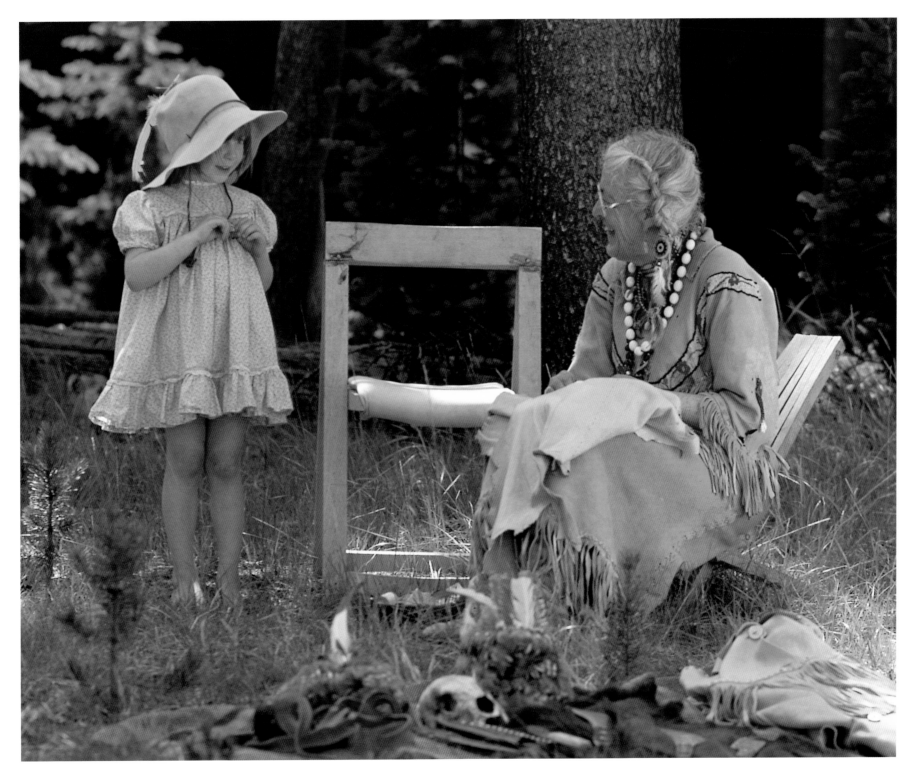

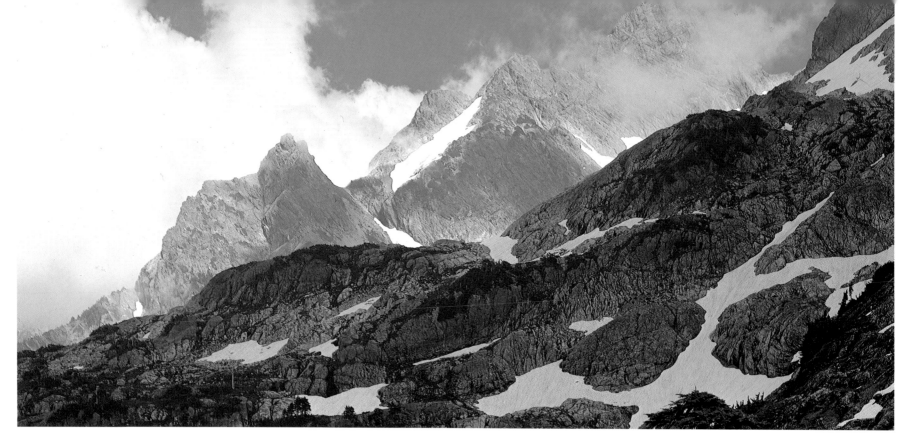

ABOVE: North Cascades National Park in Washington. The Cascade Range, of volcanic origin, extends through the Northwest to Northern California.

RIGHT: North Cascades National Park: Giant ferns in the foreground. The park is home to vanishing species such as the cougar and the grizzly bear.

OPPOSITE: Olympic National Park, on Washington's Olympic Peninsula, is washed by Pacific waters and moisture-laden winds. Lush rain forests grow in the interior.

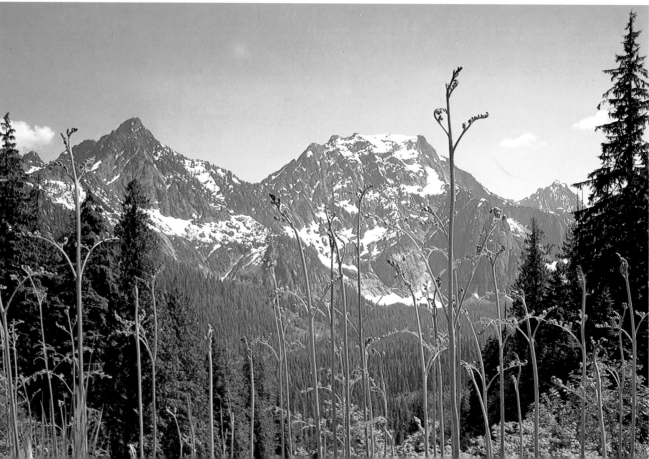

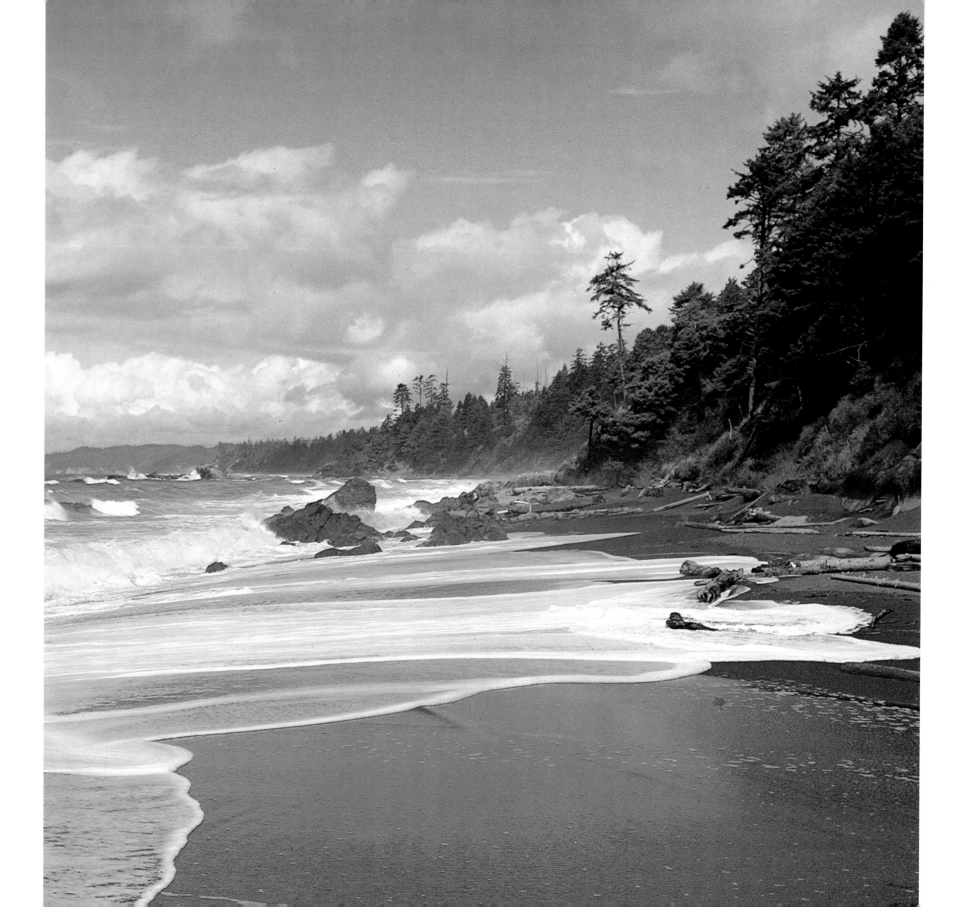

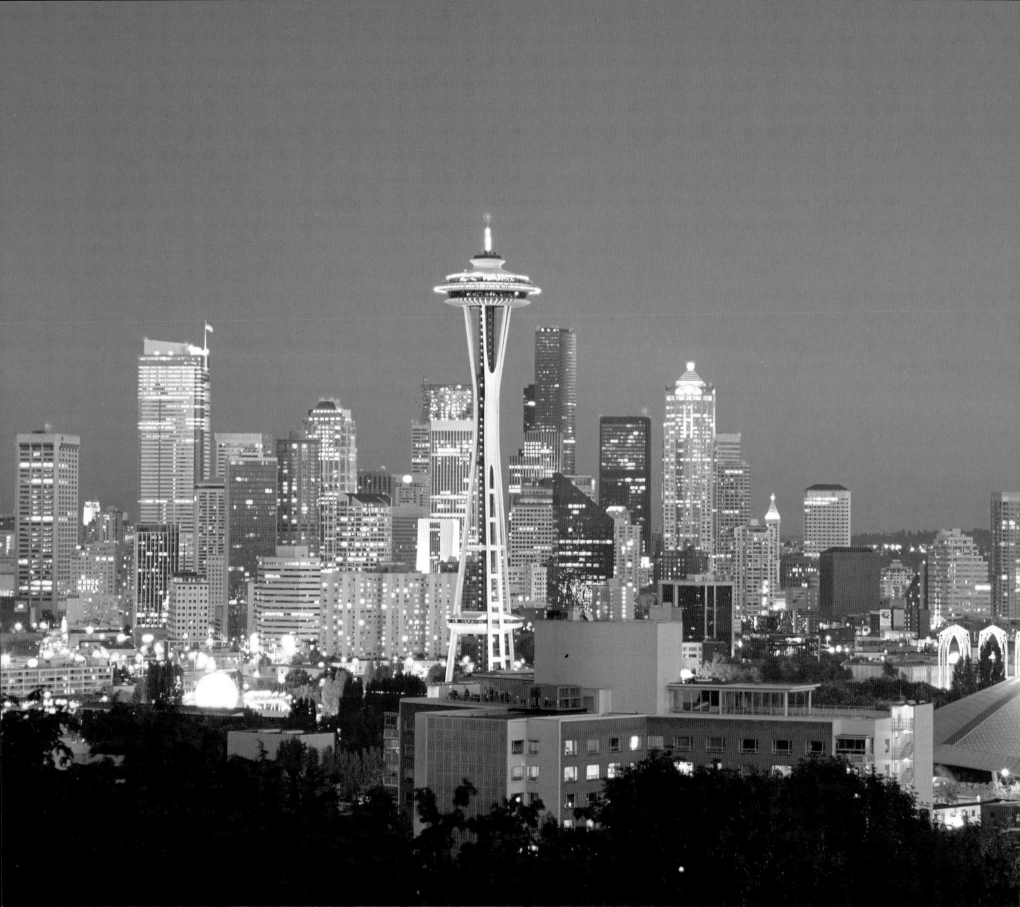

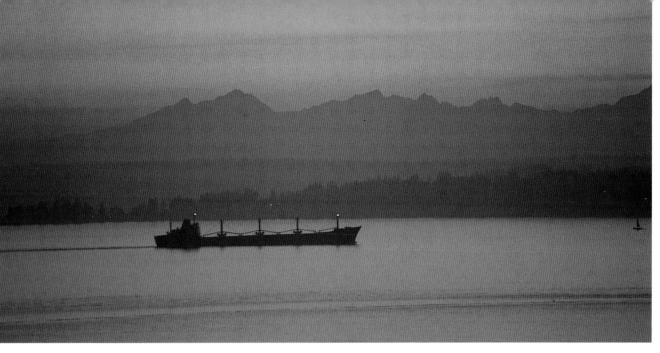

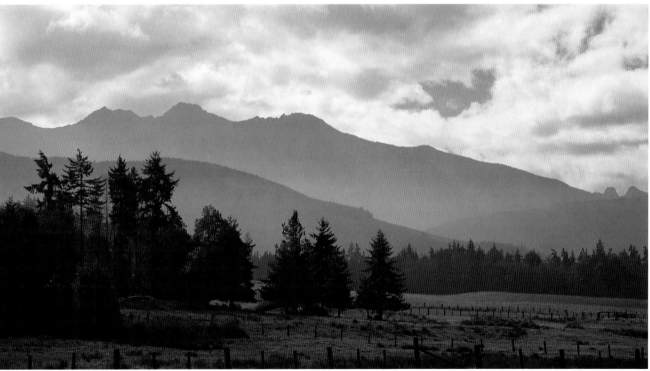

LEFT: Seattle, Washington, on the Puget Sound, is a manufacturing and commercial port of major importance. Ferryboats connect it to Canada and the San Juan Islands.

TOP: A Seattle sunset over the Puget Sound and the Olympic Mountains

ABOVE: The Olympic Mountains as seen from a point near Port Angeles, Washington.

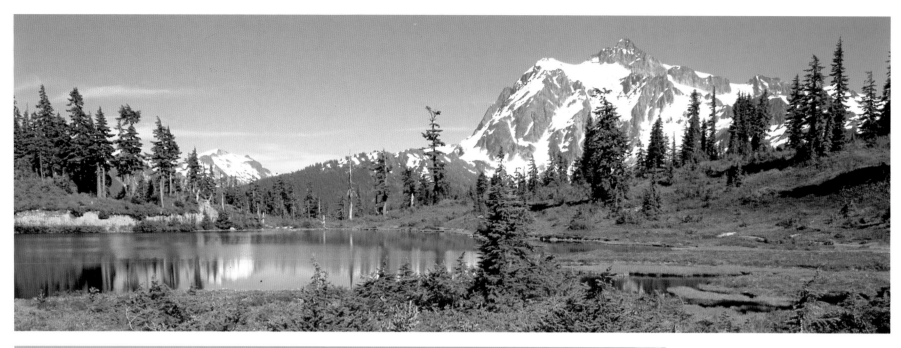

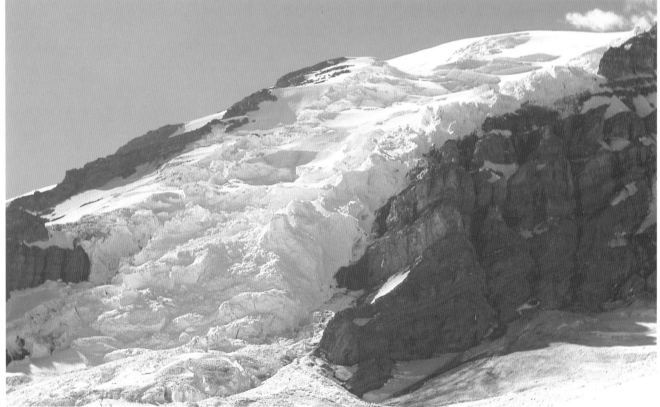

ABOVE: Mount Shuksan, Washington, part of the beautiful Cascade Range, as seen from a meadow in North Cascades National Park.

LEFT: Slow-moving rivers of ice – glaciers – mantle a rocky height in Washington's Mount Rainier National Park.

OPPOSITE: The rugged crest of Mount Rainier, 14,410 feet high, rises head and shoulders above any nearby peak on the shores of the Puget Sound.

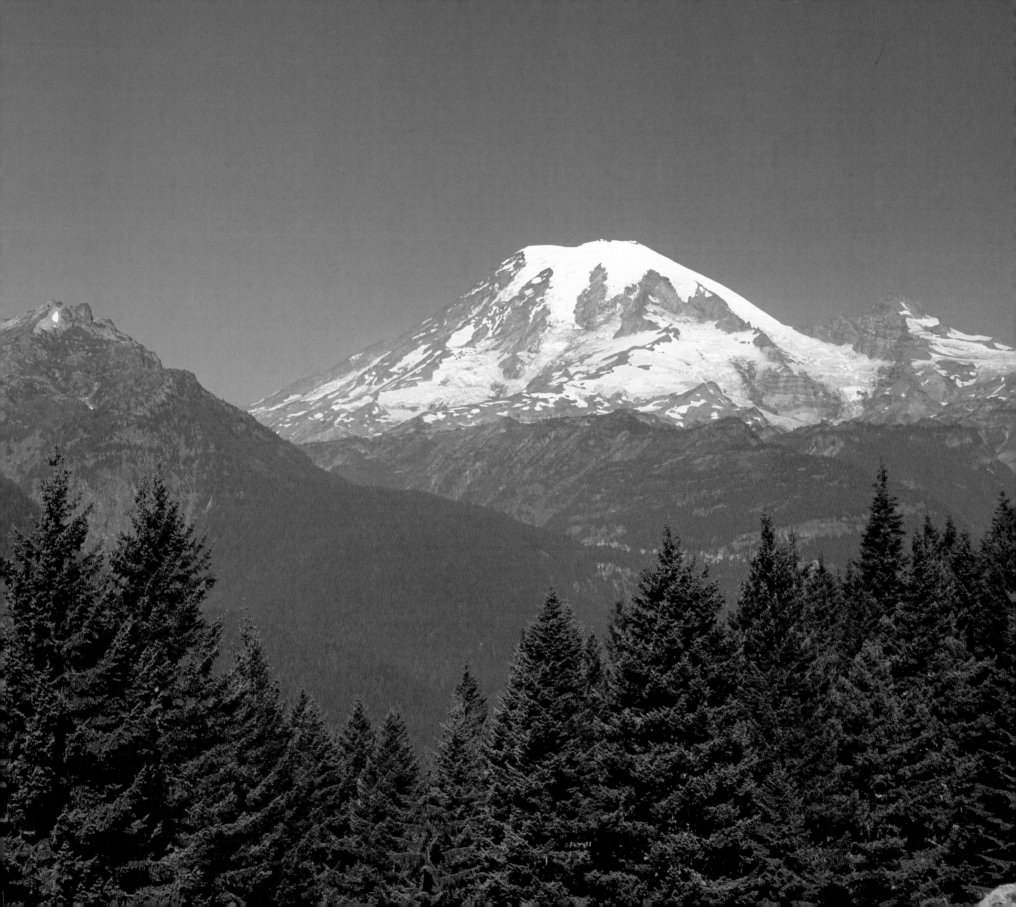

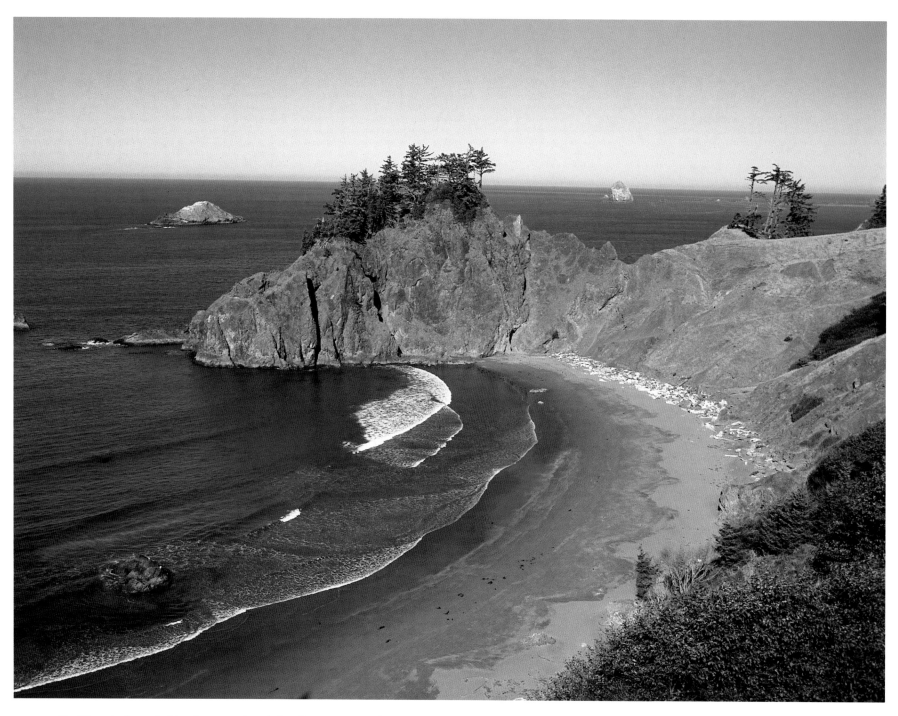

ABOVE: Pacific winds and tides have sculpted the Oregon coast into an ever-changing vista of headlands, seashore, and tidal pools.

RIGHT: Sea stacks rising abruptly from Oregon's coast were once part of the mainland, gradually cut off by the restless waters.

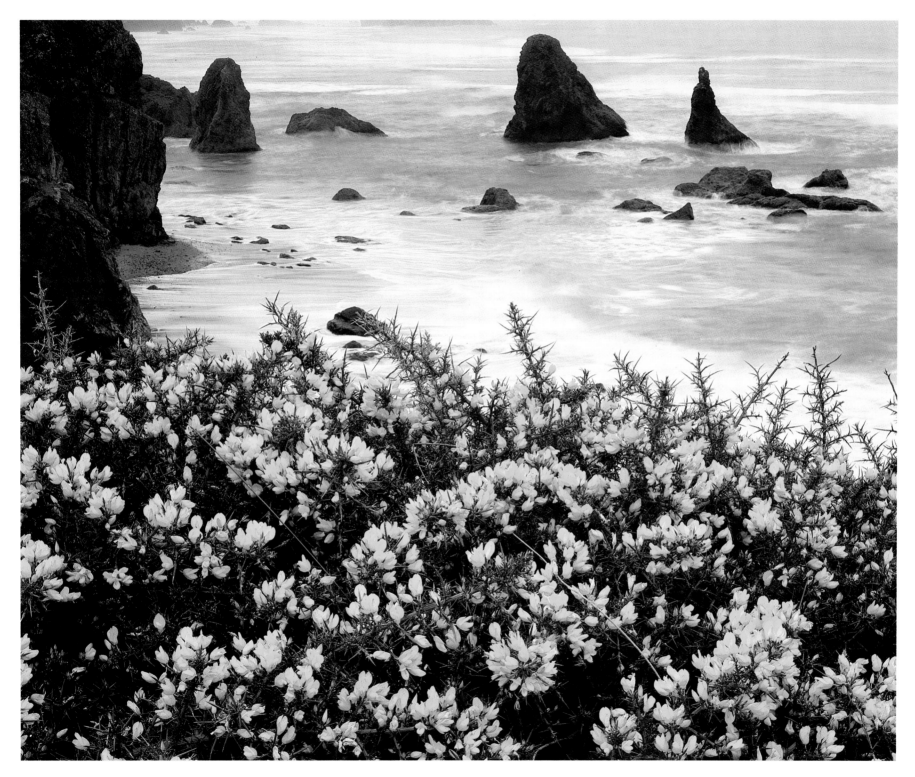

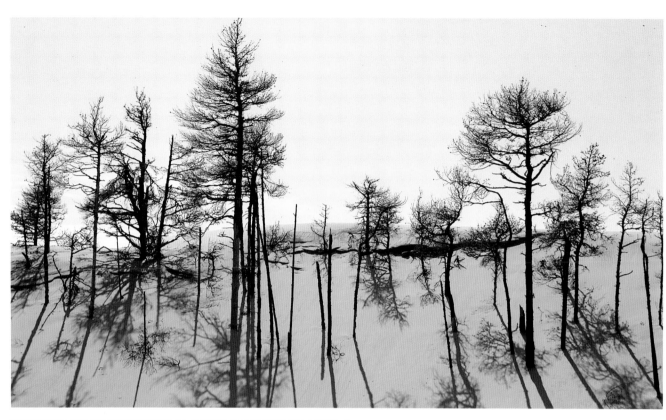

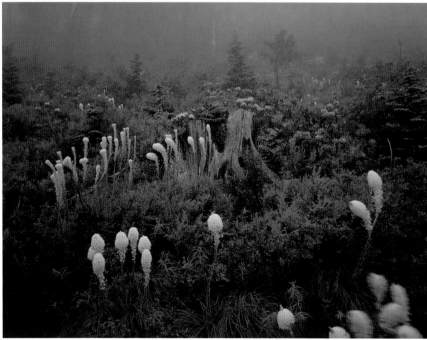

ABOVE: Ephemeral trees cast their shadows on the Oregon dunes.

LEFT: Clublike beargrass and pink rhododendron light up an overcast day at the foot of Mount Hood, Oregon.

RIGHT: The cone of an ancient volcano is the setting for gemlike Crater Lake, Oregon.

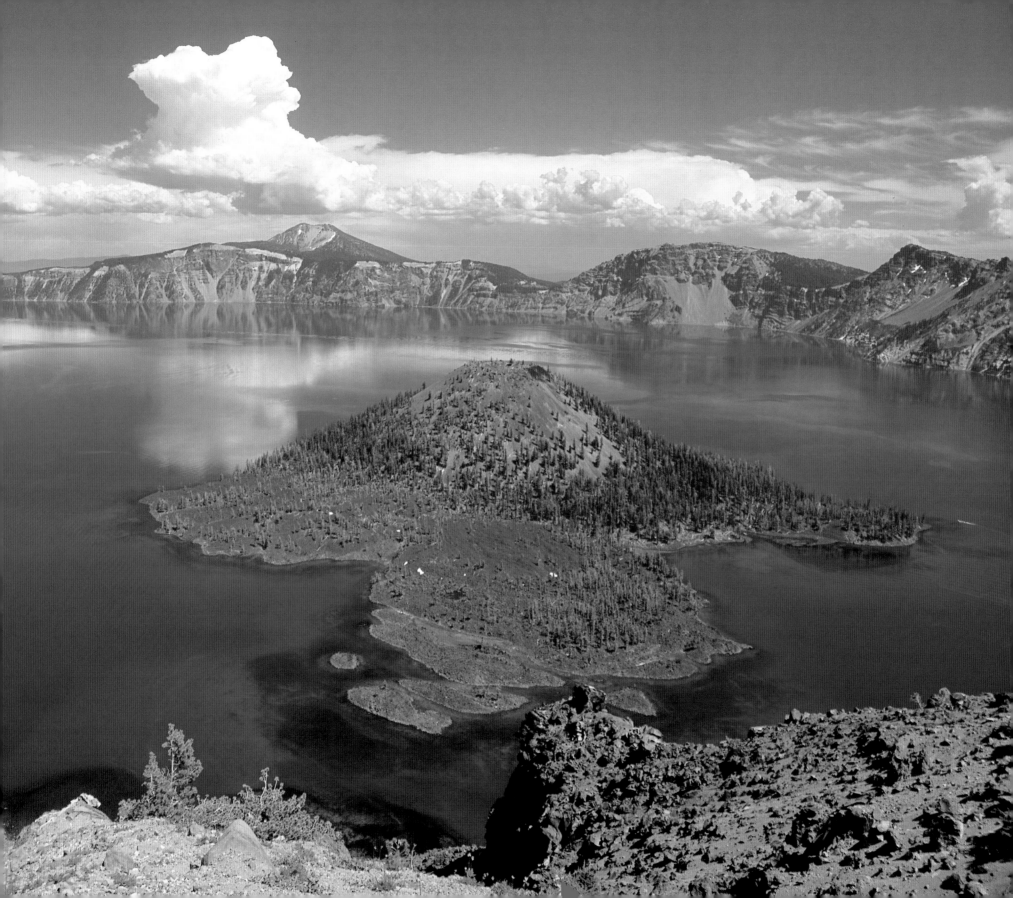

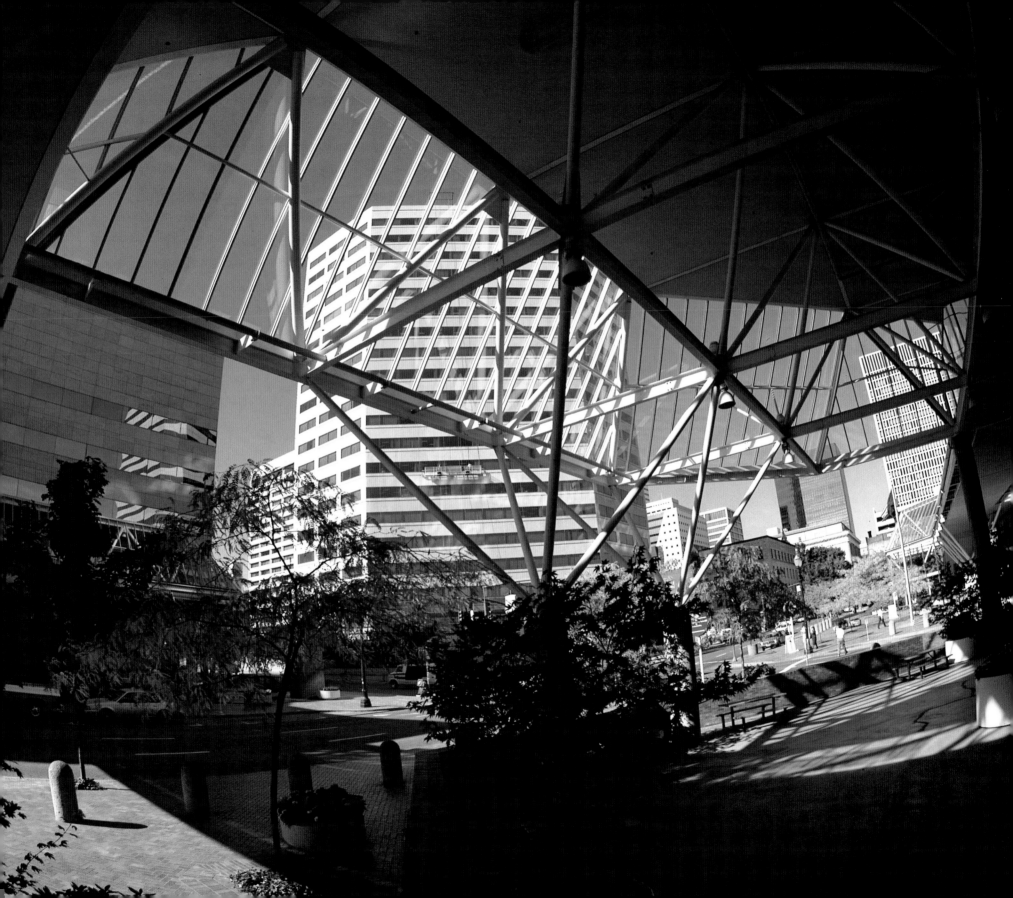

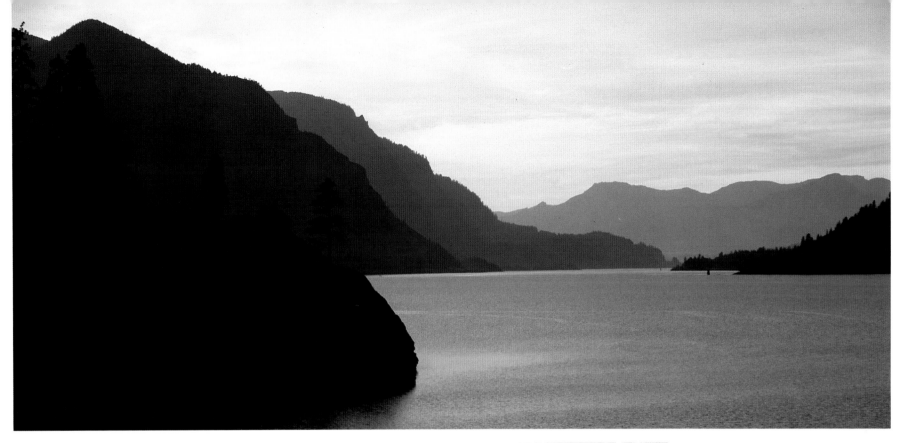

OPPOSITE: Energetic Portland, Oregon, has been growing since settlers from New England struck new roots in the Northwest.

ABOVE: At the Columbia River Gorge, east of Portland, Oregon, the West's mightiest river meets the sea.

LEFT: Heavy rainfall from the warm Pacific fosters luxuriant growth along the Salmon River Trail in Mount Hood National Forest, over a million acres in extent.

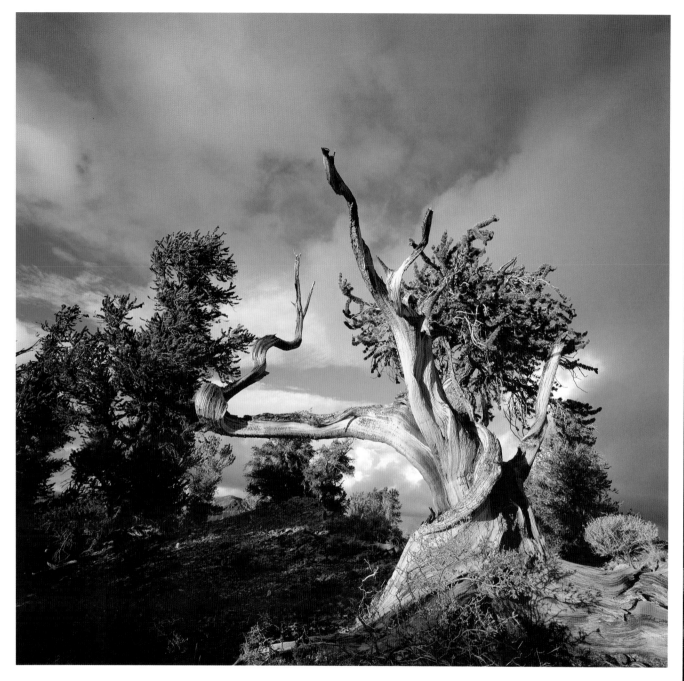

ABOVE: A tenacious bristlecone pine, contorted by generations of wind and weather, clings to the Northern California coast.

RIGHT: Huge formations of the Ice Age gouged out the Yosemite Valley and sheared off the rock faces that now shelter it in Yosemite National Park.

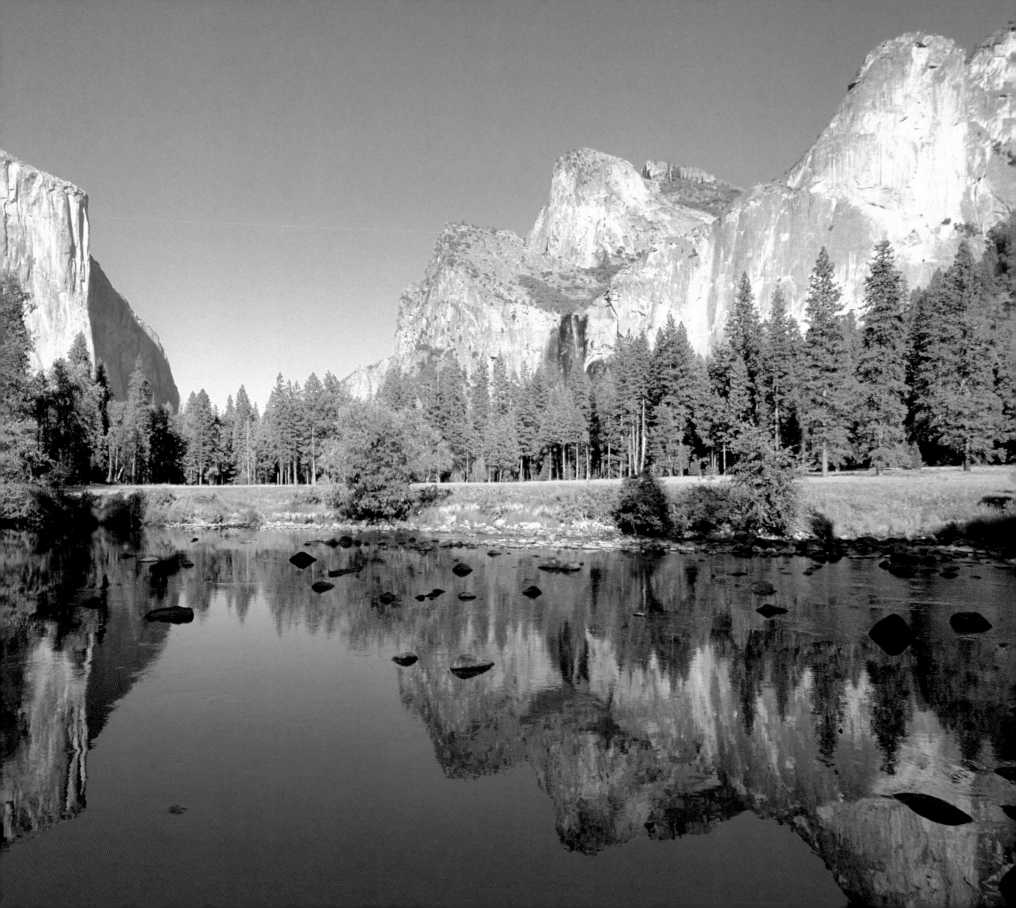

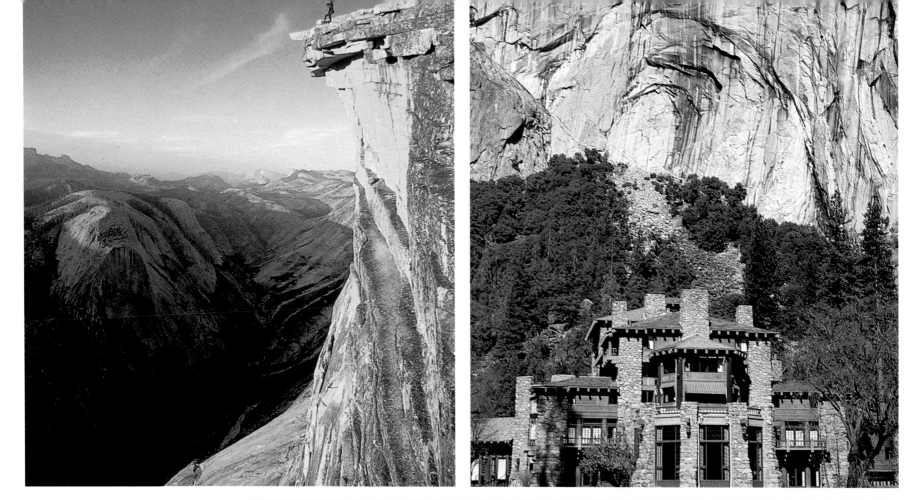

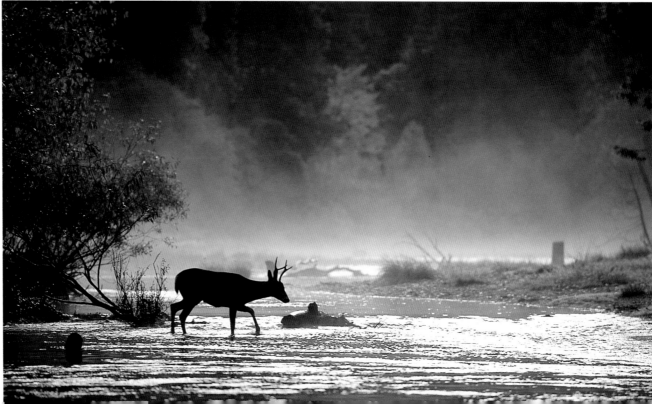

ABOVE: The dizzying height of a sheer granite precipice overlooks the entire Yosemite Valley – fold upon fold of ageless stone.

ABOVE RIGHT: The elegant Ahwahnee Hotel in Yosemite National Park.

RIGHT: A blacktail deer fords the Merced River in Yosemite National Park.

OPPOSITE: Gnarled grapevines cling to their supports at a Napa Valley winery in Northern California.

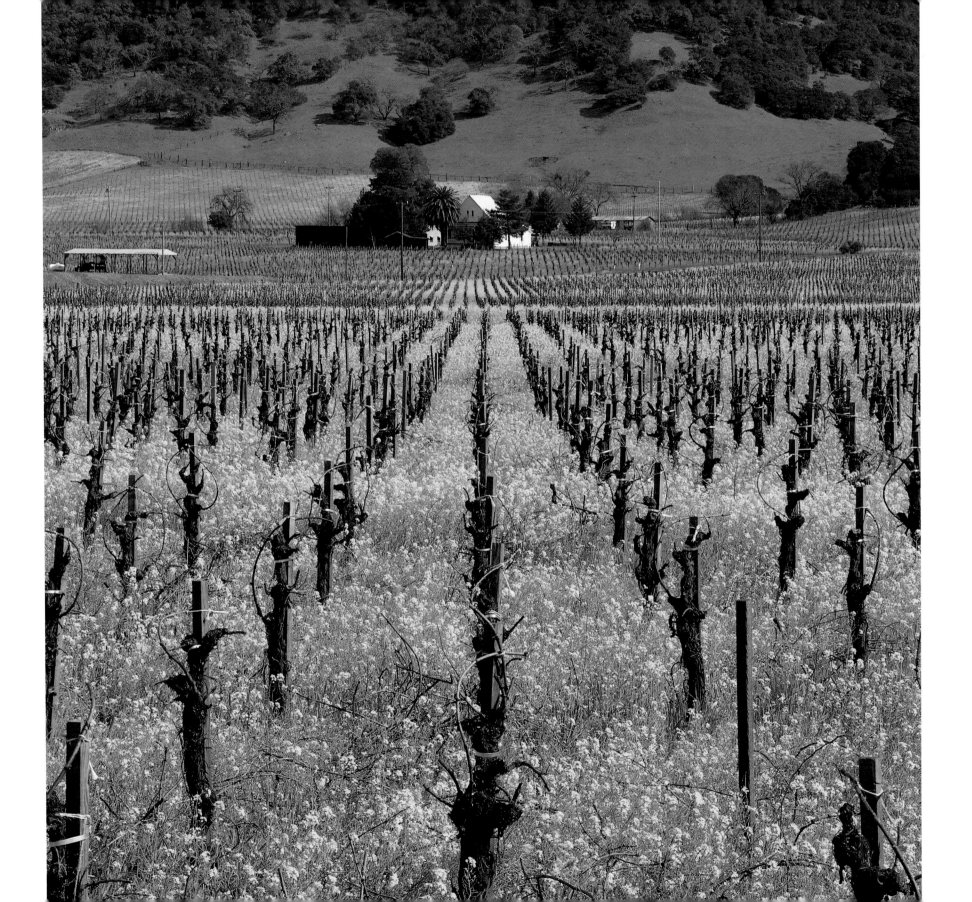

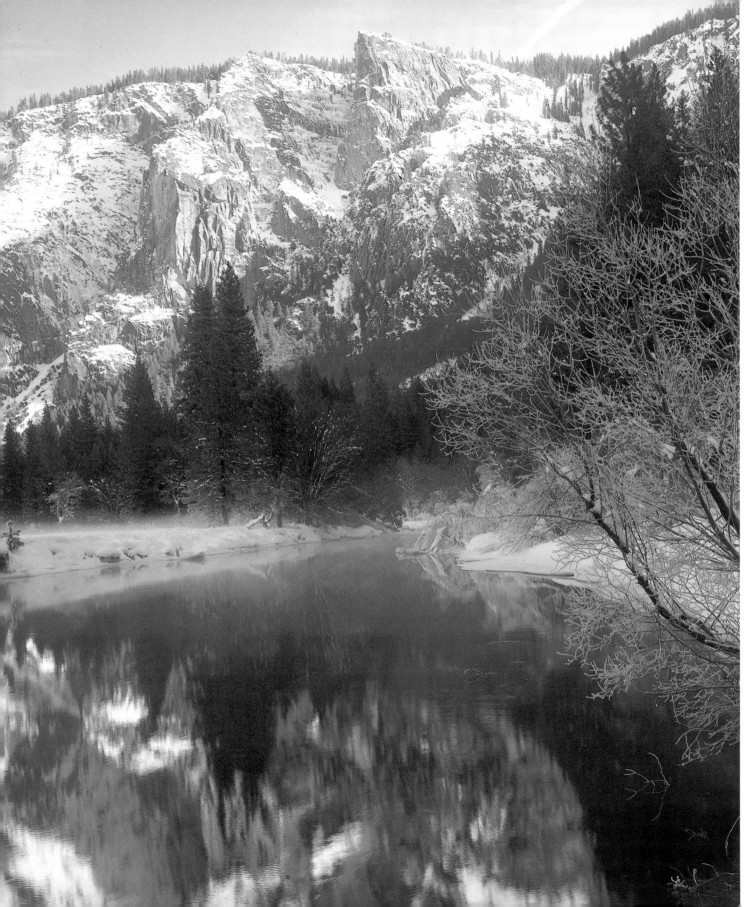

LEFT: Winter stillness reigns over the crystalline Merced River.

OPPOSITE TOP: The fabled City on the Bay, San Francisco. Here all the legends of the Golden West converge.

OPPOSITE BOTTOM: San Francisco's vibrant Chinatown personifies the cultural heritage of its many Asian-American citizens.

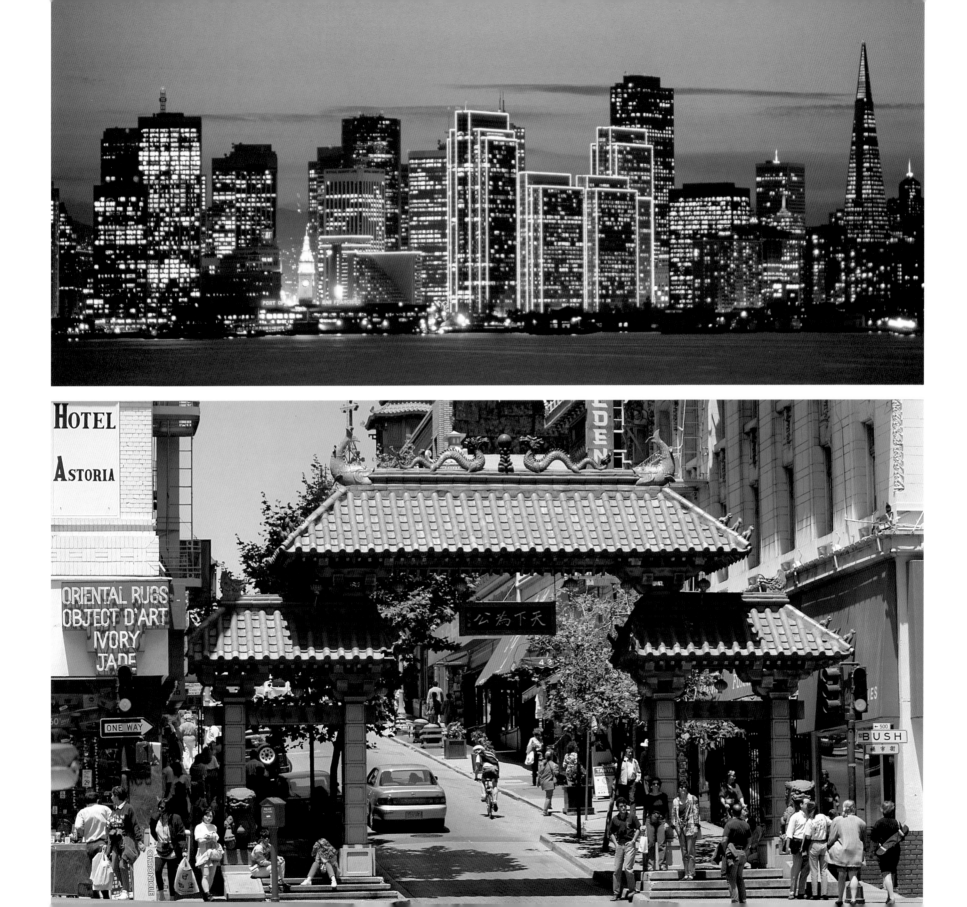

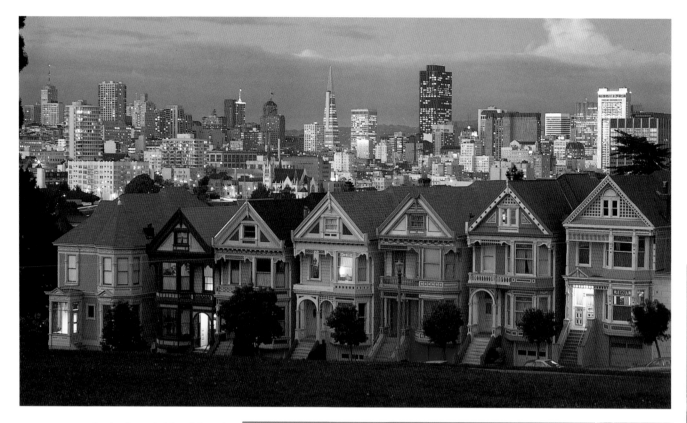

ABOVE: Purple dusk enfolds old and new San Francisco on its rolling hills starred by lights.

RIGHT: Steep Lombard Street winds past walled villas hidden behind thick flowering vines.

FAR RIGHT: San Francisco's Golden Gate Bridge is a landmark known around the world.

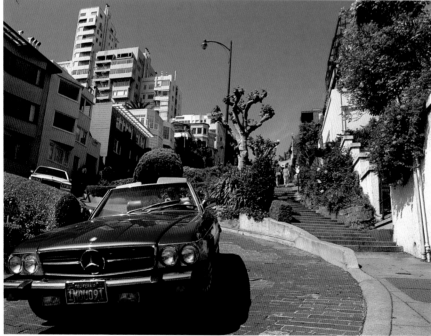

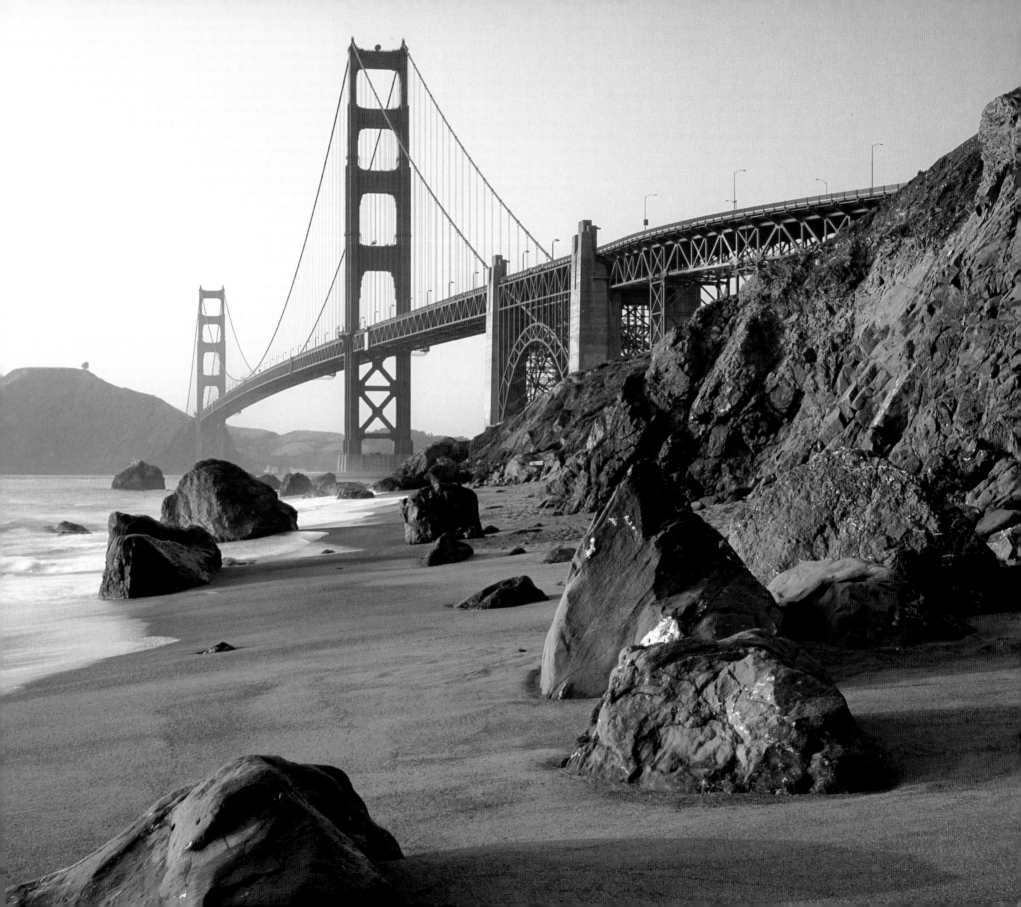

ALASKA AND HAWAII

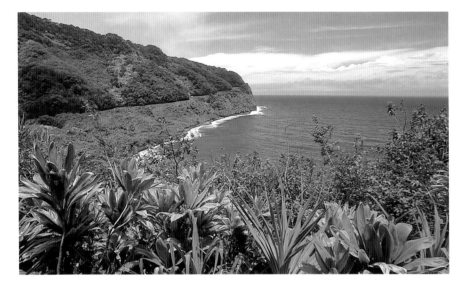

LEFT: The coastline and road to Hana on Maui, Hawaii.

OPPOSITE: The eerily beautiful northern lights over Alaska – luminous streamers of many colors seen only in the skies of the far north.

The Pacific states of Alaska and Hawaii offer a total contrast in climate, geography, and ways of life. Alaska and Hawaii are the only states that are not contiguous with the other 48. Alaska, called "the last frontier," is best known for its scenic wilderness. In 1981 almost 44 million acres of this land became part of the national park system when seven new preserves were created. They include Glacier Bay, where great tidewater glaciers move down the mountainsides and break up into the sea; Katmai, on the Alaskan Peninsula; and Kenai Fjords, on the Gulf of Alaska. Farther inland are Wrangell-St. Elias, the largest area in the park system, a day's drive east of Anchorage; and Denali (formerly Mount McKinley National Park), which contains the highest mountain in the United States. Far to the north are Kobuk Valley and Gates of the Arctic National Park, which encompass more than 7 million acres of tundra, mountains, and ice-packed waterways.

A different kind of paradise lies more than 2,000 miles southwest of San Francisco: the Pacific islands of Hawaii. They are the peaks of a chain of submerged volcanoes, two of which are still active, Mauna Loa and Kilauea, on the Big Island of Hawaii. Periodic eruptions shoot fire-fountains of lava hundreds of feet into the sky. Lava also flows from vents in the mountains' sides, obliterating sections of lush tropical forest that promptly rise from the ashes. But the name "Hawaii" is more likely to conjure up visions of the sparkling waters off Diamond Head, luxury hotels with smooth sand beaches, delicate orchids, luxuriant vines, and palm trees tracing their graceful lines against the sky.

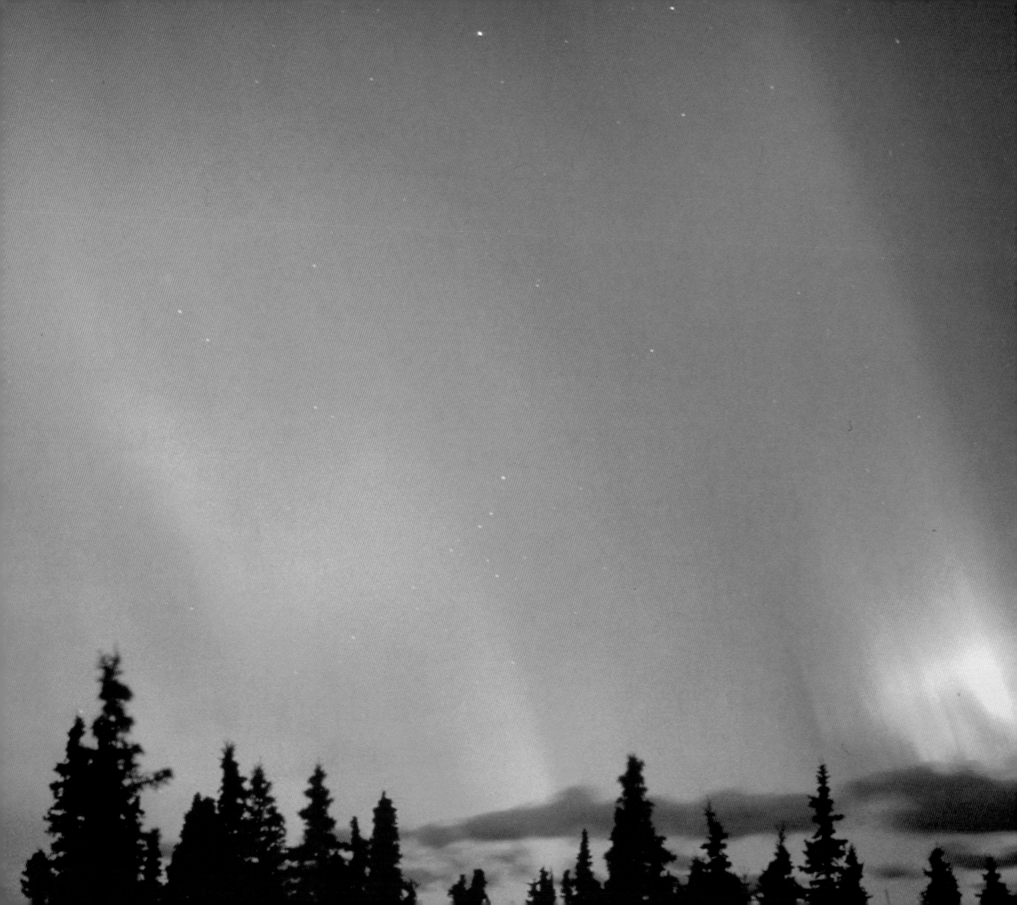

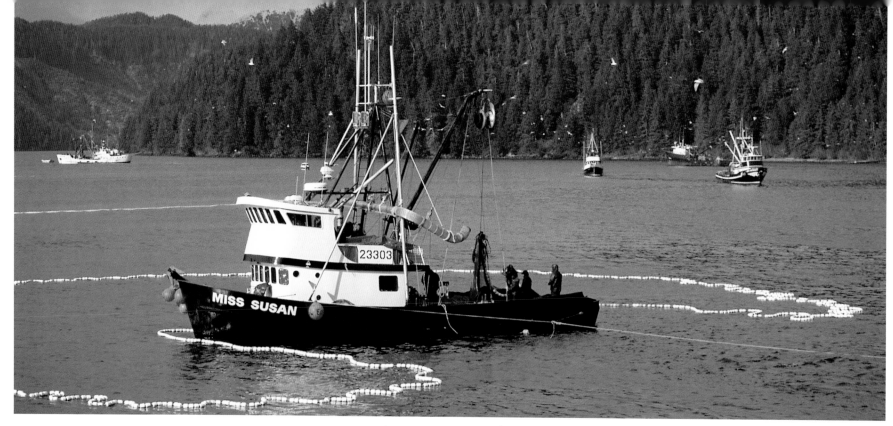

ABOVE: Sitka, a Russian colony, was Alaska's first European settlement. Here a seine-net trawler works the herring roe fishery offshore.

RIGHT: Steller sea lions sun themselves on Round Island, Alaska.

OPPOSITE: The port of Haines is home to fishing boats, pleasure craft, and runabouts used for transportation. Waterways carry far more Alaskan traffic than roads, which are nonexistent in many parts of the nation's largest state.

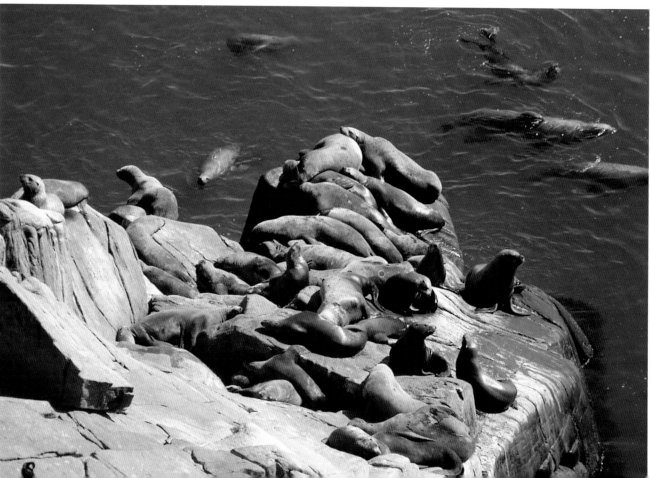

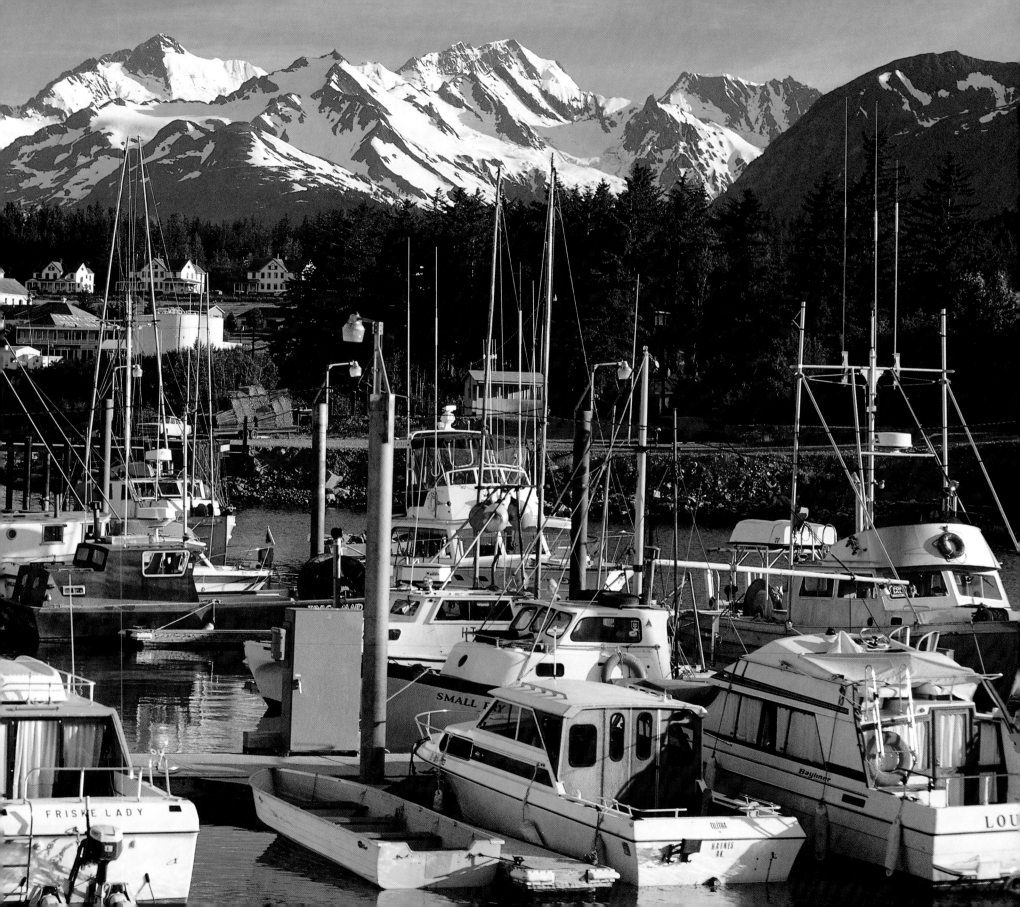

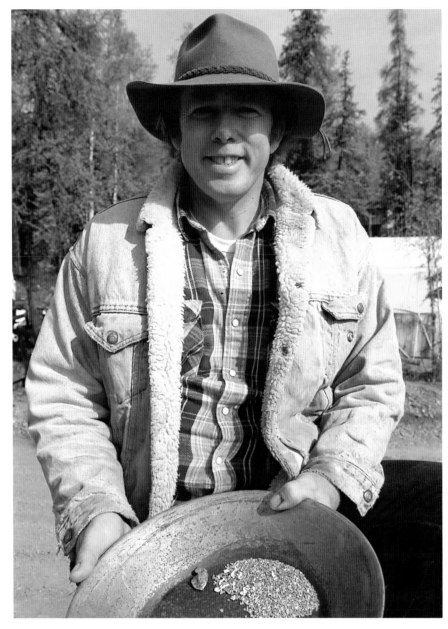

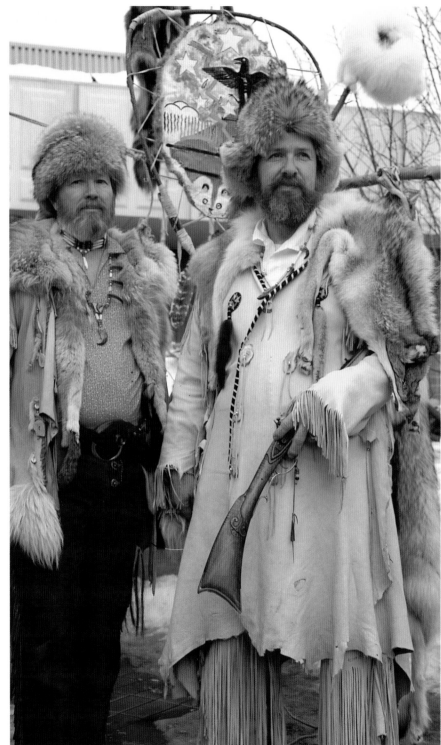

ABOVE: Hardy prospectors still pan for gold at the El Dorado Mine site in Fairbanks.

RIGHT: Mountain men at the annual Fur Rendezvous Winter Carnival in Anchorage.

OPPOSITE: Steeply pitched roofs help shed snow in Juneau, Alaska's picturesque and lively capital.

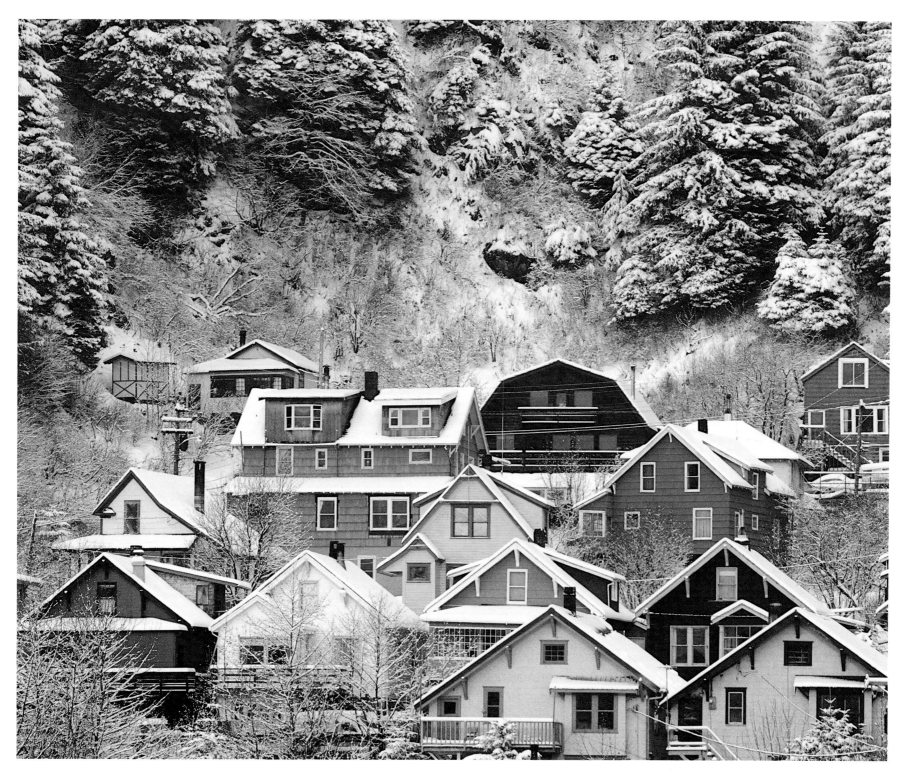

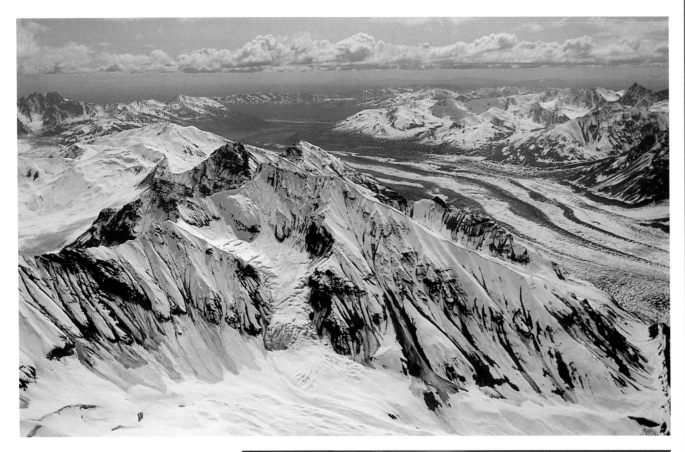

ABOVE: A sightseeing flight over Alaska's inspiring Denali National Park and Preserve.

RIGHT: Mount Foraker challenges the skills of a winter sportsman brightly clad for visibility in the vast snowfields.

FAR RIGHT: Mount Huntington, in the stark Alaska Range.

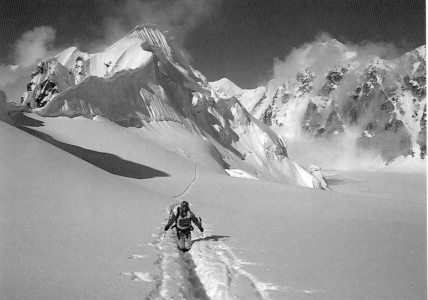

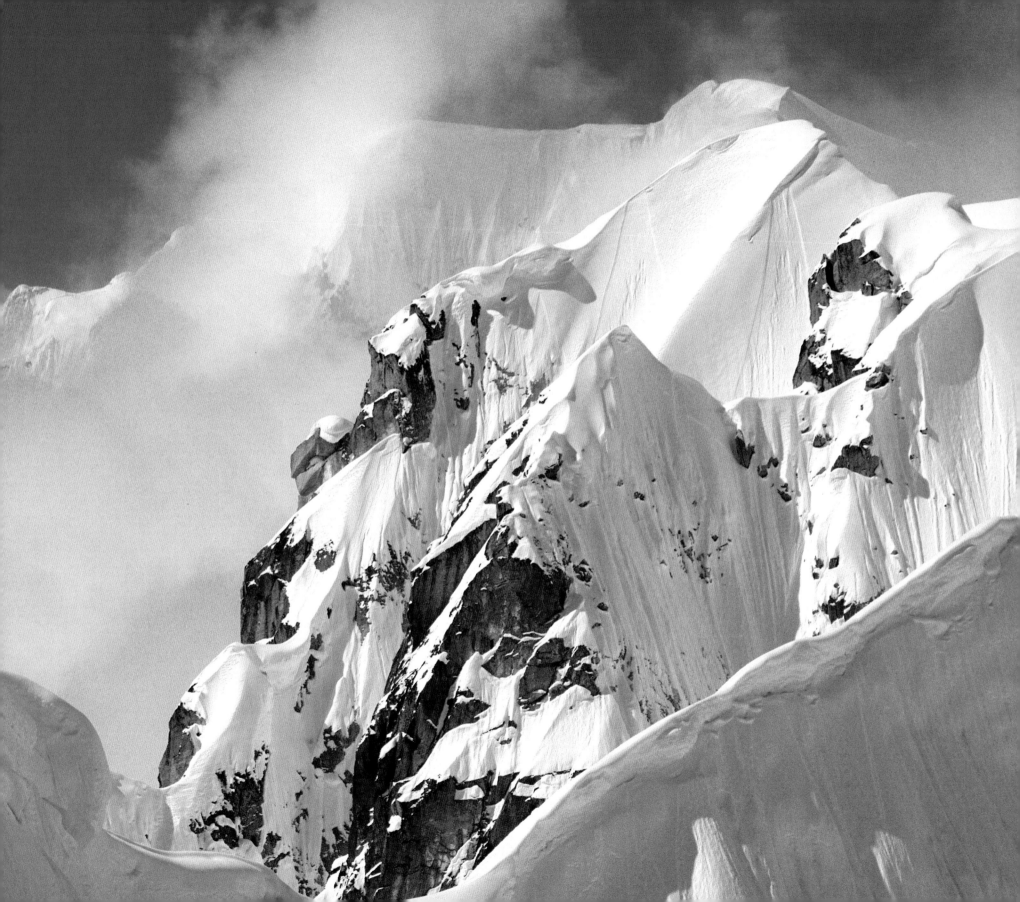

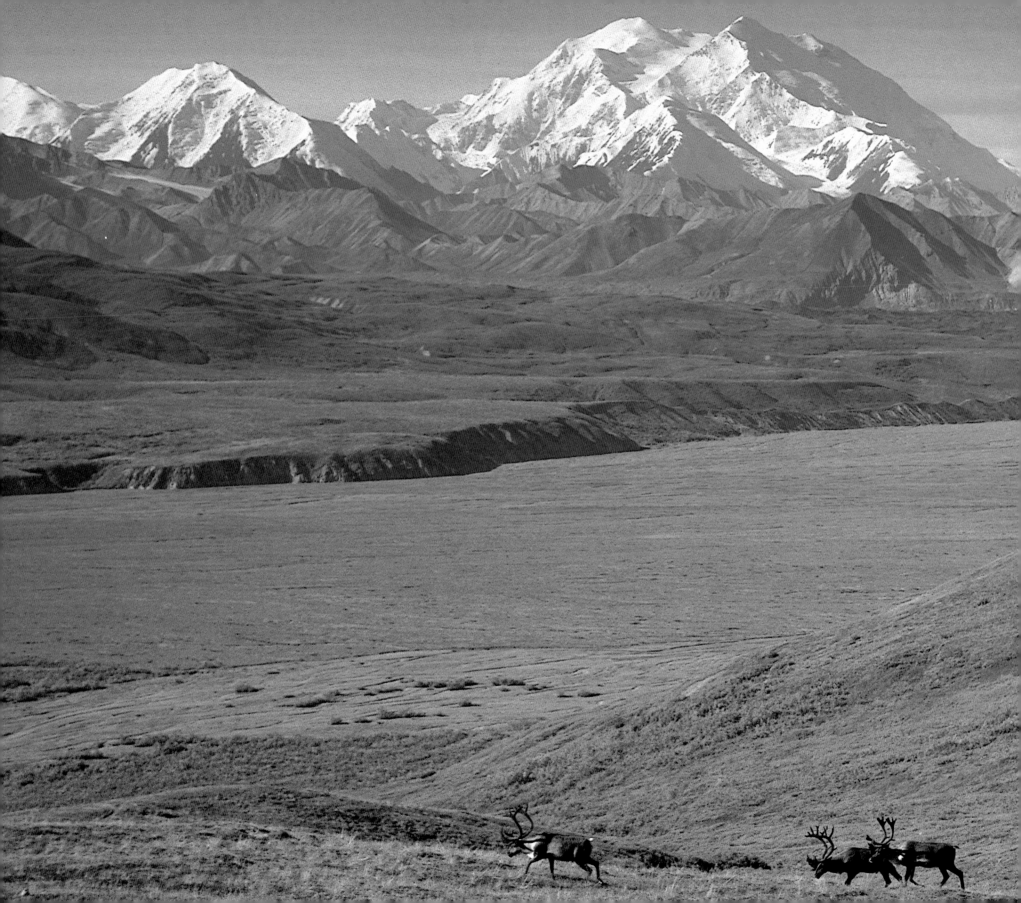

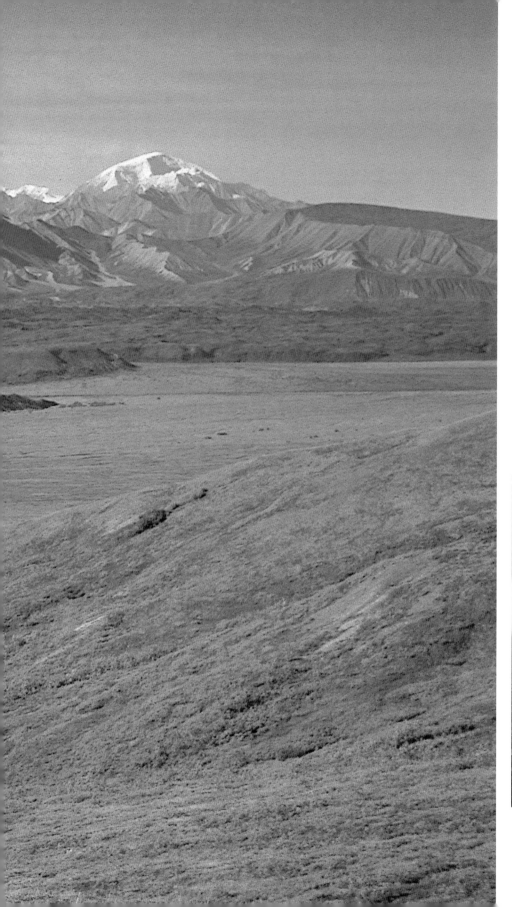

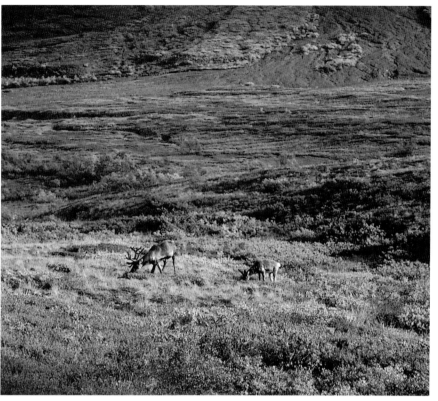

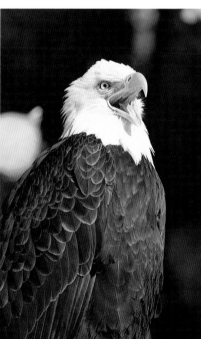

FAR LEFT: A distant view of Denali (the Great One) from Denali National Park. Formerly called Mount McKinley, this is North America's highest mountain, towering more than 20,000 feet.

ABOVE: Caribou at their summer feeding grounds on the tundra.

LEFT: An Alaskan bald eagle utters the harsh cry that announces its presence at a nesting site. These birds return to the same nests every year, usually near water, where they can fish.

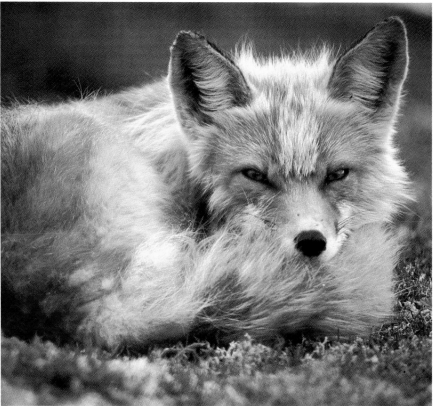

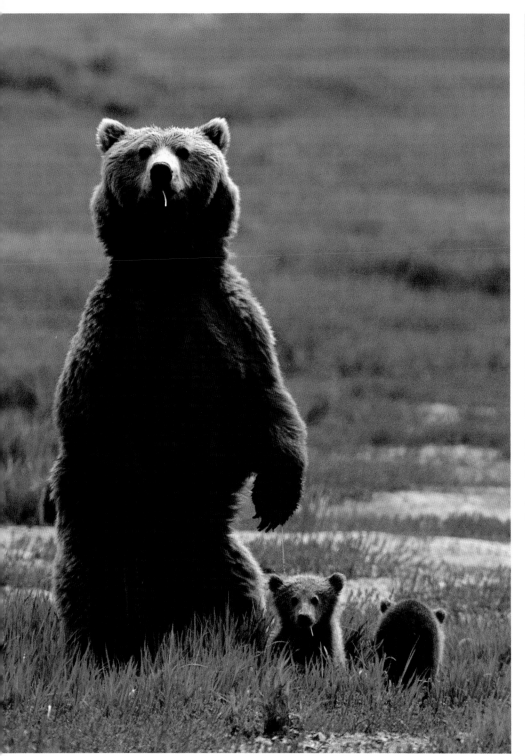

LEFT: A massive brown bear alert for any danger to her cubs on one of their first outings.

ABOVE: An arctic fox keeps a wary eye out on the Katmai Peninsula.

OPPOSITE: A bull moose grazes on water plants in the safety of Denali National Park, a haven for wildlife encompassing almost five million acres.

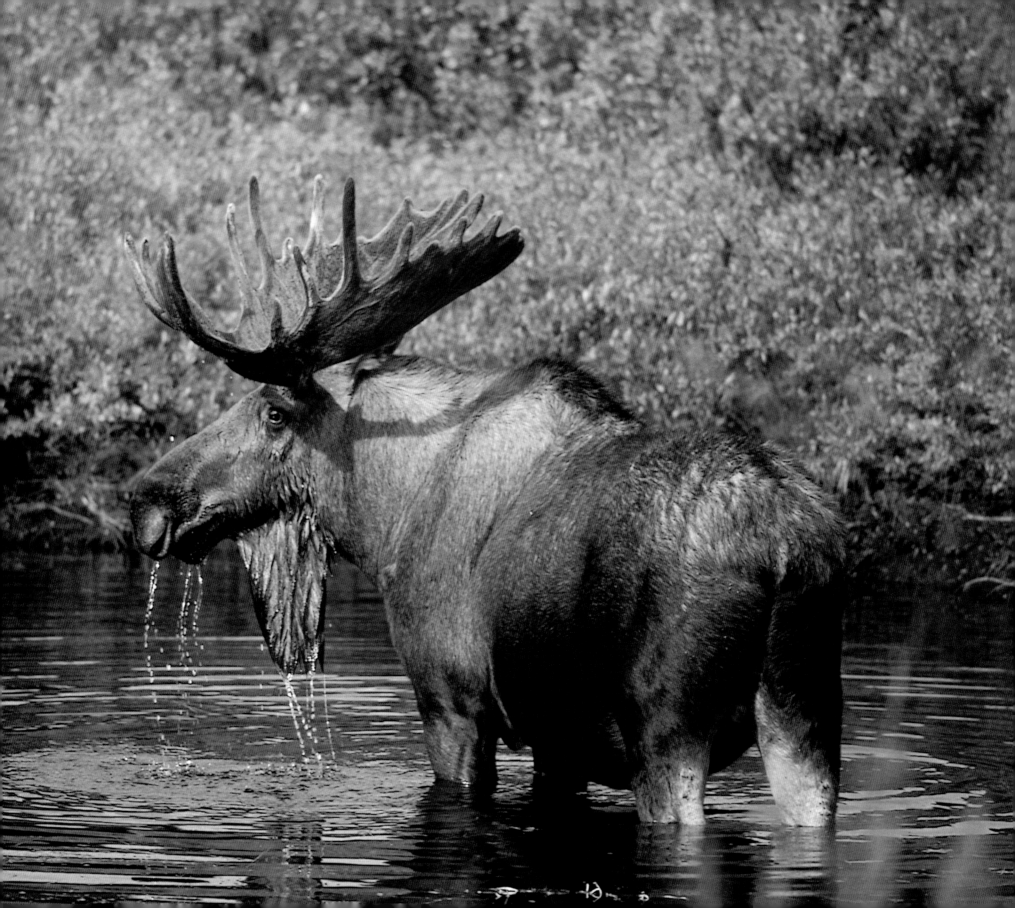

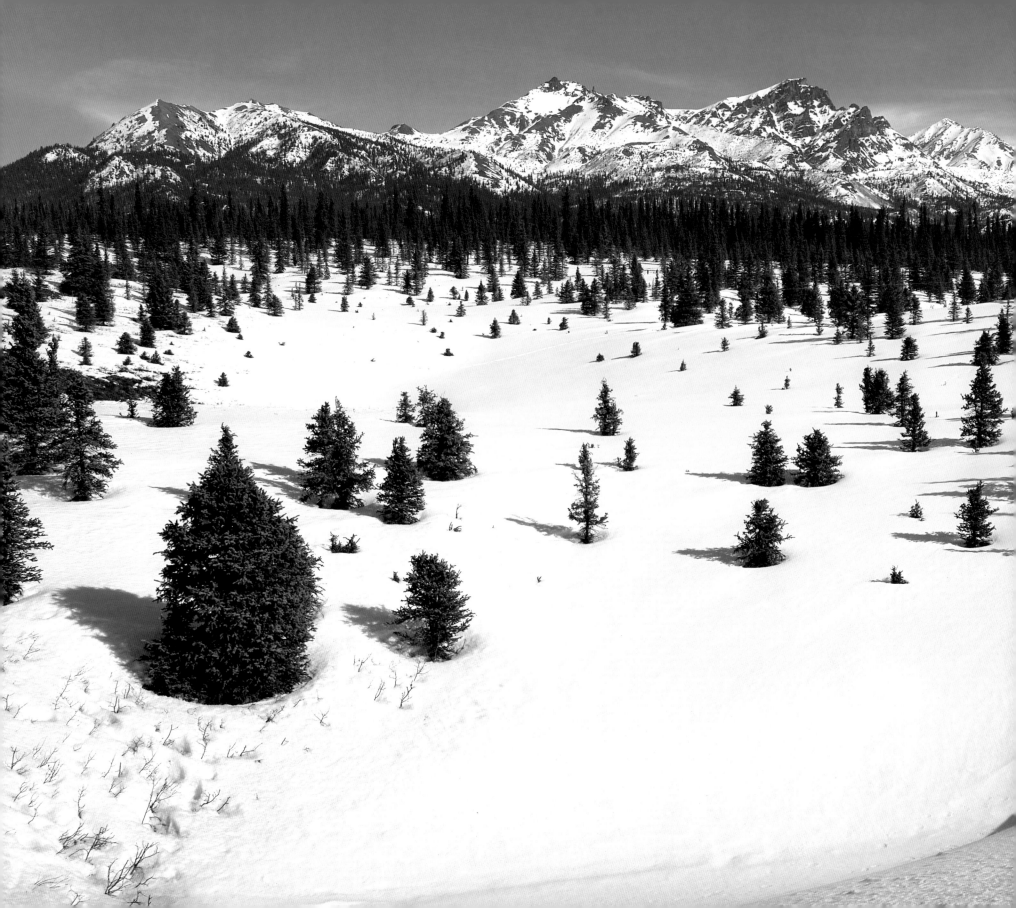

LEFT: Trees grow only in the lowlands of the Alaska Range; the peaks are perpetually covered with ice and snow.

RIGHT: Native Alaskans in traditional dress in Anchorage.

BELOW: Saxman Totem Park at Ketchikan displays the monumental wooden figures and artwork created by Alaska's coastal peoples.

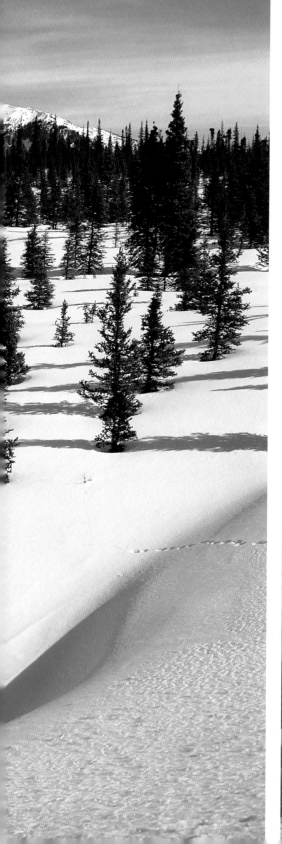

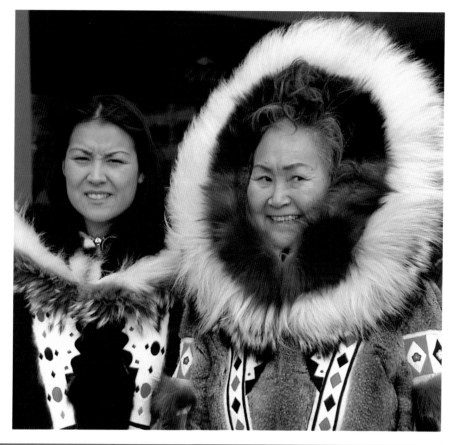

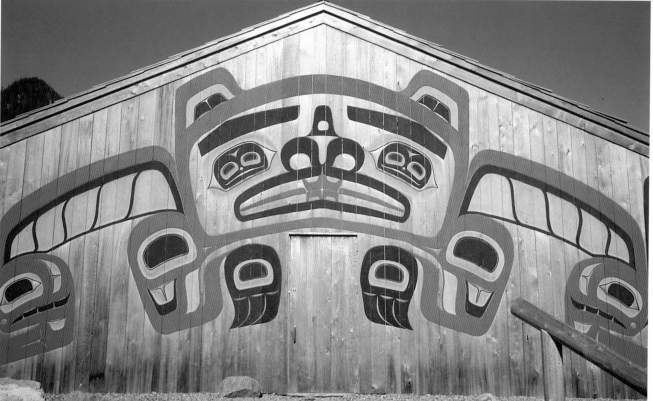

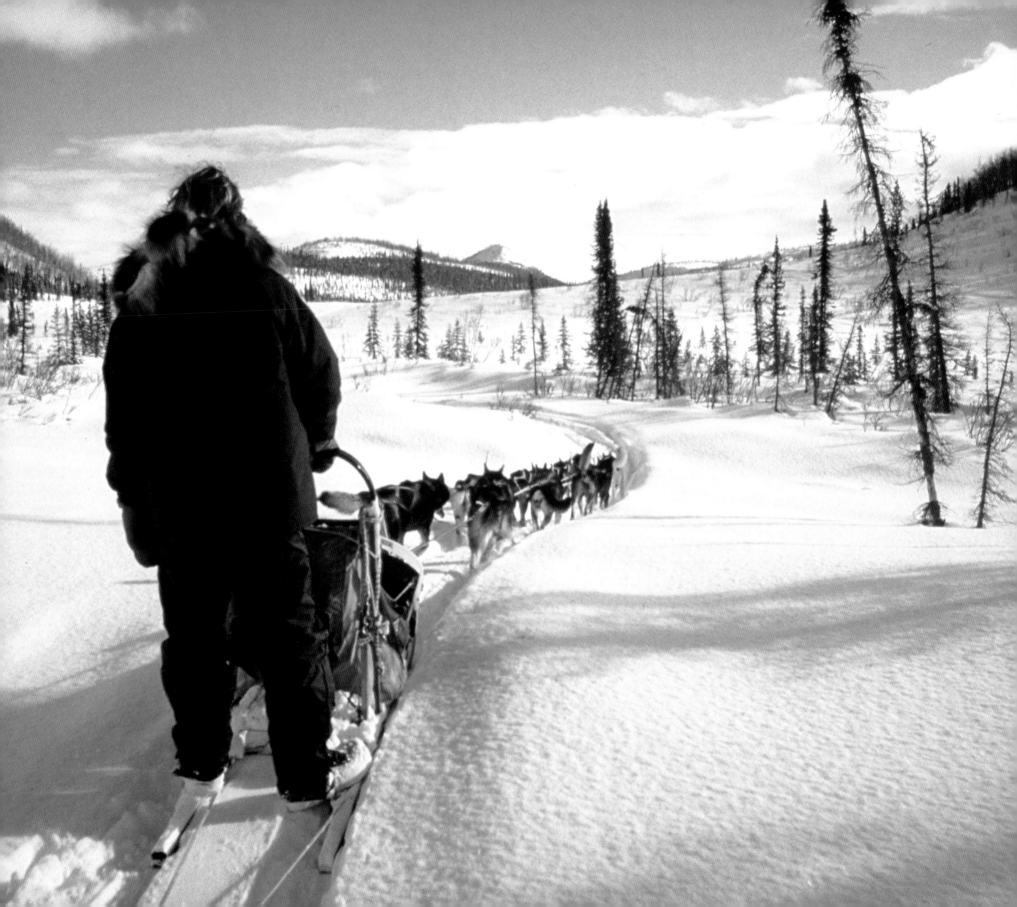

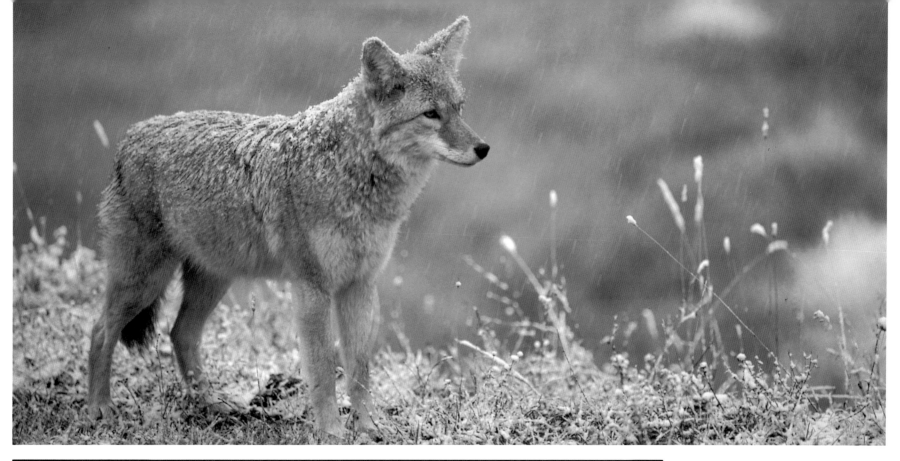

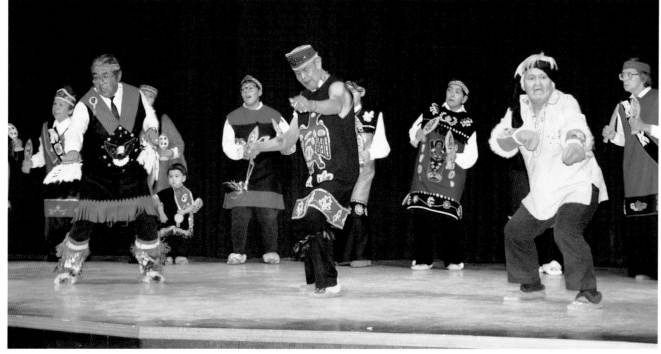

OPPOSITE: Competition is keen between Alaskan dogsledders, who sometimes match their best animals to send a team to regional races.

ABOVE: The coyote's thick coat is insulated against Alaska's subzero winters.

LEFT: Tlingit Indian dancers at Noow Plein (Castle Hill), near Sitka.

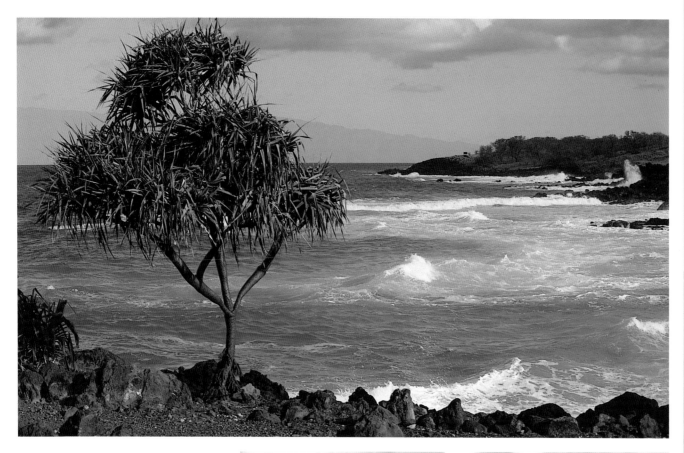

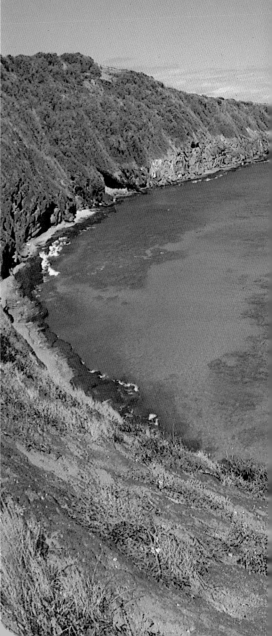

ABOVE: A remote beach on the Big Island of Hawaii.

RIGHT: The endless shoreline at Kaanapali Beach, on the west coast of Maui.

FAR RIGHT: Serene Hanauma Bay was created by a volcanic explosion on Oahu some 30,000 years ago.

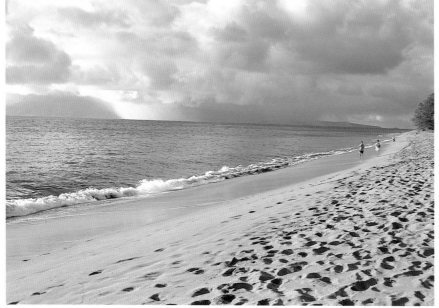

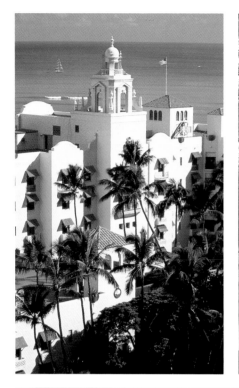

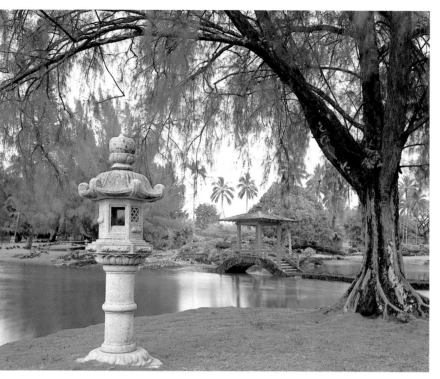

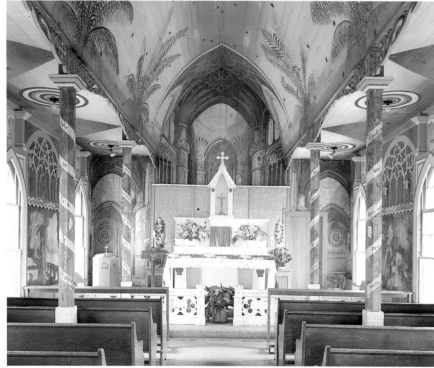

TOP LEFT: The luxurious Sheraton Royal Hawaiian Hotel, called the Pink Palace, became a popular resort in the late 1920s.

LEFT: The Painted Church – St. Benedict's at Honaunau on the Kona coast – combines traditional Biblical murals with Hawaiian motifs.

ABOVE: The five-acre Japanese garden on Hilo Bay is named for Queen Liliuokalani, Hawaii's last native ruler, who was deposed in 1893. Annexation by the United States followed in 1898.

RIGHT: Waioli Mission in Hanalei, Kauai, reflects the New England ancestry of the Protestant missionaries who brought Christianity to the islands.

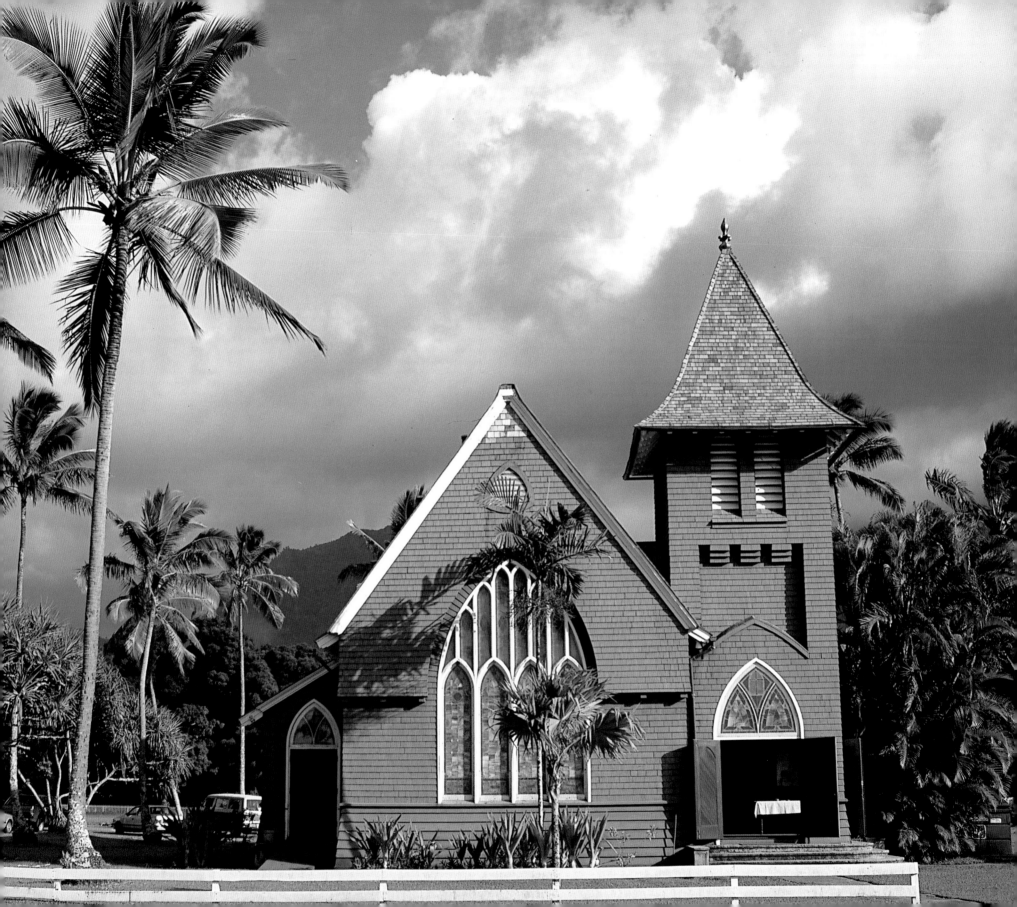

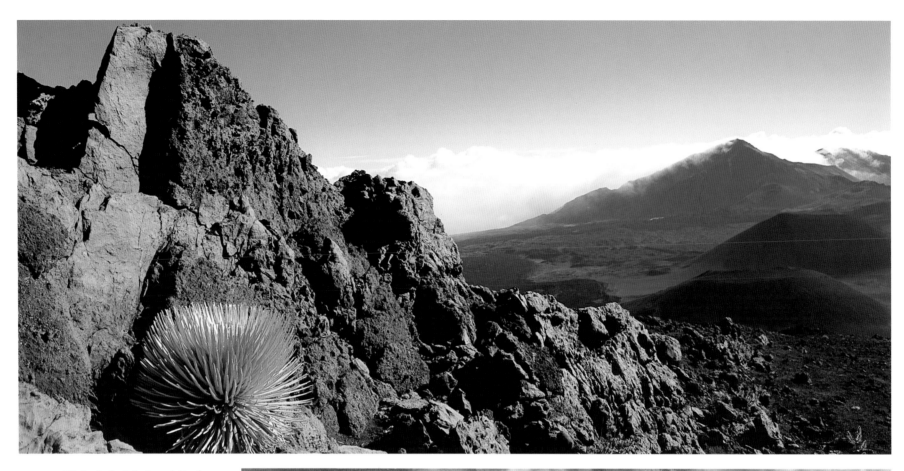

ABOVE: Haleakala National Park, on Maui, is the site of an active volcano, here seen on its parched western flank. The silversword is unique to this mountain: it blooms only once in its lifetime.

RIGHT: Molten lava sweeps down the side of Mauna Loa, one of four volcanoes on the island of Hawaii, two of which are active.

OPPOSITE: The aftermath of a devastating eruption by Kilauea, the second active volcano on the Big Island of Hawaii.

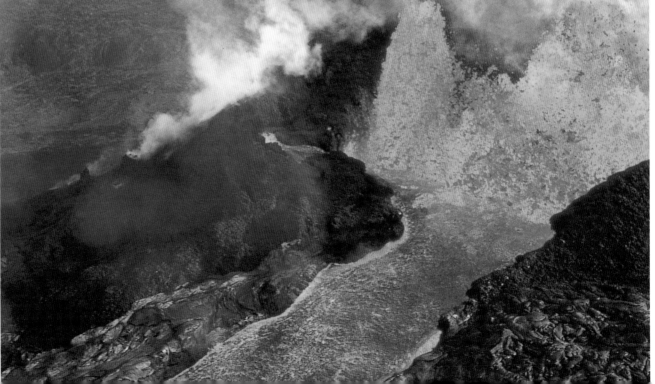

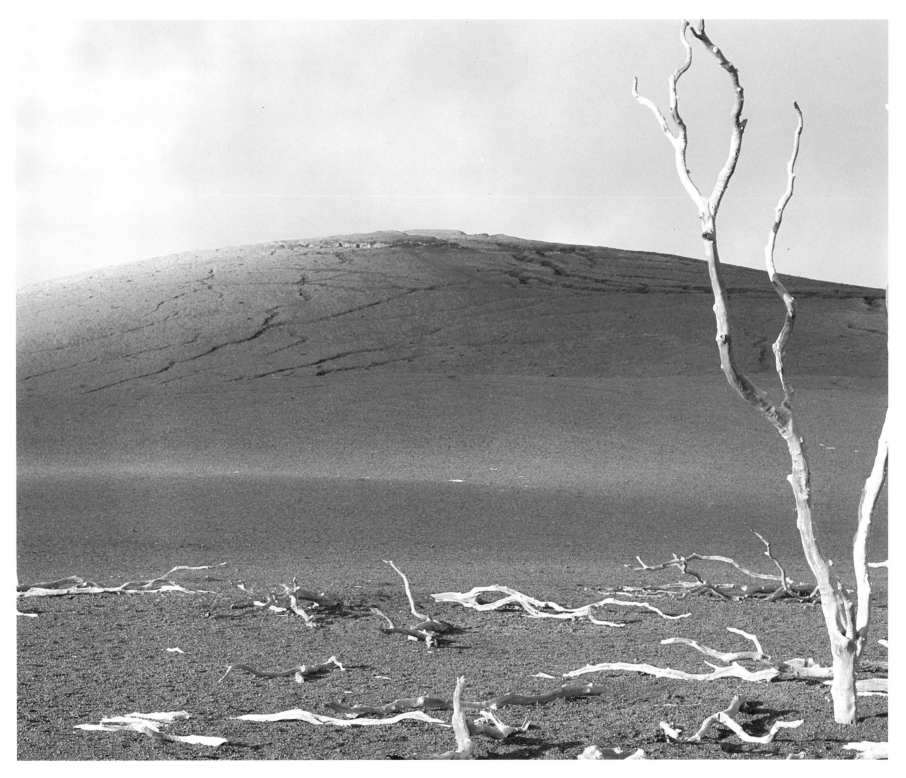

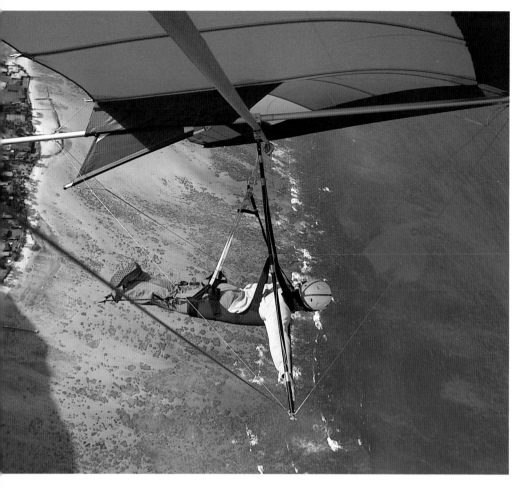

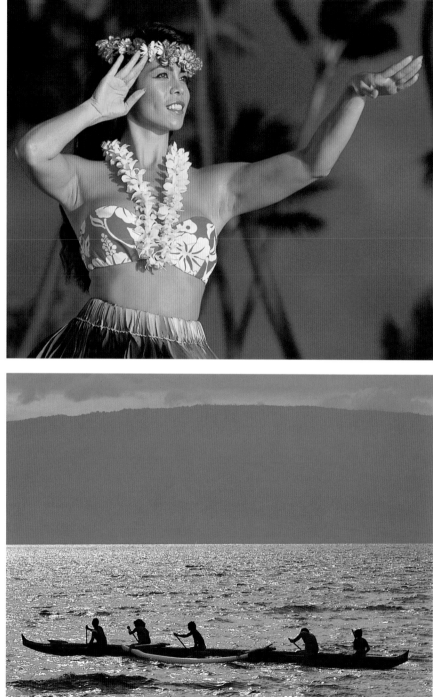

ABOVE: A hang glider sweeps through the tropical air over Molokai.

ABOVE RIGHT: A hula dancer recalls the Polynesian culture of Hawaii's first inhabitants.

RIGHT: Outrigger canoes have plied these waters for centuries.

OPPOSITE: Good surfers go to Hawaii instead of heaven.

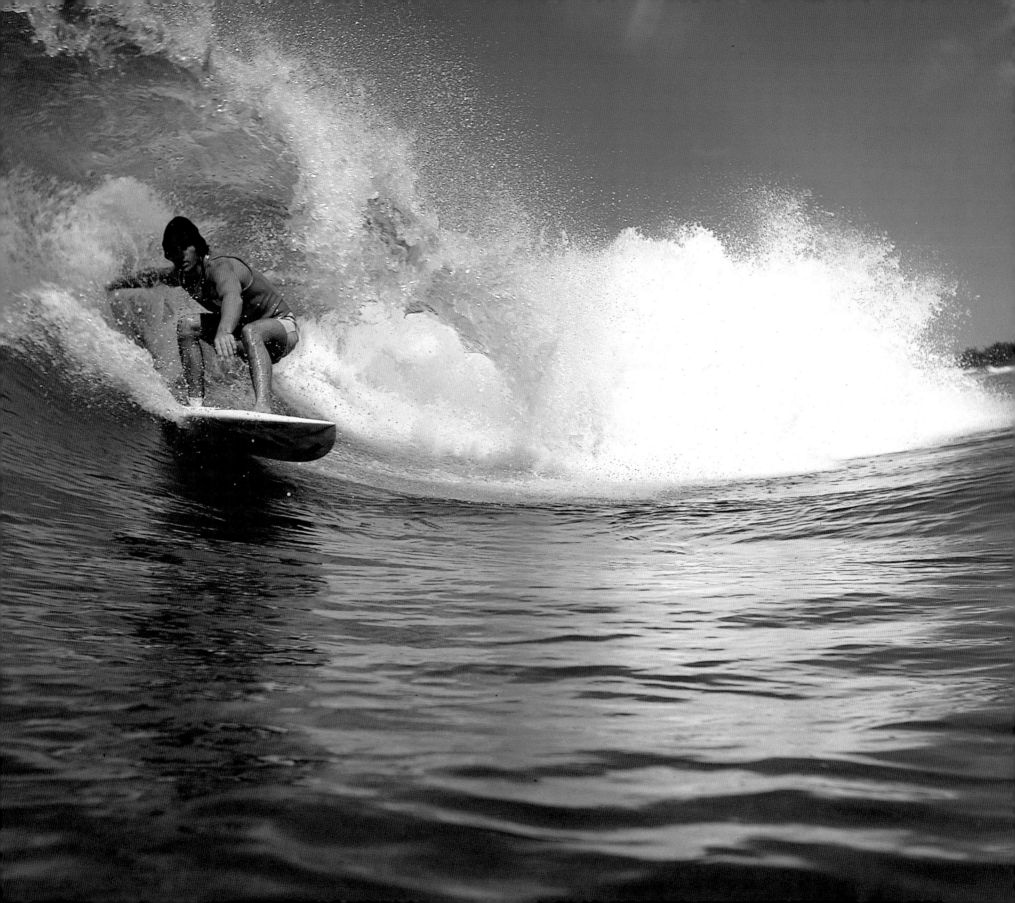

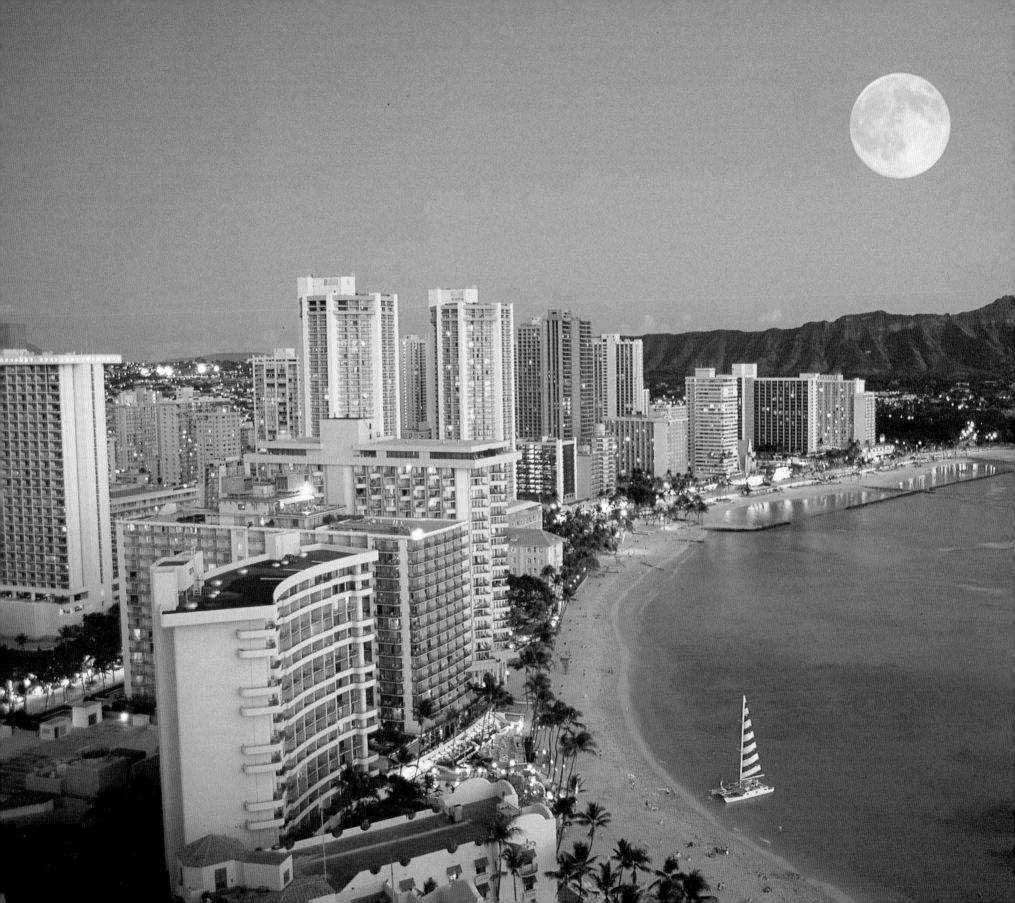

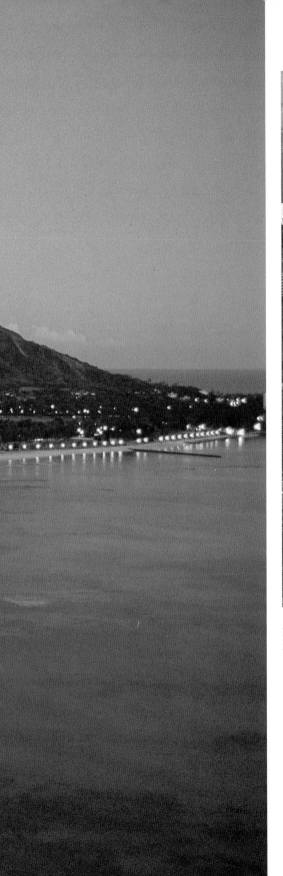

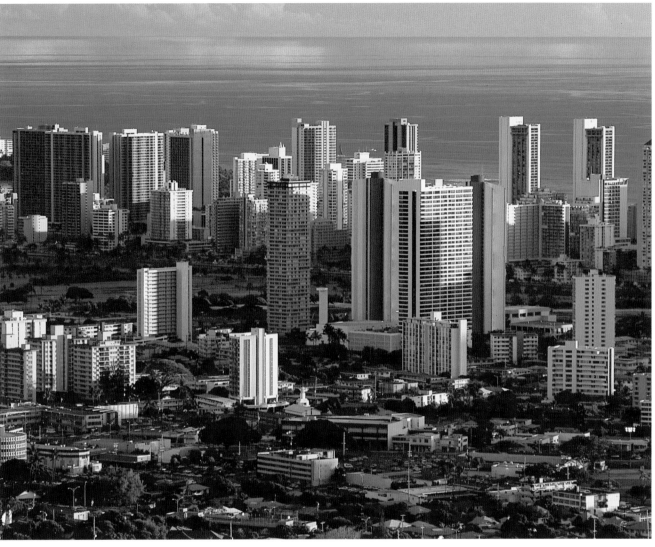

LEFT: The luxury resorts lining Hawaii's legendary Waikiki Beach.

ABOVE: Honolulu: a major Pacific port and center of trade and commerce that has never lost its unique ambience.

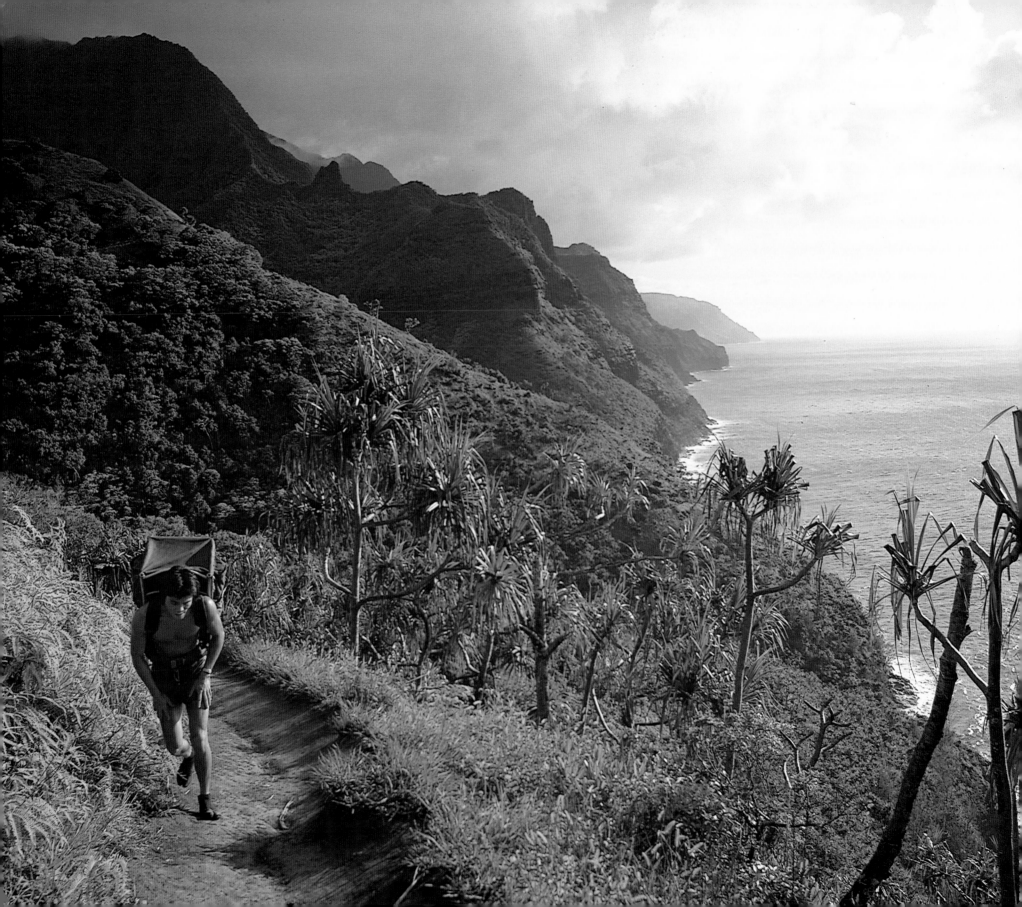

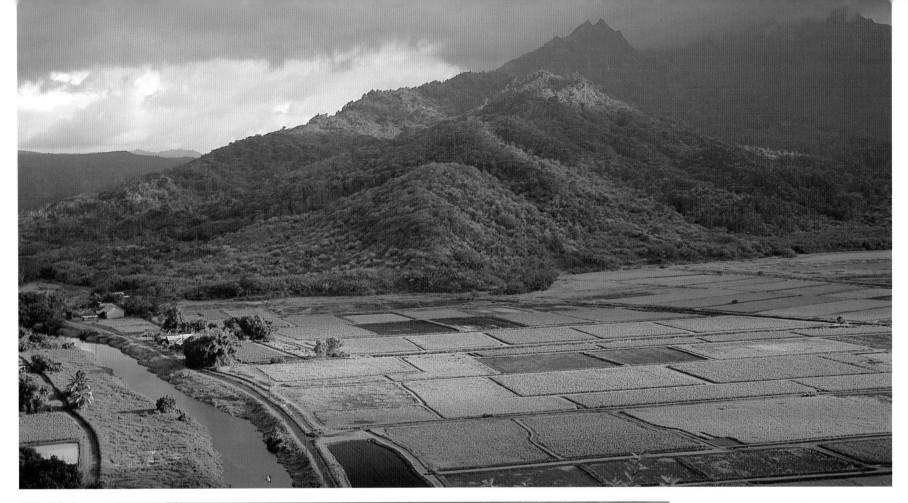

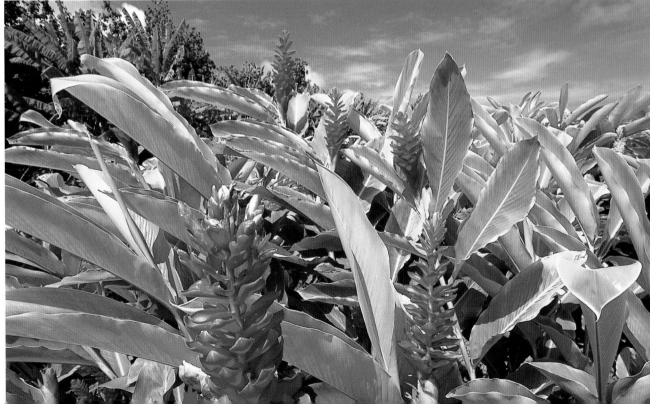

OPPOSITE: A lone hiker explores Na Pali, Kauai, with its luxuriant tropical greenery.

ABOVE: Fertile farmland in the Hanalei Valley, on Kauai. Traditional Hawaiian crops like pineapple have been joined by a thriving business in exotic plants like orchids.

LEFT: Ginger blossoms on Kauai herald another harvest for the spice trade.

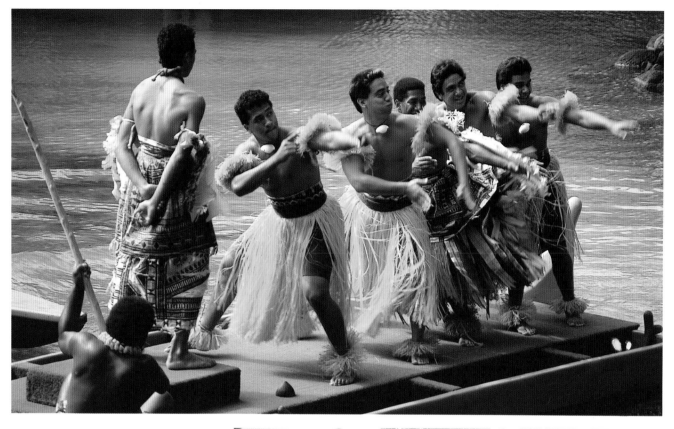

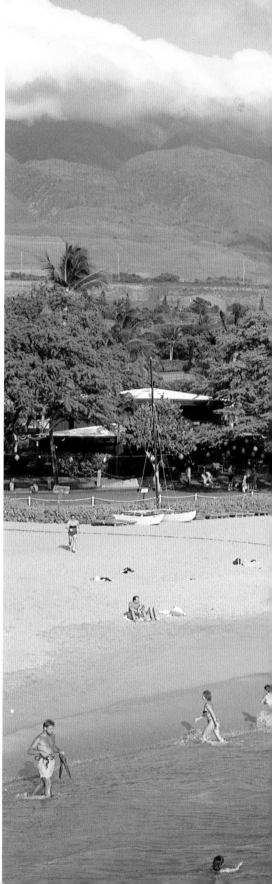

ABOVE: The historic Pageant of the Long Canoes is performed at the Polynesian Cultural Center in Honolulu.

RIGHT: A luau brings out a festive crowd for roast pork, fresh fruits, and other traditional island foods.

FAR RIGHT: Maui's pristine Kaanapali Beach attracts visitors from around the world.

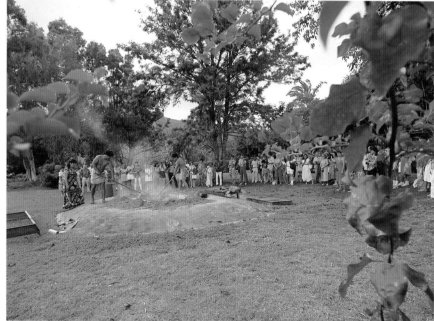

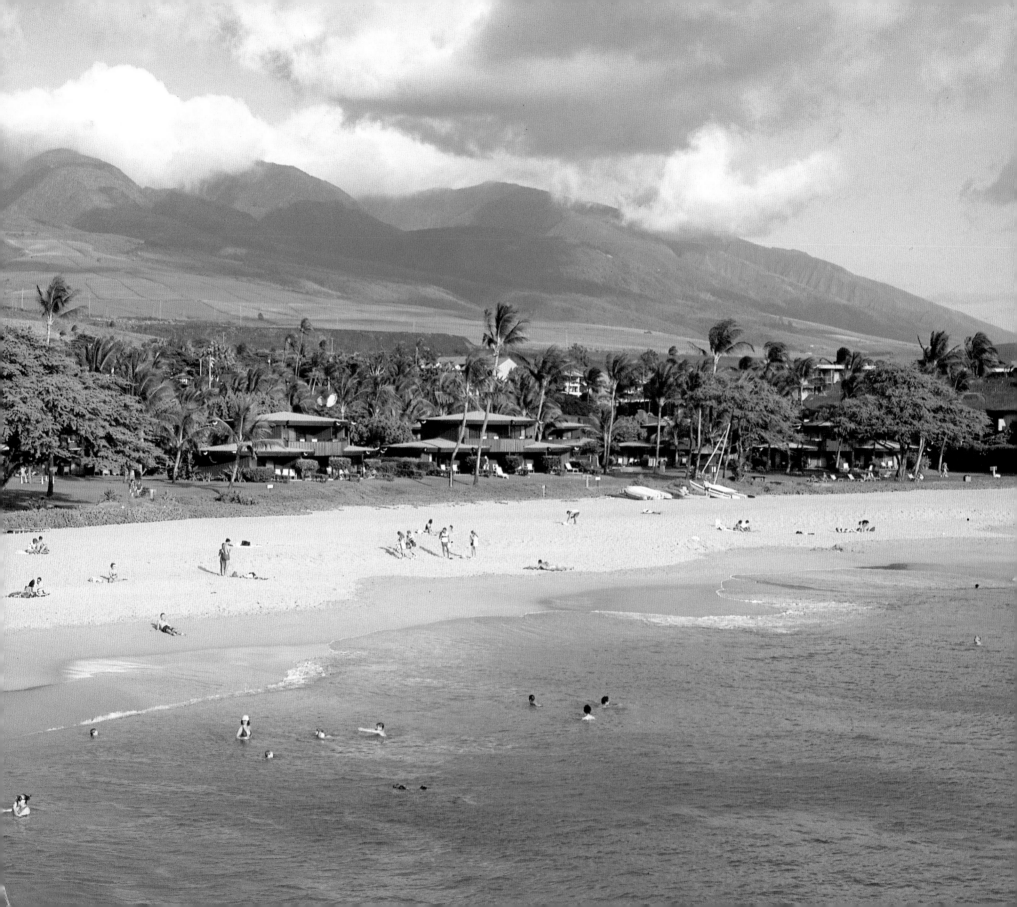

PICTURE CREDITS

Every effort has been made to trace the copyright holders of the photographs in this book.

Martin Armstrong 78(top left).

Bart Barlow 60(top left).

Susan Bernstein: 12(right), 32(left), 33(top), 38, 42, 43(top), 72(top, bottom left).

Marcello Bertinetti: 15(right), 39(top), 162(left), 164(bottom), 277.

John Calabrese 60(top right).

Cyr Color Photo Agency: James Blank 210(top), 224(left); William Crocker 130(top); John Diehl 151(right); Donald Folland 210(bottom); Robert Harry 100(top right); Sheryl McNee 148(top); Claude Newman 100(top left); Roland Paine 218(bottom); Adolph Rohrer 158(bottom); Bruce Romick 72(bottom right), 171; John Sohlden 152(bottom); Charlotte Storkamp 140(left); Tom Swift 71(top); Donald Wright 237.

Dartmouth College, Hanover, NH 26(left).

Dale Fisher 155(top right).

The Freelance Photographers Guild: 64, 93, 97, 101, 121, 169(top), 172, 197(bottom), 203(top right), 212, 216(top, bottom), 218(top), 219, 254(bottom), 255, 295; G. Ahrens 230(top); J. Blank 34(bottom), 37(top right), 228(bottom right), 233; B. Byer 24; R. Caton 265(bottom); E. Cooper 269, 270; F. Dole 55(right); A. Kearney 261; J. M. Kordell 230(bottom); R. Laird 229; Marmel Studios 62; Messerschmidt 228(bottom left); E. Nagle 17(top right); S. Osolinski 248(top); Romei 279; G. Rowell 268(top left); O. Schatz 268(top right); Sigl 27(bottom); F.G. Thoreau 248(bottom).

Jeff Gnass 17(bottom right), 179, 198-99, 213(top, bottom), 217, 227, 254(top).

Hillstrom Stock Photo: Ray Hillstrom 184(top); Marge Lawson 187(bottom); James P. Rowan 165, 177, 183(top), 187(top).

Phil Kramer 74(bottom).

New England Stock: Mark A. Auth 249, 250(bottom), 251, 252(all three), 253; Bill Bachmann 77(bottom left), 241; Dan Beigel 84(top), 86(left); Thomas P. Benincas Jr. 50; Roger Bickel 6-7, 138-9, 152(top), 153, 154, 155(top and bottom left), 159, 180, 181(both), 257(top), 257(bottom), 290(bottom), 302(top); David Blankenship 203(top left), 262(bottom), 266, 294(top); Kip Brundage 21(top), 67(bottom); Michael Carroll 49; Peter Cole 65(top), 178(top), 246, 247(both), 280(bottom), 281; Alan Detrick 61, 63(both); Brooks Dodge 22(both), 30(bottom); Fred M. Dole 11, 28(both), 31; Catherine L. Doran 203(bottom left); Travis Evans 122, 136(top right, bottom); Alison Forbes 22(bottom), 259; Jay Foreman 191(bottom right); Bradford Glass 235; Robert K. Grubbs 242(right), 244; Michael J. Howell 189, 206, 223(both), 263, 271(top), 298; Betty R. Johansen 207(left, top right); Arnold J. Kaplan 41; K.L. Kilskey 30(top); Grant Klotz 4-5, 275, 278(right), 282, 283(bottom), 284(left), 285, 287(top); Tony LaGruth 59; Jackie Linder 54; Barbara L. Moore 78(right), 104(bottom), 124(top), 207(bottom right), 209; Paul Peterson 240(top); Art Phaneuf 32(right), 52(top right); L. O'Shaughnessy 26(right); Lou Palmieri 67(top right); Brent Parrett 82, 83(top), 89; Dusty Perin 232; Mark Picard 19; David E. Rowley 238, 240(bottom), 271(bottom), 272(bottom); Dave Rusk 147, 170, 173(both); Darrin A. Schreder 236(top), 239(both); Jim Schwabel 66, 67(top left), 75, 107, 108, 124(bottom), 125, 130(bottom), 131, 149, 280(top);

Kevin Shields 21(bottom), 99, 102(bottom), 103; Frank Siteman 37(left), 40(left), 228(top); W.J. Talarowski 73, 86(right), 88, 90(both), 91, 236(bottom), 250(top).

Jack Olsen 178(bottom), 204.

Rainbow: Bill Bachmann 1, 56(bottom); Larry Brownstein 226, 231, 243, 258(top), 267, 271(bottom), 272(top), 273, 274, 293, 301(both), 303; Christiana Dittmann 2-3; Michael J. Doolittle 56(top right), 57; T.J. Florian 94(top), 140(right), 148(bottom), 158(top), 160(top), 162(right), 163(bottom), 200(bottom), 256; Jean Kepler 283(top); Maggie Leonard 114(top); Steve Lissau 291, 296(top left), 297, 300; Coco McCoy 56(top left); Dan McCoy 65(bottom), 69, 70(left), 71(bottom), 80, 118(bottom), 143(both), 150, 193(top), 294(bottom); William McCoy 119; Bonnie McGrath 35, 215; Hank Morgan 29, 37(bottom), 197(bottom right); John Neubauer 109(top left); Chris Rogers 205, 211; Stephen Rose 40(top), 44(top); Frank Siteman 106(bottom), 129; Bill Stanton 95; Ted Thai 296(bottom); Hardie Truesdale 47(bottom right), 68.

Rhode Island Dept. of Tourism 44(bottom), 48(top).

H. Armstrong Roberts: 36(top), 96(bottom); J. Irwin 14; R. Krubner 53; F. Sieb 45.

Nick Romanenko: 39(bottom), 43(bottom).

Root Resources: Kenneth Fink 186; Larry Schaefer 182; Mary M. Tremaine 183(bottom).

John R. Savage 156(top, bottom), 167, 169(bottom).

Ron Schramm 164(top).

Blair Seitz, Seitz and Seitz Inc., Harrisburg, PA 74(top).

Sheraton Public Relation Dept. 292(top

left).

Jerry Sieve 12(left), 13, 40(bottom), 104(top).

Southern Stock: 105, 106(top); Billy E. Barnes 175(bottom), 225; Scott Berner 142, 166(both), 168, 185, 191(top right), 245(bottom), 260; James Blank 81, 115, 133, 138; Matt Bradley 191(bottom left), 220(top); Melanie Carr 276(top right); J. Christopher 288; C. Davidson 184(bottom); Mark E. Gibson 123(top), 127(bottom right), 156(top right), 221, 290(top); Henry Fichner 16; T.J. Florian 141, 163, 174, 223(top); Everett Johnson 92(both), 94(bottom), 96(top), 102(top), 134, 175(top); William Koplitz 18, 20; Ralph Krubner 264, 265(top); John Laurence 114(bottom); David Lissy 199(bottom), 201; Jim McNee 195, 222; Ernest Manewal 276(both), 289(both); William Metzen 113(top), 117(top left), 132(bottom left), 137, 190, 220(bottom); Jeffry W. Myers 262(top); Timothy O'Keefe 117(top left), 117(bottom left), 214, 278(left); Jim Pickerell 32(bottom), 84(bottom), 100(bottom); Todd Powell 78, 79, 199(top), 202, 258(bottom); Les Reiss 136(top left), 144, 145(top), 145(bottom); Jon Riley 60(bottom), 110, 118(bottom); A. Rohrer 157; Pete Saloutos 245(top), 299; Jim Schwabel 34(right), 76, 109(top right, bottom), 111(bottom), 120(top), 120(bottom), 127(bottom left), 128(top), 128(bottom), 132(top), 132(bottom right), 135; Arthur Sirdofsky 70(right), 176(left); Edward Slater 111(top), 113(bottom), 123(bottom), 302(bottom); Scott B. Smith 116; Richard Stockton 191(top left), 192, 286, 287(bottom); Jim Tuten 112.

The Stockhouse: S. Berner 194(bottom); K. Krueger 193; J. McNee 194(top).

The Stock Market: J. Ceshin 196; J. Ellenburg 197(top).

State of Connecticut 52, 55(left).

Strawberry Banke, Portsmouth, ME 27(top).

Barry Tenin 47(top, bottom left).

Tennessee Photo Services 126, 127(top).

Angela White 15(left).

Acknowledgments

The author and publisher would like to thank the following people who helped in the preparation of this book: Mike Rose, the designer; Susan Bernstein, the editor; and Rita Longabucco, the photo researcher.